John Shaw's
NATURE
PHOTOGRAPHY
FIELD GUIDE

AMPHOTO BOOKS

An imprint of Watson-Guptill Publications
New York

To Andrea. I love you more every day.

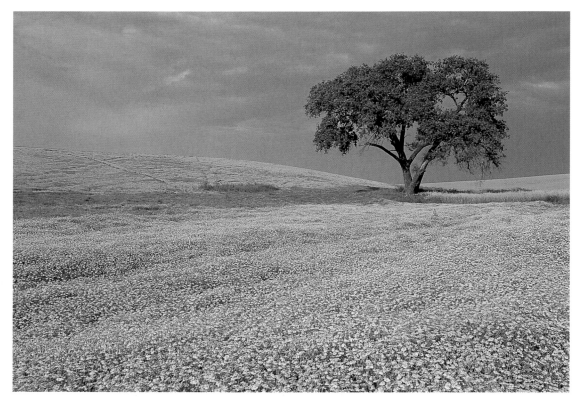

COTTONWOOD TREE IN FARM FIELD, WASHINGTON.
Nikon F5, Nikon 20–35mm lens, Fuji Velvia.

Copyright © 2000 by John Shaw

First published in 2000 by Amphoto Books,
an imprint of Watson-Guptill Publications,
a division of VNU Business Media, Inc.,
770 Broadway, New York, NY 10003
www.amphotobooks.com

Library of Congress Cataloging-in-Publication Data
Shaw, John, 1944-
 [Nature photography field guide]
 John Shaw's nature photography field guide / John Shaw.--Rev. ed.
 p. cm.
 Rev. ed. of: The nature photographer's complete guide to professional field techniques. 1984.
 ISBN 0-8174-4059-3
 1. Nature photography. I. Title: Nature photography field guide. II. Shaw, John, 1944-
. Nature photographer's complete guide to professional field techniques. III. Title.

TR721 .S52 2000
778.9'3--dc21

 00-042013

Manufactured in Malaysia

7 8 9 / 08 07 06

Cover:
MT. RUNDLE AND VERMILLION LAKE, BANFF
NATIONAL PARK, CANADA.
Nikon F4, Nikon 35–70mm lens, Fuji Velvia.

Title page:
PRAIRIE SUNFLOWERS BLOOM ON THE DUNES IN
MIDSUMMER, GREAT SAND DUNES NATIONAL
MONUMENT, COLORADO.
Nikon F5, Nikon 28–70mm lens, Fuji Velvia.

Senior Editor: Victoria Craven
Project Editor: Sarah Fass
Designer: Jay Anning, Thumb Print
Production Manager: Ellen Greene
Text set in 9-point Minion

CONTENTS

PREFACE

In 1984, Amphoto Books published my first book, *The Nature Photographer's Complete Guide to Professional Field Techniques*. While many of that book's lessons are still valid—after all, we still use tripods, good lighting continues to be good lighting, and closeups can still be worked in different ways—many aspects of nature photography have changed. I think the four innovations that have made the biggest impact on field photography are autofocus, autoexposure, the much wider palette of new films, and TTL flash.

While *John Shaw's Nature Photography Field Guide* does update some of the content of the earlier book, it is designed as a stand-alone product. However, it is not in any way intended as a final word on how to take nature pictures. Rather, it is a detailed description of the methods I currently use. I hope you will consider this work a starting point for your own explorations with a camera. Nature photography is always changing, always evolving—new products and new techniques come along all the time. I encourage you to develop your own way of working, your own equipment choices, and most of all, your own vision.

As you read the book, you will notice that I frequently refer to Nikon equipment. I do not in any way mean to imply that you should buy only Nikon products, although I've been very pleased with the system. I have worked with Nikon equipment all my professional career (I hate to say it, but that's close to thirty years now!), and I photographed my own equipment when needed for illustration. However, quality nature photos can be taken with any currently produced photographic system.

You will also notice that I don't give any specific exposure information for the photos in this book. I don't keep track of this information and see no reason to do so. After all,

I'll never again be in the exact same location in the exact same light. The camera model, lens, and film *are* noted, and are correct to the best of my knowledge.

In this age of computer-manipulated images, I feel compelled to state that none of the photographs in this book has been digitally altered. They appear as I took them in the field. I have no quarrel with those who do computer work on their images, as long as it is clearly noted that such changes have been made. I'm not anti-Photoshop; far from it. I use the program when making prints of my images, both for my own enjoyment and for sale, and I think the digital darkroom is the best means of achieving a print that corresponds to my vision at the moment I tripped the shutter.

In all of my books, I have included a sentiment that I will repeat here:

To be a better nature photographer, be a better naturalist. The more you know about nature, the more you will see to photograph. Develop a deeper compassion for the world around us, and live by an ethic of concern for the subject matter.

However, I was stunned recently by a reader's two-part question. First, he asked how becoming a naturalist could possibly improve his photography. To me, the answer is obvious. I would assume that you actually enjoy nature and the out-of-doors, and that you reap some spiritual benefits from it. Well, this passion should show itself in your work; otherwise, you're photographing for prize ribbons and not for the benefit of your inner self. In addition, learning about your subject matter will naturally lead you to many more photo opportunities. For example, learning about how dew forms leads to learning where to find a dewy meadow,

which leads to photographing dew-covered butterflies, which leads to learning how meadows, butterflies, and dew all fit together into one ecological system.

The second part of my reader's question was why, if I think being a naturalist is so important, I dwell so much on equipment. Or, to use his phrase, why am I a "gear-head"? I thought the answer to that question was also obvious. The more diverse the nature subjects you want to photograph, the more diverse your equipment has to be. You can't work birds and mammals with a 50mm lens (well, I should say emphatically that you *shouldn't,* because the close approach it requires creates stress for your subjects); you need a long lens. Along similar lines, if you want to photograph landscapes incorporating close foregrounds and distant horizons, you need a wide-angle lens. Is it possible to photograph with only one lens? Of course, but it's limiting. As a professional photographer, I use a vast array of equipment; cameras and lenses are the tools of the trade.

For a more complete discussion of certain specific aspects of nature photography that form only a part of the content of this book, I refer you to my other books, all of which are published by Amphoto:

The Nature Photographer's Complete Guide to Professional Field Techniques

John Shaw's Closeups in Nature

John Shaw's Focus on Nature

John Shaw's Landscape Photography

John Shaw's Business of Nature Photography

Finally, if you would like more information about my work, or about the workshops and tours I lead, check my Web site:
www.johnshawphoto.com.

KOALA IN EUCALYPTUS TREE, AUSTRALIA.
Nikon F4, Nikon 400mm lens, Fuji Velvia.

Recording great natural history subjects by using good photographic technique should be the goal of all nature photographers.

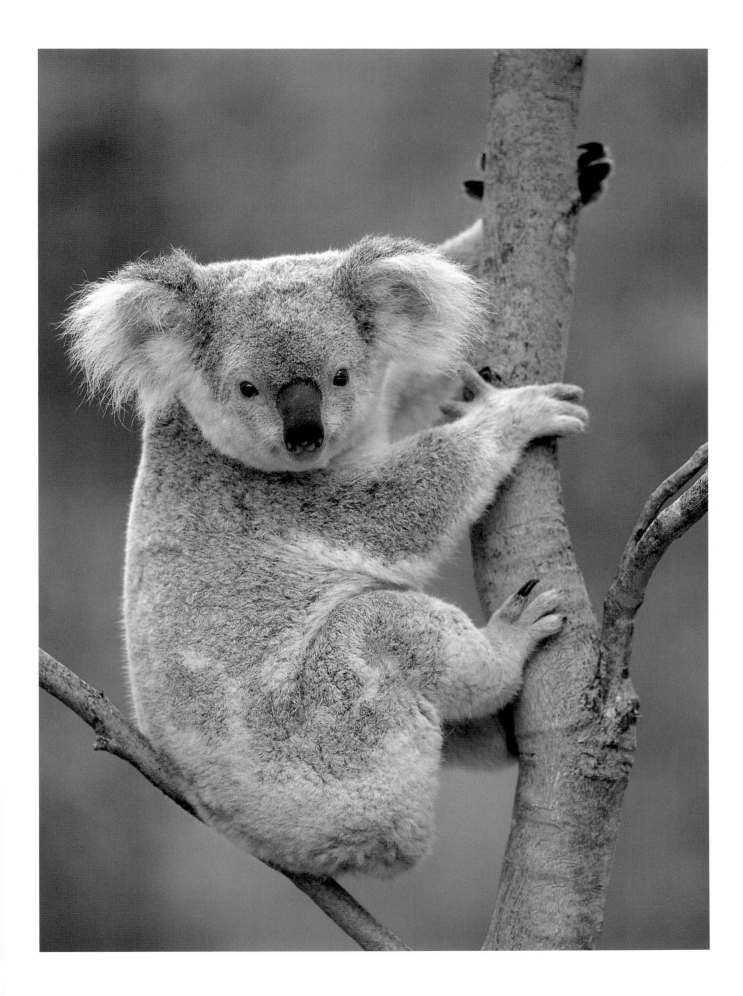

Introduction: What Is There to Photograph?

Each year, I travel the globe to take pictures, often leading photo tours or workshops. The people in these groups are specifically interested in photographing the natural world, yet it's on these trips that I inevitably hear the question, "What is there to photograph?"

Truly this is the wrong question to ask; it leads photographers to take pictures that are empty of emotional content. Without passionate involvement, our pictures are nothing more than records. The question we should always be asking is "What is there to discover?" Only after we have let our minds and eyes deal intimately with the abundance of natural marvels around us should we attempt to photograph them.

Photography should be both a process of discovery and a procedure for recording that discovery. In the process of photography, we order the chaos of the world around us by making decisions. We decide to emphasize one aspect of the world—what we have discovered—and ignore all others. We want to represent that subject in a way that conveys how it has emotionally involved us. To do this, we must make conscious decisions: what to include within the photographic frame and how to organize the content. At this point, the procedure of photography enters. Now we must make technical choices involving the mechanics of photography: lenses, films, light, and exposure.

The photographic process should be deliberate and studied. Structuring our visual environment is the role of composition, but that structure doesn't just appear from nowhere. Nor is the procedure of choosing lenses, films, and exposure automatic. We must become adept in dealing with both the aesthetics and the mechanics of photography; otherwise, our results will be failures.

Photography's dual nature has always fascinated me. In a good photograph, both aspects work in tandem, neither overwhelming the other. Form and content go hand in hand to produce a synthesis, an interesting work that engages both the viewer's mind and emotions. To achieve this synthesis, you, the photographer, must play two simultaneous roles as well. On one hand, you must be a poet and an artist, opening yourself to the

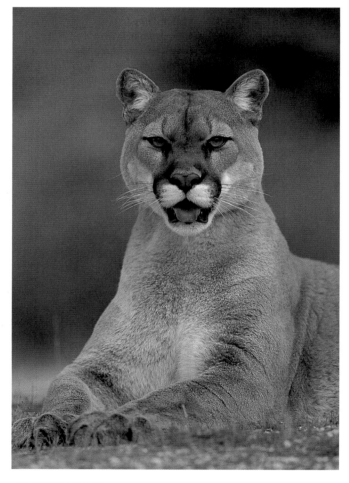

COUGAR (CONTROLLED SITUATION).
Nikon F5, Nikon 300mm lens, Fuji Velvia.

As the cougar turned its head to look directly at me, I fired a motor drive burst. However, even this was planned. I had positioned my tripod low to the ground, so that the camera would be at the cougar's eye level. The cat was looking off to one side, but I composed for when it would turn its head. I knew what I wanted: a straight-in-your-face picture.

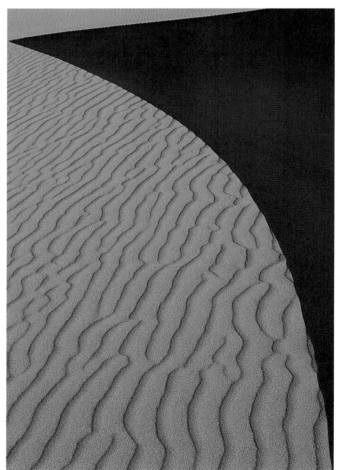

EDGE OF SAND DUNE, GREAT SAND DUNES NATIONAL MONUMENT, COLORADO.
Nikon F5, Nikon 85mm T/S lens, Fuji Velvia.

Here's a photograph reduced to its most basic design elements. I eliminated all the normal visual indicators such as a horizon line, forcing the viewer to deal directly with just two things: the curving line and the sand's texture.

intuitive and mystical world of your inner vision. On the other hand, you must be a technician, rationally dealing with shutter speeds, *f*-stops, and focal lengths. Vision without craftsmanship is as much a failure as craftsmanship without vision. We've all seen photos that are intensely personal and emotional, yet lack any technical competence. We dismiss these as lacking organization, and think the creator cannot control the medium. We've all also seen photos that are technically superb but have no soul. These are aesthetically insipid, dull, and uninspiring works.

Most people have more difficulty with the technical aspect. We all see images in our mind's eye . . . but how to record these on film? We take an interesting trip, but the resulting pictures seem to have little relationship to our experiences. Why? I'm con-

vinced that the main factor is that most of us are only occasional photographers. We're always starting over in the learning process—we never get past the basic techniques. A solution that many people adopt is to buy a fancy camera, then set it in autofocus, autoexposure, auto-everything mode, so that they don't have to think about what the camera is doing. However, this means that they have abdicated their photographic responsibilities; they have become camera-carriers, not photographers. They are allowing a machine to make decisions for them without learning how to control the machine.

I'm always amazed by people who say that cameras are much too complex for them to learn to operate. I've seen people who are otherwise extremely competent become helpless when dealing with *f*-stop numbers

or using a tripod. Yet these same people are doctors, lawyers, teachers, and computer programmers—people who make complex decisions every day. A camera is only a machine, and no more a technical mystery than any other machine. If you can drive a car, ride a bicycle, or turn on a computer, you can operate a camera.

Mastering the technical nature of photography frees you to concentrate on the aesthetic side; that's why I emphasize technique so much. If you're fumbling around with lenses and tripods, your inner vision will soon evaporate. You want to reach the point where technical mastery is second nature—where you can concentrate on the image instead of having to focus on the procedure. Control of both sides of photography, the technical and the aesthetic, is needed so that you can produce the best images possible.

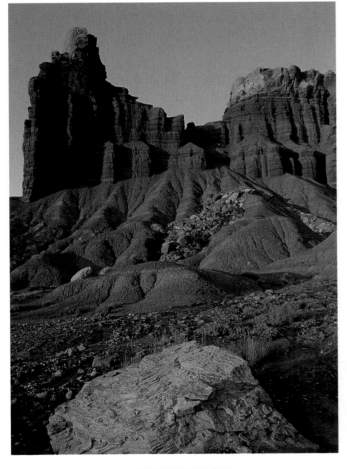

THE CHIMNEY FORMATION, CAPITOL REEF NATIONAL PARK, UTAH.
Nikon F5, Nikon 20–35mm lens, Fuji Velvia.

This photo was taken at the very last light of day, with the sun on the horizon. If it had been much earlier, the light would have been far too contrasty, too harsh. Minutes later and there would not have been any light at all. Here it's directional, but soft and warm—what I have always called the "sweet" light, a perfect moment to photograph.

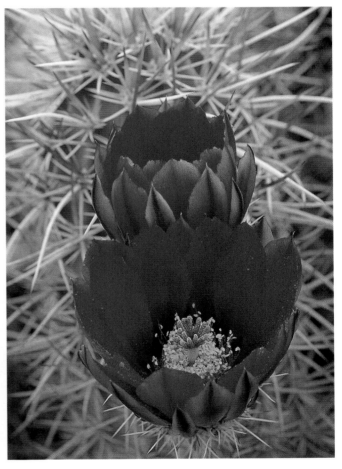

STRAWBERRY HEDGEHOG CACTUS, JOSHUA TREE NATIONAL PARK, CALIFORNIA.
Nikon F4, Nikon 200mm macro lens, Fuji Velvia.

Two aspects of this cactus struck me most: the brilliant Day-Glo color of the blossom and the contrast created by the delicate flower being surrounded by a halo of needles. I tried several compositions before I settled on this one.

EXPOSURE

1

AUTUMN COLOR, WHITE MOUNTAINS, NEW HAMPSHIRE.
Nikon F5, Nikon 80–200mm lens, Fuji Velvia.

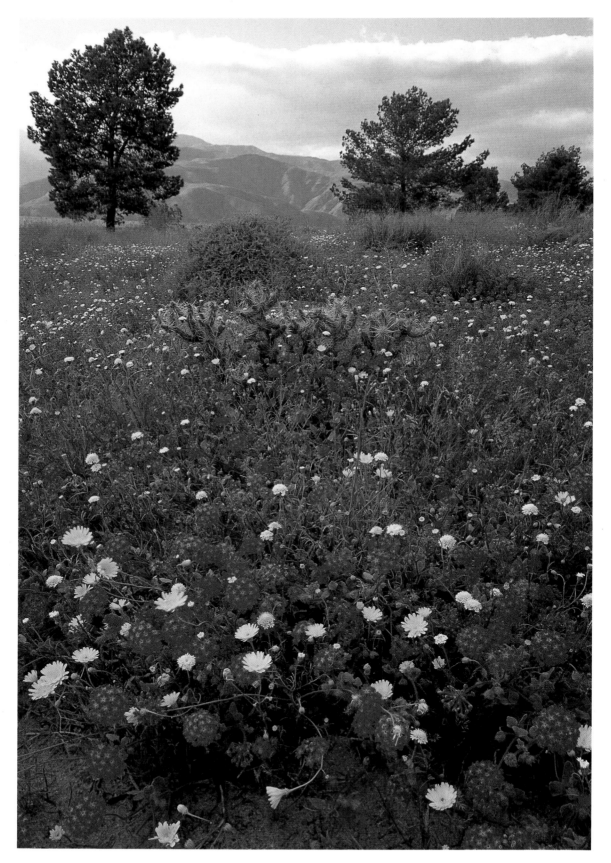

MOJAVE DESERT IN BLOOM: SAND VERBENA AND DESERT
DANDELION, ANZA-BORREGA STATE PARK, CALIFORNIA.
Nikon F5, Nikon 35–70mm lens, Fuji Velvia.

*Many of nature's most beautiful displays, such as this lush bloom of spring
flowers in the Southern California desert, are fleeting. A thorough knowledge
of proper exposure allows you to capture these ephemeral events.*

BASIC THEORY OF EXPOSURE

Recording a proper exposure on film is, without a doubt, the major problem facing all photographers, whether working professionals or amateurs. Make a mistake at this point, and all else is for naught. You can own the latest and most expensive equipment; you can travel to the most exotic locales; you can be at the perfect spot at the perfect time in the perfect light; your photographic technique can be precise . . . but expose the film incorrectly and all you've created is a pile of images to toss directly into the trash.

For far too many photographers, achieving proper exposure means shooting at whatever exposure their camera's built-in exposure meter suggests. But does the meter always give you the correct exposure settings? I would argue quite strongly that if you want to become a better photographer, the place to start is with a thorough understanding of exposure theory, since exposure is the most basic photographic concept. If you gloss over the basics of photography, you can't expect to deal successfully with advanced techniques.

I assume your pictures are important to you, or else you wouldn't be reading this book. If you want to take credit for making good pictures, then you should be in control of the entire exposure process. Control *could* mean taking one photo at every possible exposure setting on the camera and picking out the good shot later, but that is an incred-

ible waste of film and time. And if you practice such a method, how can you record that once-in-a-lifetime moment when you get only one chance? Your goal should be to be prepared for all situations, knowing that you'll get whatever picture you want. This certainly doesn't mean you'll always have to work with manually set exposure values, although I personally believe that a camera's manual mode is the easiest to use, because what you set is what you get. You can take great photos with your camera set on "aperture priority" or "shutter priority" as long as you are aware of what choices the camera is making, are knowledgeable enough to properly evaluate these choices to see if they are the settings you want, and know how to override them if necessary. As a photographer, you should always be in charge of the equipment, not the other way around.

Before I start discussing how to make an exposure, let me define some terms which are commonly misused and misunderstood. *Correct exposure* means getting your pictures back exposed the way you wanted them to be exposed. For example, let's say you're taking a photograph of a sandstone formation in Arches National Park against a light blue sky. If you want the sky to be rendered on film as a light blue, and indeed it comes out that way, then you've achieved correct exposure. You got exactly the results you wanted. You've done a good job when what

you consider to be the most important tones in a photo appear just the way you wanted them to.

So, what if that light blue sky does not turn out light blue? Now you've made an error in your exposure settings. If the tone turns out lighter than you wanted it to be, you've *overexposed* the film. In this case the light blue sky would be rendered as a pale, washed-out whitish blue, far lighter than what you had visualized when you took the shot.

Of course, the opposite problem occurs when a tone appears darker on film than what you wanted it to be. For example, that same light blue sky could appear on your slide as a medium blue or even a darker navy blue. Now you have *underexposed* the film. But if a dark tone in the subject actually turns out that way, you've properly exposed the film.

In short, correct exposure means tonal values turn out the way you wanted them to be; overexposure means that these values are lighter than you wanted; underexposure means they are darker than you wanted. Notice that in all three cases I have not mentioned the exposure meter in your camera. Achieving correct exposure has nothing to do with either meter readings or values set by an automatic exposure system, per se. An exposure meter suggests using a certain exposure level; these may or may not be the correct

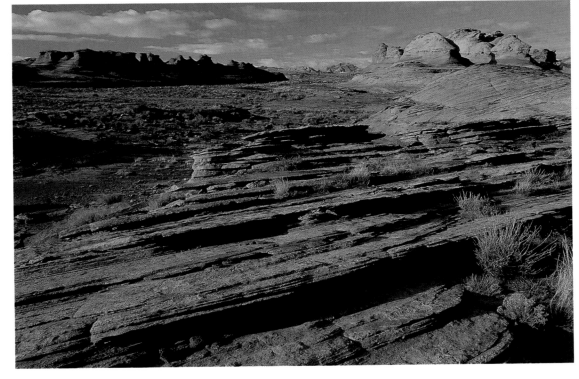

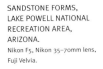

SANDSTONE FORMS,
LAKE POWELL NATIONAL
RECREATION AREA,
ARIZONA.
Nikon F5, Nikon 35–70mm lens,
Fuji Velvia.

Here's a fairly easy photograph to take. Most of the image is average in tonality, the light is consistent, the subject's not going anywhere, and I had lots of time to compose the image.

settings. If you always follow the exposure meter in your camera—for example, if you set your camera on "autoexposure" and just leave it there—you may or may not get back good results. The question is, are these the results you wanted? Why leave this to chance? One solution is to use negative film (which can deal with gross exposure problems better than slide film can) and correct any problems when prints are made. However, relying on fixing exposure problems later is no real answer. There's a lot of truth in the old saying "Garbage in, garbage out." Far better to do it correctly in the first place.

I once read an article about asking the typical man in the street to define "photographic quality." It turned out that for most people, "quality" meant you could recognize yourself. It didn't matter if things were out of focus; it didn't matter if parts of the picture were burned out; it didn't matter if colors were off. Well, I trust that this definition is far from acceptable to you. If you're about my age, you can remember when the first color televisions became available. You would go over to your neighbors' house, the first people on the block to own one, and there was the television displaying horrible, garish colors. But so what if Ed Sullivan's face appeared orange or purple? At least it was in color!

Thank goodness we've passed this point and are now more visually discriminating. Let's be that way not only with television sets but with our photographs also. What really makes a person a good photographer is not a special lens or a unique film or a rare filter known to no one else. What makes a good photographer is the use of proper photographic technique, which includes a thorough knowledge of basic exposure control. Your goal is to repeatedly achieve correct exposures, regardless of lighting conditions or location problems. Rather than leaving the photographic process to chance, you want to be able to produce technical quality whenever you want, precisely and proficiently.

Controlling exposure is, in my opinion, the most basic yet most critical aspect of the photographic process. You must be able to render on film the image you visualized before you tripped the shutter. I know there is a learning curve involved—the pictures you keep as a beginner might well be discards for the advanced photographer. Not to worry; your level of control will increase as you keep working. The goal is not to become a technocrat slavishly following a formalized set of step-by-step rules, but rather to have the complete understanding of exposure basics that allows you to grow and develop as a photographer.

Let me review some essentials so that we can discuss exposure with a common vocabulary. The entire photographic process connected with exposure revolves around the concept of stops. A *stop* is defined as a doubling or halving of any value. It's always relative, since you can have twice as much, or half as much, of any given value. This doubling or halving concept underlies all exposure discussion; the more you can think and work in stop increments, the easier exposure control will become.

There are three things that determine the actual exposure you use for any photograph: the shutter speed you set on the camera body, the aperture you use on the lens, and the type of film you load. *Shutter speed* expresses the length of time the camera's shutter blades are open, allowing light to fall on the film. The number refers to the duration of time (in seconds) that light can affect the film. *Aperture* is a measurement of the size of the lens opening, the hole through which light passes to strike the film when the shutter is open. Aperture settings control the light intensity, allowing more or less light to pass through the lens. These settings are normally expressed as a series of *f-stop* numbers. *Film sensitivity* expresses how quickly a film will chemically react to a given light level; it is normally expressed as an *ISO number* rating. All three of these variables work in the doubles and halves progression of stop increments, and all three are related to each other. Let's discuss each variable individually, and then I'll explain their interdependence.

SHUTTER SPEED

Shutter speeds are indicated in seconds and fractions of seconds in a progression of times. Camera bodies from different manufacturers have various starting and ending points on this scale, but the scale itself is what's important. All 35mm single-lens-reflex (SLR) cameras will have at least the following sequence (and probably a lot more): 1, 1/2, 1/4, 1/8, 1/15, 1/30, 1/60, 1/125, 1/250, 1/500, and 1/1000 sec. Few cameras display the fractions as written;

GENTOO PENGUIN, JUST EMERGED FROM THE OCEAN, ANTARCTIC PENINSULA.
Nikon F5, Nikon 300mm lens, Fuji Velvia.

Proper exposure was imperative for the success of this photo, since the penguin's breast and the snow both had to appear white. Can you tell where the camera was located? I was stretched out flat in the snow, so that my lens was at the penguin's eye level.

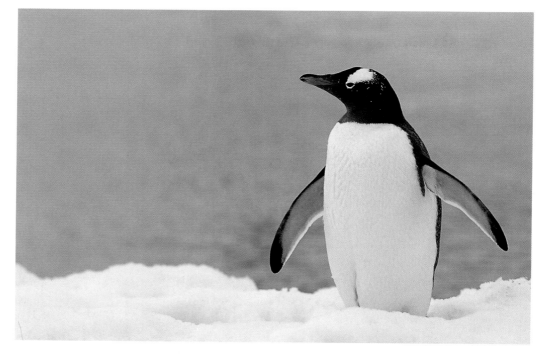

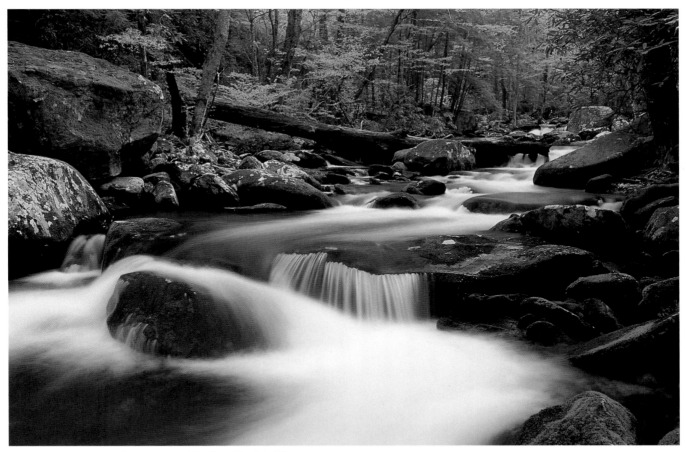

COSBY CREEK IN SPRING, GREAT SMOKY MOUNTAINS NATIONAL PARK, TENNESSEE.
Nikon F5, Nikon 28–70mm lens, Fuji Velvia.

I used a slow shutter speed of several seconds, which recorded the water as a silky flow. This shutter speed was dictated by my choice of Velvia, a slow film, and by the small f-stop I needed to use for depth of field.

instead, they abbreviate the shutter speeds, displaying "1/30" as "30." To differentiate between full seconds and fractional speeds the numbers may be color coded or have an additional mark next to them. For example, both Nikon and Canon cameras display all fractional speeds as just a number but add a " mark as an indicator of seconds. Thus 2" means 2 seconds, not 1/2 sec. Read your instruction manual carefully to figure out the system used on your camera.

If you look at the shutter speed sequence above, you'll see that each time value is half the preceding speed and double the following speed. For example, 1/125 sec. is half the time of 1/60 sec. and double the time of 1/250 sec. Each of these is a 1-stop change, since a stop is defined as a doubling or halving of any value. Going from 1/125 sec. to 1/250 sec. is a 1-stop shift (one halving), to 1/500 sec. is another stop (another halving of time), and to 1/1000 sec., a third. So here's a

little quiz: How many stops are there from 1/30 sec. to 1/500 sec.? And, going in the other direction—toward the longer times—how many stops are there from 1/30 sec. to 1/2 sec.? Did you come up with the right answers? Both sets of shutter speeds are separated by 4 stops.

When set in certain autoexposure modes, most cameras have so-called "stepless" shutter speeds. All this means is that the shutter can be electronically governed to set at any speed, not just one from a fixed progression. But even if your camera is set to a mode like this, the doubles and halves concept of stops still applies. Most newer cameras have shutter speed settings available in 1/3-stop increments. For example, my Nikon camera's shutter speeds include: 1/8, 1/10, 1/13, 1/15, 1/20, 1/25, 1/30, 1/40, 1/50, and 1/60. From 1/30 to 1/60 sec. is a one-stop shift, as is from 1/20 to 1/40 sec. or 1/13 to 1/25.

As you change shutter speeds, you change

the way in which motion is recorded on film. The faster the shutter speed, the more an image will be a recording of a moment frozen in time. Conversely, the slower the shutter speed, the longer the time the film is recording and, therefore, the blurrier the image.

APERTURE

The apertures on a lens, marked with f-stop numbers, also work in stop values. However, even though they represent a progression of doubles and halves, the numbers are not themselves doubles and halves. A standard f-stop series would be f/1, f/1.4, f/2, f/2.8, f/4, f/5.6, f/8, f/11, f/16, f/22, and f/32. Not all lenses will have all these numbers, while some, especially those used with film formats larger than 35mm, will have additional ones. The important thing to remember is that this sequence represents the varying hole size in a lens (the aperture) through which light passes. The f-stop series above is

in full stop increments. Each aperture allows twice as much or half as much light to pass as the preceding or following aperture.[1] Memorize this series of numbers; perhaps instead of singing in the shower, you can count off the f-stop numbers both forwards and backwards.

Although they are not regularly written as such, f-stop numbers are actually fractions. Thinking of them as fractions will help you realize that the larger the number, the smaller the hole actually is, and therefore less light is passed through the lens. For example, f/2 represents a fairly large hole that admits a lot of light, while f/22 is quite a small opening, admitting only a small amount of light. Think of these as fractions: 1/2 is a lot larger than 1/22.

Today, many cameras have digital readouts, allowing apertures to be set in 1/3 f-stop increments in the same manner as shutter speeds. For example, you might find this progression of f-numbers: 4, 4.5, 5, 5.6, 6.3, 7.1, 8, 9, 10, and 11. Just remember that a 1-stop change is a 1-stop change, regardless of where you start. Going from f/4 to f/5.6 is a 1-stop shift, as is changing from f/11 to f/8. But so is switching from f/5 (1/3 stop before f/5.6) to f/7.1 (1/3 stop before f/8) or from f/6.3 to f/4.5. The doubles and halves concept still applies, just not in a linear numerical fashion. I might mention that a few cameras are set up to read out in 1/2-stop increments and some, such as the Nikon F100, are programmable for full stops, 1/2 stops, or 1/3 stops. Once again, read your camera's instruction book.

Very few current lenses actually have manual aperture setting rings on them. Nikon lenses still have this feature (as do almost all lenses made for larger film formats). You can set the ring anywhere, even if it has "click-stop" detents. These "click-stops" are only there for convenience, so that you can count off the f-stops as you move the ring; they have no other meaning. Most lenses for larger formats have a simple scale and pointer. For example, I often use a panoramic camera that produces 6 x 17-cm images on 120 film. A typical lens for this camera has an aperture scale reading from f/5.6 to f/45, with the 1/3-stop increments indicated by little hash marks. A small lever connects to

an arrow pointer on the scale, and I can position it anywhere along this scale to set the f-stops—no "click-stops," no "detents," no digital readout of the f-numbers.

Two terms are traditionally used with respect to making a change in aperture. *Opening up* means going to a larger aperture, a wider hole in the lens. This means you're allowing more light to pass through the lens to the film. *Stopping down* is the reverse procedure. It means going to a smaller aperture, reducing the amount of light striking the film. Thus you open up as you go from f/8 to f/4, but stop down from f/8 to f/16.

Shutter speeds and apertures work together to control the amount of light hitting the film, and they must be thought of as a pair. They both work in stop values, and they are related to each other by what is called *reciprocity*. Once you know the amount of light needed for a correct exposure, then either the shutter speed or the aperture can be adjusted, as long as the other value in the pair is changed reciprocally. In terms of the actual amount of light available to the film, a 1-stop change in the shutter speed equals a 1-stop change in the aperture in the other direction. Double one scale and halve the other scale, and you end up in the same place.

Reciprocity is an important concept, so be sure you understand it. You could say that doubling the duration of the shutter speed and halving the intensity of light passed through the aperture is exactly the same as halving the duration the shutter is open while doubling the aperture's intensity. Let me give you two analogies. Let's say you want to draw a gallon of water. You could turn the tap on very hard for a short period of time, or you could have just a trickle of water for a longer period of time. It makes no difference; either way, you end up with a gallon of water. That's reciprocity. Or suppose you need to earn 20 dollars. You could work 5 hours at 4 dollars per hour, or you could work 4 hours at 5 dollars an hour (or for that matter, 2 hours at 10 dollars an hour, or 10 hours at 2 dollars an hour). However you manage this, you still end up with 20 dollars, and it's this final result that counts.

In photographic terms, you could use a slow shutter speed and a small aperture, or a fast shutter speed and a large aperture. Either way, the total amount of light actually hitting the film is the same. However—and this is an important point—the resulting images on film are *not* the same. The reasons for this will be explained in the sections on depth of field and subject motion control (pages 18–21). It's at this point that you, the photographer, have to start making some decisions about how you want your photograph to appear.

In practical terms, reciprocity means that once you have determined an exposure level, which you do by properly metering a scene (see pages 24–27), you are free to pick and choose shutter speeds and apertures while maintaining correct exposure. Let's say that 1/15 sec. at f/11 is the proper exposure for a scene. You could increase the shutter speed to 1/8 sec. (a 1-stop change, double the time) and decrease the aperture to f/16 (a 1-stop change, half the light). So 1/15 sec. at f/11, and 1/8 sec. at f/16 are equivalent exposures. For that matter, so are 1/4 sec. at f/22, 1/30 sec. at f/8, 1/2 sec. at f/32, and 1/60 sec. at f/5.6. All of these combinations allow the same amount of light to fall on the film, and all would be proper exposure. Knowing this, you can pick any shutter speed or any f-stop you want to use, and make the corresponding reciprocal adjustment.

In actuality, it is easier to do this with a camera in your hands than it is to talk about it. Count off the number of stops as you change either shutter speed or aperture, and count off this same number as you change the other setting. Just make sure you increase one amount and decrease the other, and you'll end up at the same equivalent exposure. For example, assume that 1/250 sec. at f/4 is the correct exposure. A 4-stop change in shutter speed to 1/15 sec. (an increased amount of time) requires the same 4-stop change in aperture to f/16 (a smaller hole) to maintain the same amount of light passing through to the film. If your camera has both shutter speeds and apertures working in the same increments, 1/2 stops or 1/3 stops for example, you can just count the number of "clicks" you change on the dials. "One-two-three" on one dial equates with "one-two-three" on the other.

FILM SPEED

The actual shutter speed and aperture you select will largely depend on what film you're using at the time. A film's sensitivity to light is expressed by its film-speed rating, or ISO number. Low ISO number films are called "slow" films because they need a lot of light in order to chemically react and record an image, while high ISO number films are called "fast" films as they need less light to do the same thing. Films with ISO numbers of less than 100 are usually grouped as slow films, those with ISO 100–200 are often referred to as medium-speed films, and those with ISO 400 and up are fast films. I'll talk more about films later, in the section devoted to them (pages 48–51), but I'll mention right now that as film speed goes up, image quality goes down.

As I noted earlier, film-speed ratings also work in stop values, the same doubles and

[1]Why such a weird progression of numbers? You might notice that each number is 1.4 times the preceding. Okay, let's do some middle-school math: apertures are holes in the lens, and are basically circular in shape. Let's write a formula so that a circle is twice the area of another circle. The formula for the area of a circle is πr^2. So . . . $2\pi r^2 = \pi x^2$. Solve for x and you get the square root of 2 (which is 1.4) times the radius. If r=1, the larger circle has a radius of 1.4; if r=1.4, x=2; if r=2, x=2.8; r=2.8, x=4. Wow, the f-stop sequence of numbers!

halves concept used by shutter speed and aperture. Once again, let me state that the more you learn to think in stop values, the easier it is to understand exposure. Film-speed ratings work in a straight numerical progression; each doubling or halving of the number represents a 1-stop change. From ISO 50 to ISO 100, there is a 1-stop difference. Continuing on to ISO 200 is another stop, and to ISO 400 is a third stop. It's easy to count stops as you double or halve the number. For example, how many stops difference are there between ISO 1600 and ISO 25? Yes, I tried to trick you by making you count backwards, but if you can do this correctly you obviously have understanding. So . . . starting at 1600 and halving the numbers we get 800, 400, 200, 100, 50, 25—for a total of 6 stops.

Knowing how the ISO numbers relate to each other helps in determining the film you need for any given situation. If you know the correct exposure for one particular film you can easily determine the correct exposure for any other film in the same light so long as you know the ISO ratings for both. Just work in stop increments. Start with your known exposure value and change it by the number of stops between the two film speeds. For example, if Kodak's E100S (ISO 100) is correctly exposed at 1/15 sec. at $f/8$, what is the correct exposure in the exact same light for Fuji's Provia 400 (ISO 400)? Count the stops difference in ISO rating—starting at 100 you double to 200, then once again to 400—and you'll come up with 2 stops. Take the E100S exposure and change it by 2 stops and you have correct exposure for the Fuji film. Let's change shutter speed: 1/60 sec. at $f/8$. Of course you could use any equivalent exposure: 1/60 sec. at $f/8$ is the same as 1/125 sec. at $f/5.6$ or 1/250 sec. at $f/4$ or 1/500 sec. at $f/2.8$ or, going the other way, 1/30 sec. at $f/11$ or 1/15 sec. at $f/16$ or 1/8 sec. at $f/22$.

The standard film speed number progression is in 1/3-stop increments.

25 32 40 **50** 64 80 **100** 125 160 **200** 250 320 **400** 500 640 **800**

Films are not available at all of these speeds, but just remember that doubling or halving the ISO number means a 1-stop change. ISO 200 is 2 stops slower than ISO 800, but 2 stops faster than ISO 50. From this sequence you can tell that Kodachrome 64 (ISO 64) is 2/3 stop slower than Provia 100F (ISO 100).

Some cameras won't show all these numbers because they don't have enough room on their display for all the numbers. The intermediate 1/3 increments are often represented by dots as follows:

25 ·· **50** ·· **100** ·· **200** ·· **400** ·· **800**

I might mention that on a few cameras you will find the intermediate f-stops or shutter speeds are also indicated by these dots. No big deal; there just wasn't enough space.

The concept of stop increments, this doubling and halving of values, is a basic tenet of photography. Learn to think of exposure in these terms. My work as a photographer, and this entire book, is based upon a comprehension of stops. If you're not comfortable with this idea, please take the time to reread this section. Understanding the fundamentals of exposure, and the concept of stops, will definitely help as you work towards becoming a better photographer.

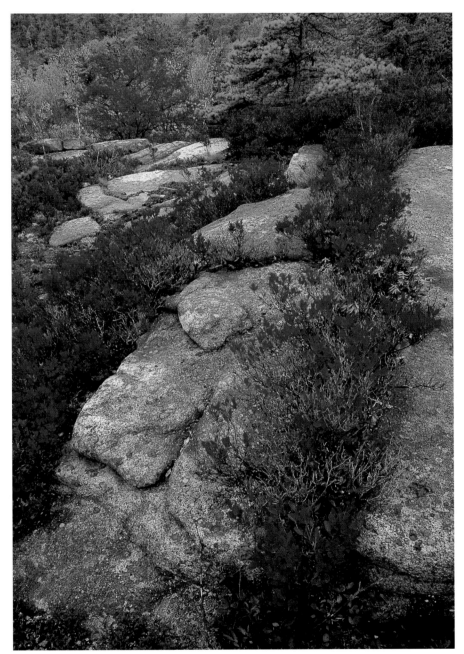

HUCKLEBERRY IN AUTUMN, GROWING IN GRANITE ROCKS ON CADILLAC MOUNTAIN, ACADIA NATIONAL PARK, MAINE.
Nikon F5, Nikon 20–35mm lens, Fuji Velvia.

The light was dropping rapidly when I took this photo. I took another meter reading after every few frames, slowing my shutter speed to maintain a constant aperture. Of course, the camera was mounted on a solid tripod—an absolute necessity when I work at long exposure times.

THE NON-METERED EXPOSURE: "SUNNY *f/16*"

Thank heavens for through-the-lens (TTL) exposure meters—they make photographic life much easier. In fact, we rely on them so much that if anything were to happen to our camera meters, we would feel lost and confused. I know there are some photographers who pride themselves on being able to estimate correct exposures, but I am certainly not one of them.

However, there is one situation where correct exposure is a known constant, and that's when you're photographing in bright sunlight. To arrive at the correct exposure values for this situation, you can follow a rule called *"sunny f/16": In bright sun (no high, thin clouds; no humidity haze; no pollution), from a few hours after sunrise until a couple of hours before sunset, the correct exposure for the average frontlit subject that is larger than a backpack is a shutter speed closest to the ISO of the film you're using and f/16, or any equivalent value.* Phew, that's quite a mouthful. Let's examine this rule in more detail.

First of all, "sunny f/16" only works in bright, direct sunlight. It's not for early morning or twilight, or for hazy, overcast days. It's not for midwinter days in North America when the sun is low on the horizon. "Sunny *f/16*" is not for closeups either, as many lenses change effective aperture when focused close. Theoretically, *f*-stop numbers are only accurate at infinity focus. Focus closer, and all the marked *f*-stops actually transmit less light. No big deal normally, as your TTL meter takes this into account. "Sunny *f/16*," however, is a *non*-metered exposure value, so it doesn't work when the numbers are changing around. It's also only applicable to frontlit subjects (where the light is coming over your shoulder and hitting the subject.) So, at high noon in the summer, when the sun is directly overhead, this rule applies only if you're looking straight down at your feet. If you are photographing normally, looking out at your subject, you'll have to modify the "sunny *f/16*" exposure for sidelighting, as I will explain shortly.

It also only works for subjects of average tonality, neither light nor dark. Most subjects are indeed average, or as photographers say, *middletoned.* Personally I don't like the word "middletone," because too many photographers always say "middletone gray," when we're talking about all tonalities, not just those of a black and white system. So let's call it "medium" instead. There is medium green, medium red, medium blue, and so forth.

Notice that when you follow the "sunny *f/16*" rule you don't have to use the actual values of the ISO number and *f/16*; you can use any equivalent exposure. And there is no mention of location in the rule. I've been asked if "sunny *f/16*" works when you're on a mountaintop. Well, since the sun is 93 million miles away from us, I don't think moving 10 or 12 thousand feet closer is going to make much difference one way or the other.

Let's assume you're using ISO 100 film. "Sunny *f/16*" for this film, under the proper conditions, is an exposure of 1/125 sec. at *f/16*, or any equivalent. You don't have to shoot at 1/125 sec. and *f/16* when working in bright sun conditions. You could use 1/250 sec. at *f/11*, 1/500 sec. at *f/8*, 1/1000 sec. at *f/5.6*, or 1/2000 sec. at *f/4*. Going to slower shutter speeds, you could photograph at 1/60 sec. at *f/22*, or 1/30 sec. at *f/32*. These exposures all represent the same amount of light hitting the film. If you have ISO 400 film, the

OLD LIMBER PINE,
GRAND TETON
NATIONAL PARK,
WYOMING.
Nikon F4, Nikon 35–70mm
lens, Fuji Velvia.

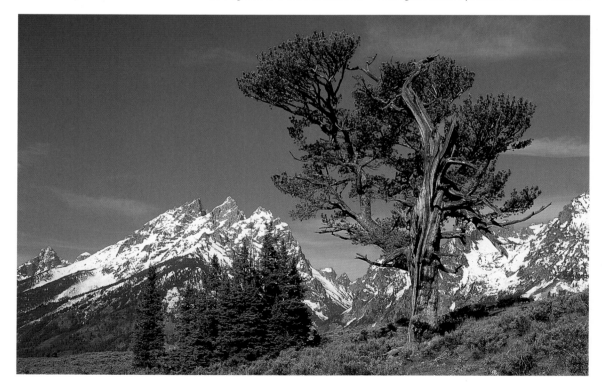

Here's a photo taken at the non-metered "sunny f/16" exposure values. Since I was photographing in bright sunlight, and the bulk of the tonalities were not at either end of the tonal scale, I could use this exposure without making any compensations. Did I actually shoot at f/16? Perhaps, perhaps not. But as long as I was at an equivalent exposure, the amount of light hitting the film remained the same.

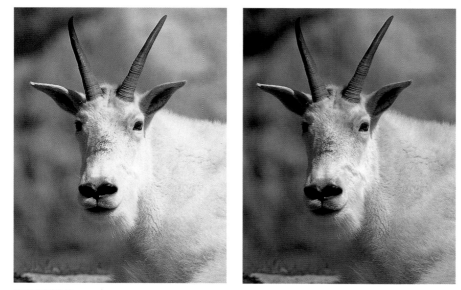

MOUNTAIN GOAT.
Nikon F5, Nikon 300mm lens, Kodak E100S.

I needed to stop down 1 stop from a standard "sunny f/16" exposure to cut the light hitting the film, in order to retain detail in the mountain goat's fur. When basing your exposure on the non-metered "sunny f/16" rule, this is the standard compensation for white subjects that fill the frame. Instead of "sunny f/16," I shot at the equivalent of sunny f/22.

starting point would be 1/400 sec. at f/16, while with ISO 25 film it's 1/25 sec. at f/16 . . . or any equivalent exposure.

Equivalent exposures use the same amount of light, so choose the values that are best suited to your photographic situation. Do you need a fast shutter speed to stop action, or a small aperture for depth of field? If you're photographing a running deer with ISO 50 film, should you use 1/50 sec. at f/16? Before you instantly say "no," think about it. Is there only one correct exposure setting for this situation? What if you want to create blurred images to impart a sense of motion? The correct shutter speed and aperture to use in any situation are totally dependent on how you want your image to appear. Correct exposure is entirely up to you.

Most of the time when you're doing wildlife photography you'll be using your longest lens and favoring shutter speed over aperture in order to stop motion. Counting over from f/16 to a wide aperture takes time, but there's an easier way. If you're in "sunny f/16" conditions, you can express the exact same exposure at a wider f-stop by using what I call "fast f/5.6." Take the ISO number of your film, add a zero, and that's the shutter speed at f/5.6. Let's check this with ISO 100 film. "Sunny f/16" gives 1/125 sec. at f/16, while "fast f/5.6" yields 1/1000 sec. at f/5.6. Are these the same? Count the stops and you'll discover they are. For critter photography, "fast f/5.6" is much easier to use, with fewer numbers to

count, because you'll more often be using an aperture close to f/5.6.

By the way, did you notice that this estimated exposure is for *frontlit* average-toned subjects? For *sidelit* subjects, open up 1 stop from your base exposure. For *backlighting,* open up 2 stops. For very light-colored subjects that fill the frame, stop down 1. For very dark subjects filling the frame, open up 1. Remember that these suggestions are only for this non-metered, estimated exposure. They do not apply to TTL-metered situations.

Here's a test: What is the correct exposure for a full-frame shot of a sidelit great egret on a sunny day in Florida? You should be able to figure this out. Since you would be using a long lens, let's start with "fast f/5.6." Stop down 1 to hold detail in the white, open up 1 for sidelighting, and you're right back to the same "fast f/5.6" exposure. Now let's try a backlit, dark-brown bison on a sunny September day in Yellowstone. It's standing still, so we'll start with "sunny f/16." Open up 1 for a very dark subject and 2 more for backlighting, for a total of 3 stops open (f/16 to f/5.6). Of course, you can open up, or stop down, with either shutter speeds, apertures, or a combination of both. Pick what's most appropriate to your situation.

While you will not take many photos using this exposure value, "sunny f/16" is still a helpful reference point. You can always use it to check your meter readings, since it provides a known baseline starting point. If

you are photographing in bright sun, your metered values and "sunny f/16" should correlate unless something is drastically wrong. Are your camera batteries about to die? Did you accidentally leave a filter on your lens? (A polarizer, for example, takes up to 2 stops of light.) When working in bright conditions, such as when photographing Florida birds or Kenyan mammals, it also pays to preset your equipment to this exposure. You'll be ready for the unexpected.

One problem with using "sunny f/16" is that you need to know exactly where f/16 is on your lens. This seems rather obvious, but it's not for all lenses. Many zooms today are of a *variable aperture* design, where the f-stop actually changes as you zoom. These lenses will be marked with two f-stops noted for their maximum apertures, such as the Nikon 28–105mm f/3.5–4.5 or the Canon 35–350mm f/3.5–5.6. To make a constant-aperture zoom lens, the aperture must actually change size as the lens is zoomed from one focal length to another. If it remains the same physical size, the f-stop will change as you zoom. With most variable-aperture lenses, the marked stops are only correct at the short end of the zoom range. With older cameras you must either use this end of your zoom with "sunny f/16" or extrapolate values as you change focal lengths. I say "older cameras" as many newer models either set the f-stops electronically or have the option of doing so. All Canon lenses are set in this manner, while Nikons can be set either mechanically via the aperture ring on the lens, or electronically using the command dial on the camera body. When you use this electronic feature, the marked stops are indeed what their numbers suggest—except for the widest and smallest apertures at the longest focal length.

I'll use the Nikon 28–105mm lens mentioned above to illustrate this fact. With the lens set wide open, the aperture will change from f/3.5 to f/4.5 as you zoom from 28mm to 105mm. This is a shift of 2/3 stop. The same 2/3-stop change happens with the smallest aperture. At 28mm, it's f/22, while at 105mm it becomes f/29. If you electronically set any f-stop between f/4.5 and f/22, the lens will stay constant throughout its zoom range. To sum this up, if you're using "sunny f/16" with a variable aperture zoom and an electronic camera, I would avoid the widest and smallest aperture. Stay in the middle, and all works fine.

By the way, if you've never before seen this information about estimated exposures and the "sunny f/16" rule, you've missed out on a great tool. For more information, check out what's printed on the inside of every film box made by Fuji and Kodak.

DEPTH OF FIELD VS. SHUTTER SPEED

All field photography involves compromise. Exactly which combination of aperture and shutter speed you should use depends on a wide variety of factors: whether you're photographing static landscapes or animate action; whether or not the wind is moving the subject; how long a lens you're using and/or the magnification rate at which you're working; and how sharp or how soft you want the resulting image to be. There is no one correct answer for all situations; rather, you must decide how you want the photograph to appear and then take the appropriate steps.

The most basic decision of all is what shutter speed/aperture combination you should use. Do you need to stop action (with a fast shutter speed requiring a large aperture), or do you need a lot of depth of field (achieved by using a small aperture necessitating a slow shutter speed)? *Depth of field* refers to the section of a photograph that appears to be in sharp focus.

Theoretically, only one plane of any subject can be in perfect focus: the plane on which the lens is focused. But in reality, things on either side of this sharp plane also appear to be in sharp focus. Beyond this section of relative sharpness, on both the near and far sides of it, the image definitely appears to be much less sharp.

The actual size of this zone of sharpness—the depth of field—is controlled by four factors:

1. The actual *f*-stop at which the picture is taken.

2. The focal length of the lens being used.

3. The size of the subject being photographed.

4. The distance between the camera and the subject.

Let's consider these four points. With all lenses, as you stop down to a smaller aperture you increase the depth of field. The reverse is also true; as you open up to a larger aperture, the depth of field decreases. Apertures such as *f*/16, *f*/22, and *f*/32 yield greater depth of field on any given composition compared to apertures such as *f*/2, *f*/2.8, and *f*/4 on the same lens. The smaller the hole, the greater the depth of field; the larger the hole, the shallower the depth of field.

If you photograph a subject several times without changing your shooting location, the depth of field decreases at any given *f*-stop as you increase the focal length of the lens you're using and vice versa. For example, if you're shooting with a 28mm lens and switch to a 200mm lens, you'll have a lot less depth of field even though you're using the same *f*-stop on both lenses. What you're changing as you switch lenses is how much of the subject you include in the photograph. The perspective remains the same in all photos since you haven't changed shooting location, but by going to a longer lens you've increased how large the subject appears in the finder. You're now seeing less of the subject than you did with your wide-angle lens, and whenever this happens you lose depth of field. To sum up, as you gain magnification, you lose depth of field.

Which leads to point #3. With any given lens at any given *f*-stop, depth of field decreases as you decrease lens-to-subject

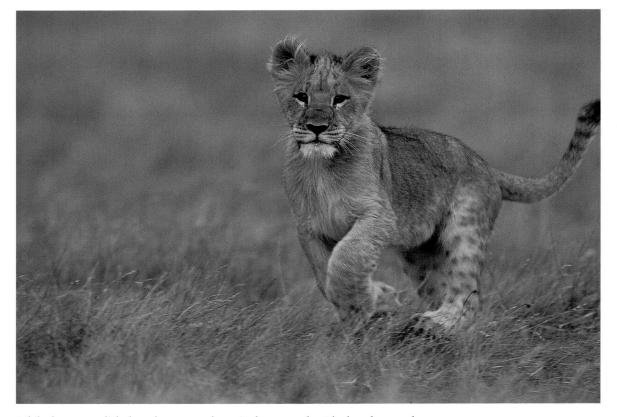

LION CUB RUNNING.
Nikon F5, Nikon 500mm lens, Kodak E100SW.

While the overcast light kept the contrast down, it also meant that I had to photograph with my lens wide open at f/4 in order to use an action-stopping fast shutter speed. Look carefully and you'll notice that only the face of this lion cub is in focus. As in all portraiture, having the eyes in sharp focus is absolutely vital.

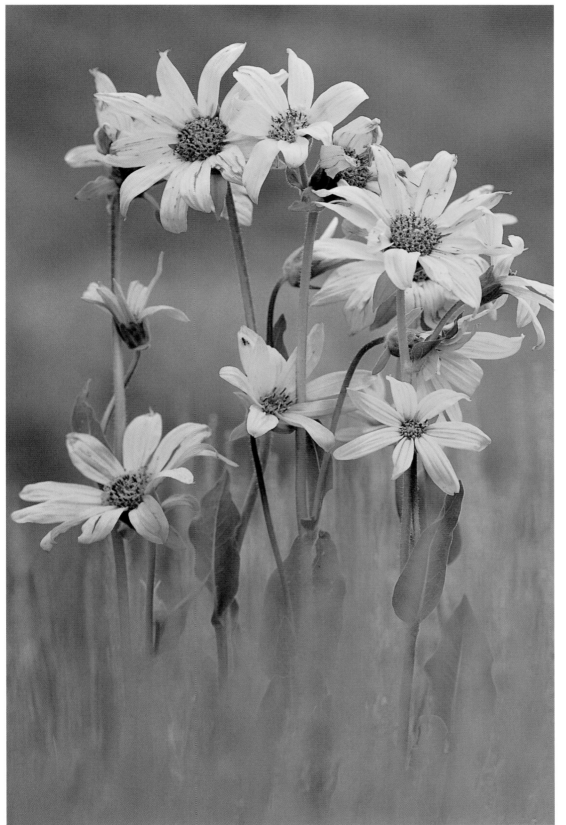

MULE'S EAR SUNFLOWERS
AND SAGEBRUSH, COLORADO.
Nikon F5, Nikon 200mm lens, Fuji
Velvia.

I used my long macro lens wide open at ƒ/4 to isolate the flowers against the soft sage green background. Notice that I positioned my camera very carefully to line up the film plane with the principal plane of these sunflowers. At this image size and an ƒ/4 aperture, depth of field is so limited that I must do everything I can to make use of what little is available.

distance. As you move closer to a subject, you see less of it through the lens. Let's say you're looking at an entire mountainside of trees and flowers. Photograph the whole thing with any lens—let's assume a 35–70mm zoom set at 70mm and f/16—and depth of field is measured in hundreds of yards. Now move up closer and photograph a single tree with the lens still set at 70mm and f/16. Depth of field can now be measured in feet. Move in even closer and work just one branch of that tree, still at 70mm and f/16, and the depth of field can now be measured in inches. Go in tighter still, photograph one small flower blossom at the base of the tree with the same lens and same aperture, and depth of field has become fractions of an inch. Again, you are gaining magnification, but losing depth of field.

But if you keep the image size the same, then all lenses you use at the same f-stop will yield pictures with the same depth of field. You might have heard it said that wide-angle lenses give you great depth of field while telephoto lenses yield shallow depth of field. This statement is not exactly true. From a given shooting location, wide-angles do take in broad coverage while telephotos pull out selected areas. Well, that was point #2. But if the coverage stays the same, then all lenses yield the same depth of field at the same f-stop. Shoot a picture with your 50mm lens, back off so that you're four times the

distance from your subject, and you'll be shooting the same coverage with your 200mm lens (four times the focal length of the 50mm lens). If both lenses are set at the same f-stop, depth of field will be the same in both resulting photographs. Double the distance again, shoot with your 400mm lens at that f-stop, and the depth of field is the same again. Halve the distance that you were at with the 50mm lens, use a 25mm lens, and depth of field still remains constant. The photographs will look radically different since background coverage changes due to the lenses' different angles of view, and perspective will be different also, but depth of field will be the same in all of the photos.

So I'm back to my original question: Do you want great depth of field or a fast shutter speed? Most of the time your actual exposure settings will be a compromise between what you would like to have and what you can get away with given the dictates of your shooting location. You would love to work that landscape at f/22, but the resulting shutter speed is too slow to stop the wind-blown grasses. Or, you would like at least 1/500 sec. shutter speed to freeze a bird's movements, but the resulting lack of depth of field means that only the head will be in focus. Compromise, compromise . . . but make your decisions carefully and deliberately. Generally speaking, in landscape work you choose the aperture that gives you the

depth of field needed; this in turn dictates the shutter speed you set. Scenic photography can be considered an aperture-priority situation. For animal photography, you choose the shutter speed you absolutely need, which in turn dictates the f-stop used. Critter work thus leads to a shutter-priority way of thinking.

There is no one correct f-stop or shutter speed for any given situation. I have heard some photographers advocate always shooting landscapes at the smallest possible f-stop on a lens to get the most depth of field, but I strongly disagree with this philosophy. Pick the f-stop that gives you the depth of field you desire. There is no valid reason to stop down any more than necessary for any given photographic situation. If an exposure setting of 1/60 sec. at f/11 yields the depth of field you want, while shooting at 1/8 sec. at f/32 increases the probability of fuzziness due to subject or camera movement, why stop down? On the other hand, I've heard other photographers suggest that you should never use the smallest f-stop on any lens because it's not the sharpest. True, the aperture on any lens that gives the sharpest image is usually about two stops down from wide open. But why use this f-stop if it doesn't yield the depth of field results you want? With modern lenses and modern films, you should use any f-stop that can give you the results you want. Better sharpness in any

PRAIRIE SUNFLOWERS, GREAT SAND DUNES NATIONAL MONUMENT, COLORADO.
Nikon F5, Nikon 105mm lens, Fuji Velvia.

Great Sand Dunes is a magical location in mid-August; the area is moist and prairie sunflowers can be found growing in the very midst of the dunes. The first photo (left) was taken with the lens wide open at f/2.8, resulting in extremely shallow depth of field. Only one part of the picture is in sharp focus: the near sunflower.

For the second photo, I stopped my lens down to f/32, the smallest aperture available on this lens. I had to slow down the shutter speed accordingly, but notice how much I've gained in depth of field. Which of these two photos do you like better, and why?

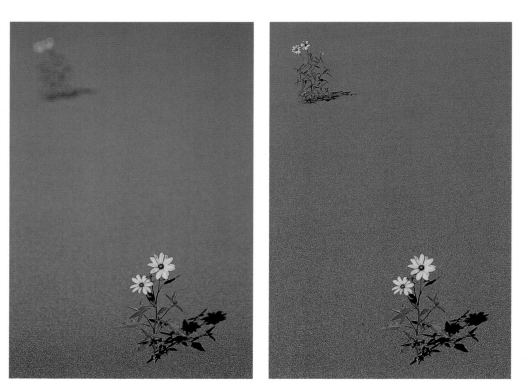

photo is far more often a question of using a sturdier tripod than an *f*-stop issue.

While it's impossible to actually "see" shutter speed effects until you process your film, you *can* "see" depth of field. Normally, when you look through the viewfinder, you are seeing the depth of field at a wide open aperture, regardless of what *f*-stop you have selected to use for your actual photograph. This can be misleading, so for serious photography I would not purchase any camera which did not offer a means of viewing through a lens while it is stopped down to shooting aperture—a depth-of-field preview. It's important to me because I want to see what the film is going to see; I want to choose the aperture that gives me the depth of field I desire; I want control of the entire photographic process.

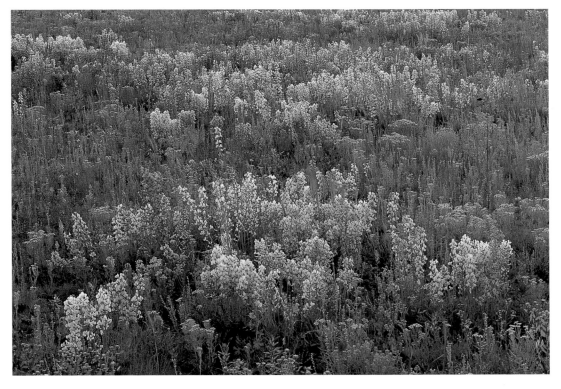

LOCOWEED PRAIRIE, COLORADO.
Nikon F4, Nikon 105mm lens, Fuji Velvia.

Since I wanted everything from foreground to background to be in focus, I had to use a small aperture and a slow shutter speed. A slight, but persistent, breeze made me wait, and wait, and wait before I could photograph.

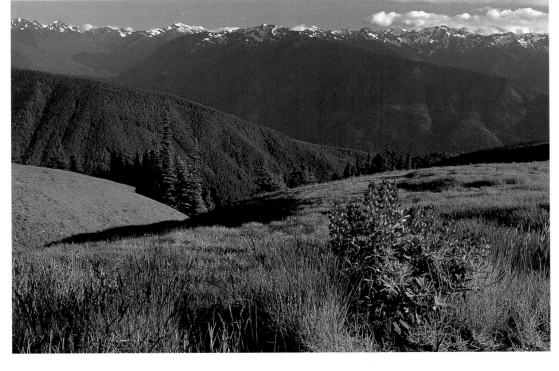

LUPINES BEFORE THE OLYMPIC RANGE, LATE AFTERNOON FROM HURRICANE RIDGE, OLYMPIC NATIONAL PARK, WASHINGTON.
Nikon F5, Nikon 20–35mm lens, Fuji Velvia.

I wanted to make sure that both the foreground lupines and the distant mountains were in focus. A small aperture gave me the depth of field I needed.

CALIBRATING YOUR METER

We photographers tend to believe that the more expensive our camera equipment, the more accurate it is. Sometimes I think we believe that Mr. Nikon himself has engraved the ISO marks on an F5, placing them at the precise location for each film. But any exposure meter, whether it's a built-in TTL meter or the most expensive handheld model, will give you a correct reading only if it is set at the proper ISO mark.

Most of the newer cameras, especially those brought to the market in the last five years or so, do tend to be remarkably accurate in their ISO setting marks; the majority are certainly within 1/3 stop of where they should be. However, older cameras have far more variance in these numbers, and are sometimes as far off as a stop or two. Regardless of how new your equipment might be, I think it's a good idea to test the ISO calibration setting of all your meters just to be absolutely positive of your starting point for tonal placement.

Choose any subject which you call medium-toned, one without any extremely bright or dark areas. (Remember that a medium tone is halfway between light and dark. It's average in tonality: medium green, medium blue, medium brown, medium red. Don't ask anyone else if they think the subject is medium-toned; after all, they're taking their pictures and you're taking yours.) Don't use a gray card for this test. Gray cards are made for indoor use; outdoors they often exhibit a glare that inflates the meter reading. In fact, I would suggest only using a gray card as a visual reference. Find a natural subject similar to the type of subject you would actually photograph in the field.

Run this test in even, unchanging light. You can even do this indoors with incandescent lighting if you must, but I would urge you to wait for a cloudy day and shoot outside where you can work under natural lighting conditions. After all, that's how you'll be taking your real photos.

Mount your camera on your tripod, focus on the subject so that your lens sees it and only it, and lock all the tripod head controls. You can use any lens you want for this test, as you're evaluating what the in-camera meter does, not how the lens works. Load a roll of medium-speed slide film (you *cannot* use print film for this test), and set the camera meter to the film manufacturer's recommended ISO number. Don't use the DX film speed mark on your meter; dial in the number manually. Set your camera to either "aperture priority" or "shutter priority" autoexposure, making sure the camera's exposure compensation dial is at the zero setting. Use either the spot or center-weighted metering pattern—*not* an evaluative pattern. Close the eyepiece shutter so that no light leaks in through the viewfinder to influence the meter reading. Now make an exposure. It's a good idea to place a small card with the ISO number written on it within the frame so that you know at what setting each test slide was taken.

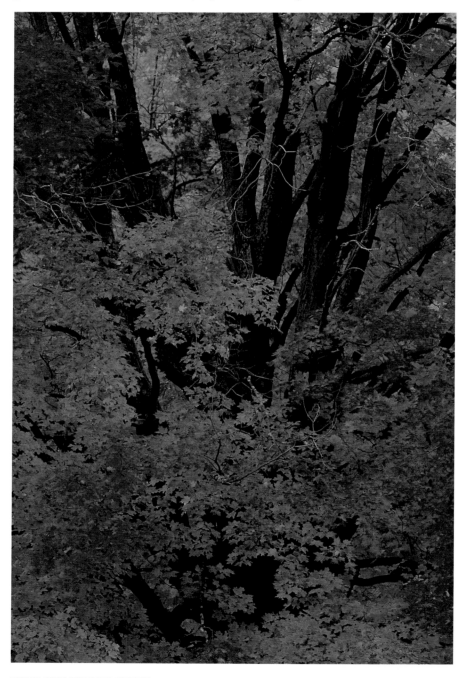

AUTUMN SUGAR MAPLE TREE, MICHIGAN.
Nikon F4, Nikon 300mm lens, Fuji Velvia.

Once a meter is calibrated to a medium placement, whatever I meter will be rendered as a medium tone if I shoot at the meter's recommended values. Sure enough, in this photo, the subject appears medium-toned.

Next, reset the meter to the next (faster) ISO number, and shoot another frame with another card. Repeat this procedure twice more, then take more slides while you go the other way on the ISO dial. You'll end up with seven slides, varying by 1/3-stop exposure, of the same medium-toned subject. For example, if you were running this test with ISO 100 film, you would start out with the meter set at ISO 100 and take a photograph, then take frames with the meter set at ISO 125, 160, and 200. Going the other way, you'd shoot with the meter at 80, 64, and 50.

Critique these slides in whatever manner you normally critique your work. Pick the one you think is best exposed, whichever one you prefer. That's the ISO number you should use for that film and that camera. It doesn't matter at all what the actual number is, and this has nothing to do with pushing film or changing development times. You're just finding the correct starting point for your meter, the setting at which a medium tone is rendered as a medium tone. Your particular number also has nothing to do with the setting anyone else uses.

Once you fine-tune one meter, you can easily calibrate any other camera meter against the known value. This is simple to do indoors. If you have one, use a lens with a tripod collar so that you can easily switch camera bodies back and forth. Meter a light-colored wall in your house in even lighting. Take a meter reading with your tested camera, then get the second camera body to give you the same reading as the first. If the ISO numbers on the two cameras don't agree, so what? It's the shutter speed/aperture combination that's important.

I currently own four camera bodies. Three of them agree on ISO numbers, but not the fourth. It is numerically off by 2/3 stop, so I have to set it at 64 for an ISO 100 film to achieve proper exposure. Big deal. Set at 64, it gives me the exact same shutter speed and aperture as do the other cameras set at 100. Most cameras tend to be linear in their ISO values. I set this body 2/3 stop under the correct speed rating for all films.

By the way, I used to suggest running this test by pointing your camera towards the clear north sky. I no longer think this is a good idea, as there is too much variation in the sky's tonality due to pollution, humidity, haze, and other factors. Besides, the test described above is far more accurate.

If you make any necessary corrections through exposure compensation, you can use your camera's DX code feature. It works in 1/3-stop increments, just like the ISO numbers. If you discover that you need to set a particular film 1/3 stop slower than its suggested number, dial in "−1/3" (or "-0.3" on some cameras). This will be your new base position for the compensation dial with that film—the equivalent of the "zero" point.

If you own a hand meter, you can calibrate it in the exact same manner. In fact, if it's a reflected-light meter (one that reads the light reflecting off of a subject), just compare it with a calibrated camera. If it is an incident meter (one that reads the light falling *on* a subject), there's an even easier way to calibrate. Go out at midday on a "sunny f/16" day and point the incident meter's dome—the little white plastic light-gathering bulb—directly at the sun. The meter should give you the "sunny f/16" values. If it doesn't, just change the ISO setting until it's correct. Some hand meters actually have a calibration method built into them. I carry a Gossen Luna-Star, which allows calibration in 1/10 stop increments. Mine needs a "-0.1" setting. That minute amount might indicate just how careful I am about correct exposure . . . or perhaps it's an indication that I'm a little too compulsive!

When you run a calibration test you're making the assumption that your processing lab is consistent in what it does, so choose a lab carefully. Pick a professional one that maintains its chemical line to the tightest tolerances. In the end, the final quality of your images is up to the lab, so don't scrimp in this area.

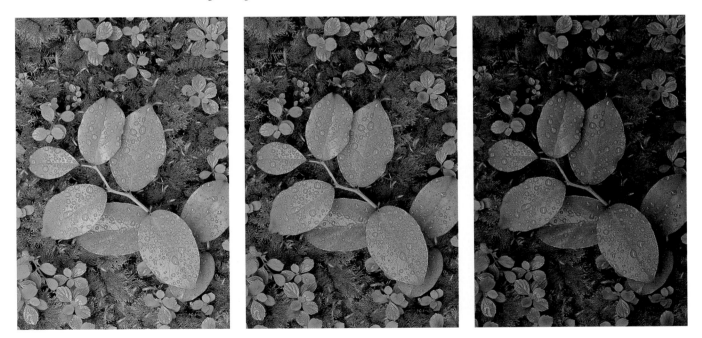

SALAL AND MOSSES ON FOREST FLOOR, OLYMPIC NATIONAL PARK, WASHINGTON.
Nikon F5, Nikon 105mm lens, Fuji Velvia.

Here are the middle three frames of an exposure meter calibration test, the exposure changing by 1/3 stop between photos. I found a subject which I called medium-toned in even, unchanging light, then mounted my camera on my tripod and composed a shot. I set my camera to an autoexposure mode, closed the eyepiece blind, and ran a series of exposures changing only the ISO setting on my TTL meter. Now I can pick the image I like the best: the one in which a medium-toned subject is rendered as a medium-toned image. The ISO number used is the one I will set on this particular camera body when using this particular film.

Using Your Camera's Exposure Meter

You bought an expensive, high-quality SLR camera, so it should give you perfect exposures all the time, right? Think again. A camera meter only gives a suggested exposure, which may or may not be the correct exposure (the exposure that will make your images look the way you want them to) for any scene. To be in charge of the photographic process you have to think about what you're doing.

All TTL camera meters are *reflected-light meters*. They measure the light reflected from any subject at which they are pointed, then suggest exposure values for that subject. Most current cameras offer a choice of built-in metering patterns: typically a spot-metering pattern, a center-weighted pattern, and a multi-segment matrix or evaluative pattern. The names indicate how much or how little of the frame is actually read by the TTL meter.

Each pattern works slightly differently. A *spot meter,* as the name implies, reads only a small spot within the frame, disregarding the rest of the scene. Spot meters are extremely useful when you want to meter one area only. Many newer cameras allow you to select where the metering spot is located on the viewfinder screen, but of course, if yours doesn't, you can just meter what you want and re-aim the camera after you take a reading. You certainly don't have to meter the image exactly as it's composed. *Center-weighted meters* place a strong emphasis on the central portion of the image. For example, in this mode, Nikon cameras place about 60% of the metering emphasis on the central area (the circle inscribed on their focusing screens), with the remaining 40% going to the edges. *Matrix and evaluative patterns* subdivide the frame into many small sections, then run a software program to evaluate the results; the Canon EOS-3, for example, has 45 sections, while a Nikon F5 has 1,005 distinct areas.

Let me note right now that the choice of metering pattern has nothing whatsoever to do with whether you're using an autoexposure mode or autofocus. You can work with spot metering in manual exposure or autoexposure. You can use matrix metering with either autofocus or manual focus. You have three distinct choices to make, and they are totally independent of each other: which metering pattern to use; whether to focus manually or have the camera and lens work in autofocus; and whether to set the exposure manually or rely on autoexposure. Mix and match as you wish depending on your subject.

All TTL meters measure the light reflected from a subject and then suggest an exposure which will render the subject on film at the tonality to which the meter has been calibrated. In other words, if you calibrate a meter to a medium tone and then take a picture at whatever exposure the meter suggests, whatever you metered—regardless of its true tonality—will be rendered as a medium tone on your final slide, whether you set the aperture and shutter speed yourself or let the camera set them for you.

The only exceptions to this rule are evaluative metering patterns. Be sure to check your camera manual to see if your "matrix" or "multi-segment" metering pattern is also evaluative. Some older matrix patterns simply subdivided the frame into many segments, compared meter readings from each segment, and tossed out anomalous readings. Evaluative meters run a software program that evaluates the tonalities, and sometimes the colors, of your subject. This software program then makes some exposure decisions about recording the scene *without consulting you, the photographer.* At the end of this section, I'll discuss working with evaluative metering.

Otherwise, all reflected-light meters do one thing and one thing only: they tell you what exposure to shoot if you want the area you metered to appear the way the meter is calibrated. You meter a particular area by choosing the metering pattern, and since you've calibrated your meter to a medium tone, the camera meter is now programmed to say only one thing: "make this particular area medium."

If the area of your subject that you meter is indeed medium-toned, and you want it to appear as a medium tone, you're all set. Simply take a meter reading of that medium area and shoot at the suggested exposure value, choosing your preferred combination of *f*-stop and shutter speed, and you'll end up with correct exposure. But if your subject is not medium-toned, an intermediate step is necessary before you can photograph. You could meter something besides your actual subject. This will work as long as your substitute is medium-toned and is in the same light. Don't take a meter reading of a sidelit object when you're going to photograph one that is frontlit; don't meter something out in the bright sunlight if you're photographing in shade. Once you meter a substitute, swing back to your original subject and recompose the picture using the exposure settings derived from the substitute to take the picture. As long as the light falling on your subject and the light on the substitute area remain the same, this is an easy way to obtain proper exposure.

What if there is no medium-toned area to meter? Well, you could carry a medium-toned object with you specifically for this purpose. All camera stores carry 18% gray cards, which reflect a photographic middle-tone.[1] If you hold one of these cards in front of your lens in the same light as your subject, you could meter it. However, it's pretty easy to imagine some of the problems with doing this. Any substitute metering area has to be in the same light as the subject you want to

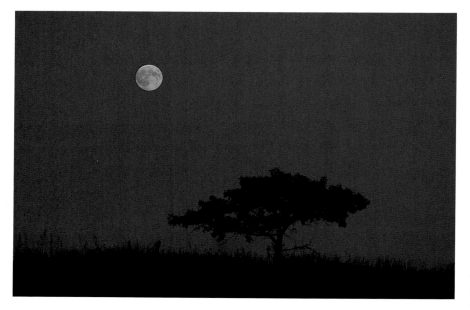

FULL MOON OVER PRAIRIE BLACK OAK, ILLINOIS.
Nikon F2, Nikon 200mm lens, Kodachrome 25.

To make the dark blue sky appear as a dark tone, I metered it—avoiding the foreground—and stopped down 1 stop.

photograph. What if you're standing in the shadow of a mountain trying to photograph a sunlit scene across a valley? Better have a very long arm, or your gray card will be in the wrong light. Considering doing tight portraits of a rattlesnake? Well, do you really want to hold that gray card in front of it? And what about photographing a sunset? There are so many situations where it doesn't work that I would just forget about using a gray card. You might want to purchase one to use as a visual reference, but don't meter from it.

It's far better to meter part of the subject you're actually photographing and then work using stop values on either side of the meter reading. You can meter anything you want so long as you know either what tonality it is, or, more importantly, what tonality you want to make it. This is one of the most important concepts when it comes to metering. Never forget that you can make any subject appear any tonality you want. You always have choices. The final photograph doesn't have to be a literal rendition of your subject; it can be an accurate representation of what you see, or it can be lighter or darker to create a particular mood. Your images don't have to match reality, just your personal vision.

An individual frame of color slide film can hold a tonal range of about 5 stops, from textureless white to detailless black. Our eyes can accommodate far more than this—somewhere in the range of 12 to 13 stops of contrast—so learning to "see" as film does is absolutely fundamental to good photography. No film records reality, only the human eye does that.

If color slide film can record 5 stops of tonality, the medium tone is right in the middle, halfway between the two extremes. There are 2 1/2 stops of tonality on either side of medium. So, you can meter any part of your scene you want and either add light to make that tonality appear lighter than medium, or take away light to make it appear darker than medium. One stop open from the meter reading—from medium-tone, that is—makes a tonality appear *light,* while 2 stops open from medium makes it appear *extremely light.* One stop down from medium (take away 1 stop of light from the meter's suggested values) and you record an area as *dark,* while 2 stops down from the meter reading yields *extremely dark.* The half stops fall in between these tones. Of course you can add or subtract stops by physically changing either shutter speeds or apertures;

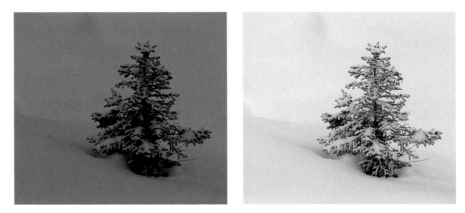

SNOW AND EVERGREEN.
Nikon F4, Nikon 80–200mm lens, Fuji Velvia.

Will a meter give you the correct exposure to make white snow white? Which of these photos do you think I got shooting at the values suggested by my center-weighted meter? It was the photo on the left. My meter had no idea that I was pointing it at snow. It told me the values to use if I wanted to make my subject medium-toned, so the white snow was rendered as a medium gray. The meter worked exactly as it was supposed to work. I had to make adjustments to get the snow to appear white.

pick the one you want to preserve for the situation and change the other one.[2] You're just adding light to lighten the area you metered, or taking away light to darken that area.

Memorize this 5-stop sequence. To use it, just fill in the name of any color at the end of the line. For example, if you meter a green area and photograph at the meter reading it will record as a "medium green" regardless of what tone it is in reality. The meter tells you what to shoot at to record a subject as a medium tone. Open up 1 stop and that metered area will now appear as "light green" in the slide. Stop down 1 stop from your meter reading and it will be rendered as a "dark green." Open up 1 1/2 stops from the meter reading, and now you'll record it as "light light green." Stop down 1/2 stop from the initial meter reading and you've got "light dark green." Get the concept? Your meter always suggests a medium-toned starting point, but by working in stop increments you can lighten or darken any particular area. Of course you can expose for only one part of the frame, and must let everything else fall where it will. Consequently, you should always check the exposure for what you consider to be the most important part of the image.

Here is a test question. Suppose you have two people standing next to each other in the same light. One is wearing a dark blue shirt, the other is wearing a light blue shirt. How

do you meter this scene to get correct exposure? Pick an area to meter—it doesn't matter what you pick. Let's say you choose the dark shirt. How do you meter a dark subject and record it as "dark"? Meter it and only it, and take away 1 stop of light. It will now be dark. But what happens to the light blue shirt? It will also be properly exposed. Make dark blue record as a dark blue, and light blue will be recorded as light blue, or vice versa. Place one tonality correctly, and all others fall into place. If this seems strange, think of what happens when you meter a medium-toned object like a gray card or medium-green grass. When you do that, medium records as medium, dark records as dark, and light records as light.

Here's another test to make sure you really understand this concept. Suppose you have a subject in front of you that has an array of

[1]Why is an 18% reflectance called middletone? Shouldn't it be 50%, halfway between black and white? Remember that photographic stops work in doubles and halves, and not a straight linear progression. Film "sees" about a 5-stop range of tones, so here are the percentages of reflectance: detailless black, 4.5%, 9%, 18%, 36%, 72%, textureless white.

Remember that each doubling is 1 stop. For example, going from 18% reflectance to 36% is 1 stop, from 36% to 72% another stop. At either end of this sequence, film records roughly 1/2 stop.

[2]You're changing the actual shutter speed or aperture you set; you're not using the "compensation setting" on your camera, which is for autoexposure only.

CHANGING A TONALITY'S APPEARANCE	
	+2 1/2 stops: textureless white
	+2 stops: extremely light
	+1 1/2 stops: light light
	+1 stop: light
	+1/2 stop: dark light
	THE METERED VALUE: medium tone
	−1/2 stop: light dark
	−1 stop: dark
	−1 1/2 stops: dark dark
	−2 stops: extremely dark
	−2 1/2 stops: detailless black

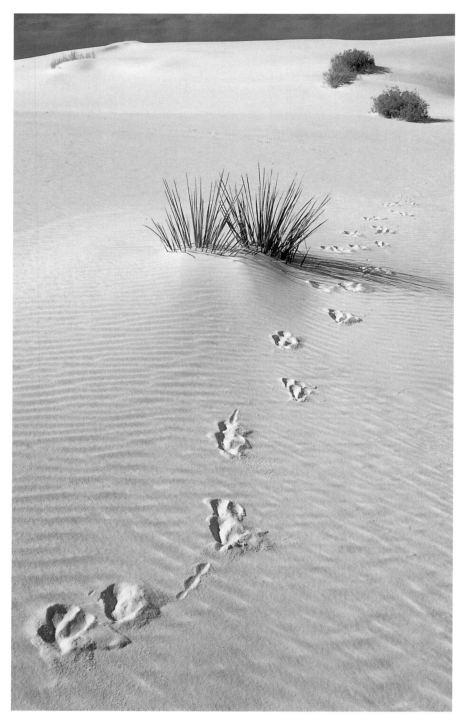

TRACKS IN THE GYPSUM SAND, WHITE SANDS NATIONAL MONUMENT, NEW MEXICO.
Nikon F5, Nikon 28–70mm lens, Fuji Velvia.

The gypsum dunes at White Sands are as white as white can be. On a sunny day they're almost blindingly white, but still have texture. To expose properly, I metered the sand and opened up two stops. Any idea what made the tracks? Those are from an oryx, which I watched walk across the dunes. Introduced into the White Sands Missile Range in 1969 as a game animal, these African antelope are definitely out of place in the middle of New Mexico. Above all, remember that you should not ask what tone a subject is in reality. You're concerned with how you want it to appear on film. How it looks, how light or how dark, is up to you.

tonalities from extremely light to extremely dark. All parts of this subject are in the same lighting. There is one medium-toned area, and when you spot-meter that particular area the meter suggests an exposure of 1/60 sec. at f/11. Now you meter a "dark" area, and stop down 1 stop from the meter reading. What are the exposure values? Next you meter a "light" area and open up 1 stop from the meter reading. What are the exposure values? Then you meter an extremely dark area, and stop down 2 stops from the meter reading. What are the exposure values? Finally you meter an extremely light area, and open up 2 stops from the meter reading. What are the exposure values? In each and every case the answer is the same: 1/60 sec. at f/11. After all, the same amount of light is falling on all parts of the subject; you're just taking meter readings of different areas and adjusting for their different tonalities.

Working in this progression of stops is exactly why I like an analog meter display in the viewfinder, which is found on many cameras. This is a viewfinder display showing where metered values fall relative to a "zero" or middletone point. Analog displays look something like this (this one is in 1/3-stop increments):

$$| \cdot \cdot | \cdot \cdot | \cdot \cdot | \cdot \cdot |$$
$$+2 \quad +1 \quad 0 \quad -1 \quad -2$$

An indicator bar or arrow will appear, displaying where the exposure is set relative to the 0 point, which is medium. Most analog displays also have a little arrow at either end to indicate that the exposure is off the scale in that direction. You should realize that this analog scale is a version of my exposure chart.

Let's say you spot-meter an area you wish to place as a "dark" tonality, such as that guy wearing the dark blue shirt. You don't have to go to the 0 point and then close down 1 stop; rather just change aperture or shutter speed until the indicator is at the −1 position. At this point you could swing over and point the lens at the light blue shirt; the analog display will now light up at the +1 setting.

I often use this scale to decide how I want to record tonal values in a difficult scene. I can spot-meter one area, place it as whatever tone I wish, then just scan the area with my camera. The indicator on the display changes as I aim at different parts of the scene, showing how many stops different each and every area will record. Let's say I'm photographing inside a forest, and I'm worried about the sunlight that is starting to dapple though the leaves. I'm concerned about burning out the highlights, the absolute worst thing you can do with slide film, so I need to determine if the film can hold the entire scene. I spot-meter

what I consider the most important part of the image—some of the nearby trees—and place them as the tonality I want them to appear. Now I swing up and aim at those bright highlights. Rats, the scale shows me that they will record as more than a +2 value. I know that if I take the shot the highlights will appear "extremely light" or even brighter, and will be quite distracting. Instead of taking the shot, then throwing it away after I get the film processed, I can pre-edit in the field before I ever press the shutter release. Why waste film on a bad shooting situation?

Now, what about evaluative metering? When you use it, the evaluative software adds or subtracts some exposure amount from a base medium reading. The problem is that you don't know how much. Let's say you meter an area which you want to render "light," 1 stop open from a medium tone. With a non-evaluative metering pattern, you take a reading of that particular area and open 1 stop. Bingo, your metered area is now a "light" tonality. Do this on evaluative, and should you open 1 stop? Half a stop? More? You don't have any idea what has already gone on. The evaluative metering has made judgment calls that are already reflected by the exposure values it presents to you. The information given you is not necessarily that of a medium-toned starting point. Nikon, for one, states point-blank in their instruction manuals that *no* compensation, whether additive or subtractive, should be used with their evaluative matrix metering.

My experience is that so long as the entire scene is within about a 1-stop range, evaluative metering does indeed work. Go outside of this range, where a good percentage of the scene is at either end of the tonal scale, and you're far better off metering and placing values with my 5-stop chart. Here's a quick way to check evaluative metering: go outside and meter snow. Pure white snow should be 2 stops open from medium, so meter it with the center-weighted pattern and then flip your camera to the evaluative pattern. Do the exposure values of the two metering systems agree? Has evaluative metering suggested an exposure that will make the white snow white? My experience is that evaluative metering tries to render snow about 1 stop lighter than medium. That's the tonality of the palm of your hand, and snow is definitely lighter in tone than the palm of my hand.

So should you just automatically add an additional stop of light to an evaluative meter reading? Definitely not. That may work for one situation, but it won't necessarily work in another. Since the algorithms used for evaluative metering vary between

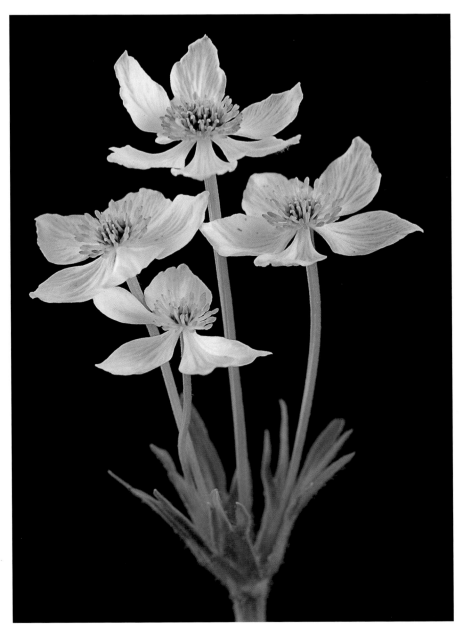

GLOBE FLOWER, COLORADO.
Nikon F5, Nikon 200mm macro lens, Fuji Velvia.

camera brands, and even between camera models of the same brand, I would suggest running some experiments before you shoot in the field. Take a meter reading in spot or center-weighted, place the tonalities as desired, then take a meter reading in evaluative and compare the results. Soon you will learn in which field situations you might want to add or subtract some light by dialing in a compensation factor. My experience with the Nikon F5 is that most of the time you are better off not compensating, but when you do it may be as small a change as 1/3 stop. Let me repeat, however, that when you're photographing a scene with predominantly very light tones, or predominantly very dark tones, I would fall back on placing tonal values using my chart. It always works.

How do you meter this picture to get correct exposure? You could do it several ways, all of which should suggest the exact same exposure settings. You could meter only the green and use those values. Or you could meter the cream-colored petals and open up about 1 1/2 stops. Why this amount? Well, they're lighter than the palm of your hand, which is 1 stop open from medium, but not pure white. What's between 1 stop open and 2 stops open? 1 1/2 stops. You'll need to set your camera on its spot-metering pattern in order to meter these small areas. An overall meter reading will not give you a correct exposure, as it will be too heavily influenced by the deeply shadowed background.

Metering Some Unusual Situations

If you understand the concepts of working in stop values and placing subjects lighter or darker than a medium-tone starting point as indicated by your meter, then you should be able to handle most situations in the field. However, my experience teaching workshops and seminars has taught me that there are two specific circumstances where many photographers have problems: working in mid-winter snow conditions and photographing sunrises and sunsets. I've read all sorts of explanations of how to meter pictures for these situations, listened to many involved schemes for arriving at proper exposure, and watched photographers bracket their images using every f-stop available. Each of these "solutions" is overly complicated. Exposure is exposure—you can work snow conditions and sunrise/sunset just like other subjects.

Photographing Snow

Let's start with winter. How often I've heard that it's the most difficult season to photograph because there are no middle-toned subjects to meter. Trust your meter to give you proper exposure, and all your pictures turn out too dark, with the snow rendered as a medium blue. Remember, the meter has no idea what subject you're pointing it at. There's no little microphone on a camera into which you can whisper, "Hey Canon,

this is snow. Make it white." The meter performs its job flawlessly, telling you the exposure to shoot in order to record the snow as a medium-toned value. Consequently you're disappointed with your photos.

The solution is simple: All you need to do is meter the snow itself and place it as whatever tone you want it to appear. That sounds easy; snow is white, so you should meter it and open up two stops, right? Not necessarily. Here's a question to ask yourself: Exactly what tone is that snow, really? If it's pure white, meter that pure white area only (use a narrow-area metering pattern such as spot-metering to do this), and open up 2 stops from the meter reading. But if there is a lot of detail in the snow—if it's sidelit, that is—then 2 stops will be too light. Sidelit snow, where you can see every crystalline detail of every surface flake, is *not* pure white. All those tiny shadows add up, so that in reality, textured snow is about 1 1/3 to 1 1/2 stops lighter than a medium tone. Snow in the shadows on a sunny day can vary from a medium placement to 1 stop lighter, and snow on an overcast day has no detail in it at all.

I've heard many people suggest that to record detail in snow you should only open up 1 stop from a meter reading taken directly off the snow. But remember, the palm of your hand is roughly 1 stop lighter than

medium. Is snow lighter or darker than the palm of your hand? Well, in my part of the world it's definitely lighter. If the tonality of your palm is 1 stop open, and pure white with texture is 2 stops open, then snow in sun should be right in between.

By the way, I've often heard this "one stop" statement made in regards to working on overcast days. But what really makes snow have texture and defines all those snowflakes is sidelighting. To put it another way, it's the shadows. Without shadows caused by side-lighting, there is no texture. On an overcast day you can't hold texture in snow no matter what you do, because there are no shadows. When you look at a snowy scene on a flat, overcast day, all you see is a flat, white expanse. If you meter this and open 1 stop, you'll end up with muddy, dull pictures of light-gray snow. For proper exposure, you must open up from your base meter reading even more than normal. You want to record textureless white as exactly that. To keep white snow looking white when shooting on an extremely overcast day you should meter the snow itself and then open up 2 1/2 stops. This is exactly the same exposure recommended by gray card manufacturers for metering the textureless white side of a gray card.

When you analyze this situation, you'll realize that once again you're working in stops. You're placing tonal values as you want them to appear. Just be sure to select one area of snow, decide how light you want it to be, then meter only that area. Open up the correct amount for that particular subject, and your snow photos will be perfectly exposed.

Sunrises and Sunsets

Photographing sunrises and sunsets is just as easy as photographing anything else if you work in stop increments. Most people have problems because they try to meter the scene just as they have composed it. Generally speaking, most sunrise/sunset photos are not of the sun itself. Usually you're not trying to fill the frame with just a giant fireball. Most of the time you'll want some foreground object to be silhouetted against a much lighter sky. However, one of two things generally happens in the average sunrise/sunset photo. If you include the sun in your shot, especially toward the center of the frame, its extreme brightness will greatly influence your meter reading. The meter always tries to render whatever it is pointed at as a medium tone, so it will tell you to stop down to make the sun itself a medium-toned subject.

OAKS IN FOG, TENNESSEE.
Nikon F5, Nikon 80–200mm lens, Fuji Velvia.

For some reason, exposing a foggy scene seems to make some photographers rather foggy in their thinking. Fog is not medium-toned. It's lighter than that, but it's not white, either. Here's a tough question: What's between medium (zero) and 2 stops open? That's right, 1 stop open. If you meter the fog and open up one stop, fog appears the light gray that it is.

Consequently, your whole photo is grossly underexposed, with a medium-orange sun appearing in near-black surroundings. Not good. On the other hand, suppose your camera is aimed at the foreground. Then the meter tries to make *that* portion of the image a medium tone, and it tells you to open up the exposure values for the dark foreground. In this case, your entire photo is overexposed, with the sky burned out.

The solution to this problem is to be very careful in choosing the area to meter, and then work in stop increments to place that area as the tone you want it to appear on film. As I've stated before, you can make any portion of your picture appear as any tone you want it to be. Indeed, it doesn't have to be this particular tone in reality. Reality and photography are two different worlds. The question to ask yourself is never "What tone is this?" but rather "What tone do I want to record this as?"

So with sunrise/sunset situations the first order of business is *not* to meter your final composition. Instead, aim your lens to one side and meter a clear portion of the sky *without* the sun appearing in the frame. This is your base meter reading; if you shoot at this exposure value, then that particular portion of the sky will be rendered as a medium tone in your photo. But do you want it that way? How about lighter or darker?

The best answer I have, and the way I work most often, is to place the sky about one stop lighter than medium, adding one stop of light to my base meter reading. This works particularly well when I'm silhouetting a subject against the morning or evening sky. In fact, almost all of my silhouette shots are done using this easy technique.

Suppose you want to silhouette some trees against a beautiful twilight sky just after sunset. Find your shooting position, determine your focal length, then aim your camera at the open sky slightly above the horizon and meter this area. Use a spot meter if you have that option, so that you're metering that one specific area only. A center-weighted metering pattern would be my second choice, and evaluative/matrix my last choice. If you must work with a matrix pattern, run a few test shots some twilight when you're at home before trying this out in the field.

Let's assume your meter says 1/8 sec. at *f*/11. Recompose exactly as you want the image to be framed, then open up the exposure one stop to 1/4 sec. at *f*/11. By doing this you ensure that the trees silhouetted in the foreground do not disappear tonally into the sky. If you make the sky "medium" by shooting at the direct meter reading, your silhouette won't show up nearly as well. This

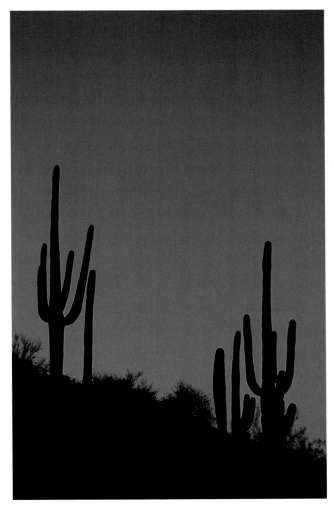

SAGUARO CACTI AT FIRST LIGHT OF DAWN, SAGUARO NATIONAL MONUMENT, ARIZONA.
Nikon F4, Nikon 300mm lens, Fuji Velvia.

I spot-metered the sky just above the horizon in the center of the frame, then opened up one stop to place the sky as a "light" tone.

is particularly true when you're working silhouettes with a wide-angle lens. In these lighting conditions, just before or after sunset, the area of the sky nearest the sun will be much brighter than any other area. Since a short-focal-length lens encompasses a wide angle of view, the edges of the frame will be much darker anyway because they are off-axis to the light source.

Actually, if you meter selected areas of the scene you can easily predict how well your foreground will silhouette. Here's the process: Meter the sky and place it at whatever tonal value you want it to appear. Now point your camera at the foreground and meter it. Count how many stops make up the difference between the two readings. Since there is less light on it than in the sky, the foreground will be that many stops darker than the sky.

For example, let's assume I'm photographing that tree silhouetted against the twilight sky. I meter the sky and get a value of 1/60 sec. at *f*/11. In order to place the sky as a "light" tonality I open up one stop, to 1/30 sec. Now I meter the foreground (which is the same thing as metering the side of the

tree facing me, since both are receiving the same amount of light). The meter reading indicates 1 second at *f*/11. When I count the difference in stops between these two meter readings I end up with 5 stops. Therefore I know that a proper exposure for the sky as a "light" tonality will place the foreground 5 stops darker in tonality. What tone will this be? If you refer to my metering chart (see page 25), you'll know exactly what will happen. Start at "light," where I placed the sky, one stop open from medium. Five stops less light drops the tree totally off the bottom of the scale. It will appear on film as a detailless black silhouette, just what I wanted it to be.

Figuring out exposures in stop values is indeed helpful when you're photographing a high-contrast situation. If you do this carefully, you will be able to determine exactly how the final image will appear even before you trip the shutter release, just by comparing meter readings from different areas of the scene. Remember that you can only place one tonal value. Pick what's most important, meter it and place it as you wish it to appear, then compare meter readings from other areas against that exposure.

AUTOEXPOSURE

Almost every 35mm SLR manufactured today has several built-in autoexposure modes. These are usually *aperture priority* (you set the *f*-stop, the camera sets the shutter speed), *shutter priority* (sometimes called "time value"; you set the shutter speed, the camera sets the aperture), and *program* (the camera sets both aperture and shutter speed, based on the light level determined by the meter and the focal length in use). Which mode you should select depends on what you're photographing. Do you want to control the depth of field? Use aperture priority. Want to make sure the shutter speed doesn't drop below a selected speed so you can freeze motion? Use shutter priority. Want to turn your expensive camera into a basic box camera where you have no control at all? Use the program mode (Canon calls it "full auto").

All of the camera manufacturers seem to suggest that if you set your camera to one of these modes, you will automatically get great exposures. Well, it's true that you will get an exposure (you can also get one by opening the back of the camera before rewinding the film)—but it won't necessarily be a great one or a correct one. Using an autoexposure mode does not mean that you can safely stop thinking about the photographic process. Autoexposure can be used whether or not the camera is autofocusing, and with any metering pattern you wish.

In the section on metering (pages 24–27), I talked about placing tonal values based on a medium-tone starting point. Autoexposure works in exactly the same fashion. With a manually set exposure system, you have to null the meter by physically changing shutter speed, aperture, or both. The meter then indicates a medium-tone exposure value for whatever it's pointed at. With aperture priority or shutter priority autoexposure, as you choose aperture or shutter speed, respectively, the camera sets the other variable for you . . . but the meter still shows a medium-toned exposure if you're using a spot or center-weighted metering pattern (reread what I said about evaluative metering systems on page 27, as it still applies). So if you're in any autoexposure mode and you point your camera at any subject and shoot at the indicated values, the subject will be rendered as a medium tone. Autoexposure works exactly the same as a manually set system; there is no difference in the results.

If autoexposure always suggests a medium-toned placement for whatever you point the camera at, how do you photograph non-medium subjects? Changing the shutter speed or aperture in an autoexposure mode has no effect on the amount of light hitting the film, as the camera automatically compensates for any change that you make. If you go to a smaller *f*-stop, it gives you a longer shutter speed. If you go to a faster shutter speed, it gives you a wider aperture. You're always right back at a medium-toned placement. To override the autoexposure system, you must use the *autoexposure compensation control* on your camera, where you can dial in plus or minus compensation. Read your instruction manual to learn how to access this feature. If you take another look at the exposure chart I gave you on page 25, you'll see that the compensation control works in exactly the same manner.

Let's say you're photographing in the sand dunes at Death Valley. The sand is "light"—a +1-stop tonality, about the tone of the palm of your hand. Since you want to use autoexposure and you're photographing a large scene you have chosen to work in aperture priority at *f*/22. You know that if you simply shoot at the camera reading the sand will be rendered as a medium. Point the camera at the sand, dial in +1 on the exposure compensation control, and the camera will automatically add 1 stop of light. Since you have set *f*/22 as your chosen aperture, it will do this by slowing the shutter speed 1 stop. The light sand will record as a light tonal value. Just remember to reset the system back to zero, or from now on you'll be adding a stop of light to all your pictures. Auto systems can automatically make mistakes for you if you're not careful.

But what happens if there are several tonal values in the picture? Suppose you want to photograph a friend who is accompanying you on your sand dune expedition. He's wearing a dark blue shirt and is standing in the same light as the dunes. So you point the camera at the sand, dial in +1 to make the sand "light," then re-compose a tight photo of your friend. Are the results correct? No. When you dialed in +1, you essentially told the camera to render whatever you pointed it at 1 stop lighter than medium. It doesn't know that you're no longer aiming at the light sand. Aim at the dark shirt, and the autoexposure system will automatically record that shirt as a +1 value, a "light" tonality. What happens to the final image? Since there are 2 stops from "dark" to "light," the entire picture will be 2 stops lighter than it should be. You've overexposed.

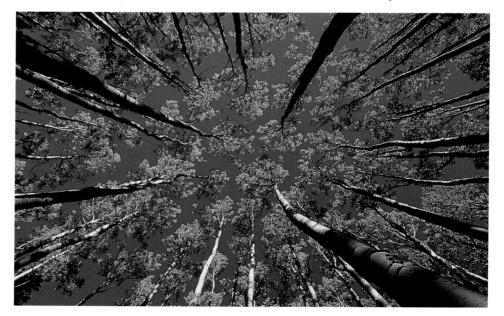

AUTUMN QUAKING ASPENS, COLORADO.
Nikon F5, Nikon 18mm lens, Fuji Velvia.

Here's how you take a picture like this one: Walk around in an aspen grove looking up until you find a treetop pattern you like, then lie down on the ground and point the camera straight up. Simple. In fact, I handheld my camera for this shot; since I was using an 18mm lens, my shutter speed was plenty fast enough to do so. I used matrix evaluative metering and the aperture priority mode. Probably the most difficult part was standing back up again.

You forgot one essential step in using an autoexposure system. You have to lock in the exposure reading off the sand. Somewhere on your camera is an *autoexposure lock* button (it might be accessed by depressing the shutter release part way). Meter your chosen area, dial in the compensation you need, then lock the exposure before re-composing. Some cameras will hold this setting for several frames, some will not. Once again, you need to read your instruction manual.

If you were taking this image with a manually set exposure system, you would meter the sand, open up 1 stop, then take the picture of your friend. The camera doesn't change settings by itself, since in manually set exposure mode what you set is what you get. But in autoexposure modes, the camera keeps compensating and changing the exposure until you tell it to quit doing so.

Here's a quick quiz: How would you make an exposure if you started by metering your friend's shirt? Would it be different from metering off the sand? The shirt is "dark," a −1 tonality. Meter the shirt, dial in −1 on the compensation and lock in the exposure, re-compose and shoot. The shirt will be recorded as a dark tone. And the sand? It will be recorded correctly as a light tone. If you place one tone correctly, everything else falls into place. Metering the dark shirt and subtracting a stop of light from the meter reading will result in the exact same shutter speed/aperture combination as metering the light sand and adding a stop of light to the meter reading. You just started your calculations from different points.

I mentioned it before, but I'll say it again: Evaluative metering patterns don't work in the same manner. You should not dial in compensation when using them, since you don't know from what starting point the meter is working. Has it already added some exposure or subtracted some? You'll need to run a few tests with your camera set in evaluative metering, as different camera brands work differently. If you set up a shot with mainly medium-toned subjects, evaluative metering should work perfectly. But if you photograph a series of increasingly non-medium subjects, I'll bet that when you fill the frame with subjects toward either end of the tonal scale you won't get proper results. Learn when you can trust evaluative metering, and when not to use it.

In some ways I think autoexposure is much harder to use than a manually set system, as you must depress the autoexposure lock button to keep your exposure setting from changing. What happens when you need both hands to slightly reposition the tripod head? With a manually set exposure mode the camera maintains the exact same settings; with an autoexposure mode it will change unless the lens remains pointed at the original subject you metered and placed.

But there certainly are times when autoexposure is a good choice. I think aperture priority is by far the most useful mode, as in landscape and closeup photography you're always concerned about the depth of field. In these situations it's nice to be able to choose the *f*-stop and watch your camera display what shutter speed is being set. Be aware that you still might have to compromise your choice of settings in order to fight the wind or subject movement.

One situation where autoexposure can really help is when you're photographing in changing light. For example, you might be photographing some prairie grasses and flowers with the light varying in intensity as high clouds move across the sky. Meter and place your tonalities as you wish, then let the camera adjust for the changing light level.

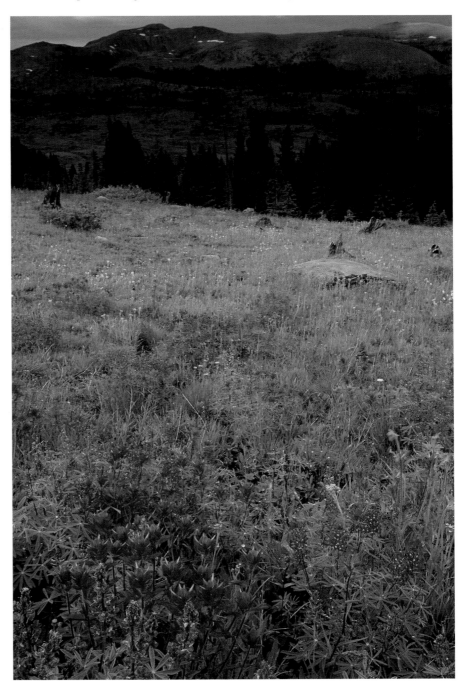

ALPINE MEADOW OF PAINTBRUSH AND LUPINE IN LIGHT RAIN, LOOKING AT THE GORE RANGE MOUNTAINS FROM SHRINE PASS, COLORADO. Nikon F4, Nikon 20–35mm lens, Kodak E100S.

I set my camera on center-weighted metering and aperture priority, then chose a small aperture for the depth of field I needed.

You can wait for lulls in the wind, knowing that the exposure will still be right regardless of the lighting differences. By the way, if you have an eyepiece shutter on your camera you should definitely use it, or use your hand or hat to block off any direct sunlight from striking the eyepiece. Some meters can be influenced both by light entering the lens and by light entering from the other direction (through the viewfinder).

It seems logical to use shutter priority mode for birds and animals, but I almost never do this. If you set the camera to aperture priority, you end up with the fastest possible shutter speed for any given *f*-stop. Suppose I want to photograph an animal that's moving around. If I set the camera on shutter priority at 1/250 sec., that's the shutter speed that will be used regardless of the light, but the lens might have to stop down a bit for correct exposure. If I use a lens that is *f*/4 when wide open and stick with 1/250 sec., the lens might go down to *f*/4.5 or slower as the animal moves in and out of the light. But if I go with aperture priority with the lens wide open at *f*/4, the shutter speed will increase to maintain correct exposure. In this situation, I would prefer to sacrifice some depth of field in order to get a faster shutter speed.

The only time I've gone to shutter priority mode is when I've used fill flash in bright sunlight. My Nikon F5's flash synchronization speed is 1/250 sec., so I set this in shutter priority and let the *f*-stop vary a bit. That's an easy way to keep from overexposing daylight flash pictures. For example, once I was working on rockhopper penguins in the Falkland Islands, using fill flash on a bright sunny day. The penguins were indeed hopping over large boulders, and in the rough terrain I was forced to handhold my 80–200mm lens as I followed them around. By setting my camera to 1/250 sec. in shutter priority I accomplished two things: I kept the shutter speed up at a marginally hand-holdable speed, and I stayed at flash sync speed.

So what about that "full auto" or "program" mode in autoexposure? As far as I'm concerned, for serious work you should skip this setting altogether. The camera sets both the shutter speed and the aperture, but how does it know if either is what you want or correct for the photographic situation? If you have to pay attention to what the camera is doing and override the camera's choices, then why not just make that decision in the first place and set either shutter speed or *f*-stop? I *can* think of at least a couple of times when program mode does come into its own. First, it's an easy way to get a complete neophyte involved with taking pictures. For example, I've handed a camera to some of my driver guides in East Africa to help them better understand what I do. My favorite driver now comments on my selection of focal length: "Are we shooting with the 500mm today?" Program mode is also useful when you want to turn your SLR into a box camera, such as when photographing a child's birthday party. Load some fairly fast negative film, stick a flash in the hot shoe, and fire away. Come to think of it, a point-and-shoot camera would probably do a much better job.

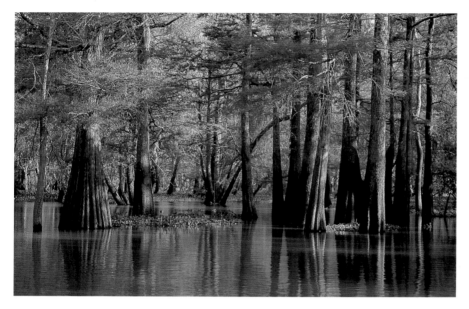

BALD CYPRESS SWAMP IN SPRING, ATCHAFALAYA BASIN, LOUISIANA.
Nikon F5, Nikon 80–200mm, Fuji Velvia.

Some darker areas and some lighter areas add up to some difficulty in figuring out proper exposure. I used matrix evaluative, shooting on aperture priority at about f/8.

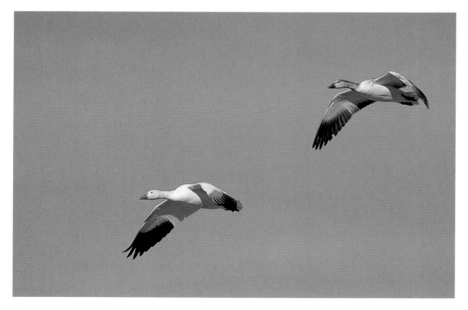

SNOW GEESE IN FLIGHT, BOSQUE DEL APACHE NATIONAL WILDLIFE REFUGE, NEW MEXICO.
Nikon F5, Nikon 500mm lens, Kodak E100SW.

This is a testament to how well the Nikon F5's version of evaluative autoexposure works. This entire frame is lighter than a medium tone—in fact it adds up to be about a +1 scene—yet the auto meter has rendered it correctly.

MULTIPLE EXPOSURES

Sometimes you may want to make several exposures on one piece of film. I'm not talking about double-exposing the moon into a picture, although that is quite easy to do. Make one image as you normally would, leaving an area of the sky blank (and very dark). Now make a second exposure without letting the film advance, this time of the moon, positioning it so that the moon is in this dark part of the frame. That's it; you have a moon over a landscape where there was none before. No exposure compensations are necessary beyond changing the settings for each shot. Note that the two exposures aren't additive in terms of the amount of light hitting the film, as the moon is dropped onto an unexposed section of the film.

The problem with this technique is that it's normally quite easy to spot. First of all, far too many of these shots are taken with radically different focal lengths—the landscape with a short lens, such as a 24mm, and the moon with about a 300mm. We've all seen enough photos to know that something is not right with the resulting mix of perspectives. Additionally, the light falling on the foreground landscape and the light on the moon should both be from exactly the same direction, since both are supposedly lit by the same light source. But in most "moon" shots this isn't true. Look carefully and you'll see that many pictures show a full moon hanging over a sidelit landscape. Impossible. To be full, the moon has to be frontlit. You can't have sidelight on earth and frontlight on the moon unless you have two suns. There's another problem with this technique. Since the moon is normally the second image exposed, it will often pick up some color from the first shot. Double-expose a moon into a blue twilight sky, and you end up with a blue-tinted moon. Not good at all.

No, when I mention multiple exposures I mean making several complete exposures on the same frame of film—layering exposures. For example, you might want to work multiple images of flowers in the wind, or many sparkles on flowing water. You'll have to check your camera's instruction manual to find out how to keep the film from advancing after each shutter trip. On some new bodies you can program in exactly how many frames you want to shoot before the film winds. On other cameras, you must push a button or trip a lever before each firing of the shutter.

If you have an older, mechanical camera, here's the procedure for multiple exposures. Before taking your first shot, gently turn the rewind crank in the rewind direction until you feel the film snug up. Don't force it; you just want the film to be securely in position with no slack. Now take your first shot, then hold the rewind knob in place so it cannot turn, depress the rewind release button, and very slowly cock the shutter again. Repeat this holding of the rewind knob and winding film sequence for as many exposures as you want.

The problem is how to figure out the correct final exposure if you're adding one image on top of another. The best—and by far the simplest—method is to work in stop values. Remember that a stop is defined as a doubling or halving of any amount. If you work in the doubling progression of 2, 4, 8, 16, etc., multiple exposures can be calculated as follows. Take a meter reading as you normally do. Let's say your exposure is 1/30 sec. at *f*/11. How many shutter trips at 1/60 sec. add up to 1/30? Two. So if you shoot two exposures on the same frame of film, each at 1/60 sec. at *f*/11, you will end up with the correct amount of light hitting the film. One 1/30 sec. exposure equals two 1/60 sec. exposures or four 1/125 sec. shots or eight 1/250 sec. or sixteen 1/500 sec. or thirty-two 1/1000 sec., and so on. The sum of all the multiple exposures equals the total amount of light for one normal exposure.

While I think this is the easiest way to work, you can use other methods to arrive at the same results. You could take a normal meter reading, then stop down the aperture the correct amount for the number of exposures you plan on making. This is easiest with the newer cameras that offer 1/3-stop shutter speed increments. For two exposures, you stop down 1 stop from your normal meter reading. To combine three exposures, close down 1 2/3 stops for each from your normal meter reading. For four exposures, close down 2 stops; for five exposures, 2 1/3 stops; for six, 2 2/3 stops. For eight exposures it's 3 stops; for sixteen, 4 stops; for thirty-two, 5 stops, and for sixty-four exposures on the same frame, it's 6 stops.

A third method is to multiply the ISO number of your film times the number of exposures you want to use. Set your ISO scale to this new number, meter the scene, and take the right number of shots on the same frame of film. The advantage to using this ISO number method is that it lets you shoot odd numbers of exposures, instead of just doubling. Let's say you want to shoot five exposures and you're using ISO 100 film. Change your ISO to the 500 mark, meter, and fire away. The catch is that you must remember to reset the ISO back to the correct number or you'll ruin the rest of your film. I would much prefer to count "2, 4, 8" out loud while I'm shooting than to start resetting my camera's controls. I make enough mistakes without the camera making them for me.

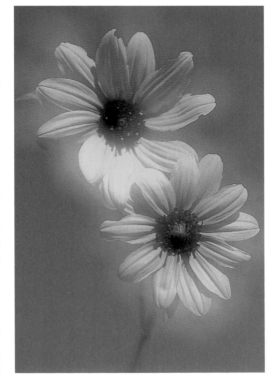

PRAIRIE SUNFLOWERS, COLORADO.
Nikon F5, Nikon 105mm lens, Fuji Velvia.

Here are two exposures on one frame of film, each exposure being 1/2 of the total required for the picture. I took a meter reading, determined the f-stop I wanted to use, then went to one faster shutter speed since I planned on exposing twice. In the first exposure, I kept the flowers in focus, while for the second one I threw them slightly out of focus to create a glowing halo effect.

Long Exposures and Reciprocity Failure

Modern cameras with sensitive TTL meters can give you exposure readings in extremely low light, but you should realize that as exposure times get longer, the reciprocal relationship between aperture and shutter speed no longer works in direct proportions. As you know, in normal lighting situations a 1-stop adjustment in aperture requires a 1-stop adjustment in shutter speed, and vice versa. But at lower light levels, the films no longer respond the way they normally do. This leads to what is called *reciprocity failure*. Every film exhibits its own distinct characteristics in regard to it.

Films are manufactured to react correctly within a particular range of light levels, what we consider normal working conditions. Photograph outside of this zone, and you must correct your exposure for how the film's chemical reaction changes. For most of us, this comes into play when we're working in extremely low light with extremely long exposure times. Films also display this reciprocity failure problem at very fast shutter speeds, and at extremely short flash durations, but in actual field photography you will rarely encounter these high-speed problems. Be more concerned with what happens during long exposures.

When working in low light, as in all other shooting situations, the first step is to meter and place tonal values. Almost all modern cameras have shutter speeds that range down to 30 seconds and normally you should not have a problem getting a meter reading even at the slowest speeds. However, if your camera doesn't allow you to take a reading in low light, here's what to do.

Meter at whatever aperture gives you a reading. Let's assume you get a reading of 1 second at *f*/2.8. What are the equivalent exposures? By now, this should be easy for you to figure out. One second at *f*/2.8 is the same as 2 seconds (1 second doubled) at *f*/4, 4 seconds at *f*/5.6, 8 seconds at *f*/8, 16 seconds at *f*/11, 32 seconds at *f*/16, and one minute (okay, so it's really 64 seconds, but the difference is meaningless) at *f*/22. What you've done is count a normal reciprocal relationship. Choose the *f*-stop you want to use for your photograph, and set the shutter speed accordingly.

However, once you're at any shutter speed longer than 1 second, you must take into account the reciprocity failure characteristics of the particular film you're using. If you shoot at the indicated value, you'll discover that your slides will come out too dark. Your film has in effect slowed down in this low-light situation, and you must add some more light to get back to correct exposure. This problem is compounded by increases in exposure time, so I would suggest you add

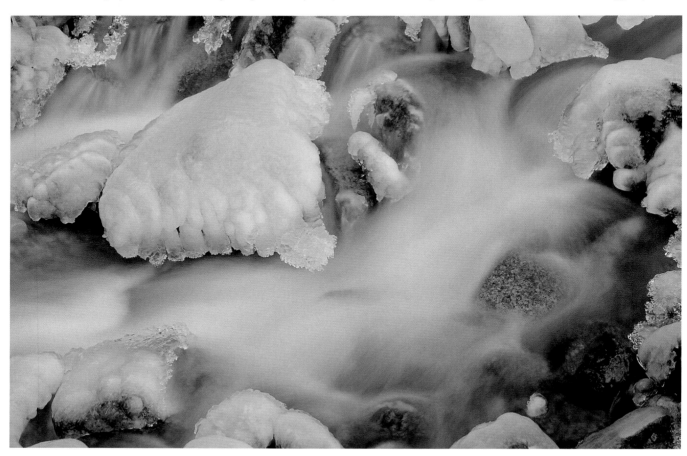

ICE IN CANYON STREAM, COLORADO.

Nikon F4, Nikon 80–200mm lens, Kodak E100S.

I waded along this stream, which drops through a steep-sided narrow canyon not far from where I live, photographing the ice-covered rocks. Even with an 81A filter (see page 56 for information about them), the blue from the sky colored the ice and water, but I think the cold tone adds to the effectiveness of the image. I spot-metered the ice at the upper left, placed the brightest area as a +2 tonality, and came up with a shutter speed of 4 seconds. Did I have to add any light for reciprocity failure? If you check the chart opposite, you'll see that I didn't.

light by opening up the aperture rather than increasing shutter speed.

In truth, you will rarely photograph at exceedingly long exposures. With current films I doubt you'll ever find yourself photographing at shutter speeds much longer than 10 or 15 seconds. If you discover that your personal photography involves working with minutes-long exposures, by all means run some tests and keep meticulous notes. Most likely you'll end up using only one film at a few unique exposure times—for example, 10 minutes or one hour. Keep it as simple as you can. For the rest of us, memorizing the reciprocity failure corrections for the films we use most often is all that's necessary.

With some films, long exposures can also result in color shift, so filters must be used to restore the original color balance. I've ignored color shift corrections in the chart. For the most neutral photos, I would use Astia or Sensia, which shift slightly warm at about 30 seconds, or E100S, which exhibits the same shift, but not until around one minute. Using a neutral film means that you don't have to add, or carry, color compensating filters. These are special-purpose filters that are rarely used otherwise, so why bother bringing them if you don't have to? Kodachrome 25 is another good choice in terms of lack of color shift, although it starts out 2 full stops slower than Sensia or E100S.

PINK EARTH-LICHEN, NORTH CAROLINA.
Nikon F4, Nikon 200mm macro, Fuji Velvia.

This is a bizarre little lichen. I found it one cloudy June day, growing beneath a forest canopy of summer leaves. A combination of factors gave me a long exposure: not much light on the subject, a 1/2X magnification rate, and an aperture of f/32. My meter indicated 10 seconds and I was using Velvia film, so I added 2/3 stop of additional light.

EXPOSURE COMPENSATION FOR RECIPROCITY FAILURE					
FILM	**1 sec.**	**2 sec.**	**4 sec.**	**15 sec.**	**30 sec.**
Velvia	none	none	+ 1/2	+ 1	N/A
Provia	none	none	none	+ 1	N/A
Astia/Sensia	none	none	none	none	none
Kodachrome 25	none	+ 1/2	+1	+1 1/2	+2
Kodachrome 64	+ 1/2	+ 2/3	+1		N/A
E100S/SW	none	none	none	+ 1/2	+1

Here are some recommendations for different films. Note that the numbers shown as "+" values are the numbers of stops of light you need to add. For example, if you want to add "+1 1/2" to an exposure calculated at f/16, open up the aperture 1 1/2 stops to between f/8 and f/11. Of course, your meter display will now say that this is overexposed. Just ignore it, as you've added a correction factor that the meter knows nothing about.

EQUIPMENT AND FILM 2

QUAKING ASPEN TREES IN MIDWINTER, DIXIE
NATIONAL FOREST, UTAH.
Nikon F5, Nikon 80–200mm lens, Fuji Velvia.

BUYING A CAMERA SYSTEM

Once you've graduated from a basic point-and-shoot camera, you will most likely purchase a 35mm single-lens-reflex (SLR) camera. These cameras, which allow you to look directly though the lens, are probably the most versatile on the market today. If you have the right lenses, you can use an SLR to photograph everything from mountains to mosquitoes, and all the subjects in between. This great versatility accounts for the popularity of the SLR. Still, you shouldn't just rush in and buy the first camera outfit you find without thinking about how you plan on using it. What do you want to photograph? How often will you use your equipment? Must it stand up to the rigors of travel into remote locations? How serious are you about photography? Do you think your photographic interest will grow in time, and you'll want to photograph a wider variety of subjects?

You can definitely produce incredible photographs with any brand of 35mm camera currently available. After all, the camera itself does not take any pictures. You, the person behind the camera, do this job. In truth, the camera body is only a light-tight box that holds the film in place. This is not to say that all cameras are created equal. Far from it, as some are better suited to a specific purpose while others offer every bell and whistle imaginable. But all too often we start to believe that the brand name is important in and of itself. In reality, the quality of the lens mounted in front of the camera has far more to do with the quality of the resulting photograph than the camera body does. And the way in which that lens is used by you, the photographer—the way in which you proceed in your picture taking—is the ultimate factor.

Buy the best equipment you can, if for no other reason than that doing so removes any excuse for poor photos in advance. Owning good gear means you can't fall back on the old self-indulgent complaint, "If I only had a good camera...." Purchase good equipment, then learn to use that equipment in the best possible manner. Proper photographic technique is by far the most important factor in producing great pictures. The very best equipment, the finest cameras and lenses available, can produce photos no better than the photographer handling them.

Let me tell you a story. Several years ago I was teaching a workshop where we would shoot during the day, then process our film and critique it in the evenings. One participant had a very expensive 300mm *f*/2.8 lens which he insisted he could hand-hold at shutter speeds of 1/60 and 1/30 sec. No problem, right? When we examined his slides, not one was in sharp focus. When I suggested he should buy a tripod and use it, his response was that surely his lens must be defective. He would buy another 300mm *f*/2.8, perhaps a different brand, and it would most certainly improve his photos. Right, and if pigs could fly....

Even though technique is the most important ingredient for producing good photos, there are some specific features I think are important to have on any camera body intended for field work. Let me say up front, though, that these are features I would want in an ideal world. If you already own an SLR and it lacks some of these, don't worry. Start off using whatever you own, then upgrade your equipment when you can justify doing so. I will also say that almost all serious photographers tend to fall into the "den of equipmentry"—the illogical belief that if only we owned more equipment it would somehow improve our pictures. We start to believe that purchasing another lens, or another camera body, or a new tripod, or six more filters, or lots of that new film, or . . . well, you get the idea. Photographers tend to be equipment junkies and gadget addicts, always "needing" more stuff. Use whatever camera and lenses you already own, and use them to the fullest, then consider purchasing new equipment.

ESSENTIAL FEATURES

First and foremost, any serious photographer's camera should provide *full control over exposure settings,* since exposure is the most fundamental concept in photography. Ideally, I would like to have options for controlling the exposure—the more options the better. A few years ago, I would have said that TTL metering was a necessary feature, but now I can think of no 35mm camera currently in production lacking TTL metering. If you own a very old camera and have to rely upon a handheld meter, my advice is to update your equipment.

Most full-featured cameras today offer total manual control of exposure values, along with autoexposure options. In the manual exposure mode I would want 1/2- or 1/3-stop increments in both shutter speed and aperture, although I could live with (and did for many years) whole-stop jumps in the shutter speeds. In all the autoexposure modes I would want the same fine-tuning available, with a complete exposure compensation system available. You must be able to override

DEW-COVERED PURPLISH COPPER BUTTERFLY.
Nikon F4, Nikon 200mm macro lens, Kodachrome 25.

A long macro lens was perfect for this photograph, as it gave working distance between the lens and butterfly while at the same time narrowing down the background coverage thanks to the longer-than-normal focal length.

the autoexposure settings so that you, and not the camera, are in control. Autoexposure compensation should be at least two stops on either side of the metered value, and should also function in 1/2- to 1/3-stop increments. Full-stop increments are way too broad when you're shooting any of the slide films which demand precise control.

Autoexposure modes include *aperture priority* (sometimes called "aperture value") where you choose the *f*-stop and the camera sets the appropriate shutter speed; and *shutter priority* (also called "time value"), where you pick the shutter speed you want while the camera sets the *f*-stop. Which to use? See the section on *autoexposure* on pages 30–32. I'll say in passing that I believe aperture priority to be by far the most useful autoexposure mode. If you're shooting landscapes or close-ups, you're always concerned about depth of field, always choosing a particular *f*-stop. If you're working birds or mammals, you often need the fastest shutter speed possible. Set the aperture wide open, using aperture priority autoexposure, and the camera gives you that shutter speed.

Another autoexposure mode generally found on cameras is *programmed exposure,* which is often indicated by a "P." Here the camera chooses both the shutter speed and the aperture. As far as I'm concerned, you should reserve this exposure mode for those times when you're using print film in your camera to take snapshots of the kids. After all, if you're working with the precise slide films, and you're serious about your photography, why give up exposure control totally to the camera? How does it know what you want to do? How does it know what shutter speed or *f*-stop is appropriate for this subject? It doesn't have a clue. As far as I'm concerned the "P" should stand for "Pass this mode."

I might mention that some of the newer cameras have "custom settings" or "custom functions," which permit you to program a camera to operate as you prefer. For example, the Nikon F100 gives users a menu of exposure increment choices. With a simple push of a button you can program the camera to use 1/3-stop, 1/2-stop, or full-stop jumps in both shutter speeds and apertures. Once a choice is programmed, it applies to both manual and autoexposure modes.

A second feature your camera should have is a *complete range of shutter speeds,* available in all exposure modes. As faster films have become available, camera makers have responded by increasing the top-end shutter speeds. Right now there are several cameras available with a blazingly fast 1/8000 sec. shutter speed, and at least one with 1/12000 sec. In all honesty, I see no point in these speeds if you're planning on

shooting nature subjects with the slow-speed slide films (and that's what you're using, right? See the section on film beginning on page 48). You will rarely use a shutter speed faster than 1/1000 sec., and indeed that will be a once-in-a-while speed. Consider the following: You're shooting in brilliant full sunlight, the brightest light possible. That is, you're working in a "sunny *f*/16" situation. Assume that you're using an ISO 100 film. What are the equivalent exposure values in this situation? You're right, 1/125 sec. at *f*/16 or 1/1000 sec. at *f*/5.6. To use 1/8000 sec. you would also have to use *f*/2. But how often are you going to do this? I cannot think of any time I've shot this exposure. First of all, I almost always want some depth of field in my pictures. And secondly, I rarely shoot in midday light, especially if I am working on a subject that requires a poetic mood. The low lights of morning and evening are far better suited for photography than high noon.

Consequently, it's far more important to disregard the fast shutter speeds on a camera —every model on the market today has a high enough top speed—but rather evaluate what slow shutter speeds are available. Most cameras now offer timed speeds down to 30 seconds, although on some models these speeds can only be accessed in certain exposure modes. Most of the time this slow speed limit will be fine, although it would be nice to round out the timed speeds at one minute. Whatever the slowest shutter speed

offered, you can always go to slower speeds by setting the camera on its "bulb" or "time" setting, then timing exposures with the second hand on your watch. (Or you can resort to reciting "one-thousand-and-one, one-thousand-and-two. . . .") If you're using very long exposure times, complete accuracy doesn't really matter too much anyway. After all, being off by 10 or 15 seconds isn't a lot if you're working with a several-minute exposure time. Consider what happens if you've determined you need 4 minutes as your shutter speed. One stop less time is 2 minutes, while 1 stop more time is 8 minutes (remember that shutter speeds work in stops, straight numerical doublings as you increase time). It's no big deal if you're off by 15 seconds either way.

I'll just mention in passing that there is another way—albeit a rather oddball method —to time multi-second exposures as long as you're working on non-moving subjects in unchanging light. Perhaps you're shooting autumn leaves on an overcast, windless day, or rock formations at twilight. Let's assume you have a camera which has a slowest speed of one second, but you need a two-second exposure for your shot. You could set the camera on "bulb" and do the counting routine, but any discrepancy will show up here if you're not careful. An answer is to do a multiple exposure (for a discussion of this, see page 30). Shoot two 1-second exposures on the same frame, without advancing the film,

DESERT COTTONTAIL AND RED ROCKS, CAPITOL REEF NATIONAL PARK, UTAH.
Nikon F5, Nikon 300mm lens, Kodak Ektachrome VS.

This photo was taken with a 300mm f/2.8 lens set wide open. I needed a fast aperture lens, due to the thick overcast, and a fast handling lens as this cottontail didn't sit still for long. I worked it for about 20 minutes before it left for parts unknown, and managed to shoot about eight frames. If you plan on working wildlife in conditions such as this, make sure your camera system does indeed offer fast long lenses.

and there's your needed shutter speed! I haven't ever had to do this with my Nikon cameras, but I also use a panoramic format camera (6 x 17-cm film format) and I've used this trick quite often with that.

You'll definitely want a *depth-of-field preview*. For serious photographic work, I would not buy any camera body that doesn't offer this absolutely vital feature. It permits you to stop the lens down to your shooting aperture and see what depth of field will appear in your final photograph. Normally, when you look through a lens, you are viewing with the lens open at its largest aperture. So, you're seeing what the depth of field looks like at that aperture, but not the depth of field at the *f*-stop you've selected to use for your photo. These are the same only if you're shooting with the lens wide open, but you will rarely do this except when taking bird and mammal photos. For landscapes and closeups you will almost always be at a smaller aperture. As part of my control over the photographic process, I want to see exactly what the film sees. I definitely don't want to guess how the image will appear on film. A depth-of-field preview solves this problem.

Of course, when you do stop the lens down, the viewfinder image gets darker. There's less light coming though the lens at the smaller aperture, so less light comes back to your eye. It becomes hard to judge the depth of field in a dim image. It's like walking into a darkened room from a brightly lit area; your eyes can't adjust instantaneously. So don't go from viewing with the lens wide open to a very small aperture all in one step. Change the *f*-stops gradually, waiting a few seconds at each full stop for your eye to adjust to the lower light level. Slowly the iris in your eye will open up, and you'll be able to see. It helps to keep out any extraneous light, either by shading your face with your hand or by using an eyecup around the viewfinder. Just wait a while and you'll be able to see through your stopped-down lens, no problem.

You can even make a dark cloth to put over your head to cut out the light. Ever see view camera photographers at work? You probably noticed that they had black cloth covering both their heads and the backs of their cameras. You literally cannot see through a view camera without one; there is too much extraneous light. If you don't want to carry a dark cloth, another easy solution is to pull your jacket up over your head and the camera. A little weird-looking, maybe, but it works!

Once you can view through the lens at different *f*-stops, how do you know which one is correct? It's simple; the right aperture, giving you the correct depth of field, is the one you like best. After all, it's *your* photo-graph, so you should make it appear the way you like it. Slowly change apertures, evaluating both the subject and the background, until the image appears as you want it to be. That's the right *f*-stop to use for this photo. I've always called this procedure using the "WOW!" factor (and indeed it's the same process I use in selecting filters). View through the lens, or through a filter held up to your eye, and if you say "WOW!" that's exactly what you ought to use.

You'll also want a *complete system of lenses* to be available. One of the major reasons for the popularity of SLR cameras is the abundance of available lenses. Just make sure that your camera brand actually offers such a choice. At the absolute minimum I would want focal lengths from 24mm to 300mm included. Preferably this range would be covered by both zoom lenses and fixed focal lengths, so you have a choice in what to use. In truth, 300mm is quite a short focal length if you plan on doing much bird and mammal photography. A far better range of lenses would be coverage from 20mm to 600mm, with a choice in lens speed in the different focal lengths also. Right now you may not think you'll ever need a 400mm *f*/2.8 lens, but it's better to have a camera system in which such a lens is manufactured, just in case.

At this time, Nikon and Canon are the predominant professional camera brands for a simple reason: they offer broad choices, both in camera bodies and in lenses. For example, assume you want a lens that covers the 105mm focal length. Let's look at Nikon's choices (Canon's are fairly similar): 105mm *f*/1.8, *f*/2, *f*/2.5, or *f*/2.8 macro in fixed focal lengths; 28–105mm, 28–200mm, 35–105mm, 35–200mm, 50–300mm 70–180mm macro, 70–210mm, 80–200mm, 70–300mm, and 100–300mm zoom lenses. Now that's choice.

I would also like to have tripod collars on all my lenses, particularly the longer focal lengths and physically large, heavy zooms. A tripod collar allow you to mount the lens, rather than the camera body, on the tripod head. Switching between horizontal and vertical compositions is then accomplished by rotating the lens in the collar, rather than flopping the head over to one side. This keeps the lens on the same optical axis and also keeps the weight of camera/lens directly over the tripod head, giving more stability. There is a partial solution to the "no tripod collar" problem, especially for shorter lenses; see my discussion of the "L-bracket" in the section on specialized support products (pages 54–55).

Your camera should also have an easily attached *remote release*. In older camera models, this is a cable release; the newer cameras use an electronic release. Personally, I would like to be able to use the old mechanical cable releases on my new cameras. Cable releases are far less expensive, far less likely to break, and far easier to attach. An electronic release is just a long wire with a pushbutton switch on one end, but that wire can easily break from repeated flexing (like repeatedly stuffing it into your camera pack).

You use a remote release to eliminate vibration problems when you're shooting static subjects. Compose carefully, set your exposure, lock the tripod head in place, then use the release. Don't leave your motor drive in its "continuous fast" setting while holding down the release; you'll get sharper photos if you shoot a frame, wait a few seconds for everything to settle down, then shoot another frame. By the way, did you notice I said to use a release only for static subjects? I've watched many beginning photographers become totally frustrated trying to use a release while shooting active birds and mammals. You simply don't have enough hands to manipulate all the equipment: one hand to position the lens as the subject moves, one hand to control the tripod head, and a third hand to find the remote release. Forget it. For action work, your right hand should always be firmly holding the camera body, index finger on the shutter button. No cable releases allowed here.

It's also not a good idea to walk around with a release fastened to your camera. They can easily catch on tree limbs, under camera pack straps, or in car doors, and can get wedged in rock crevices or a million other spots. At best no harm will be done, but all too often either the tip of the release breaks off or the electronic connection point on the camera gets destroyed. So take your release off when you're not using it.

The availability of a *sophisticated flash system,* with both TTL flash metering and fill flash capabilities, is also important. Most camera brands now offer fairly extensive choices in flash units. Make sure your camera body has a flash synchronization speed faster than 1/60 sec. A 1/250 sec. speed would be much better, but you can get away with a stop slower (1/125 sec.) if absolutely necessary. A fast flash synchronization speed is important as it enables you to combine an ambient light exposure with fill flash in daylight. This fast sync speed is absolutely necessary for fill flash use on birds or mammals. After all, when working these subjects you'll want to keep the highest possible shutter speed. You want to stop both their motion and any movement of your lens. If the fastest flash sync speed on your camera is 1/60 sec., you've got major problems.

Some manufacturers now advertise that their cameras will allow flash to be used at all

shutter speeds. Beware of this statement. You probably won't get all of the flash features, such as TTL metering or control over fill flash amount. Right now the fastest sync speed permitting complete flash operation is 1/300 sec.

OTHER USEFUL FEATURES

I consider the features above essential for a good camera system, but I can think of quite a few other features that would also be great to have. My first suggestion in this category would be *a choice of metering patterns that includes spot-metering.* Most current cameras have a user-selectable choice between a matrix metering pattern, also called multi-segment metering, and a center-weighted or averaging pattern. A few also offer spot-metering (see pages 24–27 for a discussion of all of these patterns), which I think is a great help for accurate work in the field. Spot-metering lets you meter a very small section of a scene rather than the overall image; it's a very precise meter that reads an angle of only a few degrees at most, just one spot in the scene. Suppose that you're photographing a contrasty scene, a fairly tight shot of some dark green ponderosa pines in the midst of a snowy field. It's an overcast day, so you know that the scene is within the contrast range of the film. You know that the very worst thing you can do with slide film is to burn out the highlights by overexposing the snow, but at the same time you don't want to lose detail in the trees. If you take an overall meter reading, regardless of the metering pattern, the meter

sees both the light and dark tones. The meter will give you the correct exposure values only if these tonalities are equidistant from medium tone, and only if you aim the camera precisely, so that the meter sees exactly half dark and half light.[1]

What to do? With a spot meter you could meter one precise area, such as the snow or the dark greens. Pick one area, spot-meter it, and place it as the tone you want it to appear. I would probably choose the snow, since you should always worry about the highlights, and also since there's probably more of it in the scene than any other tone. Always pick the easiest subject. How do you make white snow appear white on film? Meter the snow, and open up about 2 stops from your meter reading to render it as white, not middletone gray.

By the way, if your camera doesn't have a spot-metering provision, you can make one. Switching to a very long-focal-length lens accomplishes the same thing as it narrows down what your camera, and thus the meter, sees. Meter through a 300mm or longer lens, then transfer that exposure value to whatever lens you want to use for your photograph.

Along with spot-metering, it would be great to have an *analog meter display in the viewfinder* when working in the manual exposure mode. If you can learn to think about exposure values in the way I suggested back in the section on metering, an analog display of values will be extremely helpful. This is a viewfinder display of where metered values fall in relation to a mid-point (middletone) and looks something like this:

| . . | . . | . . | . . |
+2 +1 0 −1 −2

This particular example is set up in 1/3-stop increments, from 2 stops lighter than medium (+2), to 2 stops darker than medium (−2). A 1/2-stop increment display would show just one dot between each number bar. Good analog displays show at least a 2-stop range on either side of the mid-point, the tonal range of slide film, although some cameras only show plus and minus 1 stop. An indicator bar or light shows up on this scale, displaying where the exposure is set relative to the zero point, middletone. As you change shutter speed or aperture this indicator moves along the scale.

You probably realize that this is another way of displaying the exposure system that I described on page 25. As far as I'm concerned, having this information displayed while I look through the viewfinder is a wonderful convenience. For example, suppose I'm photographing a scene where I want a particular section to appear "light" in the slide, 1 stop lighter than a medium tone. I don't have to take a spot-meter reading of this particular area and then open up 1 stop. Instead, all I have to do is to set my exposure values so that the indicator reads out at +1. Or let's say I'm doing a tight portrait shot of a dark bison. "Dark" is 1 stop below medium. I don't have to take a reading and stop down 1 stop from medium. Instead I just change shutter speeds or apertures (or both) until the display shows −1. Quick and easy.

At one time I would have added *motor drive provision* as a desirable feature, but with today's cameras, having some sort of integral built-in motor drive to advance the film and cock the shutter is almost a given. The choice is now in motor drive speed, how fast it actually advances the film in terms of frames per second. Top-of-the-line bodies have the fastest framing rates, up to around 8 frames per second.

With most cameras you still have the option of how to power the camera and its motor drive. Should you use AA alkaline batteries, lithium AAs, special power cells, or rechargeable battery packs? Given a choice, lithium AA batteries are probably the best answer, especially in colder weather. As cameras get more and more sophisticated electronically, and add faster autofocus, film advance, and rewind speeds, they need more and more power. Consequently they go

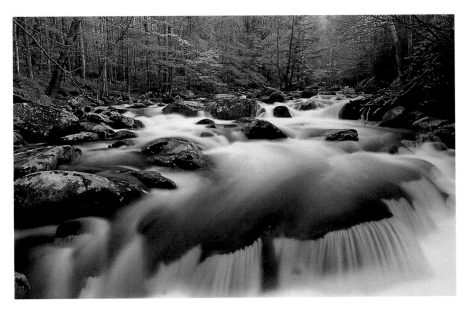

TREMONT RIVER AND SPRING FOREST, GREAT SMOKY MOUNTAINS NATIONAL PARK, TENNESSEE.
Nikon F5, Nikon 20–35mm lens, Fuji Velvia.

I needed the widest wide-angle lens I own in order to make this photograph. Also notice my location; I wanted the viewer to be right in the midst of this raging water.

[1] This is true except with some of the newer "evaluative" meters, which have software programs written to make judgments about subject tonalities. See the sections on metering and placement of values (pages 24–27) and autoexposure (pages 30–32) for more information.

though lots of batteries. It's not a bad idea to have a system that let's you fall back to alkaline AAs, as these can readily be found worldwide.

Most motor drives (or "motor winders," as the slower-advancing models are sometimes called) offer a choice as to the manner in which the film is advanced. Usually these are *single frame advance, continuous low* (or "slow"), and *continuous high* (or "fast"). In the single frame mode you get one exposure every time you press the shutter release, while in the continuous mode the camera keeps firing as long as the shutter button is depressed. When I'm shooting landscapes or closeups I always have the drive selector set at "single frame." This is slow, studied, methodical photography. I take a frame, wait for all vibrations to cease, take another frame, check my exposure and composition, take another frame, make sure the light hasn't changed. . . . Action work is another story. Here I always have the camera set at "continuous high." I always want to be prepared for the next pose and, since it might be only a fleeting moment, ready to crank off as many frames as possible. Shooting action with the

drive set at "single frame" is not a good idea. First of all, you have to push the shutter release for every frame, and if the action is fast and furious you'll find yourself rapidly jabbing your finger at the camera. Not good. If you're using autofocus (AF) (and action work is exactly where I think you'll want to use it), removing your finger from the shutter release makes the camera restart the whole focusing process over again.

I've heard beginning photographers state that they always use "single frame" in order not to waste film. This is backwards thinking when you're photographing birds and mammals. You're not wasting film by selecting single frame advance, you're missing opportunities! The best pose, the greatest photo opportunity, doesn't happen all the time, but when it does I want several frames. Even with a series of shots, one frame will almost always stand out as the very best due to minute changes in an animal's posture or position. If you only want one frame, that's fine. In the continuous high setting it's still very easy to simply lift your finger after triggering the first exposure. I might also note that concern over wasting film when photo-

graphing action is, in my opinion, false economy. Compared to the expense of purchasing a quality long lens and the time and money it takes to finally have a good-looking subject in front of you in good light, extra frames of film are not very costly. Currently, one frame of processed 35mm film represents a total outlay of roughly 40 cents.

On the other hand, some photographers think that using continuous high all the time—just holding down the shutter release —ensures that you will capture the peak of action. Not true at all. You must still be very selective as to the exact moment to photograph. Consider this: my Nikon F5 offers a top framing rate of 8 frames per second. If I'm using 1/500 sec. as my shutter speed, in one second I've captured 8/500 of the action while missing the other 492/500 of it.

A few years ago, I also would have said that a *mirror lockup* would be a desirable feature on a camera. Inside every 35mm camera is a mirror that must swing up out of the way for each exposure. Well, perhaps that is too gentle a description; the mirror must snap out of place instantly every time the shutter is tripped. Of course this movement, and the "slap" as the mirror hits against the camera's pentaprism finder, creates vibrations which in turn lead to unsharp photographs.

A mirror lockup provision is a means of avoiding this. It allows you to raise the mirror out of the light path, once you've composed and set your exposure. Now the only moving part inside the camera is the shutter curtain, which rarely causes vibration problems. The most vibration-prone shutter speeds on all cameras are 1/8 sec. to 1/15 sec. Using a longer-focal-length lens, 200mm or longer, magnifies the image and obviously magnifies any problems at these speeds. Of course, you can only use a mirror lockup if your camera is mounted on a tripod, as once the mirror is up you can no longer see through the lens.

Today very few cameras offer a mirror lockup provision. The easiest solution to mirror slap is to avoid those vibration-prone speeds when you're using longer focal lengths. You will definitely get much sharper pictures by doing so. If you're shooting with a 50mm lens on a tripod, no problem. Just fire away at any shutter speed. But shooting with a 500mm at 1/15 sec. is another story. Consider this: If 1/15 sec. is the most vibration-prone speed, then at a 1/15 sec. shutter speed, the film is recording an unsharp image the entire time the shutter is open. If you use a speed several stops slower or faster, you can virtually eliminate the problem. For example, at a 1-second exposure time, 1/15 of it may be unsharp, but the other 14/15 of it will be vibration-free.

ROCKS IN FOLDS OF BENTONITE HILLS, CAPITOL REEF NATIONAL PARK, UTAH. Nikon F5, Nikon 35–70mm lens, Fuji Velvia.

Not the easiest place to work: the road to the Bentonite Hills starts by fording the Fremont River, then it's about eight miles of bone-dry talcum-powder dust to the hills. Camera reliability is a top priority if you're going to photograph in even slightly remote areas.

If your camera happens to have a mirror lockup provision then by all means use it. It's easy to make an unsharp photograph, harder to make one absolutely sharp. I do everything I possibly can to create sharp photos, especially since I'm a working professional competing against other pros. I've always owned cameras with mirror lockup provision—although that was never the deciding factor in my purchase of a particular camera body—and use the feature whenever I can. If you don't have a mirror lockup, don't worry. Just watch your shutter speeds with long lenses. On the other hand, if you have a mirror lockup model you should run a test to see how that camera works with any autoexposure mode you might use. You might have to depress the "autoexposure lock" button to hold your set exposure when shooting, since no light is coming in through the lens. It's far easier to use mirror lockup when you're shooting in the manual exposure mode.

Interchangeable viewfinder screens are another helpful feature. Almost all current autofocus cameras come with a pretty decent viewfinder screen, usually a clear, all-matte type screen with the AF points delineated on the screen. If you're planning on shooting lots of landscapes, I would suggest using the viewfinder screens made for architectural work. These are normally the same all-matte screens with a grid overlay etched into them, in a sort of tic-tac-toe arrangement. Nikon calls their grid screen the "E" screen, while Canon calls their version a "D" screen. The advantage of using these screens is that they offer reference lines, so that your horizon remains square with the world or your vertical lines are in fact vertical. I like these screens so much, and use them as a reference so often, that I have them in all my camera bodies. I use them for all my photography, from shooting landscapes to working wildlife to doing closeups.[2]

Finally, there is *autofocus*. Is this a needed feature for general nature photography? Well, in my mind it really falls into a category all by itself, perhaps best defined as "optional, but certainly helpful at times." Can you make great photos without autofocus? Certainly, and photographers have done so ever since cameras and film were invented. Does autofocus help you make better pictures? Sometimes . . . and sometimes not. Read the autofocus section on pages 92–95 for more information.

Whatever camera body you decide to purchase, I would not do so without first actually handling it. Reading technical specifications is a great way to narrow down your choices, but how does the camera feel in your hands? Does it have an ergonomic design? Does it fit your hands or does it seem too large or too small?

PINES IN DEEP MIDWINTER SNOW, YELLOWSTONE NATIONAL PARK, WYOMING.
Nikon F5, Nikon 80–200mm lens, Fuji Velvia.

Two camera functions were needed here: a short telephoto zoom lens for precise cropping (this photo was taken at about 190mm) and an easy-handling camera body. Why the latter? Try working the camera controls at −15°F with your gloves on. How a camera actually handles is of great concern if you're going to be out in bad weather.

Can you easily reach and manipulate all the controls? How easily can you change the film—is opening the back and removing a shot roll a major fingernail-breaking experience? Look through the finder; can you easily see the entire focusing screen and all the information shown in the finder simultaneously? Try lifting it to your face; can you do so comfortably or does something poke you? Can you easily work with this camera using your predominant eye? These are all questions you should answer well before you pull out your credit card.

I might mention that many of the newest cameras have added a *diopter viewfinder correction* as a standard feature. You can dial in a standard diopter correction, adjusting the viewfinder image to your eyes. Perhaps it's just that I'm in serious middle-age, but I find these to be extremely useful. I've noticed a slight difference between focusing with my left eye (my dominant eye) and my right. About one "click" on my Nikon's diopter correction and all's well. Towards the end of a long day in the field, as my eyes get tired, I have to dial in a bit more. No problem . . . and no squinting to see the image.

One last bit of advice concerns a feature that comes with all cameras but is too often overlooked: the instruction book. I'm always amazed that people buy expensive cameras but never take the time to read how they operate. A few years ago I was in Denali National

Park photographing a superb bull caribou standing in the blazing red-gold autumn tundra. I was on the road, photographing with my 500mm lens, along with several other people. In the middle of this prime photo shoot someone came over to ask if I could help reload his camera as he didn't know how. This was not the time nor the place for him to learn how to operate his camera.

Unfortunately this is not an isolated experience. On one of my recent trips to Kenya I spoke to a group on safari about shutter speeds and f-stops. When I had finished, one man took me aside to ask about his Canon equipment. He had two new EOS bodies, a 600mm f/4, a 300mm f/2.8, and a 70–200mm f/2.8. He explained that his Canons apparently did not have f-stops. Well, it turned out his photo dealer had set the cameras on aperture priority autoexposure, with the lenses set wide open. The man had no idea that you could change the aperture. From my own experience, I know that camera manuals are not the most interesting reading, but surely a few moments of familiarization would be useful to you.

[2]When adding a grid screen, you might discover that you lose a feature. For example, the Nikon F5's normal viewfinder screen has autofocus points which darken; add an E screen and you have to refer to the frame edge to see which point is selected. If I know I'm going to be working much with AF, I simply switch back to the original screen.

TRIPODS AND TRIPOD HEADS

If you want to improve the technical quality of your photographs, the very first step is to buy a well-made tripod and use it every time you take a picture. Without any doubt, a tripod is *the* most important photographic accessory. Professional nature photographers shoot every frame possible with their cameras firmly mounted on a tripod. A good tripod is so essential to successful field photography that I'm tempted to call it a *necessity* rather than an *accessory*.

Unfortunately, the vast majority of the tripods on the market, especially some of the more readily available models, are neither well-designed nor good quality. Far too many are too flimsy for 35mm field cameras with fast lenses, too short for the average person, and too difficult to use when shooting low to the ground. Many of the tripods sold at the major discount stores are not at all suited for still photography, but are designed—and poorly at that—for video work. I have always maintained that most beginning photographers curse tripods, and consequently tend to not use them, because they have never had the opportunity to use a good one. Most handheld shots are taken that way not out of necessity—indeed, how often is it that you absolutely cannot use a tripod?—but because the photographer lacks a solid but easy-to-use tripod.

I've met lots of people who claim they can easily handhold long exposures. Try it with a one-roll test. Shoot a series of exposures of a sharply delineated test subject (you can use a cereal box or something similar) on a slow-speed slide film using a lens of about 100mm. Take four frames at every shutter speed, starting at 1/1000 sec. and working down to 1/4 sec. Process the film and examine the results using a good quality magnifier loupe and a lightbox. (If you don't have a good loupe, take your 50mm lens off the camera, set it wide open, and view through it backwards. Projecting the images will only give a rough idea of the results, because the quality of a projected image depends on the quality of the projector's lens. I doubt you have one that is in the same league as camera optics.) From this test you'll discover that while it is easy to handhold an exposure, it's not so easy to get a sharp image this way. It's not that unsharpness is necessarily bad. Perhaps you want a soft focus, ethereal photo. In that case, you should handhold the camera at a slow shutter speed. But for any other type of photo, it's a matter of control.

Can you get absolute sharpness at any time you want, regardless of shutter speed? An old photographic rule-of-thumb says that to obtain relatively sharp photos with any consistency when handholding a camera, you need a shutter speed equal to the focal length of the lens in use. For example, if you have a 50mm lens mounted on your camera, you must set a shutter speed of 1/50 sec. or faster for sharp results. Use a 100mm lens, and you'll want at least 1/100 sec. Go to a 200mm, and you need 1/200 sec., a 300mm demands 1/300 sec., and so forth. (Be aware of the effects of using a zoom lens! As it increases in focal length during zooming you must go to faster shutter speeds.)

The conclusion to be drawn here is that handholding a camera restricts you to photographing in bright light, using wide-open apertures, shooting high-speed films, using only short focal lengths, or a combination of these. If you work in the best light, at the magic times of early and late in the day, you're going to get soft pictures if you handhold. Shoot with only short lenses, and you'll miss out on all sorts of compositions. Wide-open apertures give little depth of field, while fast films add grain. Why not use a tripod and remove these restrictions? After all, you can still shoot wide open or use fast film or work in bright light with a camera mounted firmly on a tripod. But now you can do these things by choice, not by necessity.

Beginning photographers always ask for a lightweight but sturdy tripod. In my opinion, this is a contradiction of terms; there simply is no such thing. A really lightweight tripod will actually blow around in the wind, and is far from having the sturdiness necessary for 35mm work. Remember that a 35mm image is only 1 x 1 1/2 inches in size. Enlarging it at all in printing or projecting means you're also tremendously enlarging all the defects. Plus, we all use focal lengths that emphasize unsharpness problems. As you switch to longer focal length lenses, you're magnifying all the problems and limitations of a small format camera. Compared to a

INDIAN PAINTBRUSH AND PEPPERGRASS ON A SPRING PRAIRIE NEAR LAKE BUCHANAN, TEXAS.
Nikon F5, Nikon 105mm macro lens, Fuji Velvia.

Mounting my camera on a tripod allowed me to compose precisely, placing the edges of the frame exactly where I wanted them to fall. Another advantage was that I could wait for the wind to die down without having to hold my camera equipment, secure in the knowledge that my composition would remain the same.

normal 50mm lens, a 100mm lens is a two-power optic. This means that the 100mm lens will double all the problems and effects of movement, vibrations, inaccurate focusing, and poor photo technique. Go to a 200mm focal length, the long end of an 80–200mm lens, and suddenly you've magnified everything by four times. You have to be four times as careful, four times as precise, and hold the camera four times as sturdily, to achieve the same results as you did with your 50mm lens. Jump up to a 500mm; now you've magnified the image by 10 times. Better get a good, rock-solid tripod.

I've heard it said over and over again that the most vibration-free tripods are those made of wood. Let's dispel this myth once and for all. Wood is no more inherently vibration-free than metal. Consider this: Why are violins, cellos, guitars, violas, lutes, and other stringed acoustic instruments all made from wood? Because it resonates. That's right, it vibrates. Wood is indeed a little more user-friendly than metal, and is certainly not so cold on your hands at low temperatures, but tripods made of it are no better or worse than those made of any other material.

The sturdiest tripods, of whatever material, have the fewest leg sections. Every joint in a tripod is a potential weak spot that can become a potential problem area when you're far afield. In reality, the choice in tripods is usually between three-section legs (two locking joints per leg) and four-section legs (three locking joints per leg). The fewer the leg sections, the faster the tripod can be set up and taken down. The smaller the diameter of the bottom leg section, the less solid a tripod will be. That fourth leg section is the downfall of some models.

Run a tripod test to check for sturdiness by mounting a camera with a long focal length lens, something like a 400mm. Extend the legs to their full length and lock all the controls down tight. Focus on any close subject that has strongly delineated lines. Now, watch through the viewfinder as you lightly tap the tripod legs, then the front of the lens. If you see the viewfinder image jumping around, go find another tripod. A slightly more high-tech version of this test is done by taping a laser pointer to your lens. Watch that red spot jump around as you tap.

Run this same test with the centerpost fully extended. You'll find that in general the more you extend the centerpost the less stable the tripod becomes. Tripods are definitely at their best with no centerpost extension whatsoever. If at all possible, I would avoid extending the post more than a few inches except when photographing with very short lenses. Cranking up the centerpost, rather than using leg extensions, is a sure way to get

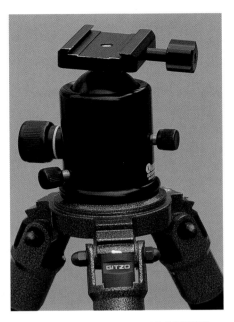

A KIRK BALL HEAD, WITH ITS INTEGRAL ARCA-STYLE QUICK-RELEASE CLAMP ON TOP.

unsharp pictures. You no longer are using a tripod, but rather a monopod with a three-legged base attached. The tripods I use actually have no centerposts, and I don't miss this feature at all.

Make sure your tripod is tall enough. With its legs fully extended, the camera should be at least slightly higher than your eye level. Working all day with a short tripod, where you must constantly stoop over, is no fun at all. Plus, you'll quickly discover that the tripod that seemed so tall in the camera store shrinks once it's outside. If you're working on uneven terrain, shooting across the side of a hill for example, one leg of your tripod must be below your body position. In effect, the tripod has just gotten shorter. It's easy to make tripods shorter, but there's no good way to lengthen them.

Making a tripod go low to the ground is another story. Very few tripods offer any provision for this. I've seen ad after ad from tripod manufacturers advocating inverting the centerpost, which is a complicated, at best, way to work. The camera is upside down, the controls are upside down, your head and shoulders are jammed in between the legs, and your lens is pointed at the leg directly opposite. How is it possible to shoot with a long lens, since moving it sideways means banging it into a leg? Perhaps it's not, and that's why none of these ads actually show a photographer working this way. But you will definitely want to work from a low position at times. Many subjects, such as wildflowers and mushrooms, are only found at ground level. Also, by simply changing your shooting position you can make your

photographs stand out from others. By far, most pictures are taken from about five feet above ground level, from human eye level. We can easily kneel down to work, if our tripods can go there with us.

Here are my recommendations for field tripods. These are well-made models that offer flexibility, sturdiness, and both low and high camera positioning.

- *Gitzo models G-1340 and G-1410.* Made in France, Gitzo tripods are well-constructed, rock-solid, and dependably long-lasting. Neither one of these models comes with a centerpost, but you can add one later if you wish. They are solid aluminum tripods, and have large wing-nut style locking rings (called "wing lock-offs" by Gitzo) that are easy to use even when you're wearing gloves. The G-1340 is my standard tripod for all-around work; if I could own only one tripod this would be it. The model G-1410 is a larger, taller version of the G-1340. It weighs 8 1/2 pounds without a head attached, compared to the 6-pound G-1340. I own the older 340 and 410 models, which are essentially the same as the current G-1340 and G-1410. When I am photographing with my longest lens (my 500mm) my pictures are definitely sharper if I'm using my 410 rather than my 340. This is especially true when I use a teleconverter and slow shutter speeds. Both of these tripods permit the legs to spread out perfectly flat so that you can work at ground level.

- *Gitzo models G-1320 and G-1224.* These are two Gitzo aluminum models with centerpost assemblies. The G-1320 has the same legs as the G-1340, but comes with standard leg locking collars. I would suggest replacing these with the "wing lock-offs" for the G-1340. Such parts can be ordered directly from the U.S. distributor, Bogen Photo Corporation, at (201) 818-9500. The G-1224, at 5 pounds, is the lightest aluminum Gitzo I would recommend. Both the G-1320 and the G-1224 have a leg-spreading feature that lets them go very low to the ground, limited only by the centerpost adjustment hanging below each tripod.

- *Gitzo models G-1348 and G-1548.* Over the last few years Gitzo has introduced a line of tripods with straight leg sections made of carbon fiber. These two are four-section, no centerpost versions. The G-1348, at 4 5/8 pounds, is absolutely the lightest-weight Gitzo I would recommend. (Their lightest carbon fiber tripod, the G-1228, is so light that it blows around in the slightest breeze. It has four-section legs, and the bottom leg section has an extremely small

diameter. This is about the only Gitzo tripod I do not recommend.) The G-1548 weighs in at 6 3/4 pounds and also has four leg sections. Since the legs are a large diameter, it is very solid.

The only problem with carbon fiber tripods is that they are quite expensive. For example, when I recently checked some prices at a New York mail-order house, a 410 Gitzo was retailing for $340, while the equivalent 1548 went for $895—a difference of $550. Since there's a 2.125-pound difference in weight, that's $258.82 per pound you'd be paying to get the carbon fiber version. If you compare the 1348, retailing at $800, with the G-1340, which is selling at $298, you'll see that the savings of 1 3/8 pounds comes at a cost of $502, or $365 per pound. Only you can answer the question of whether it's worth spending the extra money to drop this weight.

While all Gitzo products tend to be rather expensive, they do last and last, so the cost per year goes down. I'm still using a Gitzo I bought in 1977. I've upgraded the cameras I use, switched all my lenses to newer models, changed the films I use . . . but I still have that same Gitzo. Every photograph in this book that was shot from a tripod was shot from a Gitzo. I'm almost embarrassed to say so, but today I own four Gitzo tripods of various sizes.

By the way, here's a hint for using all models of Gitzo tripods. The leg locks are twist-lock collars and are sometimes difficult to use. If you start extending the legs by turning the lowermost collar, sometimes an upper one twists instead. The solution is to always start at the topmost collar when extending the legs, the bottommost when collapsing. Hold onto the leg just above the collar and you'll never have any twist problems.

If you want a less expensive tripod, consider the aluminum *Manfrotto 3021* or its black anodized twin, the *3221*. In the U.S. these are sold through Bogen for roughly $100–$135. While these are not up to the standard of quality of the Gitzo tripods, they just might be the most tripod for the least money. At 5 3/4 pounds, they aren't much lighter than a G-1340, and they are not as sturdy if you're using long lenses. The main drawback I see with the 3021/3221 is that the tripod is a tad short if you're 5'10" or taller, or if you work in uneven terrain.

HEADS

Every tripod must, of course, have a head. You can add a three-way pan/tilt head, or a ball-and-socket head. While there are major operational differences between these two styles, choosing one or the other is really a matter of personal preference colored by what subject matter you plan on photographing. Before you purchase any head, I would suggest you take your equipment to a well-stocked camera store and play with different heads to see which kind you like. You should also ask other field photographers about their likes and dislikes, and if possible mount your gear on their tripods.

Pan/tilt heads offer precise movement in each axis of adjustment. Tilting forward and backwards, tipping left and right, and swiveling around, are all governed by separate controls.[1] Being able to make a minute compositional change in one direction, without changing any other placement, is helpful for studied landscape or closeup work. However, you have to loosen, then tighten, three separate controls. The price you pay for precision is lack of operational speed.

I've watched many photographers using pan/tilt heads mount their cameras incorrectly. Almost all pan/tilt heads are constructed so that the camera flops to the left for a vertical composition. If the head has control handles, as most do, one handle should come directly toward your body while another sticks out to the right. Orient the camera correctly on the head, and you'll be able to tilt while the camera is vertical. Otherwise, you must loosen the camera-locking screw every time you want to change vertical composition.

Ball-and-socket heads, generally just called "ball heads," have only one main knob which controls all operational movements. Loosen it, and the ball is totally free to travel in any direction. This ease and speed of operation makes ball heads great for normal photography, and almost a necessity for action work. You can pan, tilt, and instinctively level the horizon all simultaneously. Neat!

The best ball heads, and the only ones which I recommend, have a tension control to set the amount of drag on the ball's movement. However, not one ball head I know of comes with instructions as to how to set this control. Here's the procedure: First of all, loosen both the tension control—it's usually a small set screw—and the main locking knob as much as possible. Mount a camera and lens on the head, then tighten the main locking knob ever so slowly while you move the camera left and right, up and down. At some point while tightening you'll say, "Ah, this is just the amount of drag I want on the ball." At this point, stop tightening the main locking knob temporarily. Run the tension control in until it stops; don't force it, just finger-tighten it. Now don't touch it again. As you continue to tighten the main locking knob, you could indeed screw the tension control in further, but you don't want to do this. You set it at the right amount, now leave it alone. Reset it using the same procedure only if you want to change the amount of drag, for example when you switch to a long lens.

MOUNTAIN GOAT KIDS, MT. EVANS, COLORADO.
Nikon F5, Nikon 300mm lens, Kodak E100SW.

I watched these two kids play together, occasionally standing side by side. Thanks to a sturdy tripod and an easy-to-use head, I got the shot . . . but in about two hours time I had the chance to take exactly one frame.

[1]The three axes of movement are properly called yaw (left/right or panoramic aiming), pitch (up/down aiming), and roll (horizontal tilt, or leveling). However, no one ever uses these terms. Stick with pan, tilt, and flop.

One overlooked advantage of ball heads is that unlike pan/tilt heads, they allow you to flop the camera for a vertical to either the left or the right. You'll normally almost always work one way or the other, whichever seems correct and most comfortable to you. However, if you need to, you can switch directions. This option allows some movement in camera placement, about 4 or 5 inches laterally, when you're working in tight, constricted areas.

An offshoot of the ball head is the *action grip head* or *pistol grip head.* These have a hand grip under the camera mount and a very small ball-and-socket at the very bottom of the grip. You squeeze the grip, rotate the head as you wish, then release the grip. If you're at all serious about your photography, avoid these heads. They won't hold solidly due to the tiny size of the ball-and-socket, plus they cantilever all the weight several inches out from the tripod axis when a camera is used in a vertical orientation. As much as possible, you want the mass of camera and lens to be directly above the axis of the tripod, not hanging out to the side. In other words, these action grip heads are extremely vibration prone. Don't go there.

Regardless of whether you like a pan/tilt head or a ball head, I would suggest fitting a quick release system to it. This consists of a plate which fastens to the tripod socket of your camera body or lens, which in turn fits into a clamp mounted on the tripod head. There are only two widely-used quick release systems, the Manfrotto (Bogen) version and the Arca-Swiss design offered by several manufacturers. The Bogen uses large hexagonal plates which drop into a fixed-cavity opening, while the Arca-Swiss version has a long, dove-tailed plate which slides into an open-ended clamp. If you have any choice whatsoever, I would strongly urge you to go with the Arca-Swiss. It's a more expensive system, but much stronger and better designed. While both designs work, the Manfrotto can be likened to a Chevy while the Arca is a Cadillac. With both quick releases, you will want a plate mounted on each camera body or lens. After all, if you have only one plate and must switch it among your equipment, you no longer are using a quick-release system. You have changed to a *slow*-release, but *quick*-frustration system.

Here are my recommendations for tripod heads:

Pan/tilt heads:
• *Bogen 3047, 3029, or 3028* (extra lightweight). The 3047 incorporates a Bogen quick release and is quite reasonably priced. If you want to add an Arca-Swiss clamp you should consider the 3029; it's basically a 3047 without the built-in Bogen release. If you must use a lightweight head, and I would caution you against doing so, the strongest one is the 3028. Add an Arca-Swiss clamp to it for convenience.

Ball heads:
• *Kirk BH-1.* A solid ball head incorporating an Arca-Swiss clamp. It comes with one quick release plate included. In my opinion, it is the best buy of all heads available today. It has become my most-used tripod head.

• *Graf Studioball QR.* A massive and heavy ball. For years this was my standard ball head. Graf keeps changing the design of their quick-release clamp, and not for the better. Although it looks like a standard Arca-Swiss clamp, the current head will only take Graf's own nylon(!) quick-release plates. You can have the current clamp replaced by Kirk Enterprises or Really Right Stuff (see below) or just avoid this head.

• *Foba QR.* A very expensive, but very strong, ball head that uses a lever as a main locking device instead of a knob. It has the Arca-Swiss quick release.

• *Arca-Swiss B1.* A pricy but precision ball head with, obviously, the Arca clamp. There are several versions of this head on the market, including a model without the Arca clamp (you don't want it), one with no base panoramic movement (you don't want it) and a giant version, the *B1G* (you don't need it). There is also a *B2* head, but although it looks like a ball and socket head, it is a pan/tilt head in a ball design. Get the standard B1 with the Arca clamp.

A few photographers have reported a problem with the B1 ball sometimes "seizing" or "freezing" tight even though the locking knob is loose. If this happens, the fix is to force the locking knob clockwise, about 1/8 inch or so, to free the jammed internal mechanism. This maneuver may take quite a bit of force on your part. I've seen this "freeze-up" happen several times to other photographers in the field, and of course it always occurs at the worst possible moment. That's one reason why the Kirk ball is, in my opinion, a better buy.

If you get a head with the Arca-Swiss quick-release system, you obviously need the camera plates which fit into the clamp jaws. Don't waste your money on the generic one-size-fits-all plates offered by Arca-Swiss, Graf, or Foba. Instead, purchase custom-made plates which are designed to fit your specific lenses and camera bodies. These plates may cost a bit more, but your lack of frustration caused by ill-fitting generic parts will make up for the expense. Two companies offer these products:

Kirk Enterprises
333 Hoosier Drive
Angola, IN 46703-9336
Phone: (800) 626-5074
Fax: (219) 665-9433
www.kirkphoto.com

Really Right Stuff
P.O. Box 6531
Los Osos, CA 93412
Phone: (805) 538-6321
Fax (805) 528-7964
www.reallyrightstuff.com

Both companies sell plates to fit just about every camera or lens on the market. All of these plates are designed for optimal performance, attach with machine screws, and incorporate anti-twist designs. Both companies also offer many other items, including separate Arca-Swiss clamps for your existing tripod heads. I would suggest you get a catalog from both.

PASQUE FLOWER, COLORADO.
Nikon F5, Nikon 200mm macro lens, Kodak E100SW.

Pasque flower is the very first flower of spring where I live in Colorado, and this photograph was taken less than 100 feet from our front door. I had my Gitzo 340 tripod absolutely flat on the ground in order to keep the camera back parallel to the plant.

FILM

Film is the canvas on which the photographer paints with light. How you actually do this—the shutter speeds and apertures you use—depends a great deal on which film you decide to use. If you have taken the trouble to purchase good quality equipment, then I think you owe it to yourself to also purchase good quality films and to demand good quality processing of them.

A film's sensitivity to light is expressed in its *ISO number,* commonly called its "film speed rating." Films with low ISO numbers are called "slow" films because they need a lot of light to record images, while films with high ISO numbers are called "fast" films as they need less light. Today we think of slow films as those with ISO numbers lower than 100, medium-speed films as those between ISO 100 and 200, and fast films as those above 200. Some slow films include Kodachrome 25 and 64 (ISO 25 and 64 respectively), and Fuji Velvia (ISO 50). The medium-speed family includes a number of the Ektachromes—100S, 100SW, 100VS— plus Fuji's Provia F, Sensia II, and Astia. All of these are ISO 100 films. Fast films include Fuji's Provia 400 and Kodak's Ektachrome 400. Both Kodak and Fuji also make a few superspeed ISO 1600 films.

Like so much else in photography, film speed ratings work in stop increments. Each numerical doubling or halving of the ISO number is a one-stop change to a faster or slower film. For example, let's start with an ISO 25 film. Doubling that to ISO 50 is a one-stop difference. Doubling that to ISO 100 is another stop, and to ISO 200 is another.

I would strongly urge you to use the slowest speed slide (more properly called "transparency") film that you can given the lighting situation. As a rule, the slower the film speed, the sharper and more grain-free the resulting image will be. I'm not suggesting that you should always shoot the slowest film on the market, or indeed that you should only use one film. Use the film that works best given your working conditions.

I recommend using slide film for many reasons, but first and foremost is the fact that slides show you your actual results. You're viewing the actual piece of film you shot, so what you've done is readily apparent. You can instantly see both your successes and your mistakes. With the first glance at a slide you can evaluate exposure, color balance and rendition, focus, and other factors. I can't tell anything at all from looking at a color negative; it's just a meaningless orange blob. And there is no direct relationship between the quality of color prints and the negatives from which they were made. You cannot evaluate your photographic technique by looking at a print, unless you are an accomplished color darkroom worker who did all the work yourself. Prints are most often made by machines that compensate for any variations from "normal," but who is to say that the machine was calibrated or performing correctly? Is your print out of focus and off-color because of something you did, or because of something the machine did? Stick with slide film to learn about photography, then shoot negative film if you wish. You should also know that it's easy to make a print from a slide, but not so easy to do the reverse. And at this writing, slow-speed fine-grained color slides are still the norm for work submitted for publication. Exceedingly few published nature pictures are shot on anything other than transparency film— negative film and digital images are not usually acceptable. Stick with slides.

If you haven't already chosen a standard film, you should run a few tests to determine film characteristics. Buy several rolls each of a few different films (one roll of a given film isn't enough for a thorough testing), then shoot side-by-side comparisons in the same light, preferably with the same lens and the same composition, by loading one camera with one film and another body with another film. Be sure to use a tripod for all the photos to ensure that camera shake isn't a factor. Take this picture in different lighting conditions to see how the films handle high- and low-contrast situations: bright sun, late sidelight, heavy overcast. Shoot some fast exposures and some very long ones. Work on different colored subjects, and especially try shooting black, neutral gray, and white.

Then, if possible, have the same photographic lab process all the film. Use the best professional lab you can find for this, as the quality of any film is no better than how it is processed. When you get the film back, lay it all out on a light table, use a good 4X to 8X loupe, and pick the shots you like. Compare color rendition, how grainy the films appear, and how they handle contrast. At this point, you should be able to settle on one or two films that you particularly like. Learn their characteristics thoroughly so that you know how to handle them in the field.

Transparency films can be divided into the Kodachromes, which must be machine processed, and the far more popular E6 films (so called because of the chemicals used) such as Ektachrome, Fujichrome, and Agfachrome. Kodachrome must usually be mailed off to a specialized lab that has one of the processing machines, but the E6 films can be done at hundreds of local labs or even at your kitchen sink. However, I would strongly advise you not to even consider doing your own processing as time and temperature must be controlled precisely for good color balance and repeatable results. Quality control is what you pay for in a good lab; in fact, if you shoot E6 films and are not getting clean whites, question how the film was processed before you blame the film. Try another lab.

Kodachrome images have the best longevity of any color films, showing the least deterioration over time if they are stored under ideal conditions: in the dark at 40°F and at 40% relative humidity. When transparency films are exposed to light, such as when slides are projected, then E6 films last longer than the Kodachromes. Actually, I'm not that concerned with the "archival" aspect of any of my images; today I can convert them to digital form via a drum scan and save the file. Besides, when I look back at some of my early work I'm amazed at the quality. If this is what I kept, what did I throw away? I trust that both you and I will continue to improve in our photography, and not the reverse. Ten years from now it would be terrible to look at our images and say "I *used to be* a good photographer."

So let me define a good film: it's one you like, that's available, and that you can afford. But what's to like about any one specific film? First, the color palette. Different films render colors differently. There is no such thing as "red" when we're dealing with film; there is Kodachrome red, Extachrome red, and Fujichrome red, and these can all be further subdivided: Ektachrome 100S red, Ektachrome 100SW red, Ektachrome VS red, and so on. Find the film or films whose color palette agrees with your taste. Next, consider the sharpness, resolution, graininess, and contrast-holding ability. How precise does a given film render detail? How do the shadows appear? Today you might also want to consider the end use of your photos; do you plan on projecting slides, submitting photos for publication, or scanning images into a computer? Choose your films carefully.

Two additional criteria are important. Is the film readily available? We're all traveling more and more, particularly the nature photographer who wants penguin and lion photos done on location along with that coverage of the National Parks. I would always use films that I could replenish locally if need be. Cost

also has to be a consideration. Does a $10-per-roll film give you better images than film that costs $5 per roll? I would beware of gray-market film, even though it is cheaper, as you have no idea how it has been handled. Compared to the cost of taking a photo—lenses, cameras, travel—film is still the smallest expense.

I'm often asked which film gives the most "realistic" results, as if a "realistic" film is somehow the best. No film even comes close to what we see with our eyes, either in color or in contrast—and that is fine with me. If I truly wanted reality I would not photograph, but rather just go outside and experience reality. Photography is a means of ordering the chaotic world around us through our choices of lenses, perspective, composition, and films. Pictures are what we take; reality is what we experience. If realistic color is a criterion for choosing a film, then where does that leave black and white? If realistic color is a criterion for good photography, then how do we evaluate Ansel Adams?

MILKWEED SEEDS AND DEW, MICHIGAN. Nikon F2, Nikon 105mm lens, Kodachrome 25.

For years, Kodachrome 25 was my standard film for most of my photography (in fact this photo, taken in 1979, was published in my first book). Today I much prefer the one-stop faster speed and more saturated color palette of Fuji Velvia. However, film choice is very personal. Decide what you like.

SANDHILL CRANE IN FLIGHT, BOSQUE
DEL APACHE NATIONAL WILDLIFE
REFUGE, NEW MEXICO.
Nikon F5, Nikon 500mm lens, Ektachrome 200.

*Just a few years ago I would
have thought this quality was
impossible from an ISO 200
film. I chose to show you this
picture because of its large
expanse of pure blue sky, the
type of area where grain is
often visible.*

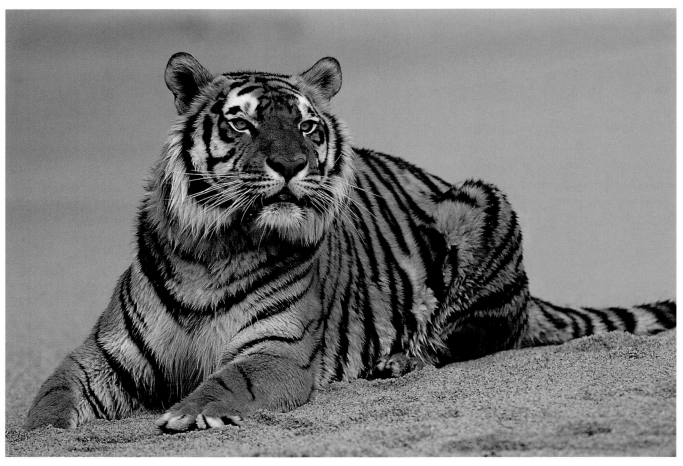

BENGAL TIGER (CONTROLLED SITUATION).
Nikon F5, Nikon 300mm lens, Kodak Ektachrome VS.

*I like how this ISO 100 film works in overcast conditions, but most of
the time I prefer E100SW if I'm using Kodak film.*

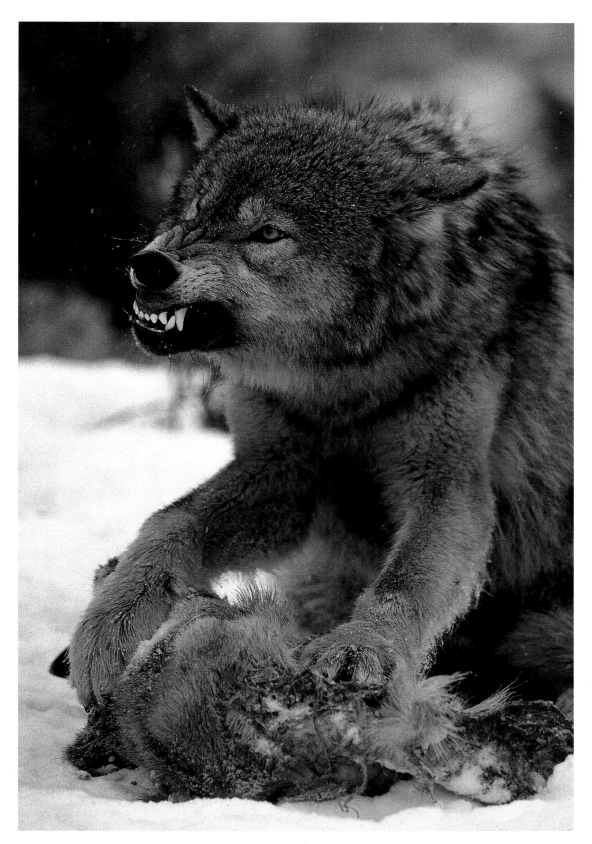

GRAY WOLF ON DEER CARCASS, SNARLING AT OTHER WOLVES (CONTROLLED SITUATION).
Nikon F4, Nikon 400mm lens, Kodachrome 200.

K200 is a very sharp film, but is also grainy. On deeply overcast winter days I like its slightly warm color rendition. What do you think?

PUSHING FILM

There are times in field photography when you'll want to use a shutter speed or *f*-stop that requires faster film than what you're using. If you don't have a faster film with you, the best solution is to "push" your film.

Pushing refers to the practice of intentionally underexposing the film, then compensating for doing so by changing the processing time when the film is developed by your lab. For example, let's say that you're photographing whitetail deer with an ISO 100 film. You're shooting at 1/60 sec. with your lens wide open, but since you're using a 400mm lens and the deer are moving around browsing, you're worried about getting unsharp pictures. If only you could have a faster shutter speed, but you have no other film with you.

Here's what to do. First of all, you must reset the ISO film speed setting on your camera. You cannot use the automatic DX setting any more, as you're going to arbitrarily reset the number. If you want a 1-stop increase in film speed, giving you a 1-stop increase in shutter speed also, double the ISO number on your camera meter to 200, since film speeds work in stop values. In effect you now have a 1 stop faster film.

You obviously cannot make this change in mid-roll. You have to shoot the entire roll at whatever ISO setting you select[1] or half of the roll will come out lighter than the other half. In addition, when you have finished shooting the new roll of film (the roll at the new film speed setting) make sure you mark it as soon as you remove it from your camera. I always carry an indelible marker for just this reason. You have to be able to identify this roll of film to your lab. Just scribble

[1] Technically, when you set your meter at any number besides the film's official speed setting, you are no longer using an ISO number. The ISO rating is an international standard for each film, and cannot change. When you reset the number on the meter, you are really using your own personal exposure index (EI) for that film.

something like "push" or "+1" or "shot at 200" right on the film cassette

When you take your film in for processing, you must tell the lab what you've done. Separate this roll, tell them what film speed rating you used . . . and that's it on your part. The lab will then "push process" the film at an additional charge to you beyond their normal processing fees. Films are developed chemically for a certain time and temperature. The lab can adjust this recipe to account for the fact that you've done something out of the ordinary.

Of course, there is no free lunch. It would be great if we could just shoot film at any speed rating we wanted, and fix things in the lab. Well, it doesn't work that way. Whenever you push film, whenever you change the normal development sequence, there is a price to pay both financially and in terms of quality. All pushing heightens the contrast of the film, to some degree creates a little extra graininess, and, depending on the film, may add a slight

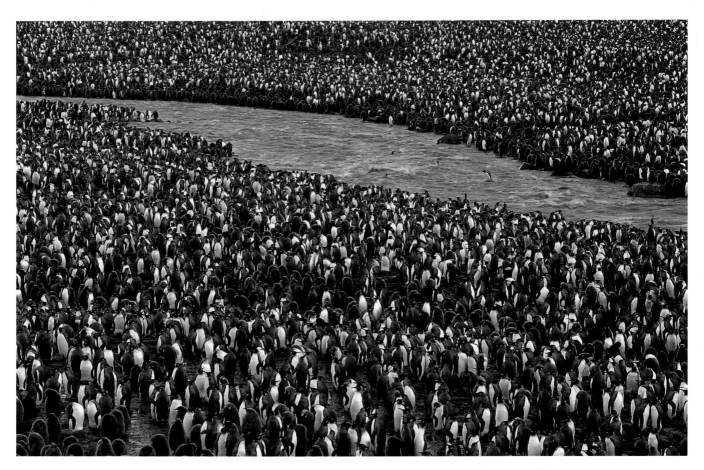

KING PENGUIN COLONY, ST. ANDREW'S BAY, SOUTH GEORGIA.
Nikon F4, Nikon 80–200mm lens, Kodak E100SW pushed one stop.

We landed at St. Andrew's Bay late in the day. I knew the shot I wanted from having been there before, but by the time I got to my location the light was fading. Pushing my film gave me the edge I needed for this situation.

color cast. All of these factors depend on how many stops you've had the film pushed.

You don't have to work in 1-stop jumps as in my example; you can "push" in increments up to about 3 stops. However, be forewarned that if you do push several stops, image quality will suffer badly. Of course you don't have to push in full-stop increments. Most professional labs can at the very least change processing times to reflect 1/3-stop film speed changes, so you could push 1 1/2 stops if you wanted, or 1/2 stop, or 2 2/3 stops, or whatever.

The E6 films—the Ektachromes and Fujichromes—are the films that are most commonly pushed. The Kodachrome family can also be pushed if needed, but very few labs actually offer this choice. At this writing there is at least one film in the general market which is designed specifically for pushing, Fuji's MS100/1000 film. The MS stands for "multi-speed" while the numbers indicate what speed ratings you can use. You mark the canister as to what you've done, then pay your lab the appropriate extra cost. I might mention that the more stops you push, the more your lab will charge for processing. Apart from this particular Fuji film, I would advise you to stick with pushing a maximum of 1 stop unless you absolutely must do so. Of course if you have the chance to photograph Elvis reappearing at your local hamburger stand, and you have to push your film 4 stops, by all means do so. In this case, any picture is better than no picture at all.

Many professional photographers often push film. Several bird and wildlife pros I know consistently shoot Velvia pushed 1 stop instead of using an ISO 100 film. Kodak's E100S and E100SW are routinely shot pushed to EI 200, while Ektachrome 200 is often used as an effective 400 speed film. I've heard various photographers state that they like these Kodak films better pushed than when used at their nominal speeds. My suggestion: run a test. Shoot two rolls of the same subject with the same lens in unchanging light, but push one of the rolls a stop. Process the film together, then critique the slides to see what you like. Also compare a pushed film against a faster film. For example, compare E100S pushed to EI 200 against Ektachrome 200 shot at 200. In all these tests, for best results be sure to use a multicolored subject.

Remember to reset your meter back to the correct number, or to the DX mark, once you no longer need to push. By the way, the opposite of pushing film is "pulling" film. It's the same exact principle going in the other direction. In truth, the only time you'll probably ever pull process film is when you accidentally shoot a roll at the wrong film speed. As you remove that roll of Ektachrome 200 from your camera, you suddenly realize you shot the whole roll with the meter set to ISO 100. Ouch, you've overexposed the whole roll by 1 stop. Mark the cassette, then tell your lab to pull it 1 stop in processing. Again, quality will suffer somewhat and you'll pay extra, but at least you'll save the images.

Don't forget to mark the cassettes of any film you push or pull immediately. There's a terrible sinking feeling that occurs immediately after you toss a couple of unmarked rolls of pushed film in with the rest of your film. Which is which? If you really want to save the images you can. Separate out all the film you're unsure of, and have your lab do a "snip test" or "clip test." The lab cuts off the first few inches of each roll, processes these little snippets of film normally, and inspects the results. In this manner they can find the rolls to push. You lose a few frames from the start of each roll, but you save the rest. Far better to carry that marker and label each roll!

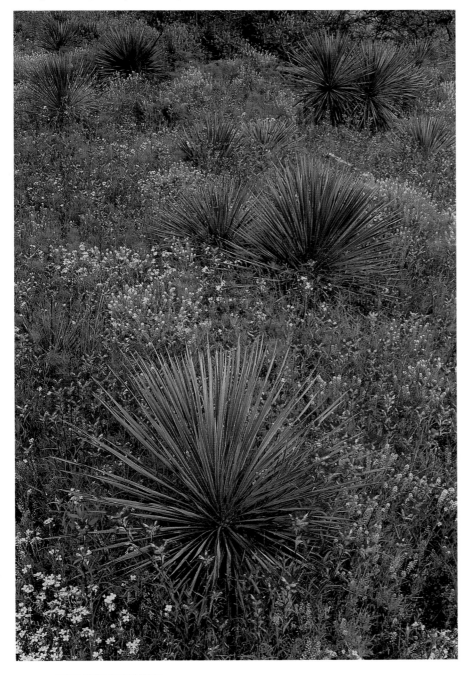

PRAIRIE IN BLOOM, LLANO COUNTY, TEXAS.
Nikon F5, Nikon 55mm lens, Fuji Velvia pushed 1 stop.

A persistent spring breeze made me resort to pushing Velvia one stop in order to increase my shutter speed. In the field, there's a big difference between 1/8 sec. and 1/15 sec.

SPECIALIZED SUPPORT PRODUCTS

Several products make field work a lot easier. These are very specialized items, and consequently are rather expensive, but they each solve a particular field problem, and solve it well. Let's look at these items and their applications.

"L" BRACKETS

Consider what happens when you shoot a vertical with your camera mounted on a tripod, whether you're using a ball head or a pan/tilt model. As you flop the camera over on its side, you're actually changing the location of the optical position of the lens. If you're using a camera such as a Nikon F5 or Canon EOS-1, you've moved the lens about 4 inches to the left, and lowered it 5 or 6 inches. So, your tall tripod just shrunk in size. In addition, all the weight of the camera and lens is now hanging off to the side, which potentially can be a problem with lighter-weight tripods. Of course, if your lens has a

tripod collar you should always use it. Mount the collar onto the tripod head, then rotate the camera without flopping the head over.

But almost all shorter-focal-length lenses, and even some zooms up to 70–300mm, lack tripod collars, so you have no choice except to flop the head over. No choice, that is, unless you're using a head with an Arca-Swiss style quick-release. At least three companies offer versions of what are commonly called *"L" brackets*. These are "L"-shaped Arca-Swiss quick-release plates, which either replace, or fasten to, your normal Arca plate. The "L" plate runs along the bottom of the camera, then up the left-hand side. When shooting a vertical composition you attach the camera to your tripod as you normally do. For a vertical photo, loosen the quick release clamp, pull the camera out, then replace it in a vertical orientation. The lens axis ends up in roughly the same place as before, your tripod maintains its height,

camera and lens weight is directly centered over the tripod axis for optimum stability, and all is well.

Don't overlook the fact that positioning the camera in an exact location is at times critical to the success of your photograph. Suppose you're working on a horizontal shot of some flower blossoms, and by carefully positioning the camera you're able to hide some bright hotspots in the background. If you flop the tripod head for a vertical, you must reposition the camera in order to take the same image. This means moving the tripod over to the right several inches, then raising the camera position several inches. Not an easy task indoors on a flat surface, let alone out in the field. Enter the "L" bracket to solve this problem.

There's actually a third use which I've only had to resort to once or twice but is still worth mentioning. What if you want to take a horizontal photograph with your camera

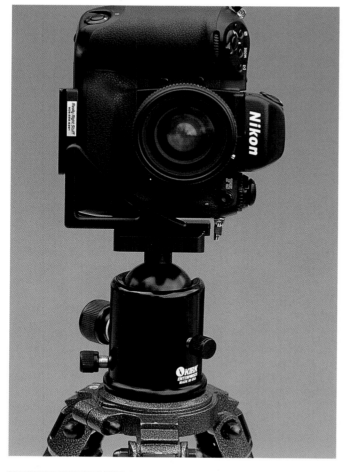

REALLY RIGHT STUFF "L" BRACKET, ON A BALL HEAD IN THE VERTICAL POSITION.

Notice that you don't have to flop the tripod head to one side, so consequently you lose no height.

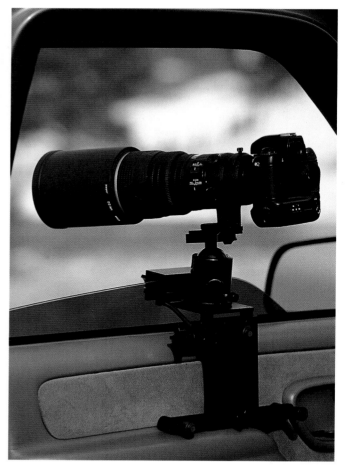

THE KIRK WINDOW MOUNT.

Here I've got my 300mm f/2.8 mounted on it.

positioned as low to the ground as possible? Even if you're using a Gitzo or Manfrotto tripod, you'll still have the height of the tripod head to contend with—several inches at least. Mount your camera as a vertical using the "L" bracket, then flop the head over (you'll have to rotate the head using the pan movement so that the camera hangs off the right-hand side of the head). Your camera is now positioned as low as possible. Actually, you could loosen the quick release clamp and slide the camera down perhaps another inch or two. Do this also and you'll end up with the bottom of the camera, the bottom of the "L" bracket, touching the ground. That's definitely a low-level photograph!

I've grown addicted to using an "L" bracket, to the point that I normally have one on each of my cameras at all times. If you're a bird and mammal photographer, someone who uses long lenses most of the time, you probably won't care about these special brackets. The lenses you use have tripod collars so you have horizontal/vertical rotation already. If you are a generalist like I am, photographing everything from mountains to mosquitoes, check out an "L" bracket. Versions are available from Really Right Stuff and Kirk Enterprises (see page 47 in the section on tripods for addresses and phone numbers) and also from a third company:

Photo-Options
533 Garden Street
Kelso, WA 98626
Phone: (800) 367-4686

KIRK WINDOW MOUNT

If you're doing much photography from your car (see the section on blinds, pages 144–146), having a way to support your long lens is imperative. A few frames can be taken by bracing your lens on a folded towel or jacket, but this method of working gets old fast. I've heard of several photographers who actually set up tripods inside their vehicles, straddling the driver's seat, but try as I might, I can't manage this feat. Far easier to use, and far safer if you're driving even a short distance, is a detachable window mount. There are several models on the market, but my preference is the heavy-duty one made by Kirk Enterprises. It slips over the lowered window glass, then an angled support plate rests against the car door.

First you must attach a tripod head to it; you can use your standard ball head if you wish. Lower your car window so that only a couple of inches of glass are exposed. Position the window clamp over the glass, but do not tighten. Keep the support brace inside your car, but do not tighten its locking mechanism either. Slowly lower the window until the brace comes into contact with the door frame. Now tighten all the locking knobs. If you're lucky, the support brace will contact the door's arm rest for additional stability.

Getting the window mount ready to use is far easier to do than to describe. Do a trial run at home before you're actually going to use it, and you'll discover a positioning procedure for your vehicle. Don't fasten your long lens onto the tripod head until after you've gotten the window mount into position. If your car's window glass is quite loose in the frame, you

might have to play around with the window in order to stop the movement.

THE WIMBERLEY HEAD

This is a very special-purpose piece of equipment. It is a large, bulky, gimbal-type tripod head designed for one thing, and one thing only: action work with a heavy long-focal-length lens. If you do much photography of birds in particular, and you use a lens such as a 500mm ƒ/4 or 600mm ƒ/4, you should definitely consider a Wimberley.

A big, heavy lens has a tendency to tip forward or flop to the side when you loosen your tripod head's locking knobs to aim it. Since the Wimberley is based on a gimbal concept, it solves this problem. Basically it allows you to align the center of gravity of a big lens with the tilt axis of the head. Thus the lens is balanced in place even though the tripod head's controls remain loose. You can aim your lens in any direction and it stays balanced. You can even let go of the lens with the head unlocked. No catastrophic crash results; the lens stays in place. You only need one hand to manipulate your lens. Keep your right hand on the motor drive grip and you can easily aim the lens in any direction, without requiring your left hand to support any of the weight of the lens.

The Wimberley is designed for use with big lenses that have tripod collars, as there is no way to reorient a lens for vertical compositions. It's not suited for everyday photography of normal subjects or for photography with shorter focal lengths; for those, you'll want your normal tripod head. It comes without a quick release, but I would definitely add an Arca-Swiss clamp immediately.

Wimberley also makes what is in essence a junior version of their full-sized Wimberley head. It's called the Sidekick, and mounts into the Arca-Swiss clamp of your ball head. Perhaps an arm with a pivoting Arca clamp mounted sideways on one end is the way to describe the Sidekick. Flop your ball head for a vertical, insert the Sidekick arm, and you have a side-gimbal to balance long lenses. It works fine for the occasional action shooter, or for the traveler concerned about the additional weight and bulk of the big Wimberley. Just remember you must first own a good ball head with an Arca clamp. If you're thinking of doing lots of bird work, especially with one of the super-telephotos, I would spring for the big head.

Contact:

Wimberley
974 Baker Lane
Winchester, VA 22603
Phone: (540) 665-2744
Fax: (540) 665-2756
www.tripodhead.com

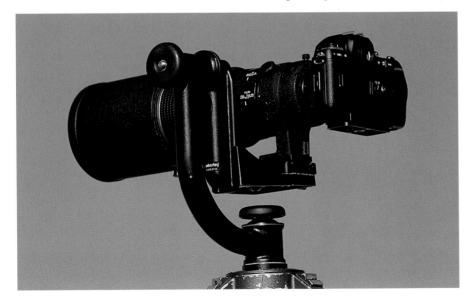

THE WIMBERLEY HEAD.

Even with the locking knobs in the unlocked position, I can balance a lens on this head. Here's my 300mm ƒ/2.8, although I more often use my 500mm ƒ/4 on this head.

FILTERS

Today there are filters available in every possible flavor: star filters, rainbow filters, multi-image filters, color enhancing filters, soft-focus filters, big filters, little filters, and many, many more. Filter systems are also available, with adapters made for stacking multiple filters in front of your lens. You can buy special filter wallets which hold 10 or 12 filters for ease of carrying.

No thanks, I'm not interested. I'm not a great fan of filter use at all, and I'm particularly not fond of these "special effect" filters, the ones with names like "cross star," "sunset sky," "multi-hue enhancement," or "color-flow." It's not that I believe using these filters is inherently bad; I just don't like their application to nature photography. I firmly believe the natural world is spectacular in and of itself and doesn't need added tinsel to appear extraordinary in photographs. I want to see and record the subject matter itself—the things that touch my soul when I'm out in the field. I don't want the experience diluted by filter fakery.

I see many photographers who always leave a filter—usually a "skylight" or ultraviolet (UV)—mounted on their lenses as "protection." I've never understood this concept. From what are they protecting the lens? Dirt and fingerprints? If so, then you must remove that dirty filter before every shot. Better always to use a lens cap to keep the front element clean. Salt spray? Great, use a filter in this situation. But if you're not working in

blowing salt spray, then your reason for the filter has disappeared. Use all filters only when appropriate. If you can't articulate exactly why you're using a filter, if it's not a fully conscious decision on your part, then I believe the filter shouldn't be on your lens. If you still want to use a UV filter as protection, then at least be aware that the added thickness that comes along with adding another filter to the lens, such as a polarizer, might create vignetting problems. And mounting any filter on a zoom lens is an invitation to flare and ghost images unless you consistently use a lens hood also. Zooms are optically complex, with 10 or more elements inside to bounce light around. Stick a flat filter on the end of the lens, directly in the sunlight, and you just create more potential problems.

That's not to say I use no filters at all. Indeed, there are two filters that I urge you to purchase. These are an *81A warming filter* and a *polarizer*. I suggest you buy them in the form of high-quality glass filters, as opposed to acrylic resin versions. Resin filters scratch rather easily, so they're better suited for special purpose filters such as the graduated neutral density filters which you use only occasionally. I would urge you to stick with the major brands, particularly with polarizers, as I've seen many cheap ones throw off autofocus systems or even a lens's ability to reach infinity focus. I recommend filters by Nikon, B+W, and Heliopan. Hoya is also a

very good brand and, in fact, is probably the best "inexpensive" filter line available. Hoya filters are also readily obtainable at large chain retailers such as Wal-Mart.

WARMING FILTER

An 81A is a weak warming filter. Its adds just a touch of warmth to any scene, particularly when you're working in open shade. I don't want to overdo this additional warmth, as the E6 films I use and recommend are already color saturated. I use this filter the most when working warm colors on overcast days. For example, when photographing autumn foliage in soft light, a weak warming filter "pops" the warm colors—the reds/yellows/oranges—recording the scene more as I experience it at the time. The filter I use is actually Nikon's A2, which is not exactly an 81A, but is quite close. I like this particular filter for its color value and for the fact that it's physically extremely thin. The thicker the glass in a filter, the more the light rays are bent and consequently the more image distortion may occur.

Occasionally I'll resort to the next strongest warming filter, the 81B, if I'm working in deep shade on a solid blue-sky day. An example of this would be photographing along a shaded canyon wall in Utah on a day with blazing sunshine. The 81B will remove the bluish cast caused by the light from the blue sky. However, I don't often work this situation and consequently don't often use my 81B. Many years ago when I used Kodachrome 25 as my primary film the 81B was my standard warming filter, with the 81C my deep shade filter. Since I now use Velvia as my film of choice I've pulled back on the strength of my filtration.

POLARIZERS

The other filter I recommend is a polarizer, which is certainly the filter I use most often. Under many lighting conditions polarizers increase color saturation, yielding richer and more intense hues. You get greener greens, richer reds, and brighter yellows. Most subjects reflect a certain amount of natural glare from their surfaces; along with atmospheric haze, this glare tends to diffuse colors that we see. Polarizers can eliminate, or at least reduce, some of these diffusing elements and consequently produce richer colors on film. To use a polarizer, screw it onto the front of your lens, then turn its rotating mount until you see what you like.

Polarizers are most commonly used to darken the blue sky, but this is actually where I use polarizers the least. Current E6 films,

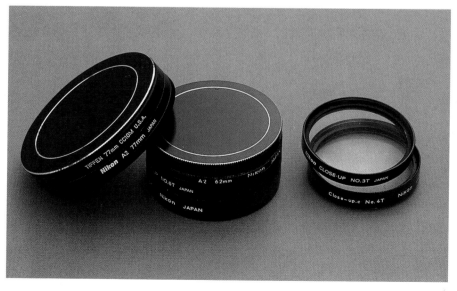

FILTER "STACK-CAPS."

Here's the best way I know of to carry standard filters. You can purchase "stacking caps" in standard filter sizes at most well-equipped camera stores. These are male and female threaded metal caps, so you screw all your filters of any one size together and add a cap on either side. No more little plastic cases taking up room in your bag!

the Fujichromes and Ektachromes, are already so saturated in color that it's easy to overdo this dark blue sky effect, especially if you're working at higher elevations. You don't want the sky to appear midnight blue—unless you're illustrating Toto leaving Kansas! How much a polarizer actually darkens the sky depends on the type of sky and your shooting angle in relation to it. Seen through a polarizer, a clear blue sky will darken appreciably at right angles to the direction of the sun, but a gray, overcast sky will show hardly any effect at all. You can't turn a gray sky blue.

There's an easy way to determine which areas of the sky will darken most. Point your index finger at the sun, then extend your thumb at a 90° angle to your finger, like a child's pretending to point a gun. If you keep your index finger extended at the sun and rotate your wrist, your thumb will traverse a plane across the sky which is at 90° to the axis of the sun. This is the plane of maximum darkening for any given elevation of the sun, the plane that will show the maximum effect when a polarizer is used. At high noon, with the sun directly overhead, this polarization area is near the horizon, while at sunset it passes overhead. This "thumb and index finger" trick always works, as long as you remember to twist your wrist.

Using a polarizer on a wide-angle lens often accentuates this plane of maximum polarization. Look closely at the sky and you will notice that it naturally darkens in tone farther away from the sun. If you take a picture of the sky with a very wide lens, like a 24mm, you will quickly notice this unevenness in tonality since the lens sees such a large angle of view (the picture angle is 84°). If you add a polarizer to the lens and take a picture, the effect is heightened even more. One side of the frame is close to the axis of

the sun and consequently shows little polarization effect, while the other side is close to 90° off axis and thus shows a great effect. This unevenness of sky tonality is not the fault of your polarizer; it's just an effect that is inescapable with a wide-angle lens's coverage of view. If the graduated tone in the sky bothers you there are several partial remedies. You could work with a longer-focal-length lens—which of course totally alters your photographic composition—or you could use your wide angle but frame the scene to encompass the least sky possible. Shooting a vertical would also help, as it narrows the angle of coverage across the top of the frame.

Far more often than to darken the sky, I use a polarizer to remove the glare from vegetation. If I'm photographing any plants with shiny leaves, including when I'm working in light rain, I use a polarizer to remove the glare and saturate the colors. The problem here is that the filter cuts the amount of light reaching the film, necessitating a slower shutter speed for any given f-stop. And inevitably, the slower the shutter speed, the more likely an increase in wind speed.

Polarizers change your base exposure—that without the filter on your lens—between 1 and 2 stops. If you mount a polarizer on a lens and see no change as you rotate it, you have, in effect, added a 1-stop neutral-density filter. At maximum polarization, where you see a major difference as you rotate the filter, it is a 2-stop difference in exposure values. Between these two extremes you can split the difference in exposure. Metering through the polarizer takes care of these factors, but you must be aware of these changes if you use a hand meter or start with the "sunny $f/16$" values. Let's say your hand meter suggests 1/30 sec. at $f/11$. If you add a polarizer and see no effect as you rotate it,

you've slowed the exposure to 1/15 sec.[1] So, what is the proper exposure if you're photographing a midday landscape using a polarizer at maximum effect on a bright, sunny day? Think carefully before you answer. Open 1 stop for sidelighting since the sun is overhead while you're photographing toward the horizon, and 2 more stops for maximum polarization effect. In other words, your starting base exposure is a total of 3 stops open from "sunny $f/16$" . . . "sunny $f/5.6$" or any equivalent.

Two kinds of polarizers are available: circular and linear. They look exactly the same; both are round filters you screw onto the end of a lens. Unless a filter is marked as a circular one, it is probably a linear type, but almost all current cameras—including all the Nikons, Canons, and Minoltas—need the circular variety to meter correctly and to autofocus precisely.

To determine whether your camera's TTL metering system works with a linear polarizer, mount one on a lens and take a meter reading off a dull, evenly-lit area that is all one tonality. A flat, off-white wall in your house will work well. Rotate the filter; if the meter reading changes as you do this, then that particular camera requires a circular polarizer to meter TTL correctly. You can still use a linear polarizer if you meter without the filter and then work in filter factors. It's just far easier to purchase a circular filter that can be used directly. Some special-purpose polarizers, such as the yellow-blue polarizer, are available only as linear models. Either work in filter factors, or rotate the filter until you get the fastest meter reading, set

[1]Getting a slower shutter speed, to blur moving water for example, is one reason to add a polarizer at times even if it doesn't seem to change the image visually. In effect, you always have a one-stop neutral-density (ND) filter with you.

BLUEBERRY FIELDS, MAINE.
Nikon F5, Nikon 35–70mm lens, Fuji Velvia.

Polarizers remove glare, and autumn blueberry leaves are exceptionally shiny. I took a photo without my polarizer, then added it for the second shot. What a difference the polarizer makes in this comparison.

your camera to that exposure, then reorient the filter to the visual effect you want.

If you're not sure if a polarizer is linear or circular, hold it at arm's length in front of a mirror so that the filter and its reflection overlap. If the overlapped area is dark (and flip the filter over, since circular polarizers are directional) then you've got a circular one. If you see no difference when filter and reflection overlap, it is a linear polarizer.

My normal procedure for deciding if I want to use a polarizer is holding it and rotating it while I look through it. At that point it's an arbitrary decision—I either like the effect or I don't. Most of the time I don't bother mounting the filter on a lens. If you do this, be careful with circular polarizers since they are not really two-directional; there is a right

direction to look through them and a wrong direction. One way, the way a lens would view through the filter, yields a pronounced polarization effect while viewing from the other direction does not. When I view through a handheld polarizer, I always make sure the filter threads are facing me; then I'm looking through it the right direction.

Check carefully for vignetting when you use a polarizer on a short-focal-length lens. Polarizers tend to be fairly thick all by themselves; if you add a lens hood, or stack filters, you can easily cut off the corners of the frame. Since you're generally viewing with your lens wide open, this vignetting may not be obvious. Point your lens at the sky and use your depth-of-field preview to see if you're getting a full-frame image. Nikon polarizers solve this

problem simply for almost all lenses: the polarizer's glass is just a little wider than the filter thread diameter. For example, Nikon's 77mm polarizer has 77mm filter threads, but the glass portion, the part that actually is in front of the lens, is roughly 80mm wide.

Finally, there is a special polarizer which can be most helpful. Most polarizers tend to be cool in tone; as they remove glare they also remove some of the warmth of a scene. Enter the warming polarizer. This is basically a circular polarizer with an 81A warming filter built into the glass. I find this polarizer particularly useful when I'm working bright autumn foliage. These are specialized filters, so I have a Singh-Ray which fits my Cokin filter holder; consequently, I can use that one filter on any of my lenses.

VIEW FROM SWAN LAKE FLATS, MIDWINTER MORNING, YELLOWSTONE NATIONAL PARK.
Nikon F5, Nikon 80–200mm lens, Fuji Velvia.

Be very careful when using a polarizer in snowy winter conditions. Since the proper exposure for snow on a sunny day is already 1 stop down from a normal "sunny f/16" setting, a polarized sky can turn out almost black. In this situation it's best to polarize only if the sky is in reality a very light blue. You don't want the picture to look like you and Toto could be headed for the Emerald City.

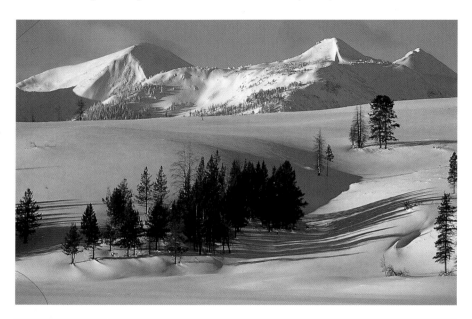

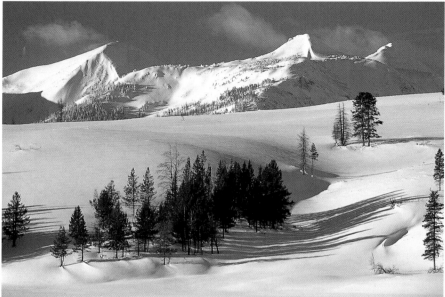

Graduated Neutral-Density Filters

No film can record the contrast range that our eyes can see. If you are standing in a location with contrasty lighting—for example, a forest on a bright, sunny day—you can see detail in both the darkest shadow areas and the brightest highlight spots simultaneously. Our eyes are very accommodating; most people's vision can handle a contrast range of about 12 to 14 stops. This is not true of film, which at best can only deal with about a 5-stop range in any one scene. Most beginning photographers ignore this limitation, only to be sadly disappointed in their photographs. Recognizing this compressed contrast range and learning to view subjects the same way that film records contrast, are vitally important to your photographic growth.

The newest cameras, the most expensive lenses, the latest films . . . all these won't change this most basic photographic fact. If you must photograph in a high-contrast situation, a scene that goes beyond those 5 stops from light to dark, you can't record all the detail on film. If you make an exposure favoring the dark area, the highlights will blow out, turning into detailless, washed-out areas. Expose for the brightest areas and the shadows block up, resulting in a solid, featureless black blob. Split the difference, and nothing looks good.

If you're not sure you can recognize this situation, it's fairly easy to use your camera meter for a precise answer. Meter both the brightest area of your scene and the darkest area, placing them tonally where you want them to be. Now compare the two meter readings. If they are beyond five stops, you've got a problem.

For example, suppose you want to photograph snow-capped Mt. Rainier. It's a beautiful morning of a blue-sky day, with puffy white clouds slowly drifting past. You're standing in a meadow filled with wildflowers that is still shadowed at this time of day. The mountain is bathed in fantastic sunlight, and you can easily envision a great picture. But can film record the scene?

Take a meter reading of the snow on the mountaintop. Remember to use a narrow-angle meter, such as your spot meter, as you want to meter the snow and only the snow. Your meter gives you the direct values of 1/125 sec. at f/16, but you know that this will render the snow as a medium tone. To make the snow a pure white, you must open up 2 stops to 1/125 sec. at f/8. Now meter the foreground—the shadowed meadow. It's basically a medium-toned area. There are some slightly lighter flowers and a few dark-

er leaves, but it averages out to a medium value. Take a meter reading here, using an overall metering pattern. The values read out as 1/60 sec. at f/2.8. Now, count how many stops difference there are between these two readings. Well, you slowed the shutter speed by 1 stop, and you opened the aperture by 3 stops, for a total of 4. If you expose the film so that the white snow is indeed rendered as a white, the meadow will be recorded four stops darker. Refer back to my exposure chart (page 25) and you'll discover that 4 stops below white will yield an "extremely dark" tonality. The meadow will become on film 2 stops darker in tonality than it appears to your eyes. Not good; it's a great meadow and you want all the flowers to be visible. But if you expose it properly, as a medium-toned subject, what happens to Mt. Rainier? You still have that 4-stop difference, so if you set your camera to record the meadow as a medium the snow on Mt. Rainier will be 4 stops lighter. Four stops lighter than medium is so light that nothing will record on the film, so there will be a blank section of film base where the snowy top of Rainier should appear.

At this point you have several choices. You could give up in frustration and not take any pictures at all. Or you could take a photo of only the meadow and a second photograph of only the mountain. But if you want both in the same frame, there's only one possible answer: you need to somehow cut the light on the sunny portion of your frame by 2 stops, or add 2 stops of light to the foreground meadow area. You need a 2-stop graduated neutral-density filter.

Neutral-density (ND) filters are simply dark filters that cut the amount of light coming through your lens. True ND filters are indeed neutral; they add no color of their own to the photo and do nothing but reduce the light. Quality ND filters are available in distinct increments of density—1 stop, 2 stops, 3 stops, and so on. *Graduated* neutral density filters are part dark and part clear. Half of the filter has the dark density, which then fades to a totally clear area on the other side of the filter. The graduation itself can occur over some distance—a so-called "soft" graduation—or it can shift abruptly—a "hard" graduation. If you add such a filter over your lens, you can reduce the light falling on one portion of your film, effectively compressing the contrast range of a scene. Exactly where this occurs within your photo depends on how you orient the dark area of the filter. Just be aware that the shift from dark density to clear filter

This is how rectangular graduated ND filters are supposed to be used. The holder can be rotated, and the filter slides back and forth into any position.

occurs in a straight line across the filter, so it helps greatly if the contrast problem in your scene is also delineated by a straight line. In that Mt. Rainier scene, suppose a tree was coming out of the shaded foreground so that its top was protruding into the sunlit half of the frame. Add density to this portion of the picture, and you'll end up with a tree that is half light and half dark.

I should mention here that graduated filters are available with colored densities as well as neutral density. My advice is to stay far away from these half-colored filters. Photographs made with them are almost always easy to spot. I've seen too many photos where a scene with even light suddenly turns tobacco-colored in the sky. Yuck.

Graduated ND filters are sold as standard round screw-in glass filters in the usual filter sizes, or in rectangular shapes designed to be inserted into filter holders that, in turn, screw onto your lens. The standard round filters have one major drawback which in my opinion renders them useless: the graduation from clear to dark falls exactly through the center of the filter. Since a screw-in filter cannot be repositioned, this shift of densities will always occur right through the middle of your picture. I don't think I've ever had reason to use a graduated ND filter with this placement. You want a system where the density can be positioned wherever you desire.

The rectangular filters are the answer. These are usually made from an acrylic-resin, and are designed to be used in special filter holders. The holder allows the filter to slide from end to end, and also to rotate. Consequently, you can position the graduation exactly in the location where you want it to fall. For years I did not use a filter holder

at all, but just held the filter up to the front of my lens during my exposure. This method worked okay, but I've gotten frustrated with trying to do several things at once. Hold the filter with one hand, take a meter reading, hold the remote release with the other hand, reposition the camera. . . . Good grief, John, use a filter holder.

Good-quality graduated NDs are available from a number of manufacturers including Tiffen, B+W, and Lee. In my opinion the best are made by Singh-Ray and can be had in 1-, 2-, and 3-stop densities in both hard and soft graduations. These are expensive acrylic-resin filters (they run about $100 each) and you probably won't need all six versions. I would suggest starting with a two-stop soft edge, then letting your field needs dictate any future purchases. For information, contact:

Singh-Ray Corporation
2721 SE Highway 31
Arcadia, FL 34266
Phone: (800) 486-5501
Fax: (863) 993-4100
www.singh-ray.com

These filters slide into a Cokin "P" series filter holder, which is available at almost any camera store. The holder uses different adapter rings which slide into the back, so with the proper ring you can use it on any lens. The Cokin holder is designed to hold several different filters at once, which creates a problem if you add it to a lens wider than about 24mm: the holder's thickness creates a vignette effect on the corners of the frame. I don't like to stack filters, so I modified my Cokin filter holder. I took a hacksaw, laid the blade in the outermost filter slot, and cut the holder down to a one-filter size. Not a very high-tech solution, but it worked perfectly. I don't like to use more than one graduated ND at a time because you can almost always spot a picture taken in this manner. It's too much filtration. We all know, from looking at thousands of photos, there should be some apparent contrast. The sign of good filter usage, in my opinion, is that the casual observer does not realize a filter has been used. If I'm ever really desperate and have no choice but to use two graduated filters, I'll just hold the second one in front. So far it's never happened.

All acrylic-resin filters scratch fairly easily if mishandled, plus they tend to hold a static charge and attract dust. While Singh-Ray filters are color neutral, this is not true of all graduated filters. If you are purchasing filters locally, try to shoot a few test frames through various filters to find the most neutral ones. At the minimum, lay several out on a light box or over a piece of white paper. You may be astonished at the color casts. Cokin filters are by far the least costly way to start working with graduated filters, but you must beware of color casts. Cokin doesn't actually offer any graduated neutral-density filters, but it does have two strengths of "graduated gray."

After all this discussion, the question of how to actually use these graduated ND filters in the field remains. Let me refer to my earlier Mt. Rainier example, in which you counted the number of stops you needed to compress the tonal range. In that case you needed to reduce the contrast by 2 stops, since you wanted the correct 2-stop difference to remain between white and middle tone. You needed a 2-stop graduated ND filter oriented so that the dark half covered the brightest part of the scene.

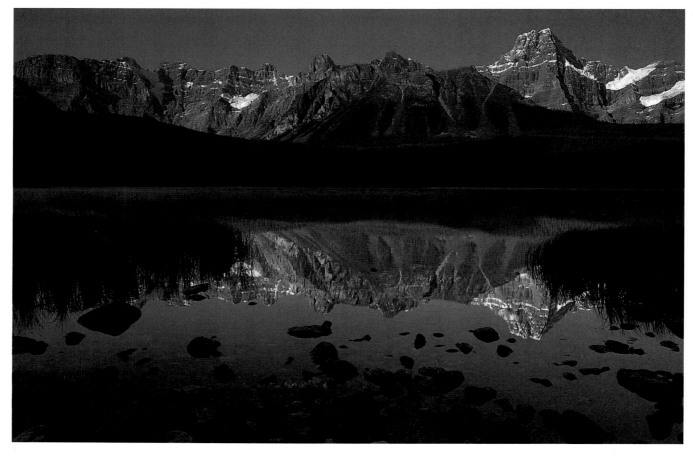

HOWSE PEAK AND REFLECTIONS IN LOWER WATERFOWL LAKE, BANFF NATIONAL PARK, CANADA.
Nikon F4, Nikon 28–70mm lens, Fuji Velvia.

This photo is over-filtered. I used a 2-stop graduated ND where I should have used a 1-stop. Notice that the reflection of the mountain is slightly lighter than the mountain itself, a physical impossibility.

The best, most precise way to meter with a graduated ND is to mount the filter over your lens so that the dark part is entirely in front of the lens. Now meter the bright area and place it at its correct tonal value. So for Mt. Rainier, meter the snowy area through the dark side of the filter, then open up the exposure by 2 stops to make the white snow record white. Metering through the dark side takes care of any possible discrepancies in the tonality of the filter. Is your filter exactly 2 stops neutral density? 2 1/3 stops? 1 7/8 stops? It doesn't matter, since you've just metered right through the dark portion. This works for all brands of graduated filters, but I will say that working with the Singh-Rays is particularly easy because the stop ratings are correct.

Now that you've placed the bright area, recompose the scene as you want it to appear, then reposition the filter. This is not always easy to do. When you're viewing through a lens, the graduation line is very difficult to see, especially when the lens is wide open. Stop down your lens with the depth-of-field preview, and slightly jiggle the filter. Doing this permits you to see exactly where the graduation occurs so that you can precisely align the filter as you desire. Be careful that you line the graduation up exactly with the shift of contrast in the scene itself. Position the density so that it overlaps into the foreground area, and you create a dark band running across the area where the highlights and shadows meet. Position it so that the graduation stops while still over the highlight area, and you get a bright highlight streak. Be exacting and precise in aligning the filter. When you look at a graduated ND filter, the greatest change from dark to clear seems to occur in the lighter area. However, what shows up on your film relates more to the dark side of the graduation.

By the way, the more you stop down for your final exposure, the greater the filter's effect. This is particularly true with wide-angle lenses, which are the lenses you'll use most with these filters. If you work with your lens set wide open, the filter will have little effect, since it lies far outside the depth of field of the wide-open aperture. Stick with apertures around $f/16$ for the best results.

One last hint: Don't try to position the filter by looking at where the graduation occurs in front of your lens. Doing so will give you a false impression of the final results. How much density covers the front element does not directly equate with how much of the film image is affected. There is absolutely no substitute for looking through your lens at your shooting aperture.

COW-PARSNIP BELOW SLATE MOUNTAIN, EAGLES NEST WILDERNESS, COLORADO.
Nikon F5, Nikon 20–35mm lens, Fuji Velvia.

In this photograph, I placed a 2-stop ND across the very top of the frame.

TTL FLASH

If you don't have a camera that supports through-the-lens (TTL) flash metering, then it's time to upgrade your system if you really want to make use of electronic flash. Yes, you can still work with a totally manual flash system, but the advances in flash technology over the past 10 years make working with TTL electronic flash units much, much easier. If you insist on keeping to a manual system, then I refer you to my earlier books, *The Nature Photographer's Complete Guide to Professional Field Techniques* and *John Shaw's Closeups in Nature*. Me? I switched over to TTL flashes as soon as they became available.

Most current flash units offer three working modes. These are manual, auto, and TTL. Let me quickly review these. In *manual*, the flash puts out the same amount of light all the time. When you trigger it, it discharges its full amount of power. Figuring out correct exposure is not exactly quick and easy; it involves a test roll of film and then a formula. The amount of light hitting any subject depends on how far away the light source is located. We've all been to concerts where some guy sitting in the third balcony fires off a flash aimed at the distant stage. He won't get an image—not because he's so far away, but because the flash-to-subject distance is

too great for the amount of light his flash emits. He needs to get the flash a lot closer to the subject. While we tend to think that flash-to-subject distance is the same as camera-to-subject distance, these are not the same. He *could* actually photograph from the third balcony if he could place his flash down near the stage with some sort of long wire.

The standard method of determining flash exposure in this case is by solving a formula: Guide Number (GN) = Aperture x Flash-to-Subject Distance. The GN is supplied by the flash manufacturer and is usually given for an ISO 100 film. Guide numbers are normally optimistic, to say the least, as they are for "average-sized rooms and average conditions." Right. If you take that flash outdoors, the GN will be overinflated by a stop or two, so you must run a test. Set your flash at a measured distance from a medium-toned subject, then run a series of exposures on slide film using different f-stops. Let's say you place the flash 5 feet from your test subject. You're using ISO 100 film, and when you get the film back you discover that $f/16$ gave you correct exposure. Well, "16" at "5" feet yields a GN of "80." Now you have to either measure the flash-to-subject distance of every shot you make, or work the formula

backwards to solve for the correct f-stop. Of course, the GN changes when you switch to a different ISO film. Good grief, no wonder I didn't like working with flash in the old days.

The second mode on most flash units is auto. Here, a small sensor on the flash reads the amount of light bouncing back from the subject and turns off the power when a predetermined level has been reached. Most flashes give you a choice of using two or three apertures. That's right, you can only use certain f-stops. Use some other aperture, and you get the wrong exposure. Since the sensor is on the flash unit, not the camera, it reads the light returning to the flash. Place the flash off to the side of your subject, and the auto mode reads the amount of light reflected over to that location, and not the part of your subject you see through the lens. Well, it's better than the old guide number formula, but it's still not a great way to work.

Enter TTL, the third mode on flash units—the one you want to have and use. Here the camera body "sees" the amount of light hitting the subject. There is a flash meter within the camera which evaluates the light coming back to it, through the lens. This meter turns the flash off once it has put out the correct amount of light needed for

A FLASH X-TENDER MOUNTED ON A NIKON HOT SHOE FLASH.

The 300mm lens shown is the shortest focal length you can use if you want the flash to cover the entire image area.

BLUE-EYED SHAG, FALKLAND ISLANDS.
Nikon F5, Nikon 300mm lens, Fuji Provia.

Fill flash opened up the minute shadows below each feather, broadened the highlight across the bird's head, and added the catchlight in the eye. Catchlights are particularly important in portraits of living creatures, as they add a spark of life to the picture.

▶ MANDRILL PORTRAIT.
Nikon F5, Nikon 500mm lens, Fuji Velvia pushed 1 stop, fill flash.

I used the Flash X-Tender to add a bit of fill plus a highlight in the eye. The flash was set on "automatic fill, -0.7" for this shot.

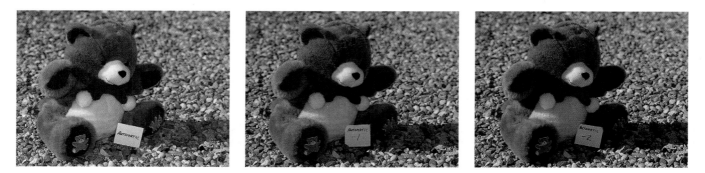

I bought this teddy bear for one specific reason: I wanted a test subject that had a shape and fur similar to the animals I would be photographing. This guy's close enough. I've used it for lens tests, film tests, and for fill-flash tests as shown here. Notice the cards in each frame so that I always have the information available if I review the images months later. I was testing fill ratios with Nikon's SB-25 flash.

Shot on "automatic fill, no compensation" the bear is definitely over-lit. Then I dialed in different amounts of compensation, still in the "auto-fill" mode. I shot an entire sequence, varying each exposure by 1/3-stop compensation. Here are the frames with −1 and −2 compensations. This is the sort of test I would suggest you should do.

any aperture, assuming that your subject occupies a good portion of your frame. Have a thin little subject, and the TTL sensor might try to light up the background. Still, TTL is the easiest way to use flash. However, you must have a camera body that supports TTL flash, plus the correct TTL flash unit for your camera body, and if you want to ever take the flash out of the camera's hot shoe, the correct off-camera cord for TTL metering. Yes, TTL has made using flash much simpler, but you can no longer use any old flash with your camera. I would suggest purchasing the full-size top-of-the-line hot shoe flash made by your camera brand, the Nikon SB-28 or Canon 540EZ or equivalent. With such a unit you are assured of all the electronic features working correctly between camera and flash, fast recycle times, plus extra power output when needed.

Okay, you've gotten a TTL flash, but now what? There are two ways to use any flash unit: you can light your subject entirely with the flash, what I call *total flash,* or you can add light to a normal natural light exposure, what is called *fill flash.* These are two distinctly different concepts and I want to discuss both in some detail.

TOTAL FLASH

Total flash is just that; the total light on the subject is from your flash. For example, you might be photographing your children at a family gathering one evening. This is the old "use a flash indoors since there's not much light" type of picture. To tell the truth, you won't often find yourself using total flash in nature photography except for (a) frogs at night, (b) cave photographs, (c) studio shots, and (d) closeup work. But you'll use it so often for certain types of closeups that I've included a separate section just on that (see pages 132–135). A few years back taking flower portraits by total flash was the rage, but thank heaven we've passed that point. All the pictures looked the same, with the same black background and same quality of light.

If you are in a situation calling for total flash, how do you set exposure? First, be sure the shutter speed is set at sync speed or slower. Then, connect the flash, power it up, and fire away. If it's on TTL mode, it will put out the correct amount of light for whatever *f*-stop you set on the lens. However, it will put out the correct amount of light to render your subject as a medium tone unless you compensate. What if your subject is a "light" tonality, one stop open from medium? Opening up the aperture on the lens won't help at all, as the flash will automatically adjust its output to a medium-toned subject placement at whatever *f*-stop you choose. So what controls are left? The answer is to use either the autoexposure compensation scale on the camera body

(regardless of what exposure mode the camera is in) or the compensation setting on the flash itself. You can either tell the camera to let some light in for an exposure, or you can tell the flash to output more light than what the camera is set. It's your choice.

When the only light source is the sun, you control exposure by adjusting either the shutter speed, aperture, or autoexposure compensation. All are controls on the camera. When you use total flash, the only light source is the flash output. Changing the shutter speed has no effect, since you're not recording ambient light. Changing the aperture has no effect, as the flash compensates. Changing one of the compensation scales is the only choice left. Doing so affects how light or how dark you want the exposure to be. It doesn't matter if the camera is in manual or autoexposure mode; use either compensation scale and work in stop values. If you want to make your subject fall as a "light" tonality, dial in +1 on the compensation, and shoot. If you want it to record as "dark" set the compensation at −1 and fire. Just remember to reset the compensation scale back to 0 afterwards. You're now working with flash in stop values, using the same increments in the same manner as you did with natural light.

FILL FLASH

When a subject is lit entirely by ambient light and you add flash, you are using fill flash. Now the flash doesn't light the subject, as in total flash, but only adds some light to the dark, shadowed areas in the same manner as a reflector. In this regard, fill flash is a means of controlling the lighting contrast. Fill flash works because you are not overpowering the main (ambient) light source. You're just taking a normal available-light photograph and adding some flash to it. The flash supplements, but doesn't supplant, the natural light.

How you actually access the fill-flash mode depends on your particular camera and flash. Read the flash section of your instruction manual carefully, then reread it, as I promise the instructions will be confusing (seemingly written by someone who speaks no language known on this planet). Most current hot shoe flashes, such as the Nikon SB-28 or Canon 540EZ, work in the same manner, so let me generalize about them. Your flash probably works this way, too.

These flashes are by default *always* in the fill-flash mode. The only question is how strong the fill light should be. You can allow these high-tech electronic flash units to make a decision as to the quantity of fill light, or you can make the decision, regardless of whether the camera itself is in manual exposure or autoexposure mode. Follow along with me here, as this can become very confusing.

Your first option is an "automatically set fill-flash ratio." Here the camera/flash combination chooses the precise amount of fill light to put out, depending on the scene's contrast as determined by the camera's TTL exposure meter. Computer chips in the camera and the flash communicate, then choose the appropriate output of fill. Most camera systems allow about 1 stop of leeway in the amount of fill, from balancing the flash with the available light to 1 stop under (a 0 to −1 range). Think of it this way: In stop values, how much darker do you want the shadows to be as compared with the rest of the frame? "Balanced" means that shadows and highlights have the same intensity; −1 means that the shadows are 1 stop darker in intensity. The computers in your camera and your flash unit talk with each other, and make a decision: "Hey, over here we need some more fill light," or "Over there we need a tad less fill light." The actual amount of fill put out is somewhere within that 1-stop sliding range.

However, you can also use the compensation scale on the flash itself to add to or subtract from the amount of fill. Remember that you are starting out with a varying amount of light, in stop values somewhere between 0 and −1. Any amount you set on the flash compensation scale—and you dial in the amount in 1/3-stop increments—is added to this starting amount. When you dial in compensation you are moving where the 1-stop variation falls. For example, setting −1 on the flash unit means you have weakened the entire fill amount by 1 stop—the "automatically set fill-flash ratio" range has been moved 1 stop. The flash will now output between −1 and −2 stops less light than the ambient reading.

The reason this 1-stop range is important is that the need for more or less fill light on a subject changes as the subject moves around. Assume that on a brilliant sunny day you have a duck swimming past you. The sunlight is coming directly over your shoulder, frontlighting the duck. At this point, you want almost no fill light at all. As the duck swims past you, it becomes sidelit . . . now you want a fair amount of fill light. Having the flash on the "automatically set fill-flash ratio" helps in this case because when you get more light when you need it. When you need less light, of course, you get less. And the flash does this all by itself with no prompting from you!

In my experience, using this mode and dialing in -0.7 or −1 (−2/3 or −1 stop, that is) yields about the right amount of fill in most situations. Adding this compensation means you end up with the flash choosing the amount of fill somewhere between −2/3 and −1 2/3 or −1 and −2. In fact, this auto fill mode and these ratios are exactly how I use my TTL fill flash most often. It's a quick and dirty method, but it works for almost all subjects.

There is another way of setting fill flash, the "manually set fill-flash ratio" mode. Here you decide the exact flash fill output you want (in stop values), compared to the available light exposure set on the camera. How dark, exactly, do you want the shadows to appear? Dial in this amount on the flash unit's compensation, and that's what you'll get. For example, a −1 setting means the shadows will have exactly one stop less light that the ambient exposure. You must change this amount for every change in lighting contrast, or else you'll end up with too much or too little fill. This is a precise but finicky method; it works great if you know what you're doing. Most photographers who use this "manually set" fill ratio start out with a −1.7 and work from there. In my thinking, this amount is at the end of my "auto fill" range, so I let my expensive flash unit decide if the situation requires more fill light. I switch over to a manually set fill amount when I'm working at a very slow, methodical pace.

With either fill-flash system, the correct available light exposure is determined by using your camera's regular metering system. The flash affects how light or how dark the shadows appear, but not the exposure for the scene. Both fill methods work fine; choose whichever one you prefer.[1] By the way, to make all the information show up on most new flash units' display panels, you must have a lens mounted on your camera and the flash connected to the hot shoe. This allows all the electronic components to interface with each other.

If your camera is in manual exposure mode, you can use fill flash at whatever shutter speed is appropriate to the situation, as long as that speed is no faster than the sync speed. You don't have to set the camera at 1/250 sec. or 1/125 sec. or whatever your top sync speed is. Say you're doing a closeup photo of an Amanita mushroom that you found deep in the forest. You take a meter reading and get 1/60 sec. at $f/4$. Using your stop down preview you realize you need $f/16$ for the proper depth of field, but at 1/60 sec., this would underexpose the background drastically. Well, 1/60 sec. at $f/4$ is the same as 1/4 sec. at $f/16$. Set your camera at this shutter speed and trip the shutter.

If you're working in aperture priority (or that dreaded program mode) you might not be able to use such a slow shutter speed so easily. Most Nikons, for example, will not let the shutter speed drop below 1/60 sec. in aperture priority when a flash is inserted into the hot shoe. Nikon designed the system this way assuming that otherwise some people would fire the camera at a moving subject in low light, resulting in blurry pictures and unhappy customers. Since you're smart enough to know what an appropriate shutter speed should be, and you know to watch the viewfinder display to monitor the speed, I'll let you in on the secret solution. Set your system on *Slow Speed Sync*, which allows the camera to drop below 1/60 sec., and the problem is solved.

TELEPHOTO FLASH

You can increase the effective power of your flash, for use either as total flash or as fill, by concentrating the light. When a flash is fired, the light spreads out at a fairly wide angle, but often you don't need this coverage. This is especially true when you're using a longer than normal focal length. By narrowing the beam of light, you direct more light onto your subject. Indeed, most higher-end flashes already have this built-in as a standard feature; the flash head appears to zoom as you change the focal length. What actually happens is that the flash tube is repositioned behind a plastic Fresnel lens, a flat sheet with concentric lens facets engraved on its surface. Most flashes that have this feature actually show about a 3/4- to 1-stop gain in light as you zoom from 24mm to 85mm. This is fine, but what if you need to throw the light much further because you're using a very long lens or want to light just one particular area?

The answer is to apply the same Fresnel concentrating principle. If you position a small Fresnel a few inches in front of your

[1]Nikon owners, here's how to tell the difference in fill modes. In "auto fill," either a matrix symbol or man-and-sun symbol appears on the back of the flash unit's display immediately next to where it says "TTL". In "manual fill," neither symbol shows.

flash, you narrow the light beam even more, yielding an increase of up to two or three stops of usable power. You can use this extra light to extend the flash range a considerable distance, or to allow a smaller aperture for additional depth of field for closer subjects. Concentrating the light also results in faster recycle times, permitting short motor drive bursts that are impossible otherwise.

There are several Fresnel concentrators on the market. In my opinion the best of these is the Flash X-Tender™ created by Walt Anderson. It's the best for field work because it folds flat when not in use so you can easily tuck it away into your camera bag. Heavy plastic wings attach to your flash with a wide elastic loop, and the Fresnel velcros onto the ends of these sides. Quick and easy to set up, the Flash X-Tender weighs less than 3 ounces and increases flash output by 2 f-stops. It's available through Kirk Enterprises and other outlets.

Once you add this Fresnel, the maximum distance for flash work depends on how fast a film you're using and the f-stop at which you're shooting. (This is always the case, flash extender or no flash extender; adding a Fresnel just increases the range.) With a medium-power TTL flash, ISO 100 film, and f/5.6, you can light subjects out to about 50 feet from the flash. As long as the flash exposure is 2 or 3 stops more than the ambient light, you can ignore the daylight exposure.

However, even though it's possible to do total flash in this manner, I would strongly urge you to be careful. The problem lies with the angle at which the light falls onto the subject. When you use a flash extender, you'll most often have the flash mounted either in the hot shoe or on a bracket attached to the lens. In other words, the light will be almost on axis with the lens. This is rarely a pleasing light. For example, if you're doing landscape work, direct frontlighting is the worst possible lighting you can have as it renders subjects flat and featureless. They lose dimensionality, appearing like cardboard stage cutouts. So why would you want to duplicate this bad lighting situation with flash? Well, at times you have no choice. If it's the only way to get an image, it's worth using.

It's far better to use extended flash not as the only light source, but as fill. Here is the reason-for-being of the Fresnel systems. You set your exposure in the exact same manner as you would without the flash extender. Remember, you're making a natural light exposure, so take a meter reading and adjust shutter speed and f-stop appropriately. Then use your preferred fill-flash method, and your preferred fill-flash amount. If you're using a long lens, you want to keep a fast shutter speed, but the flash sync speed is a limiting factor. This is why I recommend buying a camera that syncs at 1/250 sec.

Even with a long lens, you won't be trying to fill shadows on a subject hundreds of yards away. After all, at that distance you're taking a long-lens scenic, not a photograph of a bird or mammal. To get a pleasing shot of an animal the size of a mallard duck, you've got to be fairly close, within 40 feet with a 500mm lens. At this distance your Fresnel-equipped flash will have plenty of power as a fill light. Let's say you're working in early morning light, around one stop off bright sunlight. For ISO 100 film that's an exposure of 1/500 sec. at f/5.6 for frontlighting. The duck is side-lit, with dark shadow areas that will block up on film, opening up your base exposure to 1/250 sec. at f/5.6. You set your flash at "automatic fill, −2/3", slowly work your tripod-mounted camera into position, and carefully trip the shutter. Great shot!

Just remember that the camera is reading the light coming through the lens. If there are branches or leaves in the frame, the flash sensor may respond to the light on them rather than on your intended subject. And if there is a lot of foreground leading to your subject, it can be overexposed while the subject is correctly lit. When shooting with extended flash, the best results are almost always achieved when there is a clear sight path to your subject, and no close-in foreground.

When using fill flash on animate subjects, I would also urge you to use *Rear Curtain Sync*. Normally a flash fires at the moment the shutter opens, then the natural light exposure runs, and finally the shutter closes. Occasionally when you're photographing animals, they will flinch from the flash's burst of light. If this occurs at the start of the natural light exposure, it will record on film and you'll get blurry animal photos. But if you set Rear Curtain Sync, the flash fires at the exact moment the shutter starts to close. Consequently, any movement made by the animal occurs after the exposure has been made.

NUTRIA, LOUISIANA.
Nikon F5, Nikon 500mm lens, Fuji Provia, fill flash.

Here's a photo shot on a cloudy day. I wanted to add some snap to the image, so I used fill flash concentrated with my Flash X-Tender. Fill at "automatic fill, -0.7".

▶ FEMALE GORILLA, SAN DIEGO WILD ANIMAL PARK.
Nikon F5, Nikon 500mm lens, Kodak Ektachrome 200 pushed 1 stop, fill flash.

How was this metered? I set the camera on center-weighted metering, aperture priority with a −1 compensation (to make the dark gorilla appear dark on film) and added fill flash set to "automatic, -0.3" through a Flash X-Tender.

LENSES 3

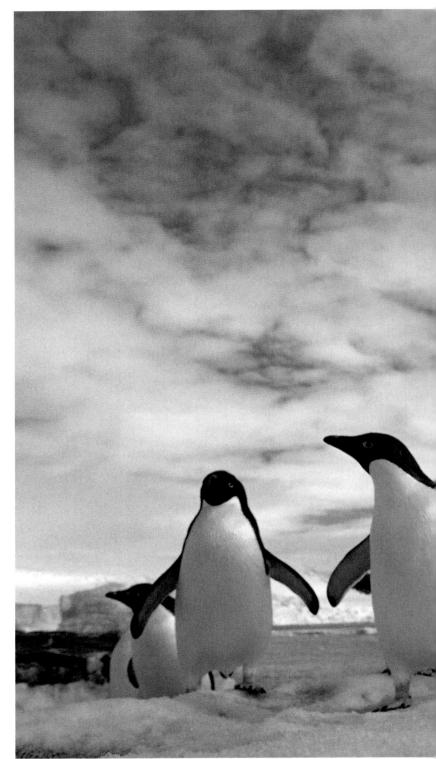

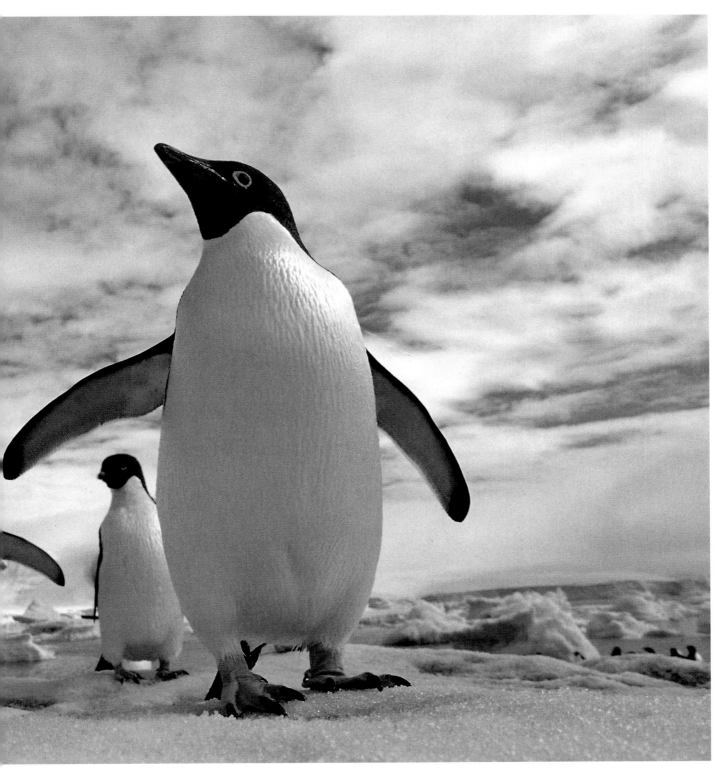

ADELIE PENGUINS RETURNING FROM THE OCEAN, ANTARCTICA.
Nikon F5, Nikon 20–35mm, Kodak E100S.

WHAT LENSES DO

One of the greatest strengths of the 35mm SLR camera is that it allows the user to change lenses with a minimum of difficulty. Instead of being limited to one view of the world, you can switch between expansive, all-inclusive coverage to tight selection of one detail, all by changing the lens mounted on the camera.

Photography helps us to create order out of the visual chaos we encounter daily. When we take a picture, we emphasize one aspect of our experience over all others; by isolating a particular subject and choosing how much of it to include within the frame, we give it importance. How we compose a picture, the point of view from which we take the photograph, and the photographic tools we use all contribute to our control of the viewer's perception. Primary to this entire procedure are the lenses we use. Before I discuss how to use specific lenses in the field, let me give an overview of lens terminology and how lens choice affects visual perception.

FOCAL LENGTH

The two most basic characteristics of any lens are its focal length and its maximum aperture, which is generally referred to as its speed. *Focal length* is defined as the distance between the optical center of a lens and the film when the lens is focused on infinity. This distance is almost always measured and expressed in millimeters, although you will occasionally find older references expressed in inches (e.g. a "2-inch lens" or "4-inch lens"). In far more useful and practical terms, focal length is an expression of how a lens "sees" an image, and how it changes that image as compared to a basic norm. In 35mm photography that norm is the image produced by a 50mm lens.

Fifty-millimeter lenses are often referred to as "normal" lenses, but all this really means is that lenses of around this focal length normally come with camera bodies. Indeed, referring to a 50mm lens as a "standard" lens would make far more sense. After all, nothing about the 50mm focal length is normal in the sense of being comparable to how the human eye sees, neither how much is taken in by the lens from side to side nor how its focal length relates to the focal length of our eyes. Fifty-millimeter lenses became the standard lenses for 35mm cameras mainly by historical accident, and not by any rational decision on the part of camera manufacturers.

If we call the 50mm lens the "standard" lens, then we can compare all other lenses to this standard and group them by focal length. Any lens with a focal length that is numerically greater that the standard 50mm is called a "long" or "telephoto" lens, while any lens with a focal length that is numerically smaller than 50mm is a "short" or "wide-angle" lens.

The focal length of any lens directly relates to both the lens's angle of view and the image size it produces. *Angle of view* refers to how much of a scene a lens encompasses from any given shooting location. Angle of view decreases as focal length increases, and vice versa. From a given location, the longer the focal length, the narrower the scene a lens sees. Telephoto lenses have very limited coverage of a scene; they are "narrow-vision" or "narrow-angle" lenses. Wide-angle lenses, as their name implies, take in a broad field of view. The "shorter" a lens's focal length, the wider its angle of view.

HUCKLEBERRY AND AUTUMN COLOR ON TOP OF CADILLAC MOUNTAIN, ACADIA NATIONAL PARK, MAINE.
Nikon F5, Nikon 80-200mm lens, Fuji Velvia.

The combination of good photographic technique plus quality optics mounted on a sturdy tripod plus careful composition lets you record wonderful moments in nature. Using a long zoom lens makes it much easier to frame your image precisely.

As angle of view changes, so does image size (how large things look through the viewfinder and on film). If you're photographing from a fixed location, there is a direct relationship between the focal length of a lens and the size of a subject's image on the film. The shorter the focal length you use, the smaller the image on the film; the longer the focal length, the larger the subject will appear on the film. So from a given shooting location, wide-angles will basically decrease the image size of any object, while telephotos will increase it. The linear size of the image varies directly with the focal length of the lens used. For example, if you double the focal length—from 50mm to 100mm, from 100mm to 200mm, from 200mm to 400mm—you double the linear size of any subject recorded on film. Let's say you're photographing a tree with your normal 50mm lens, and the tree's image is 1/4 inch on the film. From that same location, switching to a 100mm lens would increase the tree's image to 1/2 inch on the film, while a 200mm lens would make it appear 1 inch. The opposite is also true. Switching to a 24mm lens would decrease the tree's image size to 1/8 inch.

LENS SPEED

The *speed* of a lens refers to its maximum aperture, its widest *f*-stop, the biggest hole through which light can pass. Lenses with large maximum apertures are called "fast" lenses since they can let in more light than can "slow" lenses with smaller openings. A lens with *f*/2 as its wide-open aperture is "faster" than an *f*/2.8 lens, which in turn is faster that an *f*/4 lens. The *f*-stops on all lenses are determined in exactly the same way. They are numerically equal to the lens's focal length divided by the optical diameter of any given aperture hole.[1] Assume that you have a 100mm lens. If the optical diameter of its largest aperture is 50mm, then the *f*-number of this aperture is 100 ÷ 50 or *f*/2. Another 100mm lens might be *f*/4 wide open, meaning that its optical aperture is 25mm in diameter.

As you might imagine, fast lenses must be relatively large, and fast telephoto lenses, extremely large. Let's consider that 100mm *f*/4 lens with a maximum optical aperture 25mm in diameter and compare it to a 600mm *f*/4 lens with an opening 150mm in

[1]Okay, here is a precise definition: An *f*-number is a value representing the quantity of light passing through the diaphragm when the lens is focused at infinity. The "*f*" is an abbreviation for "factor," and describes the mathematical ratio of the focal length divided by the diameter of the effective aperture, which may not be the same as physical diameter because the light rays entering the front element of the lens are converged towards the diaphragm. Got that?

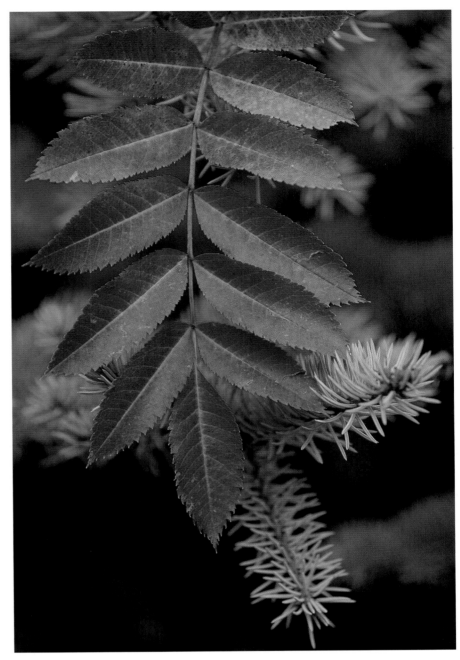

MOUNTAIN ASH LEAVES OVERLAPPING SPRUCE BOUGH, COLORADO.
Nikon F5, Nikon 80–200mm lens, Fuji Velvia.

I used the longer end of my 80–200mm zoom lens to isolate this particular area. I zoomed in until only these two branches were in the frame.

diameter. Long-focal-length fast lenses mean large elements, more weight and bulk, more difficulty in construction . . . and a lot more expense for the purchaser.

But a "fast" lens is only fast in relation to its focal length. The exact same maximum aperture could be considered fast, slow, or normal, depending on the lens. A standard 50mm *f*/2 lens is pretty ordinary, neither fast nor slow for its focal length. But a 100mm with the same maximum aperture of *f*/2 is indeed a fast lens, while a 200mm *f*/2 is

extremely fast. If there were such a thing as a 400mm *f*/2 lens we would have to invent a new term for lens speed—perhaps "supersonically fast"?—but it would also be about the size, weight, and price of a pickup truck.

An *f*-stop permits the same amount of light to pass through the diaphragm to hit the film regardless of the lens's focal length. In other words, *f*/4 on a 50mm lens, *f*/4 on a 200mm lens, and *f*/4 on a 600mm lens all transmit the same amount of light. The numbers, and the concepts represented, are

independent of the actual lenses. This is what allows us to use handheld meters and such rules of thumb as "sunny f/16."

Perspective is the relationship between all objects in a scene as viewed from any given location. All lenses yield the same perspective if used from the same camera position. The objects within the scene will appear to have the same relationship with each other in all photographs taken from the same spot. If you don't change your camera position, changing lenses simply means that you're changing the framing—how much or how little you include—of any picture. Using a long lens allows you to crop tightly into a scene, to isolate one particular area, while a short lens expands the frame. But both lenses, indeed all lenses, show the same perspective from the same viewpoint.

Here's an experience I'm sure you've had. You're driving through the mountains and you see a gorgeous vista in the valley below. Wow, it's an incredible scene! You know it would be a good photo . . . but when you

drive down there, the picture's gone. Why? It's simple: the perspective from below is different from what it was up high. You need to photograph from that position back up in the mountains where you said "Wow!" Set up your tripod there, then choose a focal length that gives you the coverage you want.

When you change your physical location, you change not only your perspective, but also the apparent relationship between elements within a scene. The distance between two objects appears to be much greater when one of them is close to you than when both are distant. For example, look down a long row of telephone poles that are spaced equally apart. The ones closest to you will seem to be a good distance apart, but as you shift your vision to the ones further away they appear to get closer together. Photographically this is often called "telephoto compression," but that's a misnomer since it has nothing at all to do with focal length. We use telephoto lenses to look at distant scenes, and things far away

seem close together. Similarly, objects that are physically quite close to the camera position appear proportionally much larger than those far away. Think of those telephone poles again—the ones nearby appear quite tall while the ones far away seem to shrink in size. Telephoto lenses compress the scene; wide-angle lenses decompress it.

Knowing all this, you can use both perspective and lens choice to affect the viewer's perception of a scene. These should be conscious, careful decisions on your part. By selecting your vantage point, you control your image's perspective. If you use a wide-angle lens, you can effectively change the relationship between foreground and background elements, and expand the scene to encompass more within your view. If on the other hand you select a telephoto lens, you can pluck out one area for the viewer, stack the elements tightly together, and effectively condense the scene. The choices are yours to make, so long as you have a selection of lenses from which to pick.

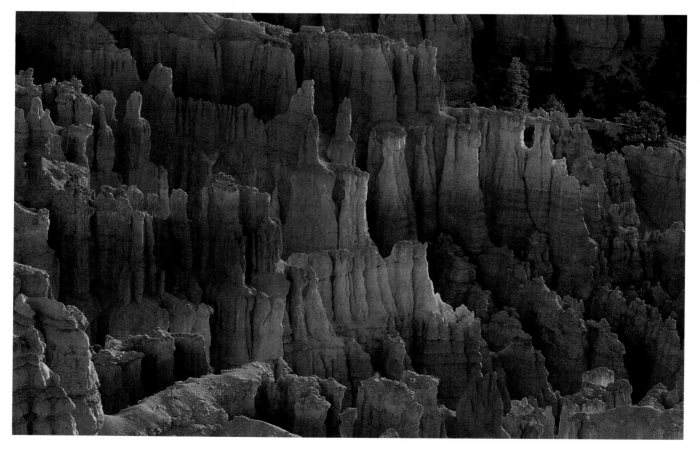

BRYCE CANYON NATIONAL PARK, EARLY MORNING, FROM INSPIRATION POINT.
Nikon F3, Nikon 50–135mm lens, Fujichrome 50.

A short telephoto lens let me isolate one section of the hoodoos in the Bryce amphitheater. Using a focal length of around 100mm kept the perspective relatively normal—about the same as our eyes. If you've never been to Bryce Canyon, you might find the scale of this photo deceptive. How big are those formations? Well, those are full-sized ponderosa pines growing among the hoodoos.

ZOOM LENSES VS. FIXED-FOCAL-LENGTH LENSES

In the mid-1980s I would have recommended that you purchase only fixed-focal-length lenses, as they were optically the best lenses available at the time. Zoom lenses, lenses that incorporate many focal lengths into one lens, were rather middle-of-the-road in terms of optical image quality. This is not true anymore. Zoom lenses have gotten much, much better, and have in fact become the most readily available lenses. I conduct nature photography tours to various locations around the world, and I rarely have a student who carries fixed-focal-length lenses. Everybody uses zooms today; even most working professional nature photographers shooting 35mm have primarily zoom lenses, with only a few fixed lenses—extremely long telephotos and macros—in their kits.

Given the same optical quality, there is no difference whatsoever between a photograph taken with a zoom lens and a fixed-focal-length lens. A zoom set at 200mm and a fixed 200mm lens will produce the exact same photograph. It's the focal length itself that determines a photograph's look, not whether a zoom lens or fixed-focal-length was used. A zoom lets you carry a lot of focal lengths all together in one package rather than carrying a number of individual lenses. The trade-off is that most zooms are rather slow (in terms of maximum aperture) and bulky compared to a single-focal-length lens. Fast aperture zooms are readily available, but they generally cost more that a single lens since you're getting a whole range of focal lengths. For example, Canon offers both a fixed 200mm $f/2.8$ and a 70–200mm $f/2.8$. The zoom is roughly double both the price and the weight of the fixed-focal-length lens. Of course, with the 70–200mm you also have a 71mm $f/2.8$, a 72mm $f/2.8$, a 73mm $f/2.8$, a 74mm $f/2.8$. . . .

However, not all zoom lenses are created equal. Buy the best you can possibly afford. The inexpensive, low-end zoom lenses tend to be soft wide open, sometimes off in color rendition, and mechanically not that reliable. This latter is important since every time you zoom all sorts of things are moving around inside the lens.

I also suggest you purchase a reasonably fast zoom if you have any choice in the matter. One way of keeping the cost of a zoom low is by making it with a slow maximum aperture, $f/5.6$ or thereabout. When you start working in low light or adding filters, this lack of lens speed can cause problems. For example, Sigma offers a 28–105mm $f/4$–5.6 lens which would seem

SLASH PINE DRAPED WITH SPANISH MOSS ON FOGGY SUNRISE, FLORIDA.

Nikon F4, Nikon 80–200mm lens, Fuji Velvia.

A photo from the remote wilderness? Actually, this photo was taken on a vacant lot right in the heart of Ft. Myers, Florida. I used my zoom at 200mm to narrow down its angle of view, while the dense fog hid the surrounding houses. Fifteen minutes later the fog was burning off and buildings, roads, and cars were all too evident.

to be a nice range of focal lengths for landscape photography. That shift in f-numbers means it is a variable-aperture lens. If you set it wide open at $f/4$ at the 28mm end and zoom to 105mm, the aperture will change as you zoom until it becomes $f/5.6$. The diameter of the hole in the lens stays constant, so as the focal length changes, the f-number must also change. What's the problem with using this lens in the field? Nothing, if $f/5.6$ is fast enough for you to see through. Imagine that you are photographing a cascading stream overhung with spring branches early on an overcast morning—perfect light for a stream shot—in the Great Smoky Mountains. Can you see through the lens to precisely compose and focus the picture? If you add a polarizer to cut down the reflections from the wet rocks, the effective aperture you're viewing though at maximum polarization is $f/11$. Now can you see? That viewfinder image would be pretty dark and dim even in bright light, let alone the soft light of an overcast morning.

My recommendation is to purchase zoom lenses with maximum apertures no slower than what you would buy if the lens were a fixed focal length. Let's look at that Sigma 28–105mm lens again. Would you purchase a 28mm $f/4$ lens for your wide-angle? How about a 105mm $f/5.6$ all by itself? I for one would definitely want more lens speed for field work.

Most zoom lenses cannot focus as close as their counterparts in fixed lengths. This may or may not be important to you, but it's best to consider it before you make a purchase. Minimum focusing distance is very important with the wide-angle focal lengths, as one effective compositional device is to place a foreground object extremely close to the lens while allowing the background to recede into the distance. There is a vast difference between a minimum focusing distance of 4 feet and one of 2 feet. All else being equal, pick the lens that focuses closer.

When using zoom lenses, always bear in mind that they have multiple focal lengths. For example, an old rule of thumb when

handholding says that for consistently sharp photos you need a shutter speed at least equal to the focal length used. That is, to handhold a 50mm lens you need at least 1/50 sec. shutter speed. When using these lenses, photographers tend to forget that as you zoom the focal length changes. Start with a 100–300mm set at 100mm, handhold it at 1/125 sec., and you're marginally okay, but as you do nothing else but zoom out to 300mm you're suddenly more than one shutter speed too slow. What was recorded sharply at the short end of the zoom is blurry at the long end. You must remember the focal-length change even when you mount the lens on a tripod. The tripod legs and head and the photographic technique that are borderline for a 100mm lens are not good enough for a 300mm. You might do better to always think about the lens in terms of its longest focal length.

What about the "one-lens-does-all" approach of the wide-range zooms? These are the 28–200mm and 28–300mm (I might even include the 100–400mm group). I would recommend one of these lenses only if

SUNSET SKY OVER FOSSIL BUTTE, BADLANDS NATIONAL PARK, SOUTH DAKOTA.
Nikon F5, Nikon 80–200mm zoom lens, Fuji Velvia.

I had little time to take this photo. As I rushed to find a location, I watched the color build in the sky. When I got to Fossil Butte, I grabbed my most-used lens, my 80–200mm, for this composition.

you can articulate exactly why you need that range encompassed in one lens. The usual answer is for travel, where size and weight restrictions are becoming more stringent all the time. If so, I would strongly urge you to have at least some backup equipment; otherwise, what recourse do you have if the lens breaks? Let me tell you a sad story. I occasionally run Kenyan safaris, and on one trip a client shooting Canon came with only two lenses in order to ease her travel. She had a Canon 24mm lens and, for her long lens, a Canon 35–350mm lens. Both are excellent optics. On about the third day of safari, she dropped her 35–350mm, damaging it beyond any possible field repair. So for the rest of the trip she had to photograph with her 24mm. The trip of a lifetime, and she was forced to take photos of lions which recorded them as mere specks in the frame. Her slide show back home included photos of tiny little elephants, tiny little zebras, and tiny little wildebeests. "One-lens-does-all" can mean "no-lens-does-anything." Carry backup.

FROST ON COTTONWOOD TREE, MIDWINTER, YELLOWSTONE NATIONAL PARK, WYOMING. Nikon F4, Nikon 20–35mm zoom lens, Fuji Velvia.

For this photo, I actually dug down through the deep snow in order to lower my shooting position. I wanted the frosted tree to stand out against the dark blue sky rather than blend into the white hillside background, so my camera position was as close to the tree as possible. This allowed me to look up at the tree. I used my zoom at its widest focal length.

WIDE-ANGLE LENSES

As their name implies, wide-angle lenses—those with focal lengths of 35mm or shorter—take in a very broad field of view. Wide-angles effectively decompress the landscape, making distant objects seem even further away than they appear to our eyes. At the same time, they accentuate near objects. So, the total effect is an emphasis on the space between foreground and background in any composition. Wide-angles are extremely useful for taking in the entire scene, for recording the grand vista stretching out in front of us. But this very inclusiveness is exactly what makes wide-angles the hardest focal lengths for most photographers to use.

The problem is generally one of composition. The temptation is to include everything you see in front of you in the image frame. Imagine standing at the base of the White Mountains in New Hampshire during the height of autumn color. You want to include all of the mountains, since they're ablaze with color . . . but that stream over there is interesting, so why not put it in the picture? . . . hey, how about that old farm—you really like old buildings—gotta include that . . . and that winding road is great, maybe you can just stick it in the frame. . . . I'm sure you can already see the difficulty. These lenses' wide angles of view make it easy to include too much in one photo. If you fit all you can in one shot, you'll end up with a mass of chaotic information, and your viewers won't be able to figure out what you wanted them to view. To make an effective photograph, you have to impose order on the chaos. One quick solution to the problem of simplifying composition—and many photographers fall back upon this—is to mount a longer focal-length lens. By selecting only a small portion of the scene, you leave yourself fewer lines, shapes, forms, and colors to organize into a pleasing arrangement. Of course, you've lost the overall view which the wide-angle offered.

Wide-angles demand that you work carefully and selectively. You must be absolutely precise about tripod position, since even a small change in location shifts the photo's emphasis to a different part of the foreground. Tiny changes in the direction the lens is aimed results in huge areas of the subject being included or excluded. Since all the elements in the composition must work together, it's best to take extra time to study the image before pressing the shutter. While wide-angle lenses are not easy to learn to use, they do offer amazing possibilities.

One of the most effective ways of working with a wide-angle is to position the lens extremely close to a foreground subject in order to to exaggerate its size. This is the traditional method for landscape photography done with a large-format view camera. Tilt the lens down at a slight angle, placing the horizon line fairly high in the frame, and work tight to the subject. Composing in this manner increases the three-dimensional feeling of a photo, because it increases the apparent depth of the scene. Viewers are forced to participate intimately in the picture; they feel they can reach out and touch

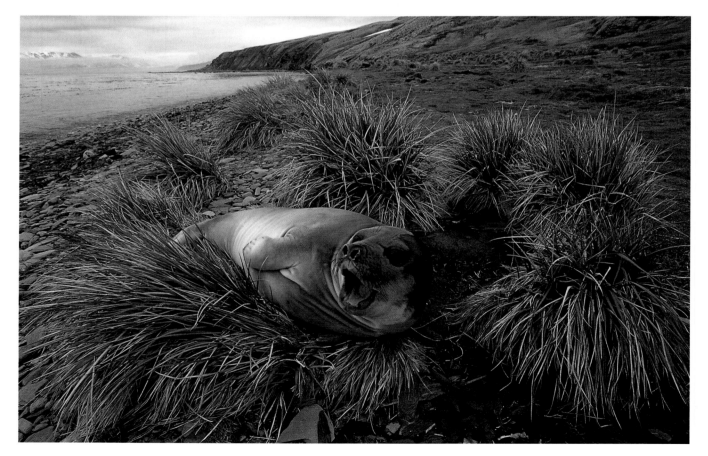

SOUTHERN ELEPHANT SEAL,
SOUTH GEORGIA.
Nikon F5, Nikon 20–35mm lens, Fuji Velvia.

Young elephant seals at this age are commonly called "weaners," as they have just been weaned. I wanted to photograph this weaner in context, showing the tussock grass and rocky shoreline near Grytviken. The receding background emphasizes the three-dimensionality of the image.

the foreground or step right into the scene. You are dramatically presenting a foreground in the context of its environment.

When using this technique, you must be absolutely sure that the foreground object is in sharp focus. It is extremely disconcerting to see a photograph shot with a wide-angle lens where the distant horizon is more in focus than the close foreground. After all, in everyday experience objects farther from us always appear to be less sharply focused. However, don't just point your lens at the closest object in your frame and focus on that. Instead, use your depth-of-field preview to evaluate the scene. If your lens has a hyperfocal scale—and few zooms do have this—use the hyperfocal distance of your shooting aperture to maximize how you utilize the depth of field available. If you have to sacrifice one area or the other, let the background go soft before you give up foreground sharpness. For example, suppose you need *f*/22 for total foreground-to-background depth but a persistent breeze requires shooting at *f*/8. Given this choice, you should keep the foreground in focus.

The closer you are to any foreground subject, the more critical your tripod and camera placement become. It's obvious how camera placement affects the appearance of any close object, but because of their wide coverage the shooting position of a wide-angle lens greatly influences how the foreground relates to the background. If you're working 20 feet from the nearest part of the scene, a 6-inch change in camera location essentially makes no difference at all. But if you're working with the lens 20 inches from the subject, the same 6 inches in any direction at all becomes a gross movement.

To immediately gain a better understanding of the foreground/background relationship, try this exercise. Hold a pencil at arm's length, shut one eye, and look past the pencil at an object about 6 feet away. Still viewing with one eye, move your head from side to side. The pencil will appear to shift its position across the background slightly. Now hold the pencil a lot closer to your face, only a foot away, and again view with one eye. Move your head from side to side as before and notice what happens. The pencil appears greatly displaced in relation to the background.

So, the closer the foreground is to the camera, and the further away the background is, the more critical the location of the camera becomes. Any subtle shift in camera position, and the entire foreground/background relationship changes. Time spent finding the exact shooting position is definitely time well spent. I often see photographers shooting from a given location not because it's the best spot, but

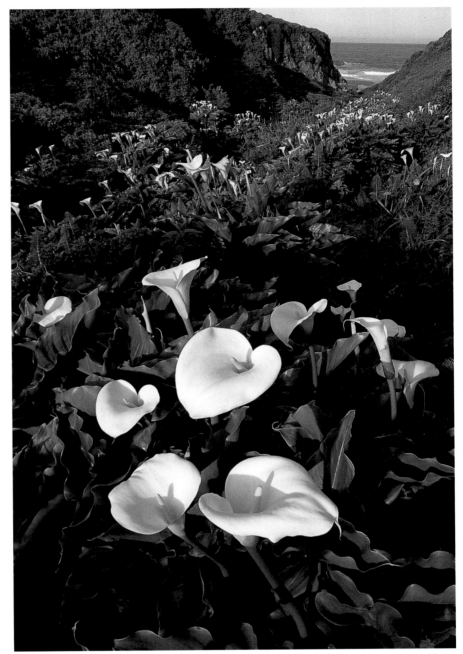

CALLA LILIES ALONG THE PACIFIC COAST, GARAPATA STATE PARK, CALIFORNIA.
Nikon F5, Nikon 20–35mm lens, Fuji Velvia.

Using my zoom set at 24mm, I took this photograph just as the sun first peeked over the coastal ridges. I was worried about holding the contrast between the white flowers and the dark green leaves, while I should have been more worried about all the poison oak I had hiked through to get to this spot. Well, live and learn.

because they set their tripod up at that location and now must justify having done so. To avoid this, I suggest first handholding your camera for ease of movement, then fine-tuning your composition with the camera mounted on a tripod.

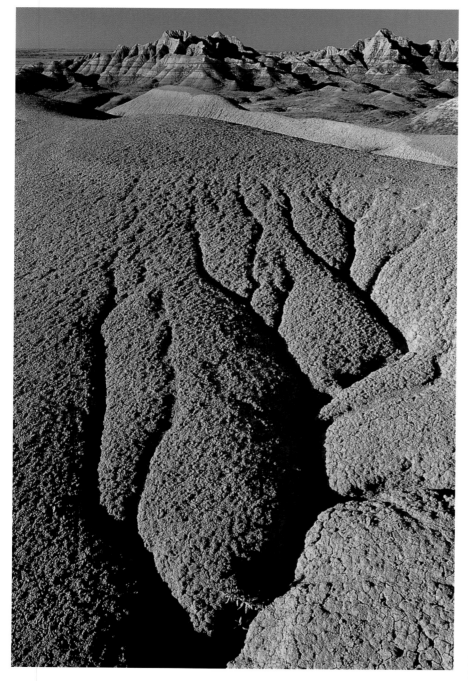

EARLY MORNING IN THE BANDED BUTTES, BADLANDS NATIONAL PARK, SOUTH DAKOTA.
Nikon F5, Nikon 20–35mm lens, Fuji Velvia.

A strong traditional technique for using a wide-angle lens is to position the camera extremely close to a foreground object while keeping the horizon high in the frame. The result is that viewers can reach out and touch the foreground; they can feel the texture of that dry clay mound.

If I were purchasing a fixed-focal-length wide-angle lens I would definitely choose a 24mm. This focal length is a good compromise between the need for wide coverage and the desire not to expand apparent distances. Let me say right here that if you already own a 28mm lens, you can stick with it. The difference in coverage between these two focal lengths is not that great, usually compensated for with only a few steps forward or backwards. Use what you already own, then take the money you would have spent on a 24mm and purchase a better tripod. A good choice in fixed-focal-length wide-angles would be a 24mm and a 35mm lens, while a three-lens group might include a 20mm, a 28mm, and a 35mm lens. I've rarely wanted any lens wider than 20mm in my years of field nature photography, certainly not enough to justify my buying a ultrawide lens. Actually the only extreme lens I would even like to borrow is a 15mm for photos of forest interiors. To be honest, I don't think I've missed any shots from the lack of an ultrawide lens.

Instead of fixed focal lengths you could purchase a wide-angle zoom lens, which is what I carry. Be aware of the fact that inexpensive zooms often fudge a little in their purported focal length, which are often a little shorter at the long end and a little longer at the short end than advertised. A lens marked 28–70mm might actually turn out to be closer to a 30mm–65mm. You don't have to worry about the long end of the zoom range—there is little practical difference between 65mm and 70mm—however, in the wide focal lengths, every millimeter counts. An easy way to check wide-angle zooms is to mount a fixed-focal-length wide-angle on one camera body and a zoom set at the same focal length on another body, and compare the viewfinder images. Make sure to do this with both lenses mounted on the same model camera to disallow any differences in viewfinder coverage.

Better quality zoom lenses are far closer to their marked focal lengths. Wide-angle zooms are the most difficult to manufacture of all zoom lenses, so I urge you to purchase the very best lens you can. This is not a place to skimp as poor image quality will be readily apparent. My favorite lens here is a 20–35mm $f/2.8$ zoom; this covers all the normal wide-angle focal lengths, and its fast $f/2.8$ speed yields plenty of focusing light even in dim conditions.

You also want your wide-angle lens to focus as close as possible, since you will often need a frame-filling foreground. Fixed-focal-length lenses definitely have the advantage here, although most quality wide-angle zooms focus adequately close. Beware of having an extreme-range zoom—such as a 28–200mm or 28–300mm—as your only wide-angle lens. Most of these have minimum focusing distances that are quite a bit longer than optimal. To give you a clearer

idea, let's consider one with a 4-foot minimum focusing distance. The subject coverage of a 28mm lens at this distance is about 4 feet across the long dimension of the frame. That means the tightest shot you could take with this lens would include a foreground roughly 2 1/2 x 4 feet in size. This is not very tight at all. Most fixed 28mm lenses will focus down to about 10 inches from the film, while the best 20–35mm lenses, such as those from Nikon and Canon, go to about 18 inches.

When you aim any wide-angle lens upwards, whether it's a zoom or a fixed-focal-length, all vertical lines appear to converge, or tip, towards the top center of the frame. This is often referred to as "wide-angle convergence" or "keystoning," but in truth it just reflects the fact that these lenses exaggerate the close/far relationship. The distance from the lens to the nearest point of the subject is much shorter than the distance from the lens to the furthest part. Put another way, as you tip the camera backwards, the bottom of the film is closer to the subject than the top of the film is, and since the lens decompresses the scene it exaggerates this small discrepancy in film-to-subject distance. Your choice is to make use of this effect compositionally or keep the lens parallel to the ground to avoid it altogether.

Finally, a few words of caution about using any type of wide-angle lens. Because wide-angles have such extreme coverage, they are prone to both *lens flare* problems and to recording unwanted subjects in the frame. Large viewing angles often capture the sun's rays hitting the front element of the lens, resulting in a line of hexagons—formed by aperture ghost images—spilling across the frame. Evaluate your image carefully before tripping the shutter as this effect—lens flare—will ruin any shot. Use the proper lens hood and, if in doubt, shade the front of your lens with your hat or hand. I might mention that you will indeed get photos with that hat or hand included. Expect to do so, and just take another frame or two. Unwanted objects do often appear in photographs even under the best of conditions. Most of us tend to concentrate visually on the centermost portion of a composition while looking through a viewfinder, glossing over the extreme edges of the picture frame. I think all photographers have taken a photo with a wide angle where right on the very edge of the image is an unwanted road, car, or person. Be extra careful both to check for lens flare and to examine the perimeter of the image. A sturdy tripod makes both of these procedures much easier to accomplish.

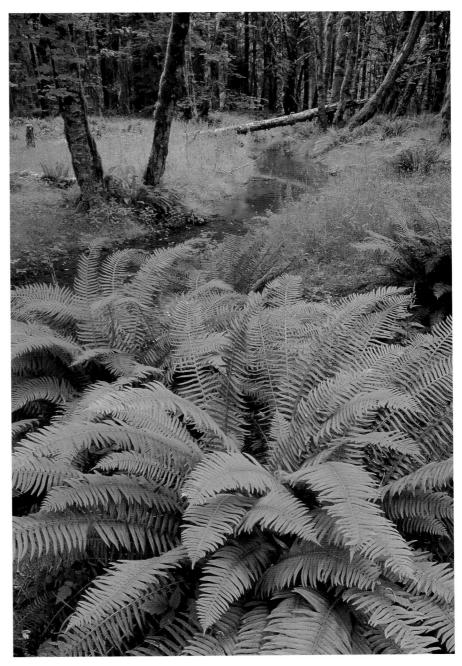

COMMON SWORD FERNS, ELWAH VALLEY, OLYMPIC NATIONAL PARK, WASHINGTON.
Nikon F4, Nikon 20–35mm lens, Kodak Lumiere.

I wanted to look down into this fern, rather than at it from the side. Getting the right camera position wasn't easy as I needed just a bit more height. I stood on a fallen log, with my tripod precariously positioned on the soft forest floor below. Thanks to my wide-angle zoom lens, I could crop the frame as precisely as I wanted.

NORMAL LENSES

Lenses in the "normal" or "standard" range (35mm to 70mm) are some of the most underrated of all lenses. In truth, probably the single most underrated lens is the plain vanilla 50mm lens of about $f/1.8$ speed. These are actually some of the sharpest, most highly corrected optics available, since this focal length has been around for years and is relatively easy to make. If you're looking for a real bargain in optical quality, look for a standard 50/55mm lens. Lots of these are available in pristine condition on the used equipment market, as they have been traded in for newer, fancier, wider-range zooms. The few dollars one of these might cost is money well spent as you'll own a very compact, razor-sharp lens which is actually quite fast when compared to many zoom lenses. In my workshops and seminars, I've heard a lot of photographers who only own zooms with wide-open apertures in the $f/4–f/5.6$ range express their amazement at how easy it is to focus the bright image of a 50mm $f/1.8$ lens, particularly in dim light.

A few years ago, a well-known writer in the photographic press said point-blank that good pictures cannot be shot with a 50mm lens because they are too limited in application. What a lot of nonsense! The only limitation to any lens of any focal length is the person using it. Cameras and lenses are only tools that photographers use to record their creative visualizations. You could own all the lenses on earth; without any imagination on your part, you'd still be unable to produce any images at all. On the other hand, the truly creative person could own only one lens and never exhaust its possibilities.

Another version of the "normal" lens, indeed another overlooked lens, is the 35–70mm zoom. Most of these have relatively fast $f/2.8$ maximum apertures constant throughout their zoom range (I wouldn't consider a slower 35–70mm) and are reasonably compact in size. Several 28–70mm $f/2.8$ zooms, which also cover the normal range of focal lengths, are on the market, but most of these are considerably larger, heavier, and

costlier than 35–70mm lenses. For example, compare the Nikon lenses in the table on this page. Are the differences in size, weight, and cost important to you? Is there a greater benefit to having the 28–70mm lens's wider range of focal lengths than the smaller size and lower price of the 35–70mm? You've got some choices to make.

If you want a multipurpose lens in the normal range, consider purchasing a macro lens in the 50mm to 60mm range. Macros offer extremely high optical quality, plus close-focusing ability. Nikon offers both a 55mm $f/2.8$ manual focus macro and a 60mm $f/2.8$ AF version, while Canon, Pentax, and Minolta all make 50mm versions. Normal-focal-length macro lenses are probably the absolute sharpest, most highly corrected lenses made for 35mm cameras. Almost all normal macros stop down to $f/32$, one stop more than most lenses, which is great if you need extra depth of field. And most current macros have a built-in focusing range from infinity to 1:1 coverage. In other words, they can focus down to a subject size of 1 x 1 1/2 inches (the size of a 35mm negative). You can photograph subjects ranging from vast landscapes to tight closeups without adding any accessories, while maintaining optical quality over the entire range. I wouldn't use a 50mm macro as my standard closeup lens (see chapter 5 for the reasons) but having close focusing available is certainly a convenient option in any lens.

I usually carry my 35–70mm $f/2.8$ zoom lens for the convenience of the zoom range. I turn to my 50mm $f/1.8$ if I need greater lens speed, since it's 1 1/2 stops faster wide open. When would I want this speed? Shooting aerials in low light is the primary situation, and is also about the only time I ever work with a lens wide open. You don't really need to stop down in this situation as depth of field is effectively infinite once you are more than 50 or 60 feet in the air. If you're trying to photograph while flying lower than 50 feet, depth of field should probably be the least of your concerns. A wide-open aperture also allows you to use the fastest shutter speed possible in order to minimize the effects of aircraft movement and vibration. Finally, I use my 55mm macro lens when I need to record the absolute sharpest image possible. One situation where this comes up is when I'm shooting something I know will be printed large. In all cases, it's a good idea to start with the best optical quality possible.

NIKON ZOOM LENSES				
Lens	Weight (oz.)	Diameter/length (in.)	Filter Size	Approximate Street Price
35–70mm $f/2.8$	23.5	2.8 x 3.7	62mm	$600
28–70mm $f/2.8$	33	3.5 x 4.9	77mm	$1600

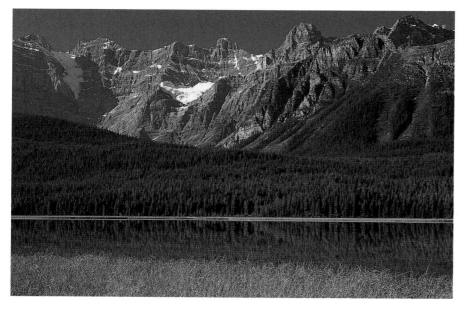

MOUNTAIN RIDGES OVER LOWER WATERFOWL LAKE, BANFF NATIONAL PARK, CANADA.
Nikon F4, Nikon 28–70mm lens, Fuji Velvia.

For this photo I used my inexpensive, lightweight, variable-aperture 28–70mm $f/3.5–4.5$ lens. I particularly like this little compact zoom, especially now that I primarily use the F5 camera body and electronically set apertures have rendered the variable-aperture feature essentially meaningless.

GHOST GUM TREE AT
THE DEVIL'S MARBLES,
NORTHERN TERRITORY,
AUSTRALIA.
Nikon F4, Nikon 35–70mm
lens, Fuji Velvia.

*Ghost gum . . . what a great name for a tree! I well remember the morning I spent at
the Devil's Marbles, a great rock formation in the very center of Australia. At dawn, it
was already over 100°F. Still, that was cooler than the previous afternoon!*

SHORT TELEPHOTO LENSES: 80–200MM

The 80–200mm zoom is probably the most popular of all lenses today. Covering a range of focal lengths, this lens was one of the very first to benefit from computer-aided design technologies. Previously, photographers—myself included—carried an array of fixed-focal-length lenses: 85mm, 105mm, 135mm, and 200mm. It always seemed as though the lens you had on the camera was the wrong focal length for what you wanted to shoot—just a bit too short or a tad too long. To keep from having to change lenses all the time, photojournalists would keep several cameras slung over their shoulders, each with a different lens—an image that Hollywood still seems to relish. Today there are not that many choices left in fixed-focal-length lenses, but there certainly is an abundance of choices in zoom lenses. Zooms in the short telephoto range are some of the best available,

maintaining high image quality across their entire focal length range.

As with all lenses, you get what you pay for with short telephotos, so buy the best quality you can possibly afford. I suggest you get a fast lens, as you'll use a lens in this range a lot with filters, especially a polarizer, and every filter cuts down the amount of light available for focusing and composing. There are a number of excellent 70–200mm or 80–200mm *f*/2.8 lenses on the market, and I highly recommend all of them. One advantage of these *f*/2.8 lenses is that they do not change aperture as you zoom, but maintain a constant maximum across the focal-length range. When you increase the focal-length numbers a bit to 100–300mm or thereabouts, most lenses are a lot slower, usually with a variable aperture from *f*/4 to *f*/5.6. That's fine if your eyesight is good, but does

present a problem when working landscapes in the beautiful but marginal lights of dawn and twilight.

If you are considering a fast 80–200mm, make sure it has a tripod collar so that you can mount the lens, rather than the camera body, to your tripod. Having an 8-inch-long lens weighing 2 1/2 to 3 pounds cantilevered out into space from the camera body is definitely a liability if you desire sharp images. At the 200mm end, an 80–200mm zoom is a 4-power optic, magnifying vibration or movement problems by 4 times, so good technique on your part is mandatory. Using a tripod collar also allows the camera to rotate for vertical or horizontal framing of the image without you having to flop the tripod head over to one side.

I've always liked short telephoto lenses for field nature photography because they are

BLACK-BROWED ALBATROSS COLONY ON STEEPLE JASON, FALKLAND ISLANDS.
Nikon F4, Nikon 80–200mm lens, Fuji Provia.

Here I used my zoom to isolate one section of a giant nesting colony, then stopped down to minimum aperture for depth of field. How did I determine the correct exposure? This is an example of what I call the zebra theory of exposure. The subject is half white, half black, so what tonality does that add up to be? Medium.

MOONSET OVER THE KISSING CAMELS IN GARDEN OF THE GODS, COLORADO.
Nikon F4, Nikon 80–200mm lens, Kodak E100SW.

The Kissing Camels is a signature formation of Colorado Springs's huge city park, Garden of the Gods. The park surrounds giant sandstone fins that jut directly upwards with Pike's Peak in the background. Altogether, a pretty impressive location. For this photograph, I used my 80–200mm zoom at its longest length to isolate the moon as it set early one morning.

reasonably easy to handle outdoors. They also yield a very pleasing perspective for their subject coverage, as they neither decompress a scene (stretch it out) or compress objects together. I once read that the focal length of the human eye is roughly proportional to that of a 105mm lens on the 35mm film format. So pictures taken with lenses of around this focal length tend to be pleasingly familiar—they're similar to how we see the world.

Lenses in this range are great for shooting "portraits" of the landscape—sections of the entire scene before you. I've always said that I consider myself a portrait photographer, it's just that instead of photographing people I take portraits of nature. I believe that thinking of your photographs this way helps in your compositional decisions. Just as when you take a portrait of someone you try to do so in the

most pleasing manner, trying to take a pleasing portrait of the landscape reminds you of the importance of lighting, perspective, composition, framing, and subject placement.

A focal length of 200mm can be considered the longest of the short lenses or the shortest of the long lenses. You can use it to photograph some wildlife subjects, particularly environmental photos with wildlife in the scene. At the same time, the focal length is not so long that you can't handhold a shot if necessary. Zoom lenses in this range are reasonably compact and easily maneuvered, so handholding that grab shot is no major physical undertaking. Just make sure that you keep the shutter speed at 1/250 sec. or faster. Of course, most of the time you should be working with your camera firmly mounted on your tripod.

LONG LENSES: 300MM AND UP

Long-focal-length lenses are a mixed blessing. They're wonderful when you want to isolate one small section of a landscape or photograph a bird or mammal without causing any disturbance. But carrying a long lens in the field, or paying for one, is not exactly easy. In the non-photographer's imagination, a photographer using a long lens can stand about a half-mile from a deer and shoot frame-filling photos. If only this were true! Even with the biggest lenses you can carry into the field, you still need to be close to your subject—a lot closer than most people realize.

Exactly how long a lens you need is primarily determined by three factors: (1) the subjects you want to photograph; (2) the amount of lens weight and bulk you're willing to carry in the field; and (3) how much money you're willing to spend on a lens. Let me say immediately that there is no such thing as a small, light-weight, low-cost, high-quality, fast long lens. Dream on.

First of all you really must define what subject matter you want to photograph with a long lens. Do you only want to photograph landscapes or is wildlife your primary interest? If it's wildlife, does that mean large mammals or small birds? Are you planning on working subjects right from your vehicle, or

backpacking into the wilderness? Are you carrying your lens to Africa or to the local city park? If you said that you want to do all of the above, be warned: you've just concluded that you need not one but at least two long lenses.

One determining factor in lens choice is how close you can get to your subject. Obviously, the larger the subject, the shorter the focal length needed from any given shooting location. Moving closer to your subject is always a good solution to focal length, but this is not always practical. A 50mm lens used at 10 feet from the subject yields the same image size on film as a 500mm used at 100 feet. But can you get 100 feet from your subject, let alone 10 feet? If you're planning on working wildlife, I must caution you about close approaches, which can put undue stress on animals. No photograph whatsoever is worth harassing subjects—and then there's your own safety to consider! Most forms of wildlife, birds in particular, are far smaller than you think, so very long focal lengths are the only answer. For example, even with a 500mm lens you must be within about 20 feet to get a tight shot of a rabbit.

Selecting a long lens always involves some kind of compromise—speed, size, cost, or a

combination of these three elements, which are directly related, will probably have to be sacrificed to some degree. Remember that the speed of a lens refers to its maximum aperture, its widest f-stop. Fast long lenses, those with fairly large maximum apertures such as $f/4$, are physically larger than their slower counterparts. They are also far heavier because they have larger glass elements and much more expensive because they are far more difficult to manufacture. They also need stronger and heavier lens barrels to hold them precisely in place.

On the other hand, faster lenses are considerably easier to focus since they transmit so much more light (each extra stop of aperture is a doubling of the amount of light coming through the lens). My middle-aged eyes appreciate this fact more and more every year. Fast apertures also make focusing easier because they give an extremely shallow plane of focus. Images made with a fast lens wide open snap into focus precisely, since there is less depth of field. Fast long lenses also allow you to use teleconverters (see pages 88–91 for details) and still end up with a reasonable maximum aperture of around $f/5.6$. Finally—and perhaps most importantly—autofocus works best with fast apertures,

These three 300mm lenses demonstrate the difference that maximum aperture makes. From left to right: a 70–300mm $f/4$–5.6 zoom lens set at its 300mm length; a 300mm $f/2.8$ lens; and a 300mm $f/4$ lens. I have not added a lens hood to any of these in order to show their actual size differences.

CHEETAH AT LAST LIGHT.
Nikon F5, Nikon 500mm lens, Kodak E100SW.

Of all the photographs I've ever taken of cheetahs, this is my favorite. Why? For two reasons: I love the warm light at the very end of the day, and I think the extremely low angle from which I was photographing really works. It puts the viewer right into the cheetah's world rather than the human world. All animals look best when photographed from their perspective, from their eye level.

and if you're going to be photographing birds and mammals you will definitely want to be able to shoot action.

Let's look at some Nikon lenses for comparisons (the results are about the same for all brands of equipment). As you can see from the chart at right, Nikon offers the following three 300mm lenses: a very fast 300mm *f*/2.8 AF-S; a medium-speed 300mm *f*/4 lens; and a slower zoom lens, the 70–300mm, which is an *f*/5.6 at the 300mm end.

The advantages of the slowest lens are that it is inexpensive and easy to carry. If all you want to photograph with this focal length is landscapes, this is a decent solution. It's definitely sharper stopped down a couple of stops, but for scenic photography that's what you will be doing most of the time anyway. If you are interested in shooting wildlife, however, this lens is not really an option. First of all, while 300mm is fine for photographing large mammals if they are approachable, it's way too short for most birds and smaller mammals. This zoom's lack of lens speed contributes to the photographic problem. Most birds and mammals are not active in the brightest part of the day; rather, they are out and about in the early morning and evening. A maximum aperture of *f*/5.6 restricts when you can photograph, or forces you to use faster film. Since the focal length is not really that long, you might be tempted to add a teleconverter, but this will only increase the problems you face in low-light conditions. An added 1.4X means the lens is *f*/8 wide open, while a 2X converts the lens into an *f*/11. If you try to use this aperture in the first light of day, your subject will walk out of the frame before the exposure is over. No thanks.

So what about the *f*/4 version of this focal length? This is a good all-around lens, especially if you plan on purchasing a very long lens for serious wildlife work. That one additional *f*-stop of light makes a major difference for field work—it's the difference between a shutter speed of 1/125 sec. and one of 1/60 sec. A 300mm *f*/4 lens is reasonably priced, not so large or heavy that you can't carry it easily, and fast enough to easily focus either manually or with autofocus. It's great for landscape work, and with the addition of a 1.4X converter it becomes a 420mm *f*/5.6 lens, usable for wildlife in decent light. (Adding a 2X teleconverter makes it a marginal 600mm *f*/8, too slow for most critter photography.)

That leaves the *f*/2.8 lens. Fast, very fast indeed. It's easy to focus manually, works great on autofocus, and is incredibly sharp. You can add teleconverters as you wish; a 1.4X gives a 420mm *f*/4, while a 2X leaves you with a 600mm *f*/5.6, which is certainly a

Lens	Weight (oz.)	Length (in.)	Approximate Street Price
300mm *f*/5.6 zoom	18.2	4.6	$300
300mm *f*/4	46.9	8.6	$900
300mm *f*/2.8	105.8	10.6	$5000

NIKON 300MM LENSES

AUTUMN SUGAR MAPLES, MICHIGAN.
Nikon F3, Nikon 300mm lens, Fujichrome 50.

Long lenses are also great for scenic photography. Here the focal length allowed me to look into the forest rather than up at the trees. Overcast light was perfect for this scene, but if I had tipped a short lens upward, patches of bald white sky might have shown through.

very functional lens speed for a 600mm. In fact, for the traveling wildlife photographer this combination of fast 300mm and both teleconverters might be an option. But look at the weight and price. How often will you use such a lens? Often enough to justify the expense of owning one?

But let me tell you a story. Many years ago, I was photographing near Jackson, Wyoming, with a friend. It was winter and we were returning to town at the end of a long, snowy day. As we approached Jackson we discovered a cow moose and her yearling calf standing quite close to the road. We jumped out of the car, jammed our tripods into the snow, and started shooting. I had just bought my first really long fast lens, a Nikon 400mm *f*/3.5. My friend was using a 400mm *f*/5.6 lens and we were both shooting the same film with our lenses wide open. I was photographing at 1/125 sec. at *f*/3.5—1¹/₂ stops faster than my friend was able to shoot in the same light—and all of my photographs were sharp. The shutter speed was high enough to stop the motion of the

moose and to compensate for the rather unstable tripod location. My friend, on the other hand, got no usable frames whatsoever. Not one. In that lighting situation, his shutter speed was just not fast enough. He could have pulled out the roll of film that was in his camera, reloaded a fresh roll and pushed it a stop . . . and after all that still have ended up 1/2 stop slower than what I was shooting. With long focal lengths you generally want all the light you can get, both to focus with and to shoot by. Photographing wildlife of any kind you will always need the option of fast shutter speeds. If you need a fast aperture—and that's the real question—then you have no choice but to purchase a large, heavy, expensive lens. So your deciding factor should be how often you think you will be photographing in this type of situation.

Among long lenses, 300mms tend to be a class by themselves in that you have options as to what to purchase. If you go much longer, you'll most likely discover that you have a choice of one lens. Want a 600mm

Here's an obvious use for a long lens. I was able to photograph from a distance, yet frame the lion tightly.

lens? Canon makes *one,* Nikon makes *one* . . . well, you get the idea. Here are my recommendations for long lenses:

- Slow 300mm lenses (including zooms): good for landscape photography (as are all quality long lenses); not for wildlife.

- 300mm $f/4$: a good compromise lens in terms of focal length, speed, and weight. Very useful if you plan on walking any distance with your equipment.

- 300mm $f/2.8$: a great fast lens, fast AF, usable with teleconverters. As your only long lens for wildlife, you'll use it with converters added most of the time.

- 400mm $f/5.6$: good focal length for larger mammals, reasonably small and easy to handle in the field, questionable use with teleconverters due to lack of lens speed. Decent lenses of this type are available in non-manufacturer brands.

- 400mm $f/2.8$: immense for the focal length and very heavy. Fast AF, very good with teleconverters, quite expensive. Do you need this much speed in this focal length?

- 500mm $f/4$: for a very long focal length, the best compromise in size, weight, and cost. My pick for an all-around, multi-purpose bird and mammal lens. A 1.4X teleconverter makes it into a 700mm $f/5.6$; a 2X a 1000mm $f/8$.

- 600mm $f/4$: if you plan on specializing in bird photography, buy this lens. Be warned, it will sag your shoulders while lightening your wallet. The Canon version, for example, weighs 13.2 pounds (no camera body, no tripod, no other lenses included) and retails for a street price in the neighborhood of $10,000. Add teleconverters, and you have an 840mm $f/5.6$ or a 1,200mm $f/8$.[1]

A good two-lens combination would be a 300mm $f/4$ and a 500mm $f/4$, while a wildlife specialist might want a 300mm $f/2.8$ and a 600mm $f/4$ (plus the truck needed to carry both of these!). Of course, what most of us would really like to have is a 300mm and a 400mm and a 500mm and a 600mm.

If the prices are scaring you, you might consider purchasing a used lens. As photographers switch over to the newest autofocus designs, older lenses become available at a considerable savings. These are top quality, professional lenses but might not have all of the features of the latest offerings. Canon has recently brought out Image Stabilizing (IS) designs of its long focal lengths, so look for the non-IS lenses. Nikon owners should look at the older series of manual focus lenses, in particular the 400mm $f/3.5$ and the 500mm $f/4$ P lens. The 500mm P was extremely popular when it was first marketed, so there are lots of these lenses around. The 400mm $f/3.5$ is about the sharpest long lens ever made, and with a 1.4X teleconverter it gives you a 560mm $f/5$ lens, a reasonably long and fast combination in a surprisingly small package. Just in passing I might mention that I'm surprised that neither Nikon nor Canon offers a similar AF lens. I think a 400mm $f/4$ AF lens would be ideal for many situations, with a great blend of speed and focal length. Those photographers basing their long-lens outfit on a 300mm $f/2.8$ plus both the 1.4X and 2X teleconverters would be better served with such a lens since most of the time they use the 300mm with the 1.4X added.

If you need a very long lens for one particular trip, another viable option is to rent a lens for that specific time frame. Rental lenses of 400mm, 500mm, and 600mm are available in all major cities; you can work out all the details by phone or fax. You can even arrange to have a rental lens delivered directly to your shooting location, a nice way to avoid the hassles of carrying it if you're traveling by air. While a lens rental will not be inexpensive, it will cost less than purchasing a lens you rarely use. I recently led a week-long bird photography trip to Bosque del Apache National Wildlife Refuge in New Mexico, and one of the participants rented the latest Nikon 500mm AF lens for about $500. Expensive? Yes indeed, but about $7000 less than purchasing one.

[1] I'll say right here that adding a 2X teleconverter to either a 500mm or 600mm lens is not a great idea. That's an incredible amount of image magnification to keep steady. If you want to try shooting this way you should use two tripods, one under the lens and another under the camera. Obviously this is not a very practical field technique for active subjects, but you can occasionally pull it off with a static subject. You'll discover that one of the most difficult aspects is simply locating the subject through the viewfinder, since a 1,200mm lens has an extremely narrow angle of view.

BLACK OYSTERCATCHER, FALKLAND ISLANDS.
Nikon F4, Nikon 400mm lens, Fuji Provia.

The black oystercatcher is one of my favorite birds. The slightly overcast light was a mixed blessing that day; it lowered the contrast, which is helpful for a black subject but means slower shutter speeds.

TELECONVERTERS

Teleconverters are optical magnifiers that increase the magnification of whatever you put in front of them. They mount between the camera body and your lens, and while they look a lot like extension tubes, they have optics in them, whereas tubes are only hollow spacers. You might hear them referred to by all sorts of names: "teleconverters," "tele-extenders," "multipliers," "converters," or (inaccurately) "doublers." I like to think of them as multipliers, since that name reflects what they really do— multiply the magnification of whatever you point them at, allowing you to get a bigger image from the same working distance.

Teleconverters are available in powers of 1.4X and 2X. (A 3X power is also available from a few sources, but don't even think about buying one; you'll be grossly disappointed with the results. In fact, they are so bad I'm going to pretend they don't exist.) When a teleconverter is mounted behind a lens it multiplies both the focal length and the *f*-stops of the lens by the power of the converter. For example, a 2X converter doubles the focal length of whatever lens it's used on and at the same time slows down all marked *f*-stops by two. A 300mm *f*/4 becomes a 600mm *f*/8 when a 2X is added.

The optical quality of teleconverters has improved over the last 20 years due to innovations in computer-aided design and better glass. Still, not all converters are equal. Basically there are two types on the market. *Dedicated units* are available from all of the major camera manufacturers and are designed specifically to work with certain lenses. For example, Nikon has TC-E converters designed specifically for its latest AF-S lenses. While these converters may also fit other lenses, they are designed for optimum optical performance with those specific lenses. *Universal models* from accessory manufacturers such as Tamron, Tokina, and Sigma are the other style of converter. These after-market converters will work on any lens on which they can be mounted, but they are not designed for any one particular lens. Think of these as a "one-size-fits-all" product versus the exact fit of the dedicated models.

Using converters is an excellent way to increase image size without having to get closer to your subject. Basically this comes down to two modes of working: either you want to make a long-focal-length lens into an even longer focal length, or you want to increase magnification when you're doing a closeup. There is a whole section on the latter in the chapter on closeups (pages 136–8), so I'll stick with increasing focal lengths for now. Most photographers are never satisfied with the focal length of their longest lens; they always want more telephoto magnification. Own a 300mm and you want a 500mm; own a 500mm and you want a 1,000mm. The problem is that lens size, weight, and price all increase dramatically as focal length and maximum aperture increase. Even if you could afford to purchase all the lenses you want, it would be impossible to carry them all simultaneously in the field. Using the highest quality teleconverters is one solution.

GENTOO PENGUIN ON NEST, GIVING "ECSTACY" CALL, PRION ISLAND, SOUTH GEORGIA.
Nikon F4, Nikon 400mm lens + 1.4X tele-extender, Fuji Provia.

This penguin kept calling and calling. I wanted to isolate it against the washed color of a blank background. From a very low shooting angle, I needed all the focal length I could possibly get.

I can make several observations about working with teleconverters:

For best results, use dedicated converters with long lenses. As a general statement, the dedicated teleconverters from Nikon, Canon, and other camera manufacturers will give you the best results it is possible to achieve when using long telephoto lenses. These converters have the best glass and the best coatings, so they preserve color fidelity without softening the image through lowered contrast or added flare. For closeup work, especially when combined with high quality macro lenses and flash illumination, all converters work great. Of course, these camera-brand teleconverters are quite a bit more expensive than the universal models, but you will see a distinct advantage on film when shooting with your prime lens wide open. Why worry about wide open results? Well, that's where you primarily work with long telephotos, especially when you're photographing birds and mammals; usually you're at maximum aperture or just a stop or two down from it.

Use the fastest lens you can. I just said you need lens speed. Start out with a lens that's $f/5.6$ wide open, add a 2X converter, and suddenly you're at an $f/11$ maximum aperture. Unless you're working at high noon, you'll barely be able to see through the lens, let alone hit sharp focus. No autofocus system today will function at this maximum f-stop since so little light is coming through the lens. An $f/11$ lens is totally useless for bird and mammal work in natural light since you're forced into such long exposure times. Animals are active early and late in the day when light levels are already low, hence you need all the lens speed you can have.

Use the best prime lens you can. The highest-quality teleconverter will yield mediocre results if used on a mediocre lens. Converters magnify whatever is put in front of them, so you want the best possible starting point. All converters magnify defects, optical aberrations, and lack of sharpness. Use a lens that

already produces these things and you'll just get more of them.

Use the best photographic technique you can. Remember that you're creating a much longer lens and you have to treat it as such. Let's say you have a 300mm lens and you add a 2X converter to make a 600mm lens. Compared to a normal 50mm, the 300mm is a 6-power optic, but the 600mm is a 12-power optic. You have to be that much better, that much more careful, that much more aware of image degrading factors than you were before adding the converter. If you have a tripod that's barely adequate for a 300mm lens, it definitely isn't enough for a 600mm. If you absolutely must handhold a photograph, remember that you need a considerably faster minimum shutter speed for sharp results since you're now using a much longer lens.

For the most part, avoid using zoom lenses. Zoom lenses are already optically complex, with many elements in the light path. If you

RED-SHOULDERED HAWK, FLORIDA.
Nikon F5, Nikon 500mm AF-S lens, Kodak E100S.

Here's a pair of photos illustrating the difference in image size when a 1.4X teleconverter is added to a 500mm lens. Birds seem to shrink when you're trying to photograph them, so you're always wanting more focal length.

BLACK-BROWED ALBATROSS COURTING, FALKLAND ISLANDS.
Nikon F4, Nikon 400mm lens + 1.4X teleconverter, Fuji Provia.

Adding a 1.4X to my 400mm f/3.5 lens gave me an effective 560mm f/5, just enough to reach out for this courting pair.

start adding more elements—like a teleconverter—image quality quickly falls apart. There are some exceptions, specifically the Canon 70–200mm *f*/2.8 EOS lens used with Canon's EF teleconverters and Nikon's 80–200mm *f*/2.8 AF-S lens mated with the TC-E converters. However, these two lenses are top-of-the-line zooms with big maximum apertures and price tags to match. It's certainly worthwhile to test other zooms that you might own, but most of the results I've seen are not encouraging. Of course, you must define what "quality" in an image means to you. Just getting a recognizable image of any sort might be enough, or perhaps you demand absolute sharpness. Ultimately, it's a personal decision.

Use a 1.4X converter in preference to a 2X. When making long lenses into longer lenses, 1.4X teleconverters are by far a better choice, because image integrity is better maintained. All converters degrade the final image on film, but the lower the power, the less you lose. You sacrifice some image size for considerably higher quality. Most tests show an approximate loss of about 10% of both resolution and contrast with a 1.4X tele-extender, and double this amount with a 2X. In this regard the higher-quality camera manufacturer's own converters will yield better results than universal converters of the same power. This loss of image resolution also suggests that you should always start with the best film you can use under the circumstances—but you should be doing that regardless.

Part of the reason that a 1.4X converter gives better results than a 2X is that it only changes the light hitting the film by one stop. Consequently you can photograph at a one-stop faster shutter speed than with a 2X, which in turn helps reduce both camera and subject movement. You may not have as much focal length, but you'll get sharper photos. By the way, if you've been wondering about that odd 1.4 number, it's because of the *f*-stop progression. Have you noticed that going from one *f*-stop to another changes the *f*-number by a power of 1.4? Each number is 1.4 times the preceding one: 2 x 1.4 =2.8; 2.8 x 1.4 = 4; 4 x 1.4 = 5.6; etc. Let's assume you're adding a 1.4X tele-extender to different lenses. A 300mm *f*/4

becomes a 420mm *f*/5.6; a 400mm *f*/5.6 becomes a 560mm *f*/8; a 500mm *f*/4 ends up as a 700mm *f*/5.6; and a 600mm *f*/4 is an 840mm *f*/5.6. Focal length is multiplied by 1.4, aperture changes by one stop.

You get the depth of field of the "new" lens. I've heard it said that when you use a teleconverter you get the depth of field of the original *f*-stop of the lens without the converter. This is not true. Suppose you have a 300mm *f*/4 with a 2X converter. If the lens's aperture is set wide open, do you have the depth of field of *f*/4, the aperture at which the lens itself is set, or of *f*/8, the aperture created by the converter? If you remember that *f*-stops are a mathematical ratio between the optical hole in the lens and the focal length you should know the answer. Since the size of the aperture doesn't change when you add a teleconverter but the focal length does, the lens becomes slower. It is a 600mm *f*/8 lens wide open with the depth of field of *f*/8 at this aperture. Depth of field depends on the *f*-stop you're using, not how you get to that effective *f*-stop.

Minimum focusing distance of the prime lens does not change. This is one of the major advantages to using a teleconverter. If your prime lens focuses to 8 feet, the lens plus teleconverter still focuses to the exact same distance. Really long focal lengths, such as 500mm or 600mm, focus down to about 15 feet minimum. Almost all 300mm lenses, however, will focus without added extension tubes to roughly 8 feet. Use a 2X tele-extender and you have a 600mm with the same 8-foot minimum focusing distance.

Autofocus may or may not work correctly. You'll have to check your teleconverter/lens combination to determine if the autofocus provision of your camera does indeed work. The slower the aperture of the final combination, the less likely AF is functional. Most camera systems cut off autofocus at $f/5.6$ or $f/8$. Early Canon EOS equipment would not autofocus at any aperture less than $f/5.6$; the cameras were programmed to bypass any AF function at speeds slower than this. For example, take the Canon EF 500mm $f/4.5$ lens, mount a 1.4X converter, and you have a 700mm $f/6.3$ lens. That extra 1/3 stop from $f/5.6$ to $f/6.3$ disabled the autofocus feature. In response to many requests for a 500mm lens usable with AF converters, Canon has brought out an $f/4$ version of the lens plus camera bodies with AF software functioning at slower maximum apertures.

The exposure readout in the camera may or may not work correctly. Most teleconverters permit correct meter readings without needing any correction factors. Here's how to check: Mount a long lens on a tripod and meter the wall of your office without a converter on the lens. You don't need to focus the lens to do this, so working distance is of no concern. Now add your converter and see if it changes the meter readout by the correct amount, 1 stop for 1.4X converters, 2 stops for 2X ones. Do this in all the exposure modes you normally use. The exposure will probably be correct, especially if your camera offers an analog meter display. However, the actual numbers may not be right.

For example, if I mount the current Tamron 2X AF converter on my 300mm $f/2.8$ lens it shows the exposure does change 2 stops from a meter reading without the converter. However, the digital readout of the f-stop in use does not change. If the lens was set wide open at $f/2.8$, the display still reads $f/2.8$ with the converter added. If I do the same test using my Nikon TC-E 2X converter both the meter reading and the display are correct. The f-stop display shows $f/5.6$, the effective f-stop created by mounting the converter. If I use my older 300mm $f/4$ lens

Just to prove you can do it, here are Nikon's TC-14E and TC-20E teleconverters stacked together. Notice that I had to add a small extension tube in the middle. I had to file off a small tab on the front lens mount of the 2X in order to do this (I removed the stainless steel lens flange when I filed), which Nikon puts on just to keep people from doing crazy stunts like this. Major disclaimer here: I did this to my own equipment, but I certainly don't suggest that you do any such butchery to yours.

Here's Teddy's photo taken with (are you ready for this?) a Nikon F5, Nikon 500mm lens + 1.4X teleconverter + 8mm extension tube + 2X teleconverter, big Gitzo tripod under the lens, smaller Gitzo under the camera body, mirror locked up, and an electronic release. Phew! It took forever to get all this gear assembled. Let's figure out what I was using: 500mm $f/4$ + 1.4X = 700mm $f/5.6$. 700mm $f/5.6$ + 2X = 1,400mm $f/11$. By the way, the picture is taken with the lens wide open. Have I ever done such a shot in the field? Never . . . but some day I'll take a few frames of a really large sun rising over the plains.

with Nikon's TC-14 converter, which is one technological generation earlier, the meter reading is again correct but no f-stop numbers at all are shown in the finder display—there are no electronic contacts in the older converter. I mention this in case you ever use a hand-meter for exposure evaluation. If the meter says "1/125 sec. at $f/5.6$" just where and how do you set this exposure on your camera? You need to check your equipment before a shooting opportunity comes along.

Teleconverters give you focal-length choices. My longest lens is the Nikon 500mm $f/4$ AF-S. When I add the 1.4X Nikon TC-E, I have a 700mm $f/5.6$, which maintains AF while adding only one inch in length and seven ounces in weight. If I use my 2X TC-E, I end up with a 1,000mm $f/8$ lens, I lose the AF feature, and I have a combination that's 2 inches longer than the prime lens alone and 12 ounces heavier. I effectively have two more lenses with me but they add little bulk or weight to my camera bag. Even though these converters are pricy, they cost much less than actually purchasing the equivalent focal lengths.

A combination that's very useful is a high-quality 300mm $f/2.8$ AF lens—the best you can buy—and both 1.4X and 2X AF teleconverters matched to the lens. Actually, a 300mm $f/2.8$ is about the only lens on which I feel comfortable using a 2X converter. These lenses are so superb optically that,

properly handled, you can get good results. Since $f/2.8$ is quite fast to begin with, you don't lose autofocus even with the 2X teleconverter. You have a fast 300mm $f/2.8$ for low-light or close work, a medium-length 420mm $f/4$ for normal telephoto use, and a long 600mm $f/5.6$ for when you really need some reach.

Teleconverters let you try out focal lengths you don't own. There's one time when I would consider adding a generic 2X teleconverter to a zoom lens, and that's when you're trying to decide if you should buy a long-focal-length lens. Quality long lenses aren't cheap; they often cost thousands of dollars. If you think you need a 500/600mm lens, I would first try to borrow one for a few days. If none are available, consider spending about $100 to add a universal 2X to your 70–300mm zoom lens. Now go out and shoot some pictures. How often did you actually use that long focal length? Do you see shots where you needed a 500mm lens, or are you pulled back to the shorter end of the zoom? You might discover that you love the long focal length; okay, then spend the bucks and buy a good lens. On the other hand, you might find out that you rarely see images with such a lens, or that the quality yielded by a converter plus a zoom is good enough for you. Take the extra cash you didn't spend, buy a better tripod and a case of film, and go take a photo trip!

AUTOFOCUS

The capability for *autofocus* (AF) is built into almost every 35mm camera currently manufactured. While it offers some incredible pluses for the nature photographer, its drawbacks can overwhelm your photographic creativity. Having autofocus built into your system doesn't mean you don't have to worry about focus problems; there may be times when the camera will automatically focus on something you don't want to be in focus. To be a successful photographer, you must maintain control of all aspects of the photographic process, so knowing how to override and control autofocus as well as when to use it is critical.

The incredible advancements in autofocus capabilities over the last five years have opened up a whole new way of working. This is particularly true of action photography, in my opinion the absolute *raison d'etre* of aut-

ofocus. In years past—indeed, until the mid-1990s—obtaining just one sharp image per roll of a subject such as a flying bird was quite an accomplishment. Now, the best autofocus systems work so well that dead-on action images are more a basic combination of being in the right place at the right time with the right equipment than the results of finely-honed focusing skills.

A reminder: Whether or not you should use autofocus is in no way dependent on the exposure mode you set or the metering pattern in use. Those are three independent choices for you to make. Confusion arises because of the way some cameras label the controls, but there are separate places to set the focus method, exposure mode, and metering pattern. How you turn autofocus on depends on your particular camera; most have a separate autofocus switch on the cam-

era body, while some lenses (principally high-end professional ones) also have a switch. With these, both camera and lens must be set to the "on" position.

Unless you have eyesight problems, I urge you to turn off the autofocus feature and keep it off until you can articulate why you need to use it. My reasoning is simple: many cameras still have their autofocus sensors right in the middle of the frame. This is compositionally about the worst location possible for a subject, but because the autofocus system works there, that's where the subject ends up being located. Turning the autofocus off will help you to be more creative in your compositional choices.

More and more camera models that allow a choice of several AF points within the frame are finally being offered. The Nikon F5, for example, offers five AF sensors in the frame:

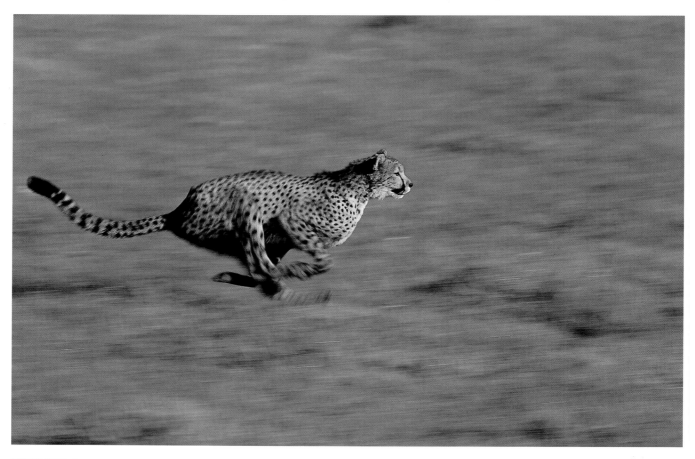

CHEETAH RUNNING.
Nikon F5, Nikon 500mm lens, Fuji Velvia.

I was shooting with my 500mm mounted on my Wimberley head—a great combination for action work. I intentionally used a medium-slow shutter speed, about 1/100 sec., to blur the image in order to suggest speed. I hoped to get some frames like this, where the face remained sharply focused.

middle, top, bottom, left, and right. The Canon EOS-3 has 45 AF points. Great! The more the better as far as I'm concerned, so long as the photographer can pick and choose which one to use. In fact, so many changes and choices in AF are coming to market that I am forced to generalize about autofocus procedures. As always, read the instruction manual for your particular camera model, as even different camera bodies within the same system may not work the same.

For the majority of nature subjects I believe you really don't need autofocus at all, especially if you're working with your camera mounted on a good tripod. If you're photographing a mountain, you certainly should be able to focus precisely. After all, the mountain's not going anywhere, so you should have plenty of time to focus accurately. For close-up work, autofocus use often adds to the difficulty of working, as you're most worried about the precise positioning of the depth of field. If you're having trouble clearly determining precise focus under normal working conditions with normal subjects, I would strongly suggest resetting the diopter correction in your viewfinder rather than relying on autofocus. Many cameras now also have an "in-focus detection" light which illuminates when sharp focus is obtained on a selected focus sensor. Of course, this means that you will have to focus, watch this display indicator, then re-compose the image. It's helpful in low light situations, but most of the time you're better off to work directly with the image on the groundglass.

All current autofocus systems offer a choice of two working modes, one basically for static subjects and the other for action situations. In the first mode, which is called "Single Servo" by Nikon and "One-Shot" by Canon, the focus locks at your selected AF point. To make the camera refocus, you must lift your finger all the way off the shutter release, then depress the release part way again.[1] Once the camera has achieved focus, so long as you maintain pressure on the shutter release, not removing your finger entirely, you can re-compose the image and take frame after frame. Some cameras, the Nikon F5 for one, also have an "AF-on" button which will function here more like an "AF-lock." Hold it down while in One-Shot/Single Servo mode and the focus

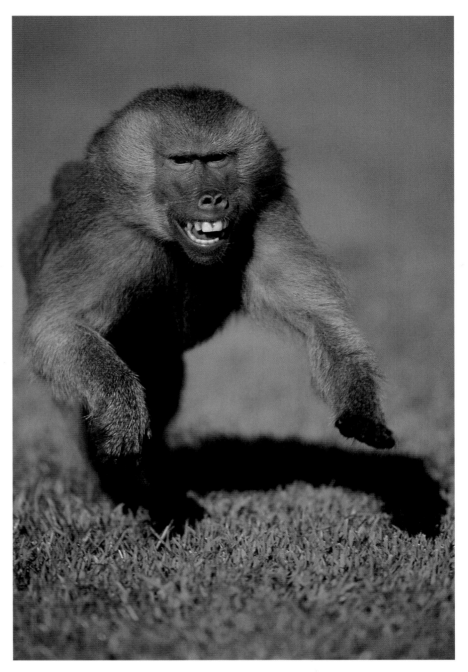

FEMALE HAMADRYAS BABOON RUNNING (CONTROLLED SITUATION).
Nikon F5, Nikon 300mm lens, Fuji Provia.

I hadn't planned on taking this picture. I didn't like the location at all and wasn't thrilled about shooting, but since I was there I though I might at least look through the camera. I used my 300mm f/2.8 AF lens and set the camera on predictive focus tracking. The baboon made two runs directly towards me, and each time I held the shutter release down, but all I could see through the viewfinder was a brown blur. Convinced that this was a waste of time and film—that nothing I'd shot would be in focus—I left. When I got my film back I was greatly surprised. Focus tracking had worked just as it was supposed to work, and I had many sharp pictures. Here's a rule of thumb: When action is moving towards you, if you see a focused image in the viewfinder you've missed the shot. But if the camera is in the focus tracking mode, it is predicting where the subject will be at the moment the shutter actually opens, and is already focusing on that spot. I needed to learn to trust the equipment.

[1]Most cameras have the AF activation tied in with the shutter release—touch the release and the camera autofocuses. Both Nikon and Canon have custom functions that allow the user to remove this feature from the shutter release and shift it to another button. While some photographers like this feature, I do not. I don't want one more thing to do—activate the AF plus depress the shutter—when I'm working action subjects. The fewer steps I have to go through, the better.

THE AIRFORCE THUNDERBIRDS.
Nikon F5, Nikon 500mm lens, Kodak E100S.

What on earth is this photo doing in a book about nature photography? It's the shot that convinced me of the value of new technologies. My camera was set on evaluative matrix metering, aperture priority, continuous AF, and full motor drive at 8 frames per second. The Thunderbirds made two close passes over where I was standing, and each time I fired off one whole roll of film. How many frames were in focus out of these two rolls of 36? Seventy-two. Yep, every frame was sharp! Sure, I cut off wing tips or tails in some, but focus was dead-on.

remains locked even if you raise your finger off the shutter release. Most cameras do have an actual AF-lock button, and some lenses have them too. Often, these function simultaneously as both an autofocus lock and an autoexposure lock; if your camera offers a choice of custom settings it is more than likely that you can re-program this button to do one or the other as you wish.

To be honest, I almost never use Single Servo mode. If I'm working a non-moving subject I prefer to focus manually. This is true even when I'm photographing birds and mammals, as I can easily fine-tune the focus for every small change in the animal's posture.

Far more useful, in my opinion, is the "Continuous Servo" (Nikon) or "AI Servo" (Canon) mode, which you should use for moving subjects. Here, so long as you maintain pressure on the shutter release and the active focusing sensor is kept on the subject as you pan the camera, focus is maintained. If you don't keep the sensor on the subject, the camera will try to focus on the background. If that happens the best thing to do is lift your finger from the shutter release, then depress it again to re-activate the system. This works better than keeping the AF on and waiting for the system to come back

into focus. Even better is to use an autofocus system with multiple AF sensors that allows what is called "dynamic autofocus." In fact, my cameras are set so that if I turn AF on at all, it's instantly in Continuous Servo, dynamic autofocus mode.

Dynamic AF means that once the subject is acquired by whichever principal AF sensor you selected, autofocus is maintained even if that sensor is moved off the subject. The AF system then shifts—all by itself, with no input from you—until it picks up the subject with one of the other AF sensors. So once you get the subject, all you have to do is keep it within the sensor pattern and you'll maintain focus. Now that continuous AF in the dynamic mode is available, autofocusing on a moving subject against an uncluttered background—a bird in flight against the clear blue sky for example—is far easier to do than it sounds.

Another AF innovation that is well worth having is what Nikon calls "Focus Tracking with Lock-On™." The "focus tracking" part of this phrase is also sometimes referred to as "predictive autofocus." Most higher-end cameras now offer it. There's always a small time lag between when you push the shutter button and when the shutter actually fires. Predictive AF works as the name implies. It

predicts where the subject will actually be located at the moment of exposure and focuses to this point rather than focusing on the point where the subject was at the start of the sequence. "Lock-On" is a solution to interruptions. When working on a moving subject, autofocus is maintained even if another subject momentarily blocks the view. The AF doesn't try to refocus on the interruption, but stays with your intended subject.

Autofocus works best with fast lenses used in bright light. In extremely dark or extremely low-contrast situations, AF won't work at all. Most cameras won't autofocus quickly or accurately if you use a maximum aperture slower than $f/5.6$, so don't expect to use AF with a 2X teleconverter on a 70–300mm $f/5.6$ lens with a polarizer mounted. The resulting effective aperture is way beyond AF capabilities. Your camera might actually autofocus at a small aperture, but it will be sluggish at best and possibly inaccurate. Run some tests to see where the cut-off points actually fall. A faster maximum aperture lens always autofocuses better that a slow lens. You can increase AF speed on long lenses by restricting their focusing range. Most long telephoto lenses allow you to set distances within which the AF will work. My Nikon 500mm $f/4$ AF-S lens, for example, has three settings: full (the entire focusing range), no closer than 10 meters, and from 12 meters to the closest focusing point of just under 5 meters. If I'm photographing a small subject such as a prairie dog, I certainly won't be working it at a long distance; even photographing with a 500mm lens, at 20 meters the prairie dog will be small in the frame. Set the focus limits for your situation, and you can reduce the time the lens spends hunting for the subject.

One feature that is now available on the best lenses is a manual focus override that doesn't take the lens out of autofocus mode. I'll use Nikon long lenses as an example since that's the system with which I'm most familiar. On the AF-S lenses there is a switch that allows you to chose the focusing mode: "A" is for autofocus only; "M" is for manual focus only; and "M/A" is for manual override of autofocus. By selecting this last mode, you can turn the focusing ring at any time to touch up focus manually, either before or after autofocus has occurred. You don't have to lift your finger from the shutter release, and you don't have to reset the camera body to manual focus. As far as I'm concerned, that M/A setting is the best of both worlds.

BENGAL TIGER
(CONTROLLED
SITUATION).
Nikon F5, Nikon
500mm lens, Kodak
Ektachrome VS.

*How often do you get the chance to photograph a tiger running through the
surf? Thanks to a fast autofocus lens, I now have lots of images of this.*

COMPOSITION 4

SUNSET AND ACACIA TREE, MASAI MARA, KENYA.
Nikon F4, Nikon 300 mm lens, Fuji Provia.

LEARNING TO SEE PHOTO-GRAPHICALLY

Composition is the art of clearly presenting your creative vision in an appealing manner. You do this by imposing order and structure on the chaotic world around us, first by your lens choice, film choice, and camera placement, then by how you organize the photographic frame itself. Any portion of the frame, anything in the picture, that dilutes or distracts from your creative vision adds visual confusion and should be eliminated if at all possible. Simply pointing a camera at a subject, regardless of how interesting you may find it, does not guarantee that the resulting photograph will engage the viewer's mind or emotions. To make successful photographs, you must make conscious, deliberate compositional choices.

Your first decision is always what to photograph. Choose a subject—but only one. Most beginning photographers make the major compositional mistake of not simplifying their pictures. They include everything: not only the flower, but also the meadow, the trees in back, the stream, and all the surroundings. Yet when asked what they are photographing, they answer "a flower." If that is true, then everything else should be eliminated from the frame. To put it simply, visual clutter ruins pictures. Define your subject precisely and specifically, then include within the viewfinder only what fits your definition. My friend David Middleton has an analogy that applies here: He compares a photograph to its written description. It takes several paragraphs to describe a bad photograph, a few sentences for a mediocre photo, one sentence for a good picture, and just a phrase for a great photograph.

Once you've decided on a subject, there are a couple of questions you should make sure you can answer before you ever press the shutter release. The first is "Why am I taking this photograph?" If you don't know, then your photography is random. Then you should ask "What do I want to show the viewer?" If you don't know the answer to this one, you're not communicating. If there are several answers to each question, you probably should be taking several photos, not one.

Think graphically. Be concerned with the basic elements of graphic design: line, color, pattern, texture, and form. What you're really doing when you take a picture is making a graphic arrangement of these elements on a piece of film. Most of the time, however, we lose sight of graphics and deal more with subject matter. Most of our day-to-day photography is actually photojournalism, where we're concerned more with the content of an image than its design. That's fine for recording events in our lives, but shouldn't carry over to the

WINTER CATTAIL STALKS AND REFLECTIONS, NEW MEXICO.
Nikon F5, Nikon 500mm lens, Fuji Velvia.

Repeating lines and angles march across the frame, since all of the stalks are bent the same direction. I used my long lens to isolate this small section, including only blue water and weathered cattails.

rest of our photography. Remember that there is a vast difference between "interesting" and "photogenic." A pile of garage sale items may be "interesting," but I doubt you would want to hang a 16 x 20-inch print of it over the mantel.

When planning a photo, I would urge you to say the following sentence out loud (this forces you to really focus on your answers), filling in the blanks and being as specific as possible:

What I like about this scene is _____

_____ ,

so I will use _____ (this equipment) _____

and _____ (these photographic techniques) _____ .

Articulate exactly what you're planning on doing. Instead of saying "I like this pretty scene so I'll take a picture," say "I like the way the color and texture of these blackberry leaves contrast with the softer, lighter green background, so I'll use my 200mm macro lens in order to give me some working distance, while narrowing the background to only include the grasses, with my tripod in a low position so that the film plane is parallel to the blackberry bush." There's a world of difference between these two descriptions.

Then, before you actually trip the shutter, go over this checklist:

• Have I chosen a good subject, out of all that are available to me?

• Is this good light for this subject?

• Is there a pleasing background?

• Have I made a pleasing composition?

• Am I sure about my choices?

Suppose you're photographing fallen autumn leaves. Why did you choose that particular leaf to photograph out of the thousands of leaves on the ground? Is this the right light for the message you want to convey about fallen autumn leaves? Does the background complement this idea, or at least not conflict with it? Is this the best location from which to photograph? Remember that not only tripods have legs; so do you. Walk around until you find the best subject and the best position from which to work. Don't allow yourself to be lazy and settle for less than your best. Don't just take pictures . . . make *photo-graphics.*

COMPOSITIONAL DO'S

Please yourself first, not someone else.
Wander around to find the best subject.
Handhold your camera to find the best composition, then set up your tripod.
Preview the depth of field.
Check for background distractions.
Check the edges of the frame for distracting brightly-lit hotspots.
Check for merging tonalities and objects accidentally sticking into the frame.
Control or enhance the light if needed.
Be deliberate about camera placement and lens selection.
Position your camera as the subject matter dictates, not as your knees or back want you to.
Simplify, simplify, simplify.

COMPOSITIONAL DON'TS

Do not photograph the first subject you find; look for the best subject.
Do not mount your camera on your tripod before you've found a good composition.
Do not extend your tripod legs before you've found your subject and composition.
Do not photograph contrasty subjects in bright sunlight.
Do not bull's-eye your subject in the frame.
Do not tilt horizons or place them running through the middle of the frame.
Do not try to capture everything with one picture.
Do not photograph low objects from a high perspective.
Do not let objects barely touch the edge of the frame.
Do not pick a flower (or harass an animal) to move it to a better spot.

DESERT MARIGOLD AND CHOLLA CACTUS, ARIZONA. Nikon F4, Nikon 105mm macro lens, Fuji Velvia.

Here's a study in contrasts. The marigold floats in space (I used a wide-open lens), its yellow contrasting with the soft green background. The delicacy of the flower plays against the sharp cactus spines.

White Sands is, in my opinion, one of the most graphical places I've ever photographed. This combination of a long, sinuous curve, strong sidelighting, and repeating ripples in this shot is indeed graphic. There's not a bit of doubt as to what I want the viewer to see.

LIGHTING

Light is what makes photography possible. In fact, the very word "photography" means "painting with light." Notice that the subject of the photograph is not mentioned in this definition; photography is the process of capturing light on film, not of capturing a subject on film. Dull light equals a dull photograph, no matter how strong the subject matter might be. Being aware of how light transforms a subject, how it influences our perceptions, is one of the most basic requirements of a photographer. We must literally "see the light" before we can start to worry about putting an image onto film.

Light has a *direction*, a *character*, and a *color*. The ability to recognize these distinctions and the ways in which they can be used graphically, both singly and in combination, is one of the things that sets the professional photographer apart from the amateur.

DIRECTION

Light's direction is usually described as how it falls on any subject relative to the camera position. There are three basic directions: frontlighting, sidelighting, and backlighting. How a subject is illuminated, the angle at which the light is falling on a subject, directly affects both the technical aspects of photography (for example, how easily exposure can be determined) and the emotional aspects.

As the name implies, frontlighting is light falling on the side of the subject facing the camera. The sun is directly behind the photographer, coming right over his or her shoulder. It is the old standard lighting situation that many of us learned to misuse with our first box camera. How many family pictures have you seen of a row of people squinting into the sun shining directly in their faces? Direct frontlighting wipes out any shadows. It is probably the worst lighting possible for landscape photographs, because it makes the scene appear flat and one-dimensional. On the other hand, it is the perfect lighting for most tight bird and mammal portraits, because all parts of the subject are illuminated equally. It's extremely disconcerting to see an animal photo where one side of the creature is totally lost in deep black shadows; we want to see the entire animal, not just part of it. Whatever the subject, determining exposure for a frontlit scene is rather easy and straightforward, since everything in the frame is receiving the same amount of light.

Sidelighting emphasizes the shape and texture of a subject, since it creates shadows. In turn, the shadows caused by sidelighting

SWEETGUM LEAF FALLEN ON BACK OF SAW PALMETTO, FLORIDA.
Nikon F3, Nikon 105mm macro lens, Kodachrome 25.

Direct backlighting silhouettes the sweetgum leaf against the glowing saw palmetto.

COTTONWOOD TREE
AND CANYON WALL IN
EARLY AUTUMN,
CAPITOL REEF
NATIONAL PARK, UTAH.
Nikon F5, Nikon 80–200mm
lens, Fuji Velvia.

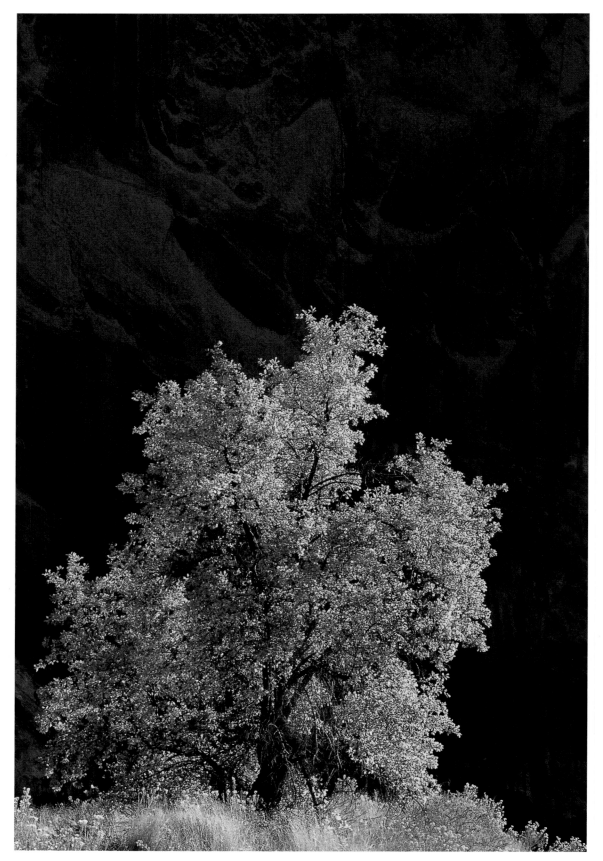

There's an odd mixture of light falling on this tree: it is side-backlit to the right by the morning sun, while at the same time the canyon wall behind me is acting like a giant reflector, bouncing some light onto both the tree and the wall behind it.

add to the three-dimensional feeling of a photograph. For these reasons, landscape photography is often done in the sidelight of early morning and late afternoon. However, a scene with shadows and highlights demands careful exposure determination on your part, as film does not handle contrast well. You must take particular care not to burn out the highlights by overexposing the image. By the way, while the light at high noon also comes from 90° to our viewing angle, it is generally referred to as "toplighting." Rare indeed is the successful picture taken at noon. At that hour, you can go scout locations, call home, or write your notes, but don't plan on photographing. I once heard pro nature photographer Dan Cox offer this wisdom to a group: "Photograph early, photograph late, take a nap during the day." Good advice, I think.

When you are facing a light source, what you see is backlighting. Backlight outlines shapes by creating glowing halos or even silhouetting subjects. In backlighting situations, there is no one correct exposure. Your settings will depend on what mood you want to create with your photograph. By varying the amount of light hitting the film, you can change the feel of an image from light and airy to dark and brooding.

CHARACTER

Light's character—the second attribute—is directly related to its source. It can be hard (i.e. when the sun hangs high in a cloudless sky) or soft (as on an overcast day when the entire sky is one giant, diffused light source). Hard lights—whether they come from the sun on a clear day or a direct on-camera flash—produce black, sharp-edged shadows because they are basically point sources of light. Under these conditions there is a vast difference of exposure, which slide films cannot hold, between the brightly lit highlight areas and the dark, dimly lit shadows. On the other hand, soft lighting is low contrast lighting, great for closeups and delicate colors. Soft-lighting exposures are easy to determine; shadows are diffused or non-existent and depth perception is limited, while colors saturate. Soft light can be created by haze or dust in the air, moisture such as veiling clouds or fog, or even the atmosphere itself just before sunrise and just after sunset.

COLOR

Light's third major attribute is its color, which ranges from warm reds and oranges early and late in the day to cooler blues at midday. Overcast also tips light toward the cool side; the heavier the sky, the cooler the color. Cool lighting can emphasize the coldness of winter or frost, but often needs to be filtered warmer for brightly-colored subjects. Autumn color can be spectacular on an overcast day, but an 81A warming filter definitely helps.

LIGHT CHANGES

One last attribute of light is something we tend to forget about: its tendency to change quickly and often. How a subject appears in one light at one moment in time is not how it will appear in another light at some other time. Since photography is painting with light, we must learn to continue painting even after we have taken a successful shot. It's all too easy to tell yourself that you're "done" with a subject, when all you've done is photograph it at a certain time in a particular light. As the light illuminating a subject changes, so does the viewer's emotional response to a photograph, so chances are you haven't exhausted the subject.

Changes in lighting can occur as quickly as moment to moment, or as slowly as season to season. Regardless, as photographers we need to become aware of these changes so that we're technically prepared to record them on film.

GREAT SMOKY MOUNTAINS AT DAWN WITH FOG IN VALLEYS, TENNESSEE.
Nikon F4, Nikon 80–200mm lens, Fuji Velvia.

This scene was photographed near Townsend, Tennessee, one of the few places where you can look to the east to see morning light coming over the mountains. The first photo, taken just before dawn, shows the cool blues of morning, while the second photo, taken just after sunrise, is much warmer. While both images are successful, they are extremely different from each other emotionally.

Working a Subject

All too often, I see people take one photograph of a subject, then declare that they have captured that subject on film. Case in point: I was once at the Grand Canyon when I saw a family walk up to an overlook and quickly snap a photo. The father declared, "All right, we've done the canyon. Let's go!" and off they went. That was not an isolated incident. A few years ago I was with a group in Kenya working some very cooperative cheetahs when a van roared up. As heads popped up through the open roof hatches, a man pointed his camera at the cheetahs, then loudly exclaimed to his driver, "It's just a cheetah. We've already seen a cheetah." I would hate to be that jaded about the world around us.

But we photographers are guilty of a similar crime—taking the easy way out. Time after time I see photographers in the national parks working at the overlooks. There's nothing inherently wrong with that; the pull-off is probably there for a good reason. But what I've noticed is that most people photograph from right in front of where they parked their car, as if the car knew the best location from which to photograph. Now I'm not suggesting that we all need to become distance hikers, carrying our gear for miles over hill and dale. But we should walk around a bit to check out different locations, even if this is just a few hundred feet.

Along the same lines, we all brag about how much film we've shot. I've been guilty of this too. In fact, all too often I find myself counting used rolls at the end of the day, not just to find out how I need to restock my field bag, but also as a gauge of my worth as a photographer. Come on, John, is the total number of rolls exposed directly proportional to how many good pictures you've taken on any given day? I don't think so; after all, you can sit indoors and run roll after roll through a camera without getting one good exposure. In truth, I think you're an excellent photographer if you can produce one exceptional shot, one knock-your-socks-off photo, one "WOW!" picture every day.

Most of all, I think we must not let ourselves feel satisfied too quickly. We should always strive to better our craft, and to work at producing new images of subjects that are new to us. If you find yourself in a rut, try working with a different lens from that which you normally use. If you often photograph landscapes with an 80–200mm, use a 20mm or a 500mm. If you do closeups with a 105mm macro, find out what's possible with a short zoom. If you always take head shots of animals with a 600mm, how about landscapes with a normal lens? Mixing things up will bring back some of the fun of photography.

I urge you to find a subject you like and work it as completely as you can. Walk around the area, view it from different sides, see it in different lights. Too often we're too concerned with rushing off to our next location, as though we think motion itself somehow equals productivity. Slow down, take your time, and look closely at what's there. And always believe you'll shoot a better picture on the next frame of film.

These three photographs were made the same morning, over the course of about three hours. The same equipment—a Nikon F5, and a Nikon 28–70mm zoom lens—and Fuji Velvia was used for all three.

MESA ARCH AT FIRST LIGHT, CANYONLANDS NATIONAL PARK, UTAH.

When I started to hike the short trail to Mesa Arch it was pitch black, not a hint of light in the sky. I needed a flashlight to find the cairns marking the way across the slickrock, and even then, I missed a few. Still, it's not a long hike to the arch, so I arrived well before sunup. About half an hour later, here's what I saw: the first light of day.

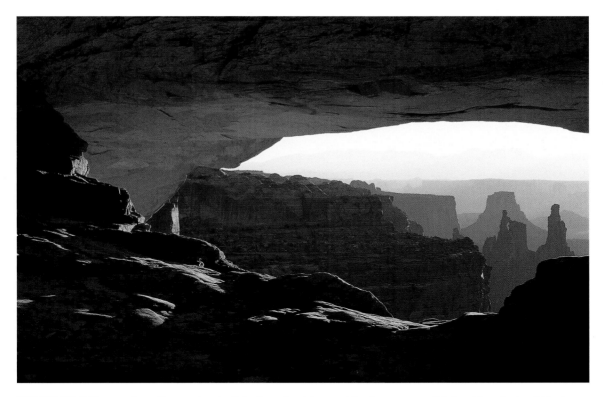

MESA ARCH JUST AFTER SUNRISE, WITH WASHERWOMAN ARCH IN THE DISTANCE.

Just after sunrise, the light from the rising sun hits the canyon wall below Mesa Arch, which glows orange from the bounced light. Should I shoot just as the sun crests the distant ridge of the LaSal Mountains, or wait? How much of the Arch should I include—the entire arch with sky above, or just a portion? Do I include the sun on the horizon, or aim my camera slightly to the side?

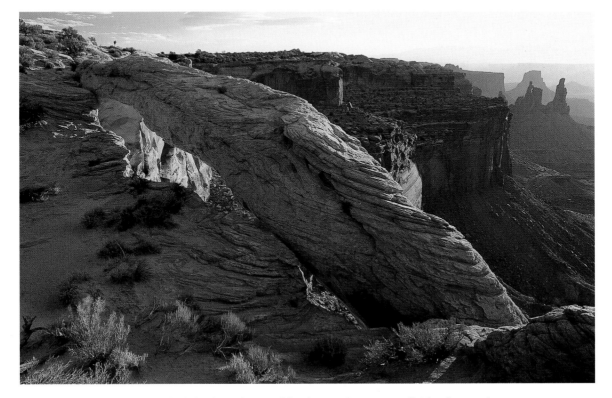

MESA ARCH, ONE AND ONE-HALF HOURS AFTER SUNRISE.

In full daylight, the arch seemed far closer to the canyon wall. The glow was long gone, and so was the one other photographer who showed up for the magical glowing period. Still, I had a great time while I was waiting, sitting to one side and watching white-throated swifts zing upward through the arch opening.

VERTICAL OR HORIZONTAL?

One of the most basic compositional decisions is whether the picture frame should have a vertical or a horizontal orientation. By far, most pictures are taken in the horizontal format. In fact, beginning photographers can be identified by the vast predominance of horizontals in their work. Granted, 35mm cameras are much easier to use, and far more comfortable to handle, when held horizontally. Flopping a camera to the side on a tripod head is not the easiest thing to do either, particularly if you're using a poorly designed pan/tilt head. In addition, the information displayed in the viewfinder and/or on the top deck of the camera is certainly harder to read when the camera is tipped over on its side. And of course, this preference for horizontal compositions may also be influenced by the natural orientation of our field of vision, which takes in far more across the horizontal view than it does vertically. Regardless of the reasons, the number of horizontal photographs taken each year far exceeds the number of vertical photos.

I suggest that you evaluate your own work. The next time you get five or six rolls of film back from your processing lab—particularly if they are all from the same day or shoot—lay all the slides out simultaneously on a lightbox. Looking at lots of images at once lets you see trends in your work. If you project slides, you're concentrating on each image individually as it comes up on the screen, so it's very easy to forget exactly what you've seen previously. If you spread out 100 or 200 slides all at once on a large light table, your photographic tendencies will jump out at you. How many horizontal pictures are there? Are your exposures consistently good, or bad, or all over the place? Are all your pictures always taken from the same vantage point—your own eye level—or are low subjects photographed from a low position? What about your choice of lenses . . . do you favor one focal length over any other that you own? Did you use a tripod at all times, or only when it was most convenient? Are the horizon lines straight, or do they all tilt in the same direction? If you were photographing a nonmoving subject where you had time to think about exposure and composition, are the results what you expected? Looking at a lot of unedited film, straight from the lab to your light table, is one of the best ways to evaluate your work.

I've heard it suggested that a horizontal format is emotionally quieter, more tranquil and calming, than a vertical one. Along the same lines, some say that a vertically framed picture conveys strength, power, vitality, and authority. I disagree with both of these statements. While changing an image's orientation certainly changes its emotional impact, I believe you cannot separate out the content of the image from this discussion. In my mind, form and content go hand in hand, and must support each other coherently. Try this little exercise: Take a sheet of paper and cut it into the 1 x 1 1/2 proportions of the 35mm image. Now hold the paper at arm's length and view it first in a horizontal orientation, then in a vertical one. Did your emotional reaction change at all? Or does that happen only when you visualize a subject within this rectangle?

I think you will most likely agree that it is extremely difficult to separate what is included within a picture from how the picture is oriented. The graphical structure of the image and the subject or content go hand in hand, supporting and reinforcing each other in order to make the strongest emotional impact on the viewer. A good photographer controls this response by choosing the appropriate vertical or horizontal format.

Of course there will be times when the format of an image is dictated to you by environmental conditions or other factors. If you ever intend to market your photos, be aware that publishers often need a choice of both vertical and horizontal images in order to fit a particular layout. Some markets are very specific about their distinct preferences. For example, how many magazine covers have you seen that used a horizontal image?

Regardless of the orientation you use, try to keep the horizon line parallel to the top and bottom of the frame. Tilting horizon photos are one of my pet peeves. Are such shots taken half-way around the globe or during an earthquake? I'm particularly annoyed by photographs of leaning lakes—I keep waiting for all the water to start pouring out one side of the picture! One primary cause of tilting horizon photos is the use of tripods that are just a little too short. If you're photographing from even a slightly bent-over position, you will lean your head one way or the other in order to see through the

viewfinder. Which way you lean depends on which eye you normally use when viewing through your camera. If you use your right eye to focus, you'll tip your head slightly to the left; if you use you left eye, you will tip to the right. The horizon line in your photo goes in whatever direction your head goes.

Here's a quick exercise that will illustrate this problem to you. Mount your camera on a tripod, and raise it until the viewfinder eyepiece is about 1 foot below your eye level. Use whichever eye you normally use to compose a photo with an obvious horizon line, and make sure that horizon appears level. Now look through the camera with your other eye, and carefully check the horizon. It will appear tilted. Keep viewing as you are, and straighten out the horizon. Now, switch back to viewing with the eye you started with, and—guess what?—the horizon is tilted once more, this time in the opposite direction. When you review a lot of your images at once for vertical/horizontal framing, check out the degree of tilt on the horizons. Most likely if you discover that your pictures do indeed tip one way or the other, they will all tilt in the same direction since you focus with the same eye most of the time.

There are several solutions. First of all, make sure your camera is actually at your eye level when you're working from a standing position. Of course, this means that your tripod has to be tall enough for you, and most tripods tend to be a bit short if you're six feet tall or over. Since you wouldn't want to take all your photos from a standing height, be especially careful about leveling the horizon in low-angle shots. A helpful trick when shooting from any position is to move back, several feet away from your camera, after you've set up your shot. Look at the back of the camera, to see if it is square with the world; if it's level, so is your photograph. Just to be sure, you could purchase a bubble level that slides into the camera's hot shoe and works for both vertical and horizontal orientations. These are available at most camera stores. A third option is to use a grid-focusing screen (a so-called "architectural" screen), which has lines etched on it in a checkerboard pattern. If your camera offers interchangeable viewfinder screens I would definitely switch over to a grid screen. I use one—Nikon's E screen—for *all* my photography, whether I'm shooting landscapes or animals.

SWAMP RABBIT, SABINE NATIONAL WILDLIFE REFUGE, LOUISIANA.
Nikon F5, Nikon 500mm lens, Fuji Velvia.

I think that one of these photos is stronger than the other. In the horizontal shot, the frame includes the area in front of the rabbit, giving the animal somewhere to look. The implied path of action leads into the frame. The vertical view gives me the feeling that the rabbit is squeezed into the picture, particularly since the upper half of the image really contains no information relating to the rabbit. On the other hand, it would certainly offer space for type if, for example, the American Swamp Rabbit Journal *ever wanted to use this as a cover shot.*

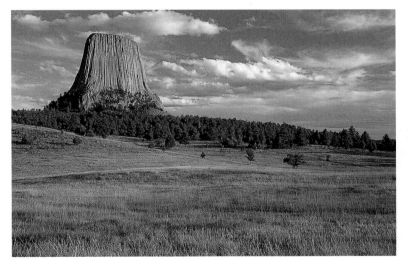

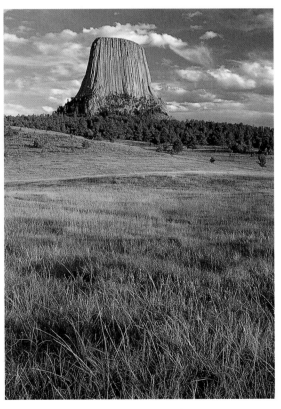

DEVIL'S TOWER NATIONAL MONUMENT, WYOMING.
Nikon F5, Nikon 35–70mm lens, Fuji Velvia.

I like both versions of this photograph, but in my opinion they impart very different messages. The horizontal shot emphasizes how abruptly Devil's Tower rises from its surroundings, thrusting into the clouds above. I feel the vertical photo says more about the Tower's prairie environment. Does the Tower seem less tall, less imposing, in the vertical photo?

Framing and Placement

Once you have chosen a subject to photograph and decided whether to take a vertical or horizontal picture, you have two other major decisions to make. First, how tightly or loosely should you frame the subject? That is, how much of the area surrounding your subject do you want to include? Where should the edges of the photographic frame fall? How much of your subject do you include and what do you exclude? Once you've made this choice, you need to answer the second question: Where within the rectangular image frame do you locate your main subject? Do you position it at the top or at the bottom? On the left or the right? Dead center or at one edge? These choices should be studied decisions on your part, as a good photograph is carefully planned, not haphazardly created.

Precise framing of a subject can be achieved in several ways. The easiest method is to use a zoom lens, carefully and precisely zooming in and out to place the frame edges exactly where you want them to fall. From any one given shooting location, changing focal lengths by zooming (or by switching fixed-focal-length lenses) alters the cropping of the frame, but not the perspective. Another possibility would be to move around the subject while using the same lens; this alters both the point of view and the background seen behind your subject. And of course you could move closer to or further from your subject while using exactly the same focal length.

When determining the framing, watch out for several compositional problems. Objects that barely touch the edge of the frame leave your viewer wondering about your intentions. Did you purposely position the object right there at the edge, or is its location pure happenstance? Is there more to be seen, or is that the entire subject? Leave some space around anything that could direct the viewer's eye out of the picture, so that visually he or she does not leave your image. Imagine a sharp-pointed pine tree whose topmost branches just touch the upper edge of the picture frame. As your viewer's eyes sweep across the picture, the converging lines of the tree's shape act like an arrow, leading directly out of the image. If you leave some space around the top of that tree the viewer can come back into the photo and linger inside your image. You want to hold on to your audience, not direct them elsewhere.

Along the same lines, don't let little things appear from nowhere into the picture edge. I call these "apparitions," since they seem to materialize from thin air. Imagine a beautiful landscape photo, lovely clouds hanging over a majestic mountain range. But up in the top corner of the frame, the end of a branch sticks out into the picture. Where did it come from? What is it doing up there? Is it attached to anything, or somehow levitating? Is having it just barely show intentional or accidental? Either include enough

QUAKING ASPEN GROVE, COLORADO.
Nikon F5, Nikon 300mm lens + 1.4X teleconverter, Fuji Velvia.

Across the entire hillside, only one group of aspens still has its leaves.

DEAD LODGEPOLE PINE AGAINST COLD SKY, MIDWINTER, YELLOWSTONE NATIONAL PARK, WYOMING.
Nikon F5, Nikon 80–200mm lens, Fuji Velvia.

Isn't this an amazingly cold photograph? The hazy sun is at the upper left "thirds" intersection, while the trees radiate from the lower right "thirds."

of the branch so that the viewer knows without a doubt that you wanted it to be part of your composition, or change your framing to get rid of it entirely. Unclear framing motives will confuse your audience. When you incorporate part of an object, do it deliberately so that your viewers know you intentionally chose that composition.

Trying to determine where to position the edges of the frame is almost impossible if you're handholding the camera, particularly if you're using a longer than normal lens. Any motion on your part is magnified by the lens, causing the viewfinder image to wander around hopelessly. One of the biggest advantages of using a good tripod is that it allows you to compose with precision. You can examine your composition before you press the shutter, fine-tuning it to resolve any framing problems.

Along with your framing decisions, you must decide where to position your subject within the photographic rectangle. The most common mistake made by beginning pho-

tographers is the placement of the main subject dead center in the frame. Most of the time this bull's-eye composition is visually unexciting and should be avoided at all costs. Unfortunately, many autofocus cameras still have their primary AF sensor in this exact location, which compounds the tendency to make dull compositions. If you're photographing large mammals using autofocus, be particularly careful. All too often, you are so excited to see a big, hairy mammal in the viewfinder that compositional decisions are not a consideration at all. With animate subjects, you generally want action or the implied path of action to be going into the frame, not leading out of it.

If you don't know where to begin in terms of subject placement, you might try the old standby *rule of thirds.* Divide your frame into thirds both vertically and horizontally, like a tic-tac-toe grid. Where the grid lines fall are strong placement positions for major lines in your scene. Horizon lines, for example, are far stronger when placed

roughly one-third of the distance from either the bottom or top of the frame rather than directly across the middle of the picture. The grid's intersection points are also very powerful locations for positioning subjects and important visual elements. Remember that there is one grid with four intersecting points for a horizontal picture, and another grid with four more possibilities when you change to a vertical. This basic compositional device is so ingrained in our western art tradition that we tend to be unaware of just how often it is used. Take a look at some of the pictures you've taken that you think are visually strong—you might be surprised to discover how often you've already composed in this manner.

Now I'm certainly not suggesting that you should compose all of your pictures in this fashion. That would be terribly boring. Good composition is very subjective, and you want to please yourself. Most of all, strive to celebrate your own unique creative vision.

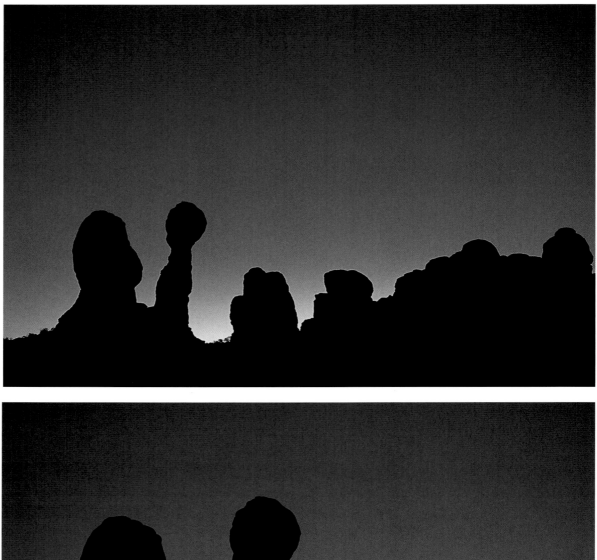

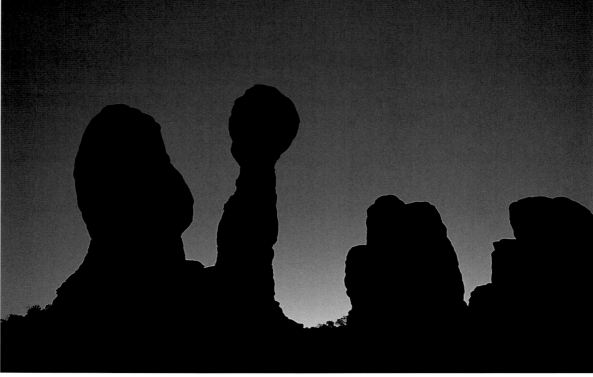

FIRST LIGHT, GARDEN OF EDEN FORMATIONS, ARCHES NATIONAL PARK, UTAH.
Nikon F4, Nikon 80–200mm lens, Fuji Velvia.

Here's about as basic a picture as possible: silhouetted shapes against a cloudless predawn sky. Where would you have placed the edges of the frame? Okay, it's test time: How did I meter these two pictures? I spot-metered the brightest part of the sky, placing it at a +1 tonality.

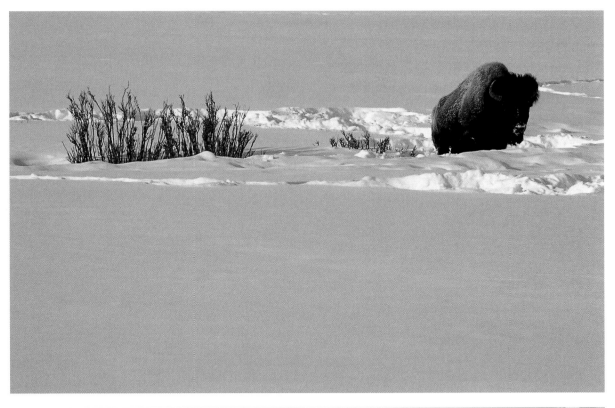

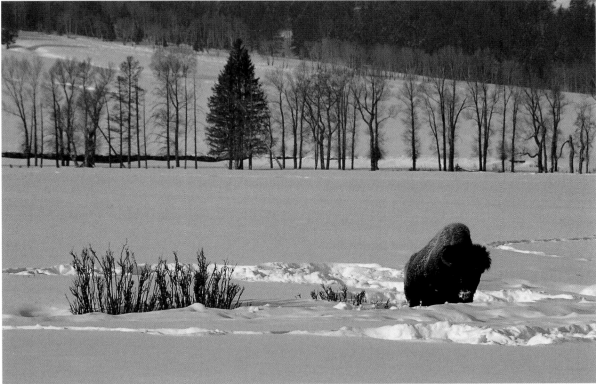

BISON IN WINTER, YELLOWSTONE NATIONAL PARK, WYOMING.
Nikon F4, Nikon 300mm lens, Fuji Provia.

I think these two photographs convey vastly different emotional messages. To me, the shot with no trees hints at a much colder, tougher winter than the other picture. The bison has no place to go—it just stands in the snow. In the second photograph, it appears to have the option of retreating into the forest. The (visual, if not actual) possibility of escape lessens the emotional impact of the winter.

CLOSEUPS

5

ZINNIA CENTER.
Nikon F5, Nikon 105mm macro lens + 2X
teleconverter, Fuji Velvia, flash.

DEFINING A CLOSEUP

When attempting to get a tight shot, the inexperienced photographer will often ask "How close can I get with this camera?" This person is thinking in ordinary terms. If you're photographing normal subjects at normal distances (especially if you're using a standard point-and-shoot camera with a fixed lens), then it is true that the closer you are to your subject, the larger the resulting image is on film. However, when you switch to a 35mm SLR and start to take closeups, you must rephrase the question. There is no longer a simple answer, because the physical distance between camera and subject does not in and of itself determine how much of the frame the subject will fill in the resulting photograph.

In order to talk about closeup photography, we must develop a mutual vocabulary, defining our terminology precisely and establishing our concepts' parameters. The best way to describe closeups is by referring not to distance, but rather to the *magnification* on the film. Doing so provides us with a constant, which is always crucial when making comparisons. Magnification on the film is the ratio between the physical size of the image on the film and the physical size of the actual object being photographed. Let's be clear on one important point: When I say "the image on the film," I'm not referring to how large you make a finished print or the size to which a slide is projected. I'm talking about the actual measurable size of the image on the piece of film.

A *magnification rate* is defined as the ratio between the size of the image of an object on film and the object's actual size. This rate is normally written as a power. Fractional rates, such as 1/4X, 1/8X, or 1/10X, mean that the film image is smaller than the actual size of the subject. At a fractional magnification rate a 1 x 1-inch subject will appear smaller than the image that is on the film. At 1X, the image and the subject will be identical in size; the image on film of that 1-inch object will measure 1 inch. At rates over 1X, such as 2X or 4X, the image size is actually larger than the subject. Past 1X you're starting to magnify on film.

As you can see, the magnification rate of 1X is a dividing line. It's often referred to as "life-size" since at 1X the image on film of the subject is the same size as the subject is in real life. At life-size, what you photograph has the same dimensions as whatever film format you happen to be using. The image area on 35mm film is 24mm x 36mm, roughly 1 x 1 1/2 inches, so at 1X you're photographing this exact area. Photographing at life size is basically the same as taking a slide mount, holding it flush against your subject, then photographing what you see within the rectangular opening of the mount.

You should bear in mind that the measurements of a "life-size" image vary depending on the film format used. If you use a 35mm camera, it's 1 x 1 1/2 inches, but if you use a Hasselblad camera with a 2 1/4-inch square film format, life size is 2 1/4 x 2 1/4 inches. The same principle applies to 4 x 5 and 8 x 10 cameras. Remember that with all of these formats, if you shoot at a magnification rate of 1X a 1-inch long subject will appear as a 1-inch long image on the film.

RED MAPLE IN SPRING, NORTH CAROLINA.
Nikon F4, Nikon 300mm lens, Fuji Velvia.

Is this a closeup? The magnification rate was about 1/12X, for a subject size of roughly 12 x 18 inches. I was not at the minimum focus of my lens, but close to it.

FROST ON LODGEPOLE
PINE, YELLOWSTONE
NATIONAL PARK,
WYOMING.
Nikon F5, Nikon 35–70mm
lens, Fuji Velvia.

This is as tight as my 35–70mm lens permits me to frame when used in its normal mode.
The lens is set at 70mm and at minimum focusing distance. To fill the frame any more—
to gain magnification—I would have to add some kind of closeup accessory.

It's the coverage of the film, how much of the surrounding area you see, that will vary.

If you know the magnification rate, you can easily figure out the size of the area you're photographing or vice versa. Divide each dimension of the 35mm frame by the magnification rate and you'll get the size of the subject covered at that rate. For example, a magnification rate of 1/8X means you're photographing a subject that is 8 x 12 inches, 1/10X is 10 x 15 inches, while 1/6X is 6 x 9 inches. Two rates and sizes you should definitely learn, since they seem to be referred to often in advertisements, are 1/4X, subject size 4 x 6 inches, and 1/2X, a subject size of 2 x 3 inches. Once you get past 1X—past life-size, that is—the subject area is of course smaller than the format. At 2X you're photographing an area that's 1/2 x 3/4 inch; at 3X, 1/3 x 1/2 inch; at 4X, 1/4 x 3/8 inch; and so on. To find the magnification rate when you know the size of the subject you're photographing, divide the dimensions of the frame by the dimensions of the subject.

Do you actually have to do all this math? Not at all. To be perfectly honest, you'll almost never need to know a precise magnification rate unless you're doing scientific work. However, knowing the approximate magnification rate has many practical uses, as you'll see when I discuss ways of making lenses focus close. Besides, as I have already said, the magnification rate is the only consistent factor there is to help you discuss closeup photography.

Used alone, most current camera lenses can focus a little tighter than 1/10X, which would cover a 10 x 15-inch subject. To work any subject that size or larger, you can just focus normally. Standard lenses are restricted to this range for several reasons, including the extra cost and added complexity of making a closer-focusing lens as well as the slight loss in image quality when a lens designed for normal photography is used for closeups. So does this mean that you have to purchase special lenses in order to make high quality closeups? No. Almost all lenses can be used for closeups with a variety of accessories, as I'll discuss shortly.

In all closeup work, however, good photographic technique is absolutely mandatory. When you magnify an image you are also magnifying its problems, whether they are caused by the optics you're using or by you, the photographer. The higher the magnification rate, the more precise and careful you have to be in your approach. Most of what we commonly think of as closeups actually fall somewhere between 1/10X and 1X magnification. As you will see, a few added accessories, used with care and precision, will let you work in this range with excellent results.

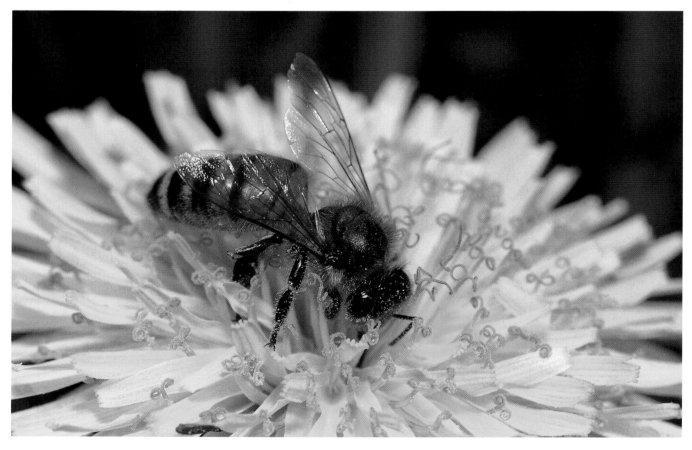

HONEY BEE ON DANDELION.
Nikon F3, Nikon 105mm macro lens + extension, Kodachrome 25, flash.

Here's a photo taken at 1X magnification. The bee's image on the film is the same size as the bee was in real life.

WORKING DISTANCE AND BACKGROUND CONTROL

An important concept to understand for closeup photography is the relationship between the focal length of the lens you use, the working distance between lens and subject, and the appearance of the background. Since all lenses can be made to focus closer, why would you pick one lens over another? What are the advantages and disadvantages of different focal lengths?

The location from which you take your picture—the actual physical spot where you place your camera—determines the "look" of your photo. Perspective is governed by location, not by lens choice. When you're shooting from any given spot, switching lenses changes the framing or coverage of a subject, but it does not change the perspective seen in the photo.

Given the perspective you want, I think one of the most important considerations for nature closeups is the amount of available *working distance* a lens offers. Let me define working distance: It is the open space between the front end of the lens and your subject.[1] Having sufficient working distance is vitally important in field work, because you often cannot get close to your subject without encountering problems. You might have difficulty setting up the tripod in your location; you might have a physical barrier such as rocks or brush between you and your subject; or you might need room for lighting control equipment like reflectors and diffusers.

Working distance is roughly proportional to focal length. The shorter the lens, the closer you must be to your subject. The longer the focal length, the further back you can work while still getting the same coverage you would with the shorter lens. If you can work 12 inches from the subject with a 50mm lens, you will get the same coverage at roughly double the distance with a 100mm lens and four times the distance with a 200mm. This is also true with lenses used in normal non-closeup situations. Photograph your car with a 100mm lens, then switch to a 50mm lens. You'll have to move roughly half the distance closer to get the same image coverage. (This is true for all lenses, whether single-focal-length or zoom. After all, focal length is focal length; a zoom set at 50mm and a fixed 50mm lens are in effect exactly the same.)

Trying to photograph closeups in the field with short focal lengths is extremely frustrating, especially with your camera mounted on a tripod. It is difficult enough to position yourself and the camera, let alone arrange tripod legs and tighten leg locks. If you try to take a tight, frame-filling shot of a dew-covered flower using a 50mm lens, the odds are you'll knock the subject with your body, the lens itself, or the tripod legs. This lack of working distance is one reason I do not recommend the shorter macro lenses (50–60mm focal lengths), or short zooms that offer a close-focusing feature. These lenses are great for normal use, but for most closeups the lack of working distance is a real drawback. For ease in closeups, the solution is simple: use a lens with a longer focal length.

I most often use 100mm, 200mm, and 300mm lenses for closeup work. Some are fixed-length macro lenses and some are zooms. These focal lengths offer me good working distance and ease of tripod positioning. In fact, the longer the focal length, the simpler it is to move your tripod around to the correct shooting location. If you're photographing with a 50mm lens and you're only 6 inches from the subject, a 1-inch discrepancy in any direction in camera location is a gross discrepancy. You have to be extremely precise and fussy here. Back off and shoot the same image with a 200mm lens from 24 inches away, and suddenly that inch either way becomes almost meaningless.

The other major consideration in selecting a lens for a closeup is its *angle of view*. Angle of view determines how much of a scene a lens takes in, how much it "sees" from side to side. Long lenses have a much narrower angle of view than normal lenses or the aptly named wide-angle lenses. For closeup work, angle of view considerations are most important in terms of background coverage—what you see behind your subject and how it appears. The narrower the angle of view, the less coverage behind a subject. You must make a choice. Do you want your photo to emphasize the relationship between a subject and its background, or do you want to isolate your subject from its background? Your decisions about focal length and camera placement will determine your results.

Remember that all lenses used at the same image size and the same *f*-stop give the exact same depth of field. Long lenses don't have a shallower depth of field to blur out backgrounds; they have a narrower angle of view that you can use to your advantage. Since longer lenses cover less background, there should be fewer potentially distracting elements in your photo if you're careful in your camera placement. Pick a subject and a shooting location that ensure that the narrow angle of view is restricted to a non-confusing

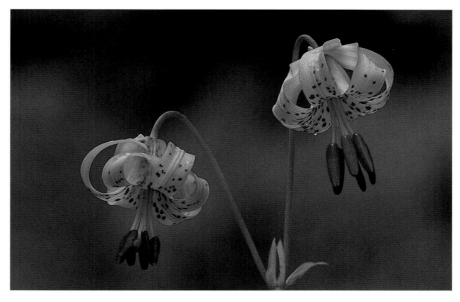

COLUMBIA LILIES, OLYMPIC NATIONAL PARK, WASHINGTON.
Nikon F4, Nikon 200mm macro lens, Fujichrome 50.

I didn't use my 200mm macro lens because it is a macro focusing lens; I used it because I needed a longer focal length. I could easily have walked over to the flowers and photographed them with a short lens, but a section of blank white sky would have been visible across the top of the frame. In order to isolate the blossoms against a uniform green background I was forced to use a long lens with its narrow background coverage.

[1]Note that many lens manufacturers measure working distance from the film plane (the back of the camera) rather than the front of the lens. But in field work, what's important is how much room you have between lens and subject.

area. Actually, backing away from a subject and using a long lens is often the solution to working with a chaotic background. You keep the subject's image size the same but see less background behind it. The less area back there, the easier it is to compose.

Another advantage to using a longer-than-normal lens for closeups is that you can often change the background tonality by shifting your shooting position a little bit. If you're using a short-focal-length lens, you take in a lot of background behind the sub-ject whether or not you want it. For example, suppose you're working flowers along a forest edge. Photograph with a short lens close to the flowers, and regardless of your camera position you have all the forest in the background. Move left or right, up or down, and the background is pretty much the same. Now switch to a long lens, say a 200mm or 300mm. Because these lenses have narrow angles of view, changing the camera position just a little will totally change your image's background. You could have just the tree trunks, just the forest shadows, or just the meadow grasses, by moving your camera position a few inches up, down, or sideways.

Background control is absolutely essential in closeup photography. One effective technique is to isolate a subject against a solid color poster-like background. Use a long-focal-length lens; carefully position the camera; make sure there is nothing distracting right behind the subject—and the narrow angle of view will work to your advantage.

This photo on the left shows the biggest problem with using a short lens for closeups. The angle of view included the field, the distant line of trees, and part of a blank sky in the background. I needed a longer lens to narrow down the background coverage.

For the image on the right, I photographed the same teasel at about the same image size, but this time used a 200mm lens. It eliminated the confusing background, not because of less depth of field but because of the narrower angle of view of the longer lens.

TEASEL.
Nikon F3, Nikon 50mm lens, Kodachrome 25.

TEASEL.
Nikon F3, Nikon 200mm lens, Kodachrome 25.

GRANITE BEACH ROCKS,
ACADIA NATIONAL PARK, MAINE.
Nikon F4, Nikon 55mm macro lens, Fuji Velvia.

Working distance was not a problem here, as I was looking almost straight down at these rocks.

RAINDROPS ON LUPINE
LEAVES, OLYMPIC
NATIONAL PARK,
WASHINGTON.
Nikon F4, Nikon 105mm
macro lens, Fuji Velvia.

*I needed some working distance between the lens and the lupine leaves so I wouldn't
accidentally knock the raindrops off the leaves. At the same time, I needed enough
magnification to get the image I wanted.*

EXTENSION

Any lens will focus closer if you move it away from the film plane. Physically moving the optics away from the camera is called *extension* and is exactly the way in which many standard lenses focus down to their closest position. If you turn a normal 50mm lens's focusing mount, the lens physically grows longer.

Extension, however you get it, is a simple way to work closeups. While most lenses have a limited amount of extension built in, some special purpose lenses have a lot. Many macro lenses, especially those in the 50mm to 105mm range, achieve close focus by using extension. Let me quickly define *macro lens* (they will be discussed in detail on pages 130–131): For practical purposes it is a lens that focuses extremely close, down to around 1X, without the need for added accessories. While these are very convenient, they are by no means a necessity for field work. For most closeup subjects non-macro lenses work just as well if you make them focus closer. Extension is one option for doing just that.

Extension is extension is extension; it is simply a spacer between lens and camera. In terms of the results it doesn't matter at all how you get a given amount of extension, although there's a vast difference in terms of convenience and handling. Extension can be built into a lens; added to a lens in the form of extension tubes or bellows units; or a combination of the two.

The total amount of extension you need in order to get to any given magnification depends on the focal length of the lens you're using. Notice that I said the "total" amount of extension. It doesn't matter how you gain the extension since the entire amount is what is important. A simple formula gives approximate magnification rates.

$$\text{Magnification} = \frac{\text{Total extension}}{\text{Focal length used}}$$

Let's plug some numbers into this formula and see what happens. Most current lenses, particularly zoom lenses, are so optically complex that this formula should be taken as only a rough guide. Still, you should find it rather useful.

Suppose you want to photograph at half life-size, at 1/2X, using a 50mm lens. You can see that you'll need 25mm of total extension to get to this magnification. Take that same 25mm of total extension, add it to a 100mm lens, and it only yields 1/4X, while on a 200mm lens if gives 1/8X. Any given amount of extension yields less magnification when used with a longer-focal-length lens.

You can also see the problem of working at higher magnifications using extension on a

PURPLISH COPPER BUTTERFLY ON GRASS BLADE, MICHIGAN.
Nikon F3, Nikon 105mm macro lens + 27.5mm extension tube, Kodachrome 25.

This photograph was taken many years ago when I lived in Michigan. I've updated my camera equipment several times since then, but I still have the exact same Nikon extension tube I used for this photo. Tubes are mechanically fairly simple pieces of equipment, so not much can go wrong with them.

very long focal length: the equipment quickly becomes physically unwieldy. Let's assume you want to use a 200mm in the field. Add those 25mm of extension for 1/8X, a subject size of 8 x 12 inches, and the equipment is very manageable. No problem. Up the magnification to 1/4X, a 4 x 6-inch subject coverage, and you need a total of 50mm of extension. Now you have the length of the lens plus the added extension all hanging out in front of the camera body. Immediately you have handling problems. Let's go to life-size, 1X, and we've gone from awkward to hopeless. You must add 200mm, or about 8 inches, of total extension between your lens and the camera body. I put this combination together using my 80–200mm *f*/2.8 Nikon lens and an F5 body and the whole thing, from the front element to the rear of the camera, measured just over 17 inches. To be honest, I was a little scared to lift the equipment from my desk as I was afraid it might actually bend in the middle. Obviously the real limit to adding extension to any lens is one of practicality, and this is especially true of long focal lengths. Imagine wanting to shoot at 2X using extension on a 500mm lens. You would need 1,000mm, one full meter, of total extension. How could you carry such a beast in the field, let alone support it? Not a good way to work. Stick to shorter amounts of extension and less magnification.

Added extension comes in two basic configurations: *extension tubes* or *bellows*. Tubes are rigid, fixed-length spacers that can be bought individually or in sets, while a bellows is an accordion-pleated variable extension. A bellows is much larger, far more fragile, currently available in only a few lens mounts . . . and basically a throw-back to very old technology. My advice about a bellows is plain and simple: don't get one. If you want extension, buy tubes.

Both Nikon and Canon currently offer extension tubes in various lengths. For the EOS system, Canon has a 12mm tube and a 25mm tube. These maintain all the electronic connections including autofocus capability and TTL metering. Nikon has three tubes in its line—8mm, 14mm, and 27.5mm—but they lack some features. They do not support autofocus or the matrix metering function of the current Nikon cameras. Come on, Nikon, it's time to update these tubes. The tubes do work perfectly; you just have to manually focus and use spot or center-weighted metering.

All extension decreases the amount of light reaching the film, as the light must travel further when the lens is moved away from the camera body. The exact amount of light lost to extension is not a set amount per tube but depends on the focal length of the lens in

NIKON EXTENSION TUBES.

Extension is extension; it's just a spacer inserted between camera and lens. Here are some Nikon tubes. Different brands may look different and be different lengths, but all tubes function the same. These tubes are (left to right) the PK-11a (8mm), PK-12 (14mm), PK-13 (27.5mm) and PN-11 (52.5mm) with its integral tripod collar.

use. This is obvious if you remember that any given amount of extension has less effect on a longer lens than on a shorter lens. Add a 14mm tube to a 600mm lens and you haven't changed the magnification any drastic amount, but put that 14mm tube on a 28mm lens and you're immediately at 1/2X magnification. Your camera meter will automatically take this light loss into account. Canon owners, just meter and shoot. Nikon owners, depending on which camera body you use, you might need to take one additional step and dial in a correction factor on the exposure compensation if you use Nikon brand tubes. Read the section of your manual on metering compatibilities with the Nikon PK tubes carefully. My tests indicate that the Nikon F100 needs no correction at all, while the F5 requires +0.7 to be set for either spot-metering or center-weighted metering. Remember to reset the compensation to the zero position as soon as you're finished using the tube.

By the way, here's why Nikon offers an extension tube with the oddball length of 27.5mm. Some time back Nikon manufactured a 55mm macro lens which focused to 1/2X all by itself. It physically grew 27.5mm longer to reach this point. To go on down to 1X you had to add extension. If you look back at that formula for the extension needed, you'll discover that sure enough you needed another 27.5mm. Hence the tube. Canon has the same history, except that its early macro lens was a 50mm which also

went to 1/2X. In other words, it grew by 25mm so it needed an additional 25mm of added extension. Regardless of their length or origin, all tubes can be used singly or combined in any order you want.

Besides the major camera manufacturers, a few off-brand extension tubes are available, the most common being Kenko brand which comes as a single 25mm tube or a set of three in 12mm, 20mm, and 36mm. In most mounts these work great, coupling to the autofocus, TTL metering, and auto-aperture mechanisms. But Nikon users, be careful. These tubes have a very narrow opening and will vignette the corners of the picture frame with some Nikon lenses. I would test your intended combinations before purchase, if at all possible. Here's what to do. Add the tube or tubes you want to use, set the lens at infinity focus and the smallest aperture, press the stop-down or preview button, and look toward a strong light source. Do you see the full frame or are the corners cut off? Now do the exact same procedure with the lens at its closest focusing distance. Once again check the corners. I would strongly recommend you shoot a frame at each setting so that you can carefully view the actual image on film.

You can also look for used extension tubes. Tubes seem to have fallen out of favor with many photographers, so lots of older model tubes can be found languishing on camera stores' shelves. Since tubes have no optics there is little to go wrong with them. Just make sure all the mechanical linkages function properly.

Older tubes might not couple with all the latest electronics, but are still worth considering. One discontinued Nikon tube is the PN–11, a huge 52.5mm long tube. It was originally designed for the manual focus 105mm Nikon macro which went to 1/2X; adding the tube brought the lens to life-size. This tube has one unique and useful feature: a built-in rotating collar that allows it to be mounted on your tripod head rather than the camera body. To shoot vertical compositions you simply loosen the collar and rotate the camera; you don't have to flop your tripod head to the side. By rotating the tube, you keep the weight of the camera and lens directly above the camera axis, and there is less vibration than when the camera is cantilevered out to the side. A great idea, but you must decide if you really need such a long tube.

One situation where you might want it is when you're taking what I call "long-distance closeups." Since long-focal-length lenses have narrow angles of view, adding a tube permits closeup work with a simultaneous increase in free working distance and decrease in background coverage. You can eliminate distracting background elements just by going to a longer focal length. Even if your subject allows a close approach at times the best solution may be to back off with a longer lens. When I need to do so I will add that PN-11 tube to my Nikon 300mm *f*/4 lens. Since the lens has a tripod collar, and the tube does also, I use a Really Right Stuff metal brace to tie the two collars together in order to eliminate some vibration problems. Minimum focus of the lens by itself is 82 inches, just under 7 feet. Add the PN-11 tube and I can go down to a tight 1/3X magnification at a long 44 inches of working distance.

I would strongly recommend owning at least one extension tube, to use on your longest lens if on no other. Non-photographers often think we use long lenses to take pictures of far-off subjects. This is true at times, but far more often we use long lenses to take tight shots of close-by subjects, especially when we're photographing birds and mammals. I almost always wish my long lenses would focus just a bit closer all by themselves. Consider photographing a small mammal such as a chipmunk. The fact that your 400mm lens goes to infinity focus has no bearing on the situation—you only care about how tight the lens focuses. It's meaningless if the chipmunk runs away from you since you wouldn't take the picture anyway, but what if it scampers towards you? Can you take its portrait? An extension tube is the answer.

Look at my Nikon 500mm *f*/4 AF lens. It's a great lens, and its minimum focusing distance of 13 feet from the front element is quite tight for this focal length. When I add a 25mm tube (well, actually Nikon's 27.5mm PK-13 tube) I can still photograph out to a distance of about 44 feet, while minimum focusing distance drops to 9 feet. By adding that one little tube I now get a subject size of 5 x 7 1/2 inches. That's chipmunk size for sure.

Or take the Nikon 300mm *f*/2.8 AF lens. This focuses down to an extremely close 6 feet all by itself (one reason I actually like this lens better than the *f*/4 version). Add that same PK-13 extension tube and the lens focuses from a maximum 14 1/2 feet distance to a close 4 feet. Magnification at this close distance? Just a bit less than 1/3X. Wow! Since this is basically the same working distance and same image magnification as with the 300mm *f*/4 + PN-11 tube, you might wonder why I would use one or the other. As always, the real decision comes down to what I happen to have with me in the field.

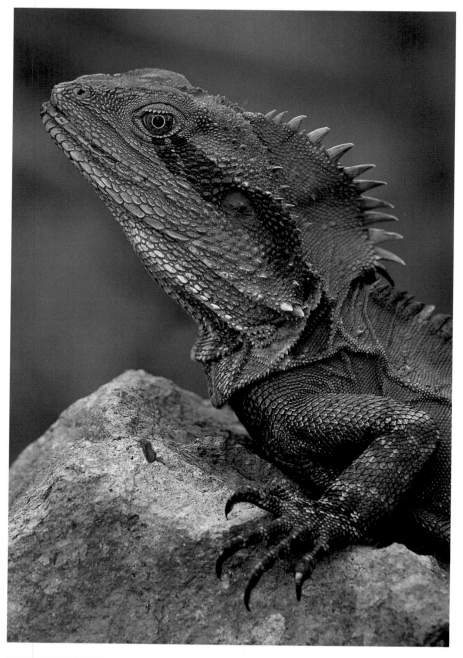

EASTERN WATER DRAGON LIZARD, QUEENSLAND, AUSTRALIA.
Nikon F4, Nikon 300mm lens, Fuji Velvia.

Water dragon! What a great name for a lizard! To keep from frightening away the dragon I needed a long working distance, but at the same time I needed close focusing ability. A tube on my 300mm f/4 lens solved the problem. Notice that I carefully positioned the camera so that the film plane was parallel to the lizard's face.

SUPPLEMENTARY LENSES

The simplest and least expensive way to make a lens focus closer is to add a *supplementary lens* to it. Supplementaries—which are also known as *closeup lenses, diopter lenses,* and *plus lenses*—are thin lenses that look just like filters and usually screw onto the front of a lens just like filters do. They are available in standard filter sizes such as 52mm, 58mm, or 62mm in diameter. Attaching a supplementary to a lens, whether a fixed-focal-length or a zoom, allows the lens to focus in the close-up range. (Of course, you must remove the supplementary in order to go back to using the lens for normal subjects.) The actual working distance you have and the subject coverage you end up with, that is, the magnification achieved, depend on the power of the diopter you're using; the focal length of the lens you add it to; and the close focusing ability of the lens itself.

Supplementary lenses are available in various strengths, which are measured in diopter powers (+1, +2, +3, etc.). The most readily available and most used supplementaries come in these "plus" powers, so we often refer to *diopters* when we mean supplementary lenses. The higher the diopter number is, the

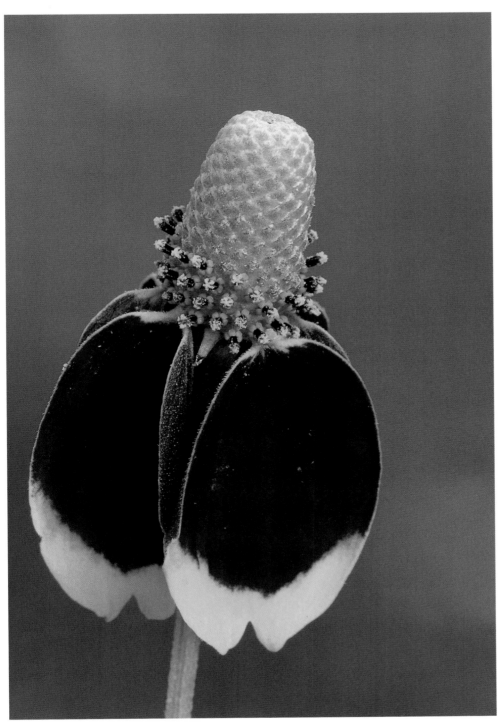

CONEFLOWER.
Nikon F5, Nikon 200mm lens + Nikon 3T closeup lens, Fuji Velvia.

A variety of coneflowers grow all over my property here in Colorado. I borrowed a fixed-focal-length 200mm lens just to take this illustration for this book.

greater the lens's strength or the more magnification it yields.

Closeup diopters have some good points and some bad points. Their low cost, small size, and ease of use are major advantages. In truth, few other closeup accessories even come close to offering so much in so small a package for so little expense. Another advantage to using diopters is that adding them does not change the amount of light coming through the lens. Since you haven't lost any light, there is no exposure change and no loss of focusing light. Consequently you end up with the brightest viewfinder image and the most light possible, which is great for faster shutter speeds. By the way, you can add diopters to any lens that has the appropriate filter thread size, including the lens on your video camera. In fact, adding a high quality diopter to a video cam is the easiest way to work macro subjects with video.

Sounds pretty good, right? But remember, I also said there were some disadvantages to consider. The most important of these is a loss of optical quality. The most commonly found diopters are simple, single-element lenses whose optical quality leaves a lot to be desired. These are the ordinary "+1, +2, +3" supplementaries usually sold in sets of three. If you add one of these to your camera and photograph with the lens wide open you'll discover a distinct loss of sharpness, especially around the edges of the frame. One solution is not to work with your camera lens wide open; always stop the prime lens down about half way. Another possibility is to compose your image so that all the important parts are in the center of the frame. By far the best solution is to buy a higher-quality diopter, a multi-element camera-quality one, which I'll discuss shortly.

Another problem with supplementary lenses is the limited range of magnification that you obtain when you use them on fixed-focal-length lenses. If you purchase the standard +1, +2, +3 set, and stack the diopters together on a 50mm lens you can reach about 1/2X magnification. A +2 and a +3 stacked together give +5 power. Mount the stronger of the diopters on your lens first, then add the weaker one. Definitely don't

RAINDROPS ON GRASS STEM.
Nikon F2, Nikon 200mm manual focus macro lens + Nikon 3T closeup lens reversed, Fuji Velvia.

This lens goes to 1/2X magnification all by itself but I needed even more. Adding a 3T diopter gave me this large image size.

GIANT ROBBER FLY, MICHIGAN.
Nikon F3, Nikon 105mm manual focus macro lens + 4T closeup lens + 27.5mm extension tube, Fujichrome 50, flash.

You can add a closeup diopter to any lens, including a macro. When photographing insects living on a sand dune, I carried a closeup lens to give me quick additional magnification.

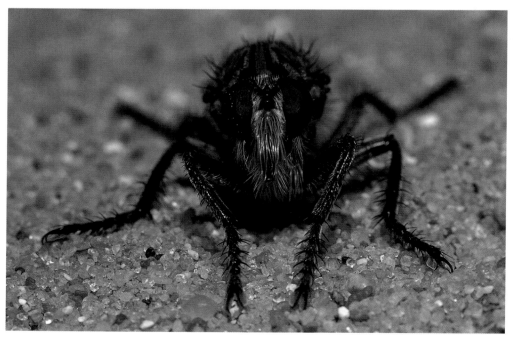

stack more than two. High power diopters are available, but don't waste your money; photographic image quality quickly deteriorates as diopter power increases.

Supplementary diopters work by shortening the effective focal length of the lens on which they are used. Here's a formula for determining the actual focal length at which you end up:

$$\frac{\text{Combined}}{\text{focal length}} = \frac{1000}{(1000 \div \text{FL prime lens}) + \text{diopter power}}$$

Let's run some numbers so that you can see what happens to focal length. Assume that you're using a +3 diopter. Add it to a 24mm lens and you end up with an effective 22.4mm lens. Place the same +3 on a 50mm and you get a 43.5mm lens. Mount that +3 on a 100mm lens and you have a 77mm lens; on a 200mm, the +3 gives you a 125mm effective focal length. Adding a diopter to a short focal length doesn't do much since the more the effective focal length changes, the more the image size changes.

All closeup diopters make whatever lenses they are added to focus at the same working distance if these prime lenses are set to the same focusing distance. In other words, if you set a 50mm, a 100mm, and a 200mm lens at infinity focus and add a +3 diopter to each, they will all focus at the exact same working distance. At infinity focus on the prime lens, the working distance of any lens will be roughly 1 meter divided by the diopter power of the supplementary lens. Therefore, a +1 diopter will make a lens focus at 1 meter; a +2 diopter gives a focused distance of 1/2 meter, or about 19 1/2 inches; and a +3 diopter yields 1/3 meter or just over 13 inches. Of course you can still use the focusing mount of the lens to gain some more magnification.

We now come to an important concept. If all lenses will be in focus at the same working distance, it follows that the longer the prime focal length is the more magnification you'll get. The longer the lens you use a diopter on, the greater the magnification achieved. But there's a catch; almost all the common single-element closeup diopters made are optically designed for use with a 50mm ("normal") lens. This is a focal length you rarely want to use for nature closeup photography because it doesn't allow for enough working distance between the lens and your subject. Adding the diopter only compounds the problem, as it leaves you with a lens that is effectively even shorter. But if you put that standard single-element +3 on a 200mm in order to gain working distance, you'll definitely have sharpness

AUTUMN RED MAPLE LEAF, TENNESSEE.
Nikon F4, Nikon 35–70mm lens + Nikon 5T closeup lens, Fuji Velvia.

This lens has a "macro" mode on it, so why would I add a closeup lens instead? The "macro" setting is limited to the 35mm focal length, not the focal length I want for closeups. By adding the diopter I gain working distance, and can still zoom to change framing.

problems, even if you close the lens down several stops. Well, what about adding a weak closeup diopter, like a +1, to a 300mm or 400mm prime lens? I wouldn't recommend this either, as image quality suffers. For faster lenses you may have a problem even finding a weak diopter in a large filter size, although both Minolta and Century Precision Optics do offer them.

The actual magnification you obtain on film at infinity focus can also be computed with a formula. Magnification equals the focal length (FL) of the camera lens divided by the focal length of the diopter lens (*not* the diopter power). A diopter's focal length in millimeters is found by dividing 1,000mm by the diopter power. Hang on, here comes some more math. Just read through this; you certainly don't need to memorize it.

$$\text{Magnification} = \frac{\text{FL of camera lens}}{\text{FL of diopter}}$$

A +3 diopter has a focal length of 333mm (1,000mm ÷ 3). Used on a 50mm lens it gives 50mm ÷ 333mm or about 0.15X. Add it to a 100mm lens instead and you have 100mm ÷ 333mm or 1/3X. Put in on a 200mm lens, and now you get 200mm ÷ 333mm or 0.6X magnification.

You could figure this out another way by multiplying the diopter power by the focal length in meters of your prime lens in use:

$$\text{Magnification} = \text{diopter power} \times \text{FL of lens (meters)}$$

To be honest, you'll never need to know any of these formulas. Just add a diopter to your lens and look through the viewfinder to see the results. You'll soon discover which ones yield what results. Mathematical formulas are fine for indoor discussions, but quick-and-easy results are more useful in the field.

Besides loss of image quality, the big problem with using diopters in the field goes back to the earlier problem of taking closeups with short-focal-length lenses. Remember that most diopters are optimized for use

on a 50mm lens. To achieve the same image size—the same magnification that is—using two different lenses, you need a stronger diopter on the shorter-focal-length lens than on the longer lens. Let's look at a few figures. To achieve 1/2X, a subject area of 2 x 3 inches, you need a +10 diopter on a 50mm lens, but only a +2.5 diopter on a 200mm. But . . . and here's that catch again . . . look what happens when you add a +10 to the 50mm. It becomes an effective 33.3mm lens with all the problems of a short focal length for closeups: lack of working distance and wider background coverage. Using a short lens for closeups is hard enough to do; adding a diopter to a short lens only compounds the very problems you're trying to eliminate. For field nature photography this is definitely not the way to go.

So why do I suggest that diopters are a good deal? Well, you might notice that so far I've referred to the single-element variety. These are the ones that are optically designed for 50mm lenses and yield low quality resolution. What you want to find are multi-element supplementaries optically designed for use with longer telephoto lenses. With them, you still get all the advantages of longer focal lengths for field work. If you take a 200mm lens and shorten it down to an effective 125mm with a +3, or shorten a 300mm to about 160mm with that same diopter, you still have enough focal length to yield good working distance and narrow background coverage.

Luckily for us at least two manufacturers offer high quality, two-element closeup diopters in different powers and different filter sizes. Both Nikon and Canon now have these available, and the quality from either company far surpasses the standard single-element lenses. These two-element diopters are optically much better corrected and have much flatter field resolution. Of course you don't need to own a Nikon or Canon to use these closeup supplementaries; they are like filters and will work with any lens made by

any manufacturer. Canon makes the 500D, a +2 diopter available in 52, 58, 72, and 77mm filter sizes.[1] Nikon makes two strengths, a +1.5 and a +2.9 (which you might as well call a +3 for practical considerations); these are available in both 52mm and 62mm filter sizes. The chart below shows Nikon's designated names for them.

The Nikon closeup lenses are optically designed for exactly the lenses that are best suited for use with diopters: those with focal lengths between 80mm and 200mm. Of course, you can certainly add them to a longer lens, such as a 300mm. (If I seem to be pushing the Nikon diopters here, it's because they are cheaper—around $45 as of this writing—and easier to find than the Canon versions.) Remember that if you need a different filter size than what Nikon offers, such as 58mm, you can always add a step-up ring, which allows larger filters to be used on smaller-diameter lenses. In this example you would want a 58mm→62mm step ring. Step rings are available at most well-stocked camera stores for only a few dollars.

Most photographers will probably only need one multi-element diopter. Figure out what magnifications you want to cover using what lenses; that should give you an idea of which diopter to purchase. If you need to, try stacking two strengths—the resulting quality will surprise you.

NIKON TWO-ELEMENT CLOSEUP DIOPTERS		
Filter size	+1.5 diopter	+3 diopter
52mm	3T	4T
62mm	5T	6T

[1]Canon also has the 250D, a +4 two-element diopter, in 52mm and 58mm filter threads, but these are optimized for lenses shorter than 135mm. Good quality, but you're right back into the problems with short focal lengths in the field.

USING ZOOM LENSES FOR CLOSEUPS

ZOOMS WITH DIOPTERS

Diopters really come into their own when they're paired with a longer-focal-length zoom lens. Zooms are incredibly popular, and most photographers already own one that reaches the 200mm or 300mm range. Pairing a quality diopter with either of these is a great way to work. In fact, if you already own a long zoom lens adding a two-element diopter would be my number one suggestion for closeup work. It's an inexpensive, easily packed, and extremely simple tool to get you started photographing closeups.

The beauty of adding a diopter to a zoom lens is that you can change focal lengths (by zooming the lens) and still maintain your point of focus. Indeed, this is the whole point of owning a zoom lens. You can zoom in and out, changing cropping by varying the focal lengths, without refocusing or moving your shooting position. Adding a diopter to the front of your lens means you can also

work closeups in this manner. For practical purposes you now have a zoom macro lens. You can zoom in or out, tightening or loosening your composition as you wish.

Many zoom lenses have a "macro" feature, which manufacturers' advertising copy implies you can use to shoot a gnat's eyelash. Don't believe this; all too often it requires the zoom be set at the shortest focal length, which means very limited working distance. And all too often "macro" really means getting down to at best around 1/4 life-size. Remember that this coverage translates into a subject area of 4 x 6 inches.

Adding a quality two-element diopter to a good quality zoom offers far more flexibility and better resolution. Good photographic technique, however, is still imperative if you want good results on film. The best zoom lens fitted with the best diopter available is still no better than how you handle the system. This is particularly true for closeups,

since magnifying the image means magnifying all potential problems. You must have the most stable tripod and head; you must choose your shooting position carefully: you must use a remote release. In short, you must do everything possible to increase the technical quality of your photograph.

In general, I would suggest starting out with the weakest of Nikon's diopters if it will fit your zoom lens. Zooms are already so optically complex that it's best to do as little as possible with added optics. In addition, most zooms in the range of 80–200mm or 70–300mm focus down to a coverage that overlaps with where the added weak diopter starts. In other words, you have no gap in coverage. Pick up the strong diopter also if you need more magnification. By the way, my informal tests suggest that diopters perform best with lenses—whether zoom or fixed-focal-length—where the front element is relatively close to the glass of the diopter. If

THISTLE LEAF, TEXAS.
Nikon F4, Nikon 70–300mm zoom lens + Nikon 3T closeup lens, Kodak Lumiere.

The most difficult part of taking this photo was positioning the lens for the composition I wanted. The long focal length of the zoom allows a lot of working distance, while the diopter gives closeup capability. The combination is very handy for field work.

NIKON 5T CLOSEUP DIOPTER LENS ON FRONT OF NIKON 70–300MM f/4–5.6 ZOOM LENS.

I would definitely add a lens hood when using this combination.

ZOOMS WITH DIOPTERS

The subject coverage you actually get when adding a closeup diopter to a zoom depends on the close-focusing limit of your prime zoom lens and the range of focal lengths it incorporates. To give you some idea of what's possible, here is the range of magnifications obtained using Nikon's 70–300mm f/4–5.6 zoom, with and without the Nikon 5T closeup diopter.

70–300mm lens alone, at closest working distance

Working distance:	48 inches		
Magnification obtained:	at 70mm	=	0.07X
	at 300mm	=	0.3X
Subject area covered:	at 70mm	=	13.7 x 20.5 inches
	at 300mm	=	3.3 x 5 inches

70–300mm lens with +1.5 Nikon 5T diopter added; lens set at infinity focus

Working distance:	26 inches		
Magnification obtained:	at 70mm	=	0.11X
	at 300mm	=	0.44X
Subject area covered:	at 70mm	=	9 x 13.5 inches
	at 300mm	=	2.25 x 3.38 inches

70–300mm lens with +1.5 Nikon 5T diopter added; lens set at closest focusing distance

Working distance:	16 inches		
Magnification obtained:	at 70mm	=	0.2X
	at 300mm	=	0.86X
Subject area covered:	at 70mm	=	5 x 7.5 inches
	at 300mm	=	1.16 x 1.75 inches

your lens is like this, so much the better. But even if the front element of the lens is recessed, or becomes so while zooming, I would still try out diopter use. If you're not sure, and want to run some tests before purchasing anything, take your camera, lens, and tripod down to your local well-stocked camera store. Politely ask to shoot a few frames (perhaps a few rolls of film you purchase there?) through a good quality diopter and evaluate the results.

When you mount a diopter supplementary on a long zoom you benefit from the effect of a focusing rail without actually having to use one. A *focusing rail* is a geared slider that goes between your camera and the tripod head, allowing you to move the camera closer or further from the subject without moving your tripod itself. These used to be popular in the days of fixed-focal-length-lenses, but are rather hard to find these days. Using a zoom with a diopter turns the question of whether to use a rail into a moot point. If you start out with your lens set about midway in its zoom range, you can zoom in or out to change cropping without moving your equipment.

For field nature photography the convenience of mating a zoom with a two-element diopter is incredible. Imagine you're working in Colorado, my part of the world. You're clambering around Mt. Evans at about 10,000 feet elevation in search of mountain goats. On such an excursion you're probably not going to be carrying your closeup equipment; far more likely you'll have a long lens for portraits and your zoom for scenics, including the animals. Tuck a two-element diopter (which takes up no more room than a filter) into your pack and now you have a complete closeup system with you. If you find a great closeup shot when you climb up that mountain, you won't have to pass it by.

Nikon's two-element diopters work so well that on many of my trips, especially where I'm primarily going for birds or mammals, I don't carry any of my specialized

macro equipment. Instead I just pack the appropriate diopter. I've published a lot of photos using this equipment, including double-page spreads and cover shots.

ZOOMS ON EXTENSION

Extension added to any lens permits that lens to focus closer. This is as true with zooms as it is with other lenses. However, adding extension to a zoom is definitely not the easiest way to work. Here's the problem: The joy of a zoom lens used normally is that you can zoom and stay in focus simultaneously. What you're actually doing when you zoom is changing the focal length in use without changing the point of focus. This is why we all like zooms. Add an extension tube, however, and this relationship no longer holds true because other factors come into play.

A given amount of extension added to a given focal length results in a given magnification on film. A 25mm extension tube added to a 75mm lens yields 1/3X. The same tube added to a 300mm gives 1/12X. If those lenses are incorporated into one 75–300mm lens,

you've got problems. Just by zooming in or out you are changing the focal length mounted on the same amount of extension. Since working distance is proportional to focal length, with a zoom lens on extension you must either refocus every time you zoom or physically move the camera position closer or further from your subject to maintain the image size.

This is not always as hard as it sounds. If you're working on an inanimate subject, such as wildflowers, using extension added to a zoom is not a big problem. However, if you're shooting any sort of moving subject, trying to zoom and quickly change focus is a hassle, since any zoom movement creates quite a shift in the focusing mount. In these situations, I suggest you either stick with one preset focal length on the lens or use diopters.

A second problem arises if you use a heavy zoom lens that doesn't have a tripod collar. If the camera body itself must be attached to the tripod with the extension and the lens hanging out in front, be prepared for vibration problems. Flopping your camera for a vertical composition becomes difficult

as well, since all the weight wants to twist downwards on the tripod head. A partial solution lies in using an Arca-style quick release with the anti-twist custom plates from Really Right Stuff or Kirk Enterprises.

So why even consider using a zoom on extension at all? Because you can gain working distance if you need it. When you add a diopter to any lens set at infinity focus, your working distance is one meter divided by the power of the diopter. With a +2 diopter, that's about 19 inches of working distance. Let's look at some numbers based on a popular lens, the lightweight Nikon 70–300mm ED.

By itself, the lens focuses down to a minimum distance of 48 inches. Add Nikon's weakest diopter, the 5T (+1.5), and you must be no more than 26 inches from your subject. What if you must shoot from an in-between distance? This is a problem specific to field work, where environmental conditions often dictate tripod location. The solution is to add extension to the zoom lens. When I need to do this, I use the Nikon PN-11 (discontinued but still readily available) tube as it has a built-in tripod collar.

A quirk of zoom technology comes up here. Most zoom lenses, and all internal focusing lenses, actually lose a little focal length as they are focused closer. If you leave such a lens set at infinity and add extension to get to a given magnification, you'll discover that you have more working distance than if you just focused the lens itself to the same image size. Of course you'll work at a slower shutter speed with the extension tube— that's the price you pay in this situation. Using that same 70–300mm Nikon zoom, set at 300mm and infinity focus and mounted on Nikon's PN-11 tube, I get a subject coverage of 5 x 7.5 inches at a working distance of 88 inches. Using the lens all by itself from the same working distance gives me a subject size of 7.5 x 10 inches.

So the first question for closeup work with a zoom lens is, "Exactly what do you need most? Working distance? The fastest shutter speed possible? Subject coverage?" And probably the most important question of all is, "What equipment do you have with you that will permit you to get a photograph?"

CABBAGE WHITE BUTTERFLY AND DEW ON GOLDENROD, MICHIGAN.
Nikon F3, Nikon 80–200mm manual focus zoom lens + Nikon 5T closeup lens, Kodachrome 25.

It was extremely difficult to position my tripod in the wet meadow where I found this cabbage white clinging to a goldenrod. The meadow's tangle of vegetation continually caught at the tripod legs. Using my zoom lens with a diopter let me crop the image without having to reposition the equipment. I photographed at several different image magnifications, but I like this version the best.

MACRO LENSES

Many beginning photographers are under the impression that in order to do closeup work they must purchase a special macro lens. They've been led to believe that macros are the only lenses that will work well up close; however, as I've discussed in other parts of this chapter, this is not the case.

Let's begin by defining the term *macro lens* again Basically, it's a lens that close focuses all by itself (without added accessories). While it is true that macros are optically optimized for maximum sharpness and flatness of field in the closeup range, in practical field terms all lenses will work fine for closeups if your photographic technique is good. Most modern lenses are optically superb, and in nature photography you normally photograph three-dimensional subjects rather than subjects that fill the frame from edge to edge in a flat field. Still, there are many reasons to own a macro lens if you do a lot of closeup work.

Macro lenses are currently available in three focal lengths: roughly 50mm, 100mm, and 200mm. Only Nikon and Canon currently offer lenses at this last focal length—the Nikon 200mm and the Canon 180mm. (By the way, Nikon calls its macro lenses "micro" lenses, but don't worry, there's no real difference except spelling.) Don't confuse these fixed-focal-length macro lenses with the so-called "macro zooms" touted by many manufacturers. "Macro zooms" may focus close compared to regular zoom lenses, but both the image size and the optical quality at the "macro" setting do not usually compare to what you can get with a standard macro lens. In fact, most zooms will produce better images if used with a good two-element diopter than when used in "macro" mode. The one exception is the Nikon 70–180mm f/4.5–5.6 Zoom Micro, a unique lens that I'll discuss shortly.

A photo shot with a macro lens will not look different from one shot with a regular lens set at the same focal length, because it is the focal length itself that determines the photo's "look." So why then even consider purchasing a macro? The answer is simple: convenience. Almost all macro lenses today focus down to life-size on the film. You don't have to add or remove diopters or tubes or do anything else to go from infinity focus to 1X magnification or any point in between. You just turn the focusing mount and shoot. It's a really easy way to work.

Occasionally I still hear that macro lenses are only useful for closeups, and that to photograph at normal distances a standard lens is needed. This is not true at all. Macro lens-es tend to be some of the most highly corrected lenses made, and are extremely good for photographing subjects at any distance. I think the real question to ask before you purchase a macro is whether or not you already own a lens in the same focal length. For example, do you already have a good quality lens in the 50mm or 60mm range? I'll bet you do, and it's probably a zoom lens. Zooms are so convenient that I would certainly think twice about adding a 50mm or 60mm macro. For example, what's the difference between a 35–70mm f/2.8 zoom lens used at 50mm and a 50mm f/2.8 macro lens? The macro focuses closer, but otherwise what the two lenses do to an image is identical. Why double up on focal lengths?

Actually, I wouldn't recommend a 50/60mm macro lens as a first choice for field closeup work no matter what. This focal length—whether as a macro lens or not—just doesn't allow enough working distance between lens and subject. It's handy for copying documents, but I rarely do that. While I do own a long-discontinued Nikon 55mm macro lens, I couldn't even begin to tell you the last time I used it for a tight closeup. I do sometimes use it for landscape photos, but I keep it around mainly because it's an old friend.

To be honest, I don't recommend that you purchase *any* macro lens unless you plan on shooting a lot of closeups. The money would be better spent upgrading your tripod and buying more film. However, if you like closeup photography, the convenience of a longer-focal-length macro might be well worth the expense. Which macro is right for you, 105mm or 200mm, depends on what subjects you want to photograph.

When I wrote my first book, *The Nature Photographer's Complete Guide to Professional Field Techniques,* I said that if I could only own one lens it would be a 105mm macro. In 1984, the year that book came out, fixed-focal-length lenses were the norm and I used the 105mm macro for all my photographic work—scenic subjects as well as closeups. Well, times have changed. Today I still shoot lots of pictures with roughly this focal length, but now for general work I get there with the best 80–200mm zoom I can buy. I reserve my 105mm macro lens for special photographic situations, not for everyday use.

The two major situations where I work with a 105mm macro lens are (1) photographing small, moving creatures such as insects or frogs, and (2) shooting higher magnification subjects (I combine the macro with a 2X teleconverter). In both situations I normally handhold the camera and add TTL flash as the primary light source.

If you're really serious about photographing closeups I would consider the long macro lenses. Both Nikon's 200mm and Canon's 180mm focus from infinity to life size, and are incredibly sharp throughout the range. The longer focal lengths also offer two big advantages: increased working distance and a narrowed angle of view. By themselves these would make the lenses tempting, but both the Canon and the Nikon have one more feature that's extremely useful for general photography as well as closeups: both lenses come with tripod collars. You can switch from horizontal to vertical, or minutely rotate the image framing, without flopping the lens on the tripod head. This is an incredible advantage for closeup work, where precise camera placement is so important. When I do carry a macro lens into the field, most of the time it's my 200mm.

Nikon's 70–180mm Zoom Micro is a one-of-a-kind lens. It's a mid-telephoto zoom lens with excellent image quality that also focuses to 3/4X magnification with no added accessories. If you're looking for an all-purpose zoom and will only occasionally want to take tight closeups, then this lens is a good choice. But for the serious macro photographer there is one major drawback: lack of working distance. Free working distance between lens and subject is crucial for nature photographers. We always need this space for tripod positioning, placing reflectors, and keeping our distance from animate subjects.

The Zoom Micro maintains its 70–180mm focal length only when it is used in the normal focus mode, working distant subjects. When you go into the macro range, the lens changes its focal length. This is normal for most zoom lenses; when they focus closer, the optics move around inside the lens. The Zoom Micro happens to be the only zoom designed for extremely tight focus, so the shift in focal length becomes more apparent than with other lenses. At minimum focus the lens provides just about the same working distance as Nikon's 105mm macro lens. At life-size magnification, which the zoom only obtains with the addition of a Nikon 6T diopter, the 105mm macro has 5 inches free working space while the zoom has only 3 1/2 inches. The Zoom Micro lens does offer great versatility, focusing over such a wide range. The image quality is excellent throughout, so you just have to decide if can you live with such short working distances when photographing closeups.

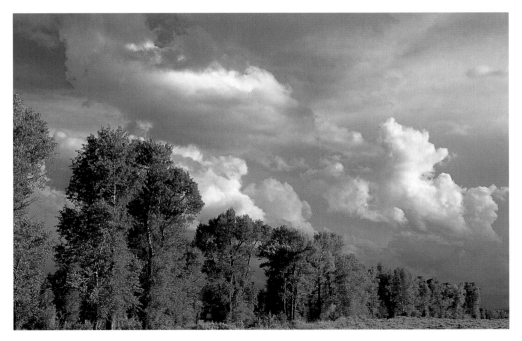

STORM CLOUDS AND COTTONWOOD TREES, GRAND TETON NATIONAL PARK, WYOMING.
Nikon F5, Nikon 55mm macro lens, Fuji Velvia.

Macros aren't only for closeup work; they also work well for general photography.

The photographs below were taken with my favorite macro lens, the Nikon 200mm. The long focal length gave me lots of free working distance, plus control over background coverage.

OWL'S CLOVER, ORGAN PIPE CACTUS NATIONAL MONUMENT, ARIZONA.
Nikon F5, Nikon 200mm macro lens, Fuji Velvia.

With my Gitzo tripod as low as possible, the 200mm focal length allowed me to keep the lens parallel to the ground, shooting into the flower rather than down at it.

COLORADO BLUE COLUMBINE, NEAR CRESTED BUTTE, COLORADO.
Nikon F5, Nikon 200mm macro lens, Fuji Velvia.

The background in this photo is the deeply shaded side of a spruce.

CLOSEUP FLASH

If you want to photograph small creatures or work at high magnifications, lighting your subject entirely with flash is the most practical way to go. Using natural light can be extremely frustrating. Consider the problems you face: You're trying to show intimate details so you use slow-speed fine-grained film in order to record every nuance. At the same time you need to stop your lens down to a small aperture since you lose depth of field as you gain magnification. Let's assume you're using Fuji Velvia at *f*/16. Even at infinity focus, not allowing for any light loss due to extension or teleconverters or other accessories, you would have to use a shutter speed no faster than 1/50 sec.—and that's in blazing sunlight. A longer focal length lens is mandatory for working distance. This shutter speed/lens combination demands tripod use for good results, but positioning a tripod in order to photograph a small moving creature is almost impossible. Even if you could get the tripod into position, that shutter speed just isn't fast enough to stop any motion.

One solution would be to immobilize the subject. I sometimes see articles suggesting catching small animals and refrigerating them until they cannot move. In my opinion this is definitely *not* what you should do. The welfare of my subject matter—whether it be flowers, a landscape, a mammal, or an insect—comes way before any photographic opportunity. I don't want to harm my subject in any way, and refrigerating subjects until they are incapable of moving is definitely harmful. If you still need to be convinced, there's also a good photographic reason not to do this. Imagine refrigerating a person until he or she couldn't move and then photographing them. Don't you think you would be able to tell that something wasn't right in the picture? The same is true for nature subjects. A good naturalist can spot chilled or manipulated photos every time. Chilled subjects yield photos of chilled subjects.

The solution is flash. For small animate creatures you want a mobile, easily used, handheld outfit based on a close-focusing lens. You could use a macro lens, a normal lens on extension, a zoom with diopters, or any other combination of equipment that lets you photograph closeups. Your camera should be positioned neither too far from nor to close to your subject. Base your equipment choice on what you own, but try to end up so that your working distance at 1/2X magnification is roughly 12 inches. This is about the working distance of a 100mm lens. While you shouldn't be fanatical about this distance, I do have a reason for suggesting it.

First of all, I'm going to assume you'll be using TTL flash to totally illuminate the subject. If you have an old camera that does not support TTL flash, I'll refer you to my earlier book *John Shaw's Closeups in Nature* (Amphoto, 1987). Manual flashes will work for closeups, and I used them for years, but modern TTL flash makes life much, much

PUMPKINWING BUTTERFLY ON LANTANA.
Nikon F5, Nikon 105mm macro lens, Nikon SB-28 flash, Fuji Velvia.

Here's a photo done with one flash positioned fairly close to the subject.

easier. The flash units I currently use for closeups are Nikon's biggest and most powerful units, the SB-28 and SB-25. These are the same units I use for all my other flash work, including fill flash on birds or mammals.

So why is that 12 inches of working distance so important? You can position a TTL flash anywhere close to a subject and it will automatically provide the right amount of illumination to render your subject as a middletone. Move it closer to the subject and it extinguishes itself faster, giving less light; move it further away and it puts out more light. The flash-to-subject distance in itself is not as important here as the relative size of the flash head compared to your subject. When you're using a handheld camera, the flash obviously will be moving around with you; consequently, it will be roughly the same distance from the subject as the camera. If you're using a focal length that keeps the camera several feet from the subject, the flash head effectively becomes a point source of light. The flash may be big, but it's a long way away from the subject, and you end up with deep black shadow areas. This is exactly why the sun creates shadows; it's huge, but since it's so far away it becomes a point source of light. If you must use longer working distances due to lens choice, you'll need two flash units, one as the main light source and one to fill in the shadows created by the first. This complicates things as the equipment becomes heavier and more awkward, but it certainly can be done.

Take that same single flash unit, move it up close to your subject, and now the flash head effectively becomes large compared to your subject. My SB-28's reflector head measures just a bit over 1 x 2 inches. Suppose you want to photograph a butterfly with wings spread, a subject about 3 inches across. If the flash is roughly a foot from the butterfly, the light source is large relative to the subject. It's a giant omni-directional light, half the size of the subject. You get softer shadows just by using one light positioned close.

Your flash's instruction manual will tell you that placing the unit so close to the subject is not recommended. In fact, the manual most likely says that TTL flash will not work in this range at all. This statement is not exactly true. TTL flash metering won't work correctly if you photograph with your lens set at its wide-open apertures. This is because TTL flashes actually measure the light bouncing off the subject, then turn themselves off when the proper amount has been reached. With the flash unit quite close to the subject and a wide aperture such as $f/4$, the unit simply cannot turn itself off fast enough. But this isn't a problem for the nature photographer because you won't usu-

HOMEMADE BRACKET HOLDING A FLASH, SET FOR A HORIZONTAL IMAGE.

The camera is a Nikon F4, with a manual focus Nikon 105mm macro lens which goes to 1/2X magnification all by itself. I've added a 27.5mm extension tube so that the range of magnifications is between 1/4X (lens at infinity focus) and 3/4X (lens racked out to minimum distance). Most small living creatures you photograph will be within this magnification range. The flash unit shown is a long-discontinued Nikon SB-18, a TTL unit which I still have around only because it is so tiny. I've removed the off-camera flash cord, which would run from the flash to the hot shoe; of course this is needed for actual use.

HOMEMADE FLASH BRACKET SET FOR A VERTICAL IMAGE.

You can flip the camera in the other direction also (with the shutter release on top), which is the position I prefer. Start with it in the position shown in the photo of the bracket set for a horizontal. Position the flash at the top end of the flash arm, turn the camera vertically, then lay the flash arm alongside the lens almost touching it. Again, you would need an off-camera cord in order to photograph.

ally want to work at these wide-open apertures anyway. When taking closeups, you normally stop down the lens to gain what little depth of field is available. If you set your lens to around $f/16$ and place the flash close to your subject, you should have no problem running a TTL system.

What you're actually doing here is lighting your subject exclusively with flash. I want to emphasize the point that you're not trying to use fill flash, but rather total flash. This allows you to handhold the camera and still get sharp photographs. If the flash is the only light source, the effective shutter speed becomes the duration of the flash. The larger TTL units, such as the Nikon SB-28 and the Canon 540EZ, are helpful in these situations because they are extremely powerful. Used close to a subject, they need only throw out a small portion of their light capacity, thus flash duration times are in the 1/5000–1/10000 sec. range. And trust me, you can easily handhold your camera for 1/10000 sec.

You can use any shutter speed you want up to the flash synchronization speed, which on most modern cameras is 1/250 sec. In fact, even if you've set the shutter speed faster, many new cameras will default to this speed as soon as the flash in connected. Read your camera's instruction book carefully. However, you don't have to use this top sync speed. In fact I would urge you to slow it down a stop or two, depending on which

film you're using. First of all, it should be obvious that you're not going to use fast film in this situation. Suppose you want to shoot an ISO 400 speed film. Proper bright sunlight exposure is 1/400 sec. at $f/16$. But you can't use 1/400 sec. shutter speed as the camera's top sync speed is 1/250 sec. Change to 1/250 sec. and $f/22$, most likely the smallest f-stop on your lens, and you're still at bright sunlight exposure. You'll end up recording ghost images, both an ambient light image and a flash image. Go to slow-speed film and the problem is solved. Let's say you use an ISO 50 film. If the camera is set at $f/16$ and 1/250 sec. shutter speed, you're already two stops away from recording a bright daylight image. Even in blazing sunlight, the flash still functions as the primary light source, exactly what you want to happen. Now when you slow the shutter speed a stop you'll let some daylight record on the film. Doing this means you're reversing the normal fill-light situation from a sunlight exposure with flash fill to a flash exposure with sunlight fill.

Remember that all TTL metering systems, whether they work with flash or ambient light, are designed to render all subjects as a medium tone. When you're shooting total flash you can control the tonality of your subject by working in stop increments. It's easiest to do this using the compensation settings on the flash unit. Look at your subject, decide what tonality you want to make it (just as you would when you make a natu-

ral light exposure), then set this reading on the flash unit's compensation. For medium-toned subjects, you can just point and shoot. But suppose you have a "light" subject. Now you need to dial in a "+1" compensation so that the TTL flash puts out enough light to render the subject lighter than medium. A dark subject would require a "-1" setting.

Before you do any field work you should run some tests with your particular camera and TTL flash, as some current cameras actually have a software program that partially controls flash exposure. Find a medium-toned subject, a light subject, and a dark subject. Set up a controlled situation, shoot some slide film, compensate on the flash unit as you think you should, and see what actually happens. What you can learn from a roll of test film is well worth the expense.

The ideal position for the flash is just above the end of the lens, pointed down at the subject at about a 30° angle. In order to place it there, you'll need to get the flash out of the hot shoe using an off-camera TTL connecting cord. Mounting the flash in the hot shoe atop the camera is not a good idea for closeup work for two reasons. First, you'll probably have a parallax problem where the lens is aimed at one point but the flash is aimed at another. If your flash unit permits you to tip it slightly downwards from its normal position, you may be able to use the hot shoe, but make sure a shadow from your lens hood isn't cast onto your subject. The second reason is that mounting the flash in the hot shoe means that when you compose a vertical shot the light will come directly from the side. You will rarely want this lighting since if your subject is an insect, frog, or other living creature, there's a good chance it will turn and you'll end up lighting its posterior end. Not good.

The best solution is to make or buy a "third hand" bracket to hold the flash unit. Since the flash reads TTL it's possible to hold it out there in one hand, and this works fine for non-moving subjects. But as soon as you're chasing a moving subject, a flash bracket becomes a necessity as you're trying simultaneously to position yourself, the camera, and the flash. A bracket is just a flash holder, nothing more, so if you're handy with tools you can certainly make your own. It doesn't have to be pretty when you finish but it does have to be practical. The easiest material to work with is 1-inch wide, 1/8-inch thick aluminum strap, which can be bought at larger hardware or home improvement stores. You need to make a few bends and drill a few holes so that the bracket can be mounted to your camera's tripod socket, but the flash itself is held over the lens. By the way, it doesn't matter in the least if the flash tube is positioned vertically over the bracket while your photographic picture frame runs horizontally. All flashes will provide more than enough coverage.

You can also purchase brackets from both Really Right Stuff and Kirk Enterprises. Both companies offer brackets specially designed for certain lenses including the 200mm Nikon macro. Any bracket that attaches to a tripod collar makes shooting

NORTHERN DWARF TREE FROG ON CALADIUM LEAF, NORTHERN TERRITORY, AUSTRALIA.
Nikon F4, Nikon 80–200mm lens + 5T closeup lens,
Nikon SB-25 flash, Fuji Velvia.

Just to prove that it can sometimes be done, here's a shot that breaks many of my rules for using closeup flash. While the lens choice is fine—Nikon's manual focus 80–200mm f/4 with a closeup diopter on it—the flash is right in the hot shoe. To shoot vertically, I turned the camera on its side, putting the flash to the right of the frame, towards where the frog's head was positioned. So if this is not how I would recommend working, why did I do it this way? Simple—because that's the only equipment I had with me at the time. A picture is better than no picture.

EYESPOTS ON OWL BUTTERFLY WING.
Nikon F5, Nikon 105mm macro lens, Nikon SB-28 flash, Fuji Velvia.

This was taken at 1X magnification; in other words, I was at the closest focusing distance of my new 105mm macro lens. I worked hard to position the camera so that the film plane was parallel to the plane of the butterfly's wings. By the way, this is a living, free-flying specimen. It just shows that with a little patience, and by moving slowly into position, you can work at this image size.

FIDDLER CRAB.
Nikon F4, Nikon 105mm macro lens (manual focus) + 25mm extension tube, Nikon SB-18 flash, Fuji Velvia.

Fiddler crabs are easy to find, but not so easy to photograph. They tend to run sideways out of the frame just when you're pressing the shutter release; I think they watch what you're doing. This photo was done with my old 105mm macro lens plus extension and little flash, the outfit shown in the illustration picture.

vertical compositions easy, because you can just rotate the camera while the flash stays in the exact same position.

To use this outfit in the field, set the rough magnification you need, make sure the camera and flash are turned on and the lens is at the correct *f*-stop, and then lean in and out to achieve perfect focus. Trying to turn a focusing ring while you're handholding a camera at 1/2 life size magnification is a quick lesson in frustration. Every small movement on your part necessitates another touch-up on the focusing ring . . . it's a never-ending procedure. Autofocus is not a good idea either, as the system will do the same hunting for focus, even if an AF sensor falls on the subject. It's far easier to turn off AF, hold the camera with one hand while supporting the lens with the other, set one magnification, then physically move in and out until the image comes into focus.

Brace yourself as much as possible before you press the shutter. Depth of field is so limited when you are shooting small subjects that a slight accidental shift of the camera can ruin a photograph. If you're 1/4 inch out of position, the slide you create will go straight into the trash. Just as when you work from a tripod, you must be careful to keep the camera's film plane parallel to what you've deemed is visually the most important plane of the subject. Pay extra attention to camera positioning as it is much more difficult to adjust when you are handholding a camera at higher magnifications. A photo with the principal plane of focus slightly off

the subject, or off the eyes of a small creature, will appear unacceptably out of focus. Overall, the process of taking flash photos of small, animate subjects with handheld gear is an extremely physical and involved form of photography.

I would suggest using one flash as the primary light source as often as possible, setting the shutter speed so that sunlight acts as a weak fill. There will be times, dictated by your preferences, where two flashes are called for, one acting as the main light while the other fills in the shadows. This will most likely be your choice if you want to work with longer-focal-length lenses, such as the 180/200mm macro lenses. Immediately, some physical problems present themselves. How do you carry this outfit? What sort of bracket do you make to hold two flash units, especially if you're using fairly large flashes? How do you shoot a vertical?

Well, it's going to weigh a ton and be awkward to handle no matter what you do. You will need to make a different bracket to hold the flashes, one strong enough to hold two flash units. Since I rarely work this way I jury-rigged the simplest bracket I could: it's a straight piece of aluminum strap (the same stuff I used for my single-flash brackets) with a small ball-socket head on either end. In the center of the strap I mounted an Arca quick-release clamp so the bracket can clamp onto the quick release plate of my 200mm macro lens. By mounting the bracket on the macro's collar I can rotate the camera for horizontal or vertical compositions.

Actually there have been very few times when I've used this two-flash bracket with my 105mm macro lens; to flip vertical/horizontal I've used the "L-bracket" on my camera body to position the camera in the Arca clamp. Not easy, not quick, but it works fine as often as I need it.

Remember that both flashes have to be connected to the camera to get TTL flash metering. You can hard wire them using off-camera cords (see your instruction manual for ways of doing this), or use a TTL slave unit (a wireless flash-triggering device) such as Nikon's SU–4 or even use a flash with a built-in slave like Canon's 550EZ. Most camera systems do not allow you to make the second flash output a different amount of light from the main flash (again, check your instruction manual), so you will probably end up with two equal light sources on opposite sides of your subject. This creates flat, shadowless lighting, which is not what you want (the same problem is created by ringlights, which is why I don't recommend them). You want to lower the contrast caused by one point source of light, not wipe out all shadows—they are what create apparent sharpness in a photograph. Total frontlighting is not attractive; you would rarely use it for landscape photos, so why do so for close-ups? Some Canon flash units do allow you to set different power ratios when they are used in tandem, but otherwise you'll have to tape an ND gel over the second flash tube to cut the light. It's much easier to use one light positioned up close to the subject.

HIGHER MAGNIFICATIONS

As I've discussed, there are several ways to reach life-size magnification on film. Extension tubes used with medium telephoto lenses, diopters mounted on longer focal lengths, and special-purpose macro lenses are all options. But once you want to go to magnifications higher than 1X, there aren't as many choices for field work.

In the old days of a decade ago, I relied on a bellows unit when I needed lots of extension and stacked lenses to reach extremely high magnification rates.[1] Would I do this today? No way. I no longer own a bellows—haven't for many years—and don't want to deal with their awkwardness and fragility in the field ever again. Stacking lenses—adding a reversed short-mount lens on the front of a telephoto—gave me lots of magnification, but with limited working distances. Today I don't even own any lenses that would permit me to stack them together, as like most photographers I've gone to zooms for the bulk of my photography. Current zooms don't work optically with stacked lens techniques.

A really old technique for attaining high magnification was to reverse a short-focal-length lens on extension. For example, if you take a 50mm lens and reverse it using a "reversal ring," you have instant magnification. You can add extension for even more

magnification. I never used to do this, as it created too many problems for field photography: you lose your automatic diaphragm and must focus with the lens stopped down to shooting aperture; working distances are incredibly short; TTL flash (even if you can get the light past the lens and onto the subject) may not work correctly; and you're limited in the magnifications available. It wasn't a useful field technique fifteen years ago and is even less so today. So why do I even mention it? Only because I still see references in print to this "handy" method for field work. Don't even think of working this way.

When I work at higher magnifications today, I rely on my 105mm and 200mm macro lenses used with some added accessories. In the Nikon line both of these lenses focus down to 1:1—that is, life-size—all by themselves. I base my system on these lenses because they are state-of-the-art, high resolution optics.

Let's begin by discussing the 105mm macro. Working distance is always a concern, and adding a diopter to the front decreases working distance since it decreases the effective focal length. However, for a small gain in magnification I sometimes screw on a Nikon 3T closeup lens. For higher magnification with this macro I add a 2X teleconverter, which takes the magnification rate to twice life-size

when the lens is close focused. By adding an extension tube (or tubes) between the converter and the lens I can achieve magnifications in the 2.5X to 3X range, which is about as much magnification as you can work in the field. I don't use a 1.4X teleconverter in this fashion because it doesn't offer enough power. When I want magnification, I really want magnification. A converter multiplies by its power whatever you put in front of it. If you're at 1X, adding a 2X teleconverter doubles this magnification, so you're instantly at 2X.

When using long telephoto lenses, I would stick with the dedicated teleconverters from Nikon, Canon, and other camera manufacturers. But for macro magnifications, almost any teleconverter works fine, including the ones from Tamron, Sigma, and Tokina. For this application, the so-called "universal" converters are good choices, particularly the better quality seven element models. These are considerably less expensive than dedicated converters and will normally mount directly onto most of your lenses. In passing, I'll mention that most of these "universal" converters maintain autofocus features, but for higher magnification

[1]See my earlier book *John Shaw's Closeups in Nature* (Amphoto, 1987) for more information.

JUMPING SPIDER, TEXAS.
Nikon N90s, Nikon 105mm macro lens + 27.5mm extension tube, Tamron 2X teleconverter, Nikon SB-24 flash, Kodachrome 25.

This photograph was made at about 2.5X magnification.

macro work this has little bearing. You focus by moving the whole camera/lens unit closer to or farther from your subject.

For several reasons, all teleconverters give good results when used with macro lenses at higher magnifications. While teleconverters do magnify all optical defects and problems, most macro lenses are optically some of the best lenses available. Image integrity can be further enhanced by choosing the best resolving slow-speed films available. Adding a 2X converter to a lens does not significantly degrade the image if you're starting out with the highest resolution possible. Because of the magnifications at which you'll be working, and the diminished light reaching the film due to the converter and extension, you will use electronic flash as your light source. Consequently, you'll benefit from a faster effective shutter speed, the flash duration rather than the actual shutter speed set on camera. This minimizes problems caused by subject or camera movement. Flash also allows working at the optimum apertures on lenses rather than shooting at the wide-open f-stops. Stick to about the f/11 setting on your lens.

The reason I sometimes add a tube between lens and converter is to gain a bit more magnification. It's easy to vary the total magnification by changing the total tube length. To make only slight changes, assemble the parts in a different order. I'll often use my Nikon 105mm f/2.8 AF macro lenses, a Tamron 2X converter, and a Nikon 27.5mm extension tube, putting them together in different ways. First let's look at the combination of lens plus converter and no tube.

Lens set at minimum focus (1X) + converter = 2X magnification

Working distance (from front element) = 6 inches

Now I'll add the tube between lens and converter.

Lens at minimum focus (1X) + tube + converter = 2.7X magnification

Working distance (from front element) = 4.75 inches

In this case I've multiplied—that is, doubled—the magnification achieved by the lens and tube. Now I'll reverse that order of assembly.

Lens at minimum focus (1X) + converter + tube = 2.5X magnification

Working distance = 5.25 inches

You can see that there isn't a big difference, but I would go for the most magnification by mounting the converter next to the camera body. Speaking of magnification, if I really need to do so I'll add a Nikon 4T diopter. Let me use the same lens and converter but use Nikon's 52.5mm PN-11 tube in the middle as well as the 4T.

Lens set at minimum focus (1X) + PN-11 tube + converter + 4T closeup lens = 4.3X magnification

Working distance = 3 inches

I can already hear some Nikon owners reminding me that a Nikon 2X teleconverter, and in particular the current Nikon TC-E model, won't permit a tube such as Nikon's PK-13 to be mounted on the front of it. That's correct; they won't fit together. Both the 1.4X and 2X TC-E converters have a little metal tab on the lens mount flange to prevent you from mounting either converter onto any non-"S" Nikon lens or tube. Since there are no "S" tubes at all and the 105mm macro is not an "S" lens, I would seem to be stuck if I wanted to use this combination. What I have done to solve this problem might be sacrilege to Nikon, and I definitely don't advise that you do this, but I decided that since I own my gear I can do with it as I please. So I unscrewed the mounting flange from the front of my expensive 2X TC-E converter and filed off that little tab. Removing the tab didn't change the converter in any way. It still works perfectly with my long-focal-length "S" lenses, and I do heed Nikon's advice about not using some of the older-model tubes which might damage the electronic contacts. You Canon owners out there don't have to consider doing this butchery, as Canon EOS parts will fit together directly without any problems.

I sometimes use my 200mm macro lens as the starting optic, although usually the deciding factor is simply what equipment I have with me at any given time. Using this longer lens yields a little more working distance, which in all closeup work is a primary concern. By adding a Nikon 6T closeup lens, which is a +3 diopter, I can get to almost 2X on the film at a working distance of just over 6 inches. This combination has a couple of advantages over the teleconverter/105mm macro route: There's more focusing light, a real plus at all times. Additionally the lens has a built-in tripod collar so that rotating for vertical or horizontal framing is a breeze, whether I'm using a tripod or a flash bracket.

One quirk of Nikon's 200mm macro lens, both the current AF version and the older manual-focus model, is that the Nikon closeup diopters yield better results with them if they are mounted in a reverse position. I have no idea why this is so, but my test photos indicate that it is the case. It seems to hold true for these two particular lenses and no others. To reverse the diopter I use a 62mm male-to-male coupling ring, a ring that has male filter threads on both sides. Male-to-male rings in many different sizes can be purchased from Kirk Enterprises and other sources. If I want even more magnification when using the 200mm macro I add a second closeup diopter, another +3 one. Since the first one is already reversed, when I add this second one it ends up in a reversed position also. Using both I can get to 2.5X, about what my 105mm macro + converter combination offers, but with less light loss.

For extreme situations there are extreme answers. Consider this string of equipment: my 105mm Nikon macro set at minimum focus, two +3-power diopters in front, 100mm of extension (all my tubes together), and a 2X teleconverter. This is so much equipment strung together that I worry about it bending in the middle! This unwieldy rig lets me shoot at 7.5X on the film. At this magnification it's extremely difficult to find the subject while looking through the viewfinder, since if either the subject or lens moves even slightly, you're out of the plane of focus.

To be honest, I have rarely used this combination of equipment—I almost never need to photograph a subject that is 1/8 x 3/16 inch. So, how on earth did I come up with such a combination? The answer is that on one gray winter day I sat indoors and played with my camera equipment. If you want to take high-magnification pictures I would strongly suggest that you do the same. In the realm of higher magnifications there is no one correct way to work. With today's variety of lenses and accessories it's hard for me to generalize about equipment; you need to try out what you have. Dig out every lens, every extension tube, every teleconverter, every diopter you own. Spread the whole works out on the floor, pull up a lamp, and play with the equipment. Try every possible combination no matter how weird it seems. Look through all the combinations at a test subject, something with sharply delineated lines such as the printing on a film box, and note the working distance for each combination. Add a TTL flash on a remote cord and pop off a few test frames at a medium aperture. Keep careful notes about what you're doing and match the notes with your film when it's processed. You just might be surprised at the possibilities of your equipment.

CENTER SECTION OF A VIOLET.
Nikon F5, Nikon 200mm macro lens, 5T and 6T diopters, Nikon SB-28 flash, Fuji Velvia.

I photographed this with my 200mm macro lens and diopters just to see how stacking diopters would work. What's your opinion?

HALICTID BEE ON DANDELION.
Nikon F4, Nikon 105mm manual focus macro lens + 27.5mm extension tube + 52.5mm extension tube, Tamron 2X teleconverter, Nikon SB-24 flash.

This shot was done with the old Nikon manual-focus 105mm macro which went to 1/2 life-size. I had to add more extension in the middle to gain the same magnification I can now achieve with the newer version of this lens.

CLOSEUP PROCEDURES

A number of simple techniques will greatly improve your closeup photography. Being extremely careful with your photographic technique is certainly the best starting point; here are some other suggestions.

PARALLELING THE SUBJECT

Positioning your camera for closeup work is far different from what you do if you're photographing a landscape. For instance, let's assume you're photographing a mountain. Moving the camera a few feet closer or further, or to the side in one direction or the other, really doesn't have any major effect on the outcome. Your camera position doesn't change enough relative to the mountain to make a difference, and the depth of field at almost any aperture is measured in yards. When you photograph closeups, all this changes. Shifting the camera only an inch can be a gross change in shooting location and can radically change the appearance of the picture. As you increase magnification, precise camera positioning becomes more and more critical since as you gain magnification you lose depth of field. At 1/10X magnification, a subject size of 10 x 15 inches, the depth of field at $f/16$ is roughly 4 1/4 inches. At 1/2X, and still working at $f/16$, depth of field is only 1/4 inch, while at 1X at the same f-stop it's a minuscule 1/16 inch.

Obviously you need to maximize the effectiveness of what little depth of field you have. The solution is to carefully align the film plane—that is, the camera back—with the most important subject plane, so that the

two planes are parallel. Choosing what plane is the most important part of your subject is an arbitrary decision on your part. Study the subject and decide what you want to emphasize—what part absolutely must be recorded in sharp focus.

For closeup work, precise camera placement is the most important factor, since you simply cannot stop down enough to cover imprecise placement. Working your tripod into the correct position where the film plane can be made parallel is one of the most difficult, time-consuming aspects of closeup photography, but it is absolutely essential. Here is a sequence to help you in critically positioning your equipment:

1. Look at your subject and determine the most important plane. Every photograph can have only one absolutely sharp plane of focus, so don't make this choice lightly.

2. Reach down and position your flat, open hand parallel to this plane and as close to it as possible. Bring your hand back toward the camera position, then align the film plane with the angle of your hand.

3. Once you've positioned the camera, take a giant step to the side and look at the camera's relation to your subject. It's easier to determine if the film plane really is parallel to the subject plane when you're viewing both from the side. The extra time and effort in doing this will pay for itself in better quality photographs.

Using a longer than normal lens will also

help, since it gives you more working distance. If you do make an error in positioning the camera it will not be so critical. Any positioning mistake is magnified proportionally; the shorter the working distance, the worse it is. Being 1 inch off when the camera is 24 inches from the subject is not too bad, but being 1 inch off when the camera is 6 inches away is truly catastrophic.

CONTROLLING THE LIGHT

Good light is good light, whether you're photographing a landscape, a bird or mammal, or a closeup. When you're photographing landscapes you must wait for good light as there is no way to control the lighting over a large area. When shooting closeups, since you're working a small area, controlling the natural light falling on your subject is mandatory. Film, with its limited range of vision, cannot record detail in both highlights and shadows in strong light. It can accommodate far less contrast than can the human eye. Transparency film has a usable range of roughly 5 stops maximum from pure, detailless black to detailless white—2 1/2 stops on either side of where a middletone exposure falls. If the shadows or highlights fall within this tonal range they will record, otherwise shadow areas record as blocked-up black blobs or highlight areas appear burned out and detailless. With landscape subjects we can often use blocked shadow areas as compositional devices, but this is not an option with tight closeups. The answer is to compress the tonal range by controlling the light.

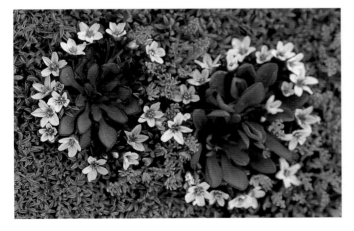

BIG-ROOTED SPRING BEAUTY, MT. EVANS, COLORADO.
Nikon F5, Nikon 200mm macro lens, Fuji Velvia.

Big-rooted spring beauty is a true alpine flower; this photo was taken at 13,500 feet of elevation. I used f/11, but I didn't have the camera parallel to the subject and the right side of the frame is badly out of focus.

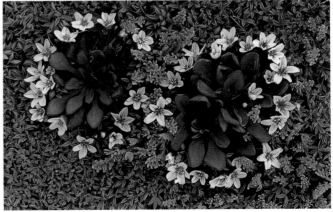

BIG-ROOTED SPRING BEAUTY, MT. EVANS, COLORADO.
Nikon F5, Nikon 200mm macro lens, Fuji Velvia.

By moving my camera position slightly, I brought the entire plant into focus at f/11.

MAGENTA PAINTBRUSH, COLORADO.
Nikon F5, Nikon 200mm macro, Fuji Velvia.

Magenta paintbrush is another alpine plant. I photographed this specimen high in the West Elk Mountains, and you can easily see the contrast problem caused by the bright sunlight.

MAGENTA PAINTBRUSH, COLORADO.
Nikon F5, Nikon 200mm macro, Fuji Velvia.

I placed a large diffuser extremely close to the paintbrush to soften the light, but you'll notice that there are still directional highlights. For this shot I used my largest diffuser, a 52-inch Litedisc, actually wrapping it around my tripod legs, which were straddling the plant.

LITEDISC.

Here's a folded diffuser, partially pulled from its case.

One good solution is to photograph closeups on overcast days. Too often we've been led to believe that the best time to photograph is a sunny, cloudless day. Beginning photographers especially—the point-and-shoot crowd—seem to put stock in this theory. In reality, for most closeup photography, this is the absolute worst lighting condition possible. You want to record all the minute details of a small subject, but harsh contrasty lighting hides many of these very details in shadow or washed-out areas. If you shoot on an overcast day, details stand out, colors come alive and saturate, and subtle nuances return. On a day with high overcast the entire sky acts as a giant diffused light source.

But having an overcast day when you want one rarely seems to happen, so it's good to know how to control the harsh sunlight falling on the subject, to even out the contrast, by using diffusers and reflectors. These can be as elaborate or as simple as you wish. The most basic diffuser is a thin white cloth held between the light source and the subject, and for years I used reflectors made of crumpled aluminum foil rubber-cemented to cardboard.

Now I've gone upscale by carrying Litedisc™ brand diffusers and reflectors made by Photoflex. These are round, steel-framed fabric panels which can be folded with a twist of the hands. (Hint: Place your hands on either side of the Litedisc with your fingers on opposite sides. Now twist. Being able to fold a large Litedisc in one try is a mark of becoming a professional photographer!) My suggestion is to buy the largest diffuser you can pack, or perhaps two of them, since you want to control the light falling on both your subject and the background, and this can be a fairly large area. Then get one or two of the smallest reflectors. Litediscs come in sizes ranging from 12

to 52 inches in diameter. The diffusers are sold as "white/translucent," while the reflectors come with a color woven into either side of the fabric. They are offered in a number of combinations, but I would recommend the "white/gold." The white side yields a soft light, while the highly reflective gold side gives a much warmer light. My choices would be either a 42- or 52-inch diameter diffuser and the little 12-inch reflectors.

To use a diffuser, position it as close to your subject as you possibly can without it protruding into the picture frame. You want the soft, broad highlights that you get with such a close placement. If you hold the diffuser far away from the subject, it throws a shadow, but as you move it closer the lighting gets better and better. Experiment with placement on a sunny day. Pick any subject you want, start by holding the diffuser about 10 feet away, then watch the light improve as you move it closer. In the field you can lean the diffuser against an extended tripod leg or your pack or anything else that's available. I keep an old lightweight tripod in my car to use as a diffuser holder. I added a fairly substantial spring-loaded clamp (from my local hardware store) to its head to allow me to position the diffuser. The tripod itself is basically too flimsy to use for anything else, but it makes the best outdoor lightstand I know since the legs are adjustable for uneven terrain. When I add one or two small reflectors I essentially have a field version of a studio lighting setup. By the way, you can also fire TTL flash right through the diffuser if you want to add a touch more light.

CONTROLLING MOVEMENT

The wind seems to know when you are trying to photograph flowers; it always blows just enough to make slow shutter speeds impossible. This is particularly true when you're photographing long-stemmed blossoms such as columbine. You squat by your tripod, remote release in hand, peering through the viewfinder as the image goes first to the left, then to the right, then to the left. . . . A low-tech solution is to shove a 3/8-inch diameter dowel rod into the ground next to the plant. Wrap a long twist-tie around the dowel, then ever so gently tie the plant's stem just outside your picture area. Don't twist tight enough to damage the plant, just enough to hold it in place. This will reduce the pendulating movement to a minimum at a total cost of about $1.00. By the way, you can also use the dowel to prop up a diffuser or reflector. Low-tech to be sure, but it works.

SHOOTING THROUGH FLOWERS

Here's a photo technique that also helps to defeat wind problems, although you can use it at any time. Position your camera so that you're shooting right through one flower blossom very close to your lens while you're aimed at another blossom that's much further away. For best results, use a long lens in the 200–300mm range. Handhold the camera and scan around the area, repositioning as necessary, before you set up your tripod.

Don't stop down very far, so you can keep shutter speeds up. You'll get one sharply-focused flower surrounded by a wash of out-of-focus color from the other blossoms. This works best when you have different flowers mixed together, so that you can play off the contrasting colors against one another. It's not a bad trick for autumn foliage, either.

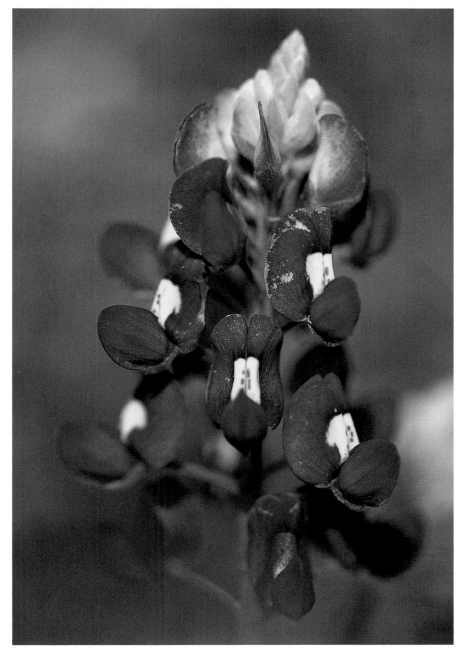

TEXAS BLUEBONNET, SEEN THROUGH INDIAN PAINTBRUSH, TEXAS.
Nikon F5, Nikon 200mm macro lens, Fuji Velvia.

I searched around this prairie section with a handheld camera to find the right combination of bluebonnet and paintbrush, then set up my tripod. Notice that even though I'm shooting at a wide aperture, I've paralleled the subject with my film plane. The closest paintbrush is about 4 inches in front of my lens, giving me a brilliant wash of red.

WORKING
IN THE FIELD

6

BALD CYPRESS SWAMP IN SPRING,
ATCHAFALAYA BASIN, LOUISIANA.
Nikon F5, Nikon 80–200mm lens, Fuji Velvia.

BLINDS

▲ ROD PLANCK'S
N-VISABAG BLIND

▶ L.L. RUE'S ULTIMATE
BLIND

At least once in a while, you'll want to work from a *blind*—a hiding place for you and your camera equipment. Blinds are a great means of getting closer to wary subjects, because you can position the blind right where the subjects are likely to appear. Locations such as bird feeders, watering holes, and well-used game trails are obvious choices, as are bird nests.

Let me state right here that I would strongly urge you *not* to photograph birds at their nests. It's extremely easy to disrupt an animal's normal activity when you erect a blind, especially if it appears abruptly. Nesting birds have a strong instinct to care for their young, so up-close photographic activity of any sort just adds stress to an already stressful time. Some birds tolerate very little disruption at the nest site and will immediately desert the nest, dooming eggs or chicks. Nesting birds have been photographed over and over, and I doubt if any new or unique pictures are to be had. No photograph whatsoever is more important than the welfare of the subject.

If you want to work from a blind, stick with other locations where wildlife gather. Move the blind into location s-l-o-w-l-y; the period of time necessary to do this might be up to a few days. A lightweight, portable, self-supporting blind is simplest to use since the entire blind can be moved forward at once. Just pick it up, halve the distance you are from your final intended location, and set it back down again. Each time you move the blind closer, back off with binoculars and see if it has been accepted. If not, remove it immediately and leave the area.

I would suggest you learn about working from a blind at the one location where you probably won't disrupt anything: your backyard bird feeding station. If you've been feeding birds for any length of time in the same general location, then they have probably become fairly tolerant of your presence. I keep my feeders well-stocked year-round with a variety of foods; consequently, quite a number of the birds who visit have become almost tame. At times I expect to hear a pounding on my door as one particularly bold Steller's jay demands his favorite treat.

Blinds can be as complex or simple, as permanent or temporary, as spartan or luxurious as you wish. There's one type—the kind I use most often—that you already own: your vehicle. Birds and mammals are far more tolerant of vehicular traffic than of human disturbance. We've all had the experience of driving close to an animal that

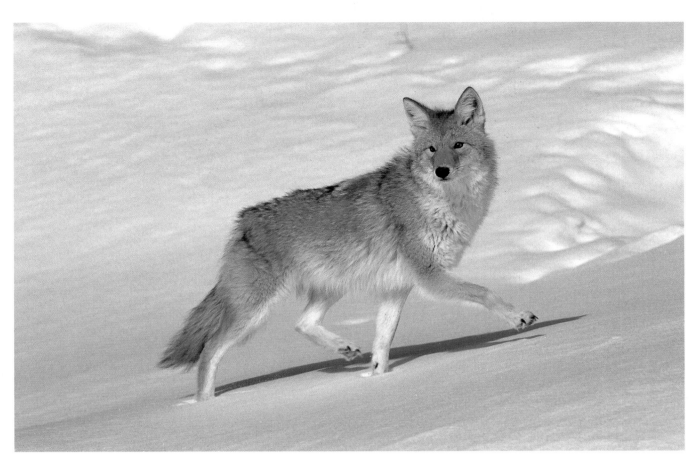

seemed blissfully ignorant of our presence, only to watch it disappear over the far hill at the first "snick" of the car door opening. Shooting from your car can be particularly productive in parks and refuges with auto-tour routes where animals have become accustomed to slow-moving and stopped vehicles. Scout out possible locations before trying to work the good light. A quick trip around the tour route at high noon should reveal possible situations; try to figure out where the sun will be both early and late in the day. When you're ready to photograph, slowly drive up to your subject and, as you get close to where you want to be, turn the engine off and coast into position. You'll never get sharp photos if you leave the engine running. Have your window lowered and your camera gear ready. Should you have passengers, be sure that they remain absolutely motionless while you're shooting. Ask them to be still well before you've positioned your vehicle, then remind them again when you're about to shoot. A gentle reminder not to make any loud noises is probably a good idea also. I was once trying to photograph from my car at Bosque del Apache National Wildlife Refuge, only to hear the Grateful Dead blaring from an approaching car at a volume close to the pain threshold.

When working from your car you'll generally be using the longest lens you own. You can't very well handhold it out the window, and laying it directly on the window frame doesn't work well either. Far more effective is to rest the lens on a beanbag or use a window mount. I normally use the Kirk Window Mount, either laying a beanbag on top or adding a ball-and-socket head. I use the former if I know I'm going to be moving my car quite often, since I can place my lens on the passenger seat, drive the required distance, and quickly drop the lens back into place. On the other hand, if I know I'm going to work from one spot I add the ball-and-socket head so that I can release my grip on the lens, thus relaxing my arm and hand muscles. Whenever I have to reposition my car I always leave the window mount in place, removing only the lens. When I'm working from my "car blind" I always keep a 1.4X teleconverter and extra film within a quick and easy reach. By the way, the best shooting technique I've learned is to tuck my left arm in tight between my body and the seat back while my right elbow is braced against the steering wheel.

The other two blinds I use and would recommend are L.L. Rue's *Ultimate Blind™* and Rod Planck's *N-Visabag Blind™*. Rue's is a self-supporting blind that is extremely quick to erect. The old traditional blind of four

COYOTE IN WINTER, YELLOWSTONE NATIONAL PARK, WYOMING.

Nikon F4, Nikon 500mm lens, Fuji Provia.

This was photographed out of my car window as I drove through Lamar Valley. The coyote was trotting along, paralleling the road, so I repeatedly pulled ahead of it and waited for it to pass.

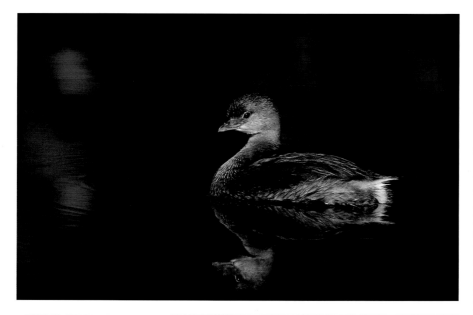

▲ PIE-BILLED GREBE, WINTER PLUMAGE, NEW MEXICO.
Nikon F5, Nikon 500mm lens, Fuji Velvia.

When I left for New Mexico to photograph landscapes, I decided to take my N-Visabag blind at the last minute. On the day I stopped at a small, marshy area and saw a group of grebes, I was glad I had taken it along! I had photos in less than thirty minutes.

▶ MALE YELLOW-HEADED BLACKBIRD, MONTE VISTA NATIONAL WILDLIFE REFUGE, COLORADO.
Nikon F5, Nikon 500mm lens, Kodak E100SW.

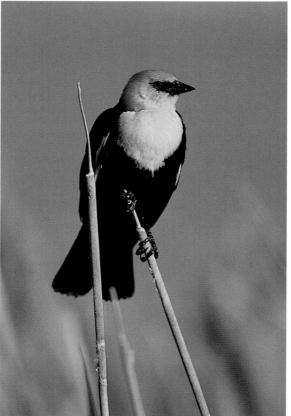

I was photographing late in the day, using my 500mm lens on a Kirk window mount. I had positioned my car and was shooting out the driver's-side window. I hung some cloth across the open window to disguise my movement in the car, as I was working close to my lens's minimum focusing distance.

uprights guywired into place is extremely difficult to position, as you seem to always end up just a few feet out in the wrong direction. No problem with the Ultimate Blind since it's not fastened down. However, I certainly would stake it down once it's correctly positioned to keep any strong wind gusts from blowing it away.

Planck's blind is literally a bag, which you place over your head and tripod. It's made of camouflage-pattern cotton and netting so that on a warm day you don't feel like you're in a sauna. The idea is to find your location and toss the "bag blind" over yourself. Where I've used it with good luck is along the edges of marsh ponds. Wear waterproof chest waders and simply sit down along the water's edge, preferably adjacent to cattails or other vegetation. When you drape the blind over yourself and your tripod-mounted long lens, you immediately disappear. If you don't see anything worth shooting within a short period of time, perhaps half an hour or so, you can easily move to another location.

A few times I've taken the bag blind and draped it over a framework to give myself a bit more room inside. Years ago I used a cover fitted over a standard Welt Safe-Lock projection stand for a blind. The cover is long gone but I still own the same projection stand, and if need be the bag blind goes over the top.

In passing, I might mention that whatever blind you use, I would suggest getting it in a camouflage design unless it's on private property and unlikely to be disturbed. I'm not suggesting having a camouflage pattern in order to hide from your subjects. Unfortunately blinds are sometimes stolen or vandalized so the camouflage helps to disguise it from passing humans. If nothing else, a curious soul won't come peeking in at the most inopportune moment, just as that critter you're been waiting for finally comes down the trail. A camouflage blind helps you keep a low profile, which is this day and age is probably good advice for photographers.

L.L. Rue's Ultimate Blind is available from:

Leonard Rue Enterprises, Inc.
138 Millbrook Road
Blairstown, NJ 07825-9534
Phone: (908) 362-6616; (800) 734-2568
 (orders only)
Fax: (908) 362-5808.
www.rue.com

Rod Planck's N-Visabag may be ordered from:

Rod Planck Photography
P.O. Box 169
Paradise, MI 49768
Phone: (906) 492-3444

Aerials

Whenever you have the opportunity to take aerial photos, do so. Just by getting above the landscape , you'll gain a radically different perspective from which few other photographers ever work. The view is truly unique: so few aerial photos are taken that it's rare to see two of them that are even remotely similar.

Shooting from a commercial airliner window through the layers of Plexiglas is rarely productive, although given the right conditions you can occasionally get a good shot. Obviously you'll need a window seat, but be sure it's in the front part of the plane so you can avoid any heat distortion from the engines. You'll also be better off if you can work from the shaded side of the aircraft. Direct sunlight will emphasize any defects or scratches in the windows, which are common on older planes. You should book your seat assignment with these considerations in mind, but as to the condition of the plane itself you can only hope for one which is fairly new and clean. Carry a camera with a medium zoom lens, such as a 35–70mm or 28–105mm, to give you some cropping options. Don't try to use anything much longer unless you like soft-focus photos, which the multiple layers of Plexi will result in. Keep your lens from touching the window, try to shoot with the least angle possible, and forget about using any filters. A polarizer will not emphasize the landscape, but will show you a rainbow of colors from stress patterns in the window.

Commercial airplanes are okay for the occasional photo, but for real aerial work you'll need to rent a plane. For most of us that means a fixed-wing aircraft, as helicopter time is far more expensive. Given the chance, you could work from a hot air balloon, but then there's the problem of not being able to go around for a second time. Actually, what I really would like to do is work from a blimp. I'm convinced it would be the ideal shooting platform; slow and low-flying, large windows which open, a cabin where I could easily spread out my gear . . . wow! A blimp would indeed be perfect if one were available, but it would undoubtedly also be quite pricey to rent.

A more realistic idea is to rent a small airplane with a competent pilot. The latter is the most important aspect of aerial work as far as I'm concerned. A saying I learned long ago runs through my mind: There are old pilots, and bold pilots, but there are no old bold pilots. Be positive that your pilot is well qualified and has flown with photographers before. Long before you take off, go over what you want to photograph, how high you want to fly, and how long the flight will last. Be as specific as possible, since the odds are that the pilot has seen far more of the local terrain from the air than you have and might suggest some even better locales. The more communication between you and the pilot—both before and during the flight—the better your chances of getting good shooting opportunities.

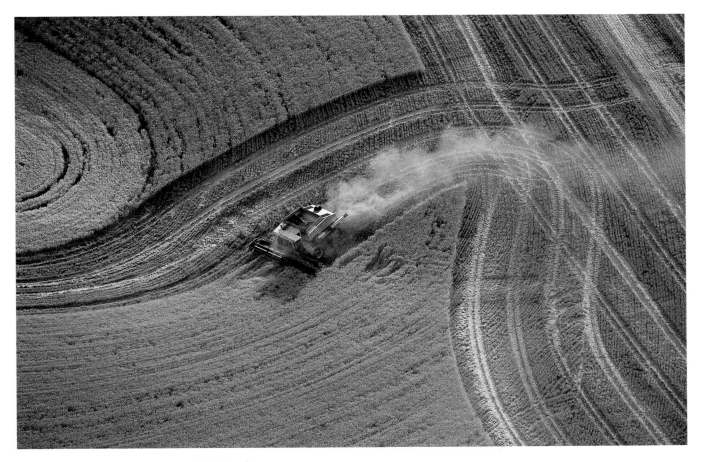

COMBINE HARVESTING WHEAT NEAR PULLMAN, WASHINGTON.
Nikon F5, Nikon 80–200mm lens, Fuji Velvia pushed 1 stop.

A late afternoon photograph on a dusty August day, photographed from a Cessna 172.

As far as the aircraft itself, the most commonly available planes are the smaller Cessnas. The 172 is probably the easiest to work from; it's a four-place plane which gives you enough room for gear, while its slow airspeed range is just about ideal for photography. In order to get sharp images you'll want to avoid shooting through a closed window. Have the pilot remove the window hinge pin (this probably has already been done if the pilot has flown other photographers). Once aloft you can open the window, which hinges upwards, and it will remain open, held against the wing by the airstream. Keep your camera well back from the window, away from the rushing airstream. I rarely use lens shades when photographing from a plane, because it is all too easy for them to protrude into the slipstream, resulting in either terrible camera shake or a skydiving shade. In order to minimize the airplane's vibrations, avoid touching the aircraft body with either your camera or your upper body. Lean forward a bit in the seat so that you can rock your body to cancel the buffeting winds.

Other planes can certainly be used for photography, although trying to photograph from a low-wing plane, or through a bubble canopy, yields far more frustration than I care to deal with. The tradeoff you always must consider is between minimum safe airspeed and range, fuel consumption, and rental expense. With a Cessna 172 you can usually photograph with the window open at speeds under 100 miles per hour. Larger planes need faster airspeeds to keep from stalling, which also necessitates faster shutter speeds to minimize blur. Still, the one other plane that I've used with great success is the Cessna 206. This has a fairly large rear door, actually for loading luggage and other freight, which can easily be removed. Reverse the rearmost seat (you'll be flying sitting backwards—just a warning if you have any tendencies toward airsickness) and the working space through the door is greatly increased over an open window. Since both the wing strut and landing gear are forward of the opening, you can also use shorter lenses than you can in smaller planes; I've photographed this way with lenses as short as 24mm and cleared the wings. However, since you're sitting in the back of the aircraft, you can't easily direct the pilot as to where you want to go. Having another person up front who knows your intentions is pretty much your only option unless you can rely totally on the pilot's judgement. My easiest aerial photography trips in this plane have been when I've worked with another photographer. One of us would sit up front, directing the pilot and working through the opened window, while the other was in the back, shooting through the open door. Headsets are an absolute necessity for communication in this situation. The photographer in the back is facing a different direction from the people up front, and the noise from the open door drowns out normal speech.

In terms of equipment, the motor drive now built into all cameras is extremely helpful since you can't stay in position for long when aloft. Make quick compositional decisions and fire away. The cost of extra film and processing is nothing compared to the time and expense of renting a plane or having to repeat a flight. Make sure you can load and unload your camera quickly and easily. When you're bumping around in a small plane it's definitely not the time to practice.

I suggest using a fast aperture zoom lens if you own one, or a fast 50mm. All lenses are optically at their best when closed down about 2 f-stops from wide open. Start with an $f/2.8$ lens and you'll be working at $f/5.6$, but start with a slower $f/5.6$ lens and you're at $f/11$. You will almost never work at an aperture smaller than $f/5.6$, and in low light you'll be shooting wide open since you always need to use fast shutter speeds. After all, you're handholding the camera, the airplane is bouncing around, and you're constantly moving rapidly over your subject. I always try to keep my shutter speed at no slower than 1/500 sec. if I can, which means I normally use ISO 100 film. Push processing the film 1 stop is an option if you need more shutter speed. By the way, remember that the lower the plane's altitude the faster the shutter speed needed to compensate for increased relative ground movement.

My two favorite aerial zoom lenses are my 35–70mm $f/2.8$ and my 80–200mm $f/2.8$. Quality zooms are especially useful for aerial work as you can quickly change framing without changing altitude. Fixed-focal-length lenses demand that you mount and dismount them, although you could have several cameras with a different focal length on each. The one advantage of a fixed focal length is the possibility of wider apertures for low-light photography. Many pros keep a 50mm lens in the $f/1.4$ to $f/2$ range just for aerial work. These lenses certainly don't have to be the latest autofocus models, since for practical purposes you're always shooting aerials at infinity focus. Start to worry if you ever need to focus closer!

Remember that just because it's an aerial view, that doesn't mean it's a good photograph. Always keep composition and lighting concepts in mind, whether photographing from the air or from a solid position on the ground. Working early or late in the day, especially immediately after a storm has cleared the air, is probably the best choice. But regardless of the conditions, try to shoot aerial photographs whenever you can.

COTTONWOOD TREES IN CANYON, GRAND STAIRCASE-ESCALANTE NATIONAL MONUMENT, UTAH.
Nikon F5, Nikon 80–200mm lens, Fuji Velvia.

This photograph was taken at almost noon, normally the worst time of day for aerials, from a small Cessna.

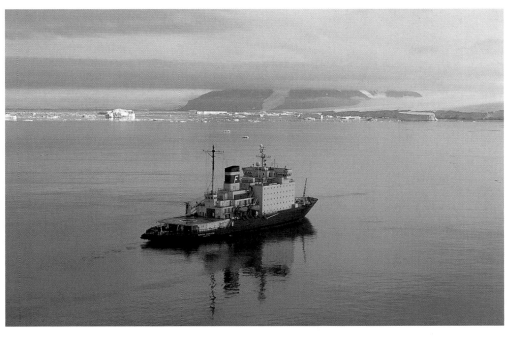

TOUR BOAT AND ICE, ANTARCTICA.
Nikon F4, Nikon 35–70mm lens, Fuji Provia.

This photo illustrates the fact that you should always take pictures, even if the situation isn't ideal. It was shot through the extremely scratched and dirty Plexiglas window of a Russian helicopter.

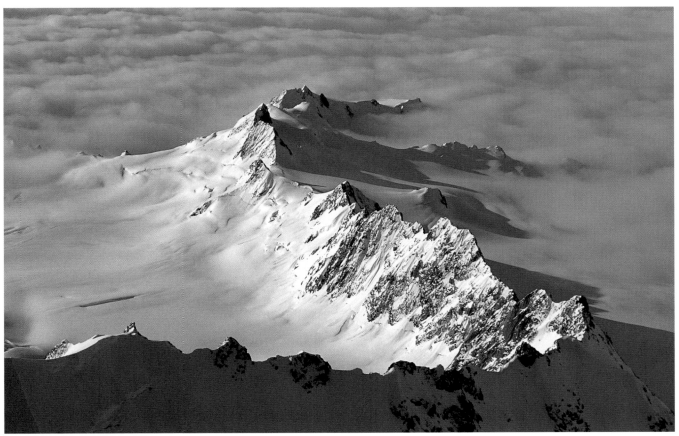

MOUNTAIN RIDGE IN THE SOUTHERN ALPS,
SOUTH ISLAND, NEW ZEALAND.
Nikon F4, Nikon 35–70mm lens, Fuji Provia.

The Southern Alps surround Mt. Cook on the South Island of New Zealand. One look at this knife-edged ridge and I was glad to be flying over it, rather than trying to hike its length.

WEATHER CONCERNS

Camera equipment seems to be designed to be used in good weather—fairly mild temperatures and no adverse environmental conditions impacting either equipment or photographer. Cameras are easy to handle when used indoors, tripods simple to erect on hard, flat surfaces, lenses quick to focus at 80°F. But as nature photographers, we work in all sorts of weather. In fact, that perfect cloudless blue-sky day is about the last time we would be out photographing. For us, bad weather is good weather because it has mood and emotion, but there are certain precautions you should take. Here are some helpful hints.

TRIPOD LEG COVERS
Metal tripods are cold in winter, hot to handle in midsummer, and hard on shoulders when carried. However, I certainly don't want to give up my aluminum Gitzo tripods; picture quality is worth a little inconvenience. So, make your tripod a bit more user-friendly by covering the legs.

Even when you're wearing heavy gloves, holding a metal tripod in winter quickly draws heat from your hands. You'll get colder and colder the more you have to deal with the tripod. An easy solution is to wrap the legs with tape, creating a simple heat barrier. Nothing fancy here; even electrician's tape works fine. Bicycle handlebar tape is even better, although quite a bit more expensive.

Many photographers cover their tripod legs with foam padding, which makes the tripod more pleasant to handle while at the same time more comfortable to carry over your shoulder. Padding kits are available from several companies, but you can easily make your own from foam pipe insulation for only a few dollars. Even better, as far as I'm concerned, is the closed-cell foam insulation for air conditioning and heating units. Regular pipe insulation is open-cell foam. It's slightly scratchy and often comes slit down its entire length. The closed-cell insulation I use (sometimes referred to as "armaflex insulation") is harder to find, but in my opinion a bit more comfortable on both your hands and shoulders. It stays in place all by itself, since it slips right over the tripod legs—you'll have to remove the lower leg section in order to put it on.

WEATHER COVERS
There are some great pictures to be made in wretched weather. However, I'm not crazy about taking my expensive electronic cameras and lenses out when it's raining or snowing. Weather covers help.

The simplest cover is a plastic shower cap. To be honest, I have shower caps from almost every hotel I've ever stayed in overnight. You don't want to photograph through the shower cap, but just use it to protect your camera. I'm in the habit of walking around looking for a composition while carrying my tripod over my shoulder with the camera mounted on its head. Covering the camera with a shower cap protects it from rain or snow. The elastic band keeps the cap from blowing off. When I see a potential photo, off comes the shower cap, just long enough to take a few frames.

But shower caps don't work if you're using big lenses or if you need to keep shooting. If either of these is true about your situation, the only answer is a rain cover. Several companies offer them (see the ads in any issue of *Outdoor Photographer* magazine), or you can sew your own. It doesn't have to be pretty; it just has to work. If you do make one, remember that you must be able to access the camera controls and rotate the lens for vertical/horizontal positioning. I've got a nice Gore-Tex cover for my 500mm made by Christy Covers, and a rather funky homemade cover for my 300mm. Between the two of them, they let me keep shooting regardless of the weather conditions.

TRIPOD SNOWSHOES
Photographing in winter in the western states is a shock to many photographers; that snow is *really* deep! It's bad enough that you sink into it, but your tripod also disappears beneath the drifts. Well, just as you can use snowshoes on your feet (and snowshoes are far easier to use for photography than cross-country skis), you can put snowshoes on your tripod's feet.

As with tripod leg pads, you can purchase tripod snowshoes ready made. But it is extremely easy to make your own set for a total cost of about $3. Head for your local home improvement store and purchase the following:

- A set of slip-on crutch tips (the rubber furniture-leg tips) in a size large enough to slip snugly over your tripod feet.

- 3 1/4–20 one-inch long bolts, the nuts for them, and six flat washers that fit the bolts.

- 3 flat plastic test caps (look in the plastic pipe section). Mine are for 4-inch pipe and cost 25 cents each.

TRIPOD SNOWSHOE, DISASSEMBLED.

TRIPOD DECK SHOE, MOUNTED ON TRIPOD FOOT.

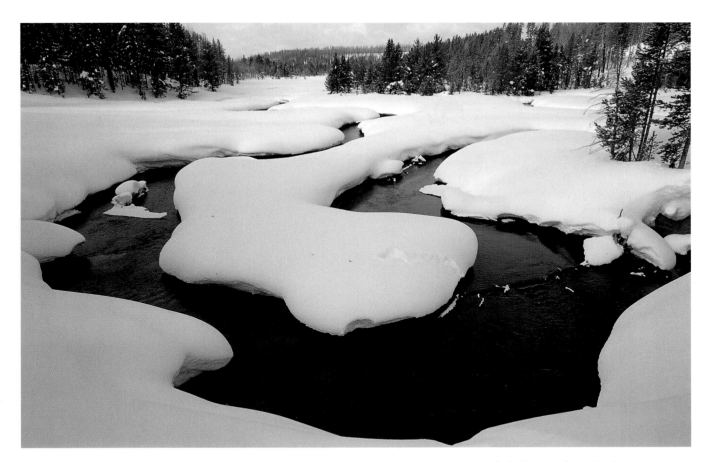

MEANDERING STREAM IN MIDWINTER, YELLOWSTONE NATIONAL PARK, WYOMING.

Nikon F5, Nikon 20–35mm lens, Fuji Velvia.

The snow depth at this location was about to my waist, so snowshoes for both me and my tripod were necessary. In fact, the most difficult aspect of taking this shot was climbing back up a 45° embankment to the winter road.

Now, to assemble: Drill a hole through the center of the bottom of each crutch tip, and through the middle of each plastic test cap. Take a bolt, add a washer, and thread it through the crutch tip, then through the test cap, then add a second washer and a nut and tighten. That's it—you've got a tripod snowshoe! Slip one on each tripod leg, strap on your own snowshoes, and go photograph. Just as you will still sink a little into the snow when you're wearing snowshoes, your tripod will also . . . but it won't go out of sight in powder snow as it would otherwise.

By the way, if you're working in fairly deep snow without using tripod snowshoes, it's very easy to break your tripod's top casting, the center piece to which all the legs connect. The tendency is to erect the tripod just as you would if there were no snow; you spread the tripod legs until they hit against the stops, then shove it down into the snow. What happens, however, is that even though the legs are already spread as far as they will go, shoving the tripod into the snow forces the legs even further apart. Since the legs are already against the stops, what usually gives is the top casting. Lots of force is applied at a

right angle to this piece, so it fractures, leaving you with a broken tripod. Avoiding this potential problem is easy; if you must shove your tripod down into snow, don't spread the legs out all the way. As the tripod goes down into the snow the legs can then continue to spread open without hindrance.

TRIPOD DECK SHOES

If you ever have to photograph from the deck of a boat while the engine is running, here's a vibration damper for your tripod. Buy a sheet of closed-cell foam in whatever thickness you can find. This stuff is often sold in a roll as a "sleeping bag mat" at stores such as Wal-Mart or REI, and should cost about $8. Just buy one roll; it will be enough for you and all your photographer friends with lots of the foam left over.

Cut three triangular pieces. Make each triangle so that two sides are roughly 10 inches in length, while the third side is only 4 inches, so you've got a long, skinny, pointed piece of foam. Now fold it around a tripod leg, and wrap it with strapping tape (look at the picture if you don't understand these instructions). You should be able to shove it on, or

pull it back off, with little effort.

What inspired me to make these things in the first place? I've been to Antarctica on several trips, each time on a steel-hulled, diesel-powered ship. Cruising through the islands and bays of the Antarctic Peninsula is breathtakingly beautiful, but that diesel engine keeps on running. I wanted to use my tripod, for compositional reasons if for nothing else, but lots of vibrations come up through the steel decks. I needed vibration dampers, and I needed something that would stay with my tripod as I repositioned it from one side of the ship to the other. Deck shoes were the answer.

Now don't get me wrong, these won't solve all vibration problems, and they certainly do nothing for the rock-and-roll motion of the ocean. But they will give you a little advantage over other photographers who resort to handholding their lenses. I've used lenses up to 400mm in this fashion, and gotten good results. Leave the tripod head slightly loose since the boat is still moving and you must pan with the subject; remember to lock it down before you let go of your lens. Keep your shutter speed reasonably fast, and fire away.

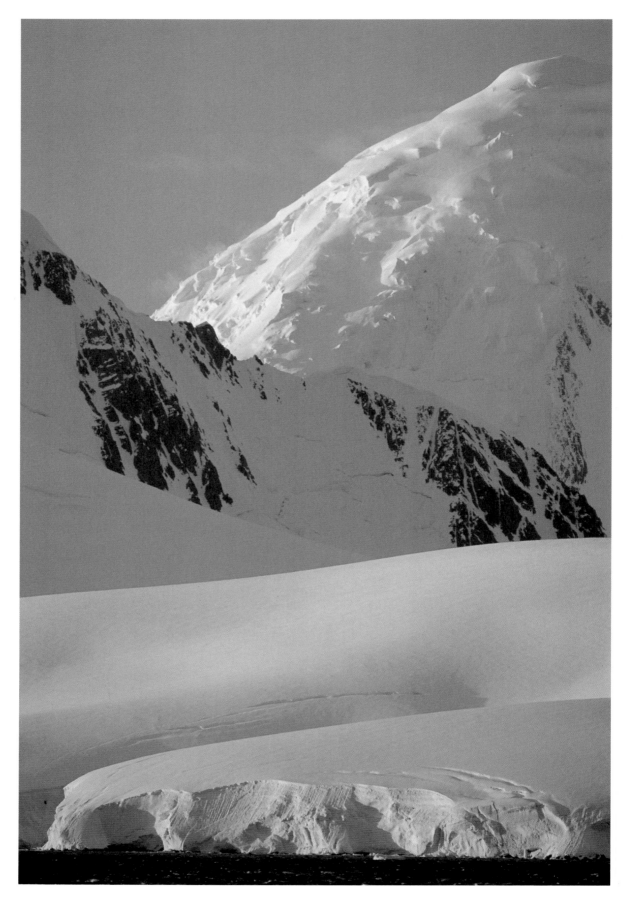

TIDEWATER
GLACIER IN
THE NEUMAYER
CHANNEL,
ANTARCTIC
PENINSULA.
Nikon F4, Nikon
80–200mm lens, Fuji
Velvia, tripod with
deck shoes.

Photographed at first light, about 3:00 A.M.

MY PERSONAL FIELD GEAR

I'm often asked about what specific equipment I carry. In some ways this is a pointless question, since equipment in and of itself does not take pictures—photographers do that. The very best equipment used poorly can produce bad images, while mediocre equipment used well can produce exquisite ones. I've joked for years about the fact that a comment I often hear is "Gee, you must have a good lens," as if some lens went out all by itself and took pictures. You know, every morning I tell my lenses to go do some work while I relax with another latte. But they never do! Quality equipment certainly does make life easier in the field, but all the fact that you own good equipment means is that you've invested some money in your photographic outfit.

On the other hand, let me acknowledge that I'm an equipment junkie. Most photographers fall into this category, and I'm probably leading the pack. The following lists will not be correct for long, as I will undoubtedly switch my gear around as new lenses and cameras become available. I don't want to present these lists as endorsements per se of any equipment, although I've tried all sorts of cameras, lenses, and camera bags over the years to arrive at my current outfits. This equipment works for me, but don't copy my gear; develop your own outfit tailored exactly to your needs, your subject matter, your expense account, and your preferences. And here's an honest warning from one who knows: it's just as easy to have too much equipment as it is to have too little.

I use Nikon equipment, and have for my entire professional career. I'm very happy with Nikon gear, but you can certainly take good pictures with any brand. I'll mention right here that I do not work for Nikon, nor am I on any sort of financial retainer from the company—although if it offered I would certainly listen! I buy my camera equipment with my own money, just as you do. I normally carry gear in a Lowepro Pro Trekker AW photo backpack. This pack has the best harness and strap system of any backpack I've ever used, so it's comfortable to carry all day in the field. When I'm working directly from my vehicle—for example, when I'm driving to locations and doing day trips based from the car—I keep extra gear in an old Tamrac 612 shoulder bag and transfer equipment as needed to the Lowepro. I'm a charter member of the "bag-of-the-month" club, and have a number of smaller bags and backpacks around with odds and ends in them.

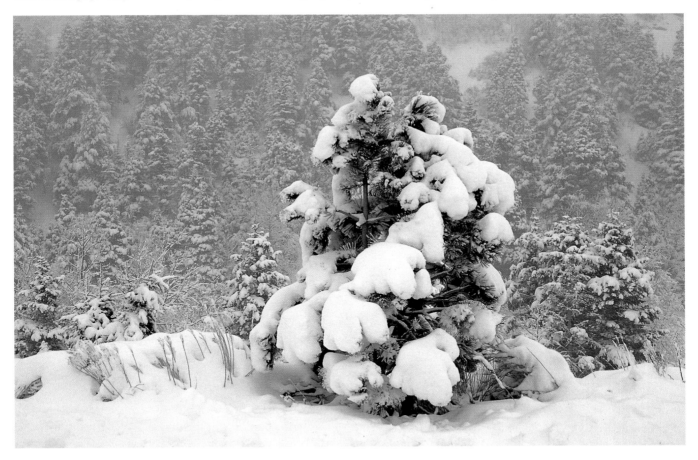

PONDEROSA PINE IN SNOWSTORM, COLORADO.
Nikon F4, Nikon 28–70mm, Fuji Velvia.

I almost got stuck taking this picture. I was preoccupied with my photography and hadn't realized how much it was snowing . . . and I had driven many miles down a narrow dirt road to this location. Part of working in the field means being prepared for times like this, and not just with the correct camera equipment. For winter shooting trips I always load my Suburban with the essentials: water, food, a warm sleeping bag, a flashlight, and a thick book to read.

The following is a list of what I carry:

CAMERA BODIES:

- Two identical Nikon F5 bodies, so that I don't fumble around using them. The neckstraps are different colors denoting different film in each body. One camera is normally loaded with Velvia, the other with an ISO 100 film. Occasionally I will carry a third body for backup, if my destination warrants such precaution.

LENSES (ALL ARE NIKON):

- 20–35mm *f*/2.8 AF
- 35–70mm *f*/2.8 AF
- 80–200mm *f*/2.8 AF
- 300mm *f*/4 ED-AF lens if I'm only going to be working landscapes; otherwise a 300mm *f*/2.8 ED AF-S lens plus both 1.4X and 2X Nikon TC-E teleconverters (if Nikon releases a 400mm *f*/4 ED AF-S lens I will definitely replace both 300mm lenses with it).

ACCESSORIES:

- Nikon SB–28 flash + off-camera cord.
- Flash X-Tender folding fresnel tele-flash concentrator.
- Nikon 5T closeup lens (works on the 35–70mm for quick and dirty closeups).
- Extension tubes: Nikon PK-11a, PK-12, and PK-13.
- Filters: Nikon A2 (an 81A equivalent) and circular polarizers for all lenses (including drop-in polarizers for the long lenses); Singh-Ray 1- and 2-stop graduated ND filters with a Cokin filter holder and adapters to fit all lenses.
- Nikon MC-30 remote release.
- Gossen Luna Star F2 incident light meter (I carry this more for my 6 x 17cm panoramic work than for 35mm).
- Photoflex Litedisc 42-inch diffuser and 12-inch reflector.
- If birds and mammals are in the forecast, I add my 500mm *f*/4 ED AF-S lens, carried in an old Domke long lens bag (with an

extra layer of closed-cell foam inserted). I keep a rain cover for this lens in the bag's outer pocket. Using teleconverters on this lens gives me a 700mm *f*/5.6 or a rarely-used 1,000mm *f*/8.

- For macro photography of flowers I usually work with the 200mm *f*/4 AF Micro-Nikkor, but I pack the 105mm *f*/2.8 AF Micro when space is limited.

ODDS AND ENDS SCATTERED THROUGH BAG POCKETS:

- as much film as possible in zip-lock bags
- tiny MagLight flashlight (one AAA battery)

- Swiss army knife
- 12 feet of nylon parachute cord (for tying back branches)
- tiny screwdriver (actually meant for eyeglass repair; it has a straight blade on one end, Phillips on the other)
- Allen wrench that fits all quick-release plates
- the largest blower bulb I can find
- lens tissue; micro-fiber cleaning cloth
- Sharpie marker
- old toothbrush (to remove sand from tripod leg locks)

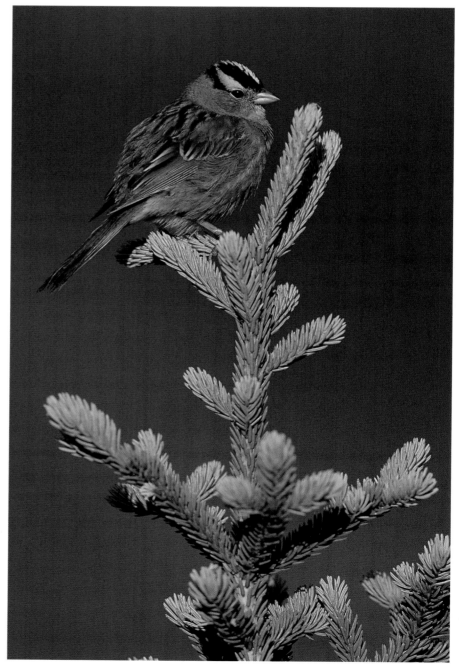

WHITE-THROATED SPARROW ON SPRUCE, DENALI NATIONAL PARK, ALASKA.
Nikon F4, Nikon 500mm lens, Fuji Provia.

I was camped in Alaska's Denali National Park, and this white-throated sparrow's favorite singing perch was the small spruce just a few yards away.

- heavy-duty trash bag
- small notebook and pen
- insect repellant
- sunblock
- ibuprofen tablets

In my car I carry a repair/parts kit (this goes in my luggage whenever I travel by air): needlenose pliers (with a stout rubber band around the handle it also works as a vise); a jeweler's screwdriver set; two 4-inch long crescent wrenches (to tighten tripod legs); a crutch tip (in case a tripod foot departs); a film retriever; a Leatherman tool; an Allen wrench set; an extra knob and spacer for the tripod head's quick-release clamp (lose those, and your tripod is useless); Singh-Ray optical cleaning fluid; a plastic film canister filled with small camera parts (machine screws, washers, springs, etc.); a tube of Krazy Glue; a small roll of duct tape; and an extra MC-30 remote release. To tell you the truth, I fix other people's tripods and cameras far more often than I ever have to work on mine. Still, an ounce of prevention. . . .

My absolute minimal outfit when size and weight are the overriding concerns fits into an ancient fanny pack:

- one F5 body
- 28–70mm *f*/3.5–4.5 lens
- 70–300mm *f*/4–5.6 lens
- Nikon A2 filters, circular polarizers, 5T closeup lens, remote release

I always photograph from a tripod. The number of natural light handheld photos I take per year is minuscule. For normal photography, I use Gitzo G-1340 legs with Kirk BH-1 quick-release equipped ball head. For long-lens action work, I use Gitzo 410 legs plus Wimberley head with quick-release, and when weight is an overriding concern, I choose Gitzo 1348 carbon fiber legs with Kirk head.

TROPICAL BUCKEYE BUTTERFLY, SOUTHERN FLORIDA.
Nikon F4, Nikon 105mm macro lens, Nikon SB-25 flash, Fuji Velvia.

I knew that when I went to Florida I would have a great opportunity to photograph a number of butterfly species, and consequently I had all the right equipment with me to do so.

MOONRISE AND CLOUDS, BUFFALO GAP NATIONAL GRASSLANDS, WYOMING.
Nikon F4, Nikon 20–35mm lens, Fuji Velvia.

Twilight on a late summer's day in the high prairie . . . the perfect place to be. But come to think of it, there are many perfect locations. Good shooting!

A Nature Photographer's Calendar: A Seasonal Guide to Locations

Anyplace in the world is beautiful if you're there at the right time. Being in the most exotic locale on earth at exactly the wrong time, whether it be the wrong time of day or the wrong season or the wrong year, is far worse than being in a mediocre location at the perfect time with great light and great conditions. But how to plan it so you're always in the right place at the right time?

There are many resources available, including tourist bureaus and travel councils. Information specifically geared for photographers can also be found in dedicated publications. You may want to subscribe to:

Outdoor Photographer
P.O. Box 56381
Boulder, CO 80322-6381
Phone: (800) 283-4410
Fax: (303) 604-7644
www.outdoorphotographer.com

Photograph America Newsletter
P.O. Box 86
Novato, CA 94948-0086
Phone: (415) 898-3736
Fax: (415) 898-3377
www.photographamerica.com

With the Internet, you can easily access more information than you can possibly absorb. Check out photography forums and chat rooms, or do a search for a specific site. Some of the National Parks and Monuments have real-time video images. Want to know if there is snow on the red rocks of Canyonlands? Check their home page to look outside the entrance station.

There are also tour companies that take care of organizing a trip for you, whether you want to travel alone or with a group. Be sure you deal with a photography-oriented company, as most tours are designed for the casual tourist to whom an 8:00 A.M. departure is the crack of dawn. Pick a company that specializes in nature photography, then check out their itineraries and their leaders to make sure both meet your qualifications. I recommend a company offering worldwide trips; I lead a few tours for them every year.

Joseph Van Os Photo Safaris, Inc.
P.O. Box 655
Vashon, Washington 98070
Phone: (206) 463-5383
Fax: (206) 463-5484
www.photosafaris.com

Wherever I travel I pick up every map, brochure, and handout that I can find. These are all filed by location in my office, for future reference. I keep a shooting log of my field work, jotting down lots of notes as I go. I keep track of specific locations, names of features not marked on maps, blooming dates, the best times of day for certain subjects, and important phone numbers. If a DeLorme Atlas and Gazeteer is available for any state I photograph, I make sure I purchase one. These are the most practical, most highly detailed state maps I've ever used; they cover not only all the roads, including dirt ones, but also mark out waterfalls, lighthouses, covered bridges and more. I highlight good areas on these maps and make notes right on the pages about the best time of day to shoot and other info. Many larger bookstores—including Amazon.com—carry these mapbooks, or you can go directly to the publisher:

DeLorme
Two DeLorme Drive
P.O. Box 298
Yarmouth, ME 04096
Phone: (800) 452-5931
Fax: (800) 575-2244
www.delorme.com

Here is a month-by-month calendar for some suggested photography locations. This list is by no means complete—great pictures can be found anywhere. As you read this list, remember that nature doesn't follow any formal schedule so the peak time for a natural event may vary from year to year.

A Calendar

January
Death Valley is wonderful in the winter, since the temperatures are tolerable and it's not overrun with tourists. Check out the **Valley of Fire** in southern Nevada. The **Oregon coast** offers winter storms—crashing surf, that is—as a backdrop to miles of public coastal access. Work the seastacks at Cannon Beach or the dunes near Florence. Snow on red rock formations is possible across the high desert of the Colorado Plateau, so plan a trip to the **Utah parks**: Arches, Canyonlands, Capitol Reef, Zion, and Bryce. Some other possibilities: the overwintering monarch butterflies in **Mexico,** or gray whales in **Baja California.**

February
This is a great time of year to work the interior of **Yellowstone,** with deep snow and the best chance of blue sky days. Hope for extremely cold weather, all the better for frost-laden "ghost trees" in the thermal areas. Lots of wildlife can be found on the north side of the park, including bison, big-horn sheep, elk, and pronghorn (near the Gardiner entrance). You can drive the Lamar valley road, the only plowed road, all the way to Cooke City. **Yosemite** also offers great winter scenics, although the snow can be short-lived in the valley, but at this time of year you won't have the crush of people that summer brings. For warmer weather, head to **Florida.** Ding Darling National Wildlife Refuge on Sanibel Island, near Ft. Myers, is world-renowned for its wintering bird populations. Right in Venice is a famous heron and egret rookery offering close-in, eye-level views of the nesting activity. Other good locations: Myakka River State Park, and Estero Lagoon near Ft. Myers Beach where the best opportunities are found by wading. For landscape work, my favorite area is Big Cypress National Preserve, adjoining Everglades National Park. Big Cypress has few amenities, so it attracts relatively few tourists.

March
Head to the deserts, especially those in **Arizona.** I like the western section of Saguaro National Monument outside Tucson; the Superstition Mountains near Phoenix; and Picacho Peak State park between Phoenix and Tucson. Organpipe Cactus National Monument, on the Mexican border, is my favorite destination as it is more rugged and less developed; be prepared to camp—there's just one motel in Lukeville, the nearest town. **California** wildflowers are just starting to appear, as are blooms in Big Bend National Park, **Texas.** If you still want to shoot in cold weather conditions, try the harp seal pups on the ice off the **Magdalen Islands** in the Saint Lawrence.

APRIL

April is wildflower month. In the west, head for **California.** If the autumn and winter rains were good, spring in Anza-Borrego State Park and Joshua Tree National Park can be spectacular with carpets of flowers. Check out the California Poppy Preserve in Antelope Valley, near Lancaster. Just a bit further is the area around the Gorman Post Road for rolling hills. In the middle of the country, head for **Texas.** On a good year, the Hill Country around Austin is, in my opinion, the greatest wildflower display in the US, especially the fields that have a mixture of red paintbrush, bluebonnets, and yellow composites. The best flowers are right along the highways, so you don't even have to con-

sider trespassing. The National Wildflower Research Center in Austin has handouts detailing driving routes, and many smaller towns have "Bluebonnet Trail" celebrations. I've had great luck around the Lake Buchanan and Kingsland areas northwest of Austin, and also in the area just south of Brenham (home of Blue Bell ice cream, reason in itself to go there!). At the end of the month, head to the southern **Appalachians** for another spring bloom. The Great Smoky Mountains National Park is best in late April: you'll find woodland wildflowers, flowering dogwoods, cascading streams, and mountain scenes. The Tennessee side is slightly wetter and consequently more lush, while the North Carolina side has far fewer visitors.

MAY

Early May is a great time to work the **Utah** National Parks. Summer heat hasn't started yet, skies are generally clear, and wildflowers are blooming. Look for paintbrush growing in the sandstone cracks. Head over to Monument Valley for some additional scenics. In mid-month, waterfalls are normally running at their fullest in **Yosemite,** while the vacationing crowds are not yet so numerous. In **the Northwest,** moss-green forests are at their most lush with vine maples glowing emerald amidst the spruce and hemlock. Late in the month, along **northern California**'s Coastal Range, hills are green and rhododendrons are blooming in the redwood groves. In the upper midwest, spring is just arriving. Woodland flowers are coming out strong in

SOUTHERN GIANT PETREL, SOUTH GEORGIA, DECEMBER.
Nikon F5, Nikon 300mm lens, Fuji Velvia.

SAGUARO CACTUS AT DAWN, SAGUARO NATIONAL MONUMENT, ARIZONA, APRIL.
Nikon F4, Nikon 80–200mm lens, Fuji Velvia.

Michigan, although mosquitoes are not far behind. In the east, hundreds of thousands of horseshoe crabs are on the beaches of **Delaware Bay,** attracting huge flocks of migratory birds. Check out Bombay Hook National Wildlife Refuge.

JUNE

June is the time for baby animals. In **Yellowstone** and **Grand Teton** National Parks this means bison and elk in particular. Wind Cave National Park, in southwestern **South Dakota,** offers the chance for young pronghorn as well. Prairie dogs have young pups out and about; accessible towns are in Wind Cave, Devil's Tower National Monument, Badlands National Park, and many other locations. Badlands offers many scenic possibilities also at this time of year, with new grasses and wildflowers contrasting with the massive formations. The Konza Prairie in northeast **Kansas,** and the Nature Conservancy's Tall Grass Prairie Preserve in **Oklahoma** are at their finest. In California, June is the month for the eastern **Sierras.**

WHITE MULE'S EARS,
WYOMING, JUNE.
Nikon F5, Nikon 20–35mm
lens, Fuji Velvia.

Photograph at Mono Lake and the Alabama Hills, and hike into the early lushness of Onion Valley not far from Lone Pine. By late in the month the roads into the White Mountains should be open, for scenes with the ancient bristlecone pines.

JULY

As summer heats up, head for the mountains. Going-To-The-Sun Highway, over Logan Pass in **Glacier National Park** in Montana is normally open by the first of the month. So is Trail Ridge Road in Rocky Mountain National Park. For even higher elevations, check out the Mt. Evans road, near Idaho Springs, **Colorado**—it's paved all the way to just over 14,000 feet elevation and has bristlecones and mountain goats. Of course, on a normal year late July means wildflowers in the alpine basins of the high Rockies. Head up a jeep road, then hike up-valley. Much further north, July is a peak time for bears in **Alaska,** since it's also a peak time for salmon runs. Brown bears can be photographed at Katmai National Park,

black bears at the Anan Creek Bear Observatory near Wrangell. For more adventure, head to the remote **Pribilof Islands,** north of the Aleutians, for millions of seabirds, arctic fox, and northern fur seals.

AUGUST

August is the best time to photograph killer whales. The easiest ones to get to are in the waters northwest of **Seattle,** in the **San Juan Islands,** and particularly a bit further north in the **Johnstone Straits** between Vancouver Island and the British Columbia mainland. Go with an organized tour, and observe all the rules. Head further north to **Denali National Park** in Alaska in late August to catch the height of fall color. The tundra can be ablaze with the reds and gold of alpine bearberry and dwarf birch, and the snowy Alaska Range towers above—it's a landscape photographer's dreamscape. Denali also offers arctic ground squirrels, hoary marmots, collared pika, willow ptarmigan in varied plumage, caribou, and moose. Of course the occasional sow grizzly with cubs in tow will probably cost you a few frames of film also. For something a little tamer, but no less spectacular, prairie sunflowers bloom at the **Great Sand Dunes National Monument.** Hike out along the base of the dunes, as far from the entrance as possible to get away from footprints. The dune system is wet, with water not that far below the surface, and the sunflowers appear directly from the sand. An otherworldly scene to be sure.

SEPTEMBER

Early in the month, head for Badlands National Park and its close neighbor, Wind Cave National Park (both in **South Dakota**) for landscape work. Mid-September would be my choice of time to photograph in Banff and Jasper National Parks in the **Canadian Rockies.** These are two of the most scenic mountain locales in North America. You'll believe you've seen every possibly combination of mountain reflecting in azure lake until you turn the next corner and find yet another combo. By mid-September the mobs of summer tourists have gone, and the first touch of autumn color is arriving. Speaking of autumn, fall comes to the aspen groves of the **Rockies** at the end of the month. In **Grand Teton** (Wyoming), don't miss the classic views from Ox-Bow Bend and Schwabacher's Landing, both exceptionally good in the early morning. Check out Mt. Nebo near Park City, **Utah,** for more aspens, as well as Boulder Mountain, between Torrey and Escalante, Utah, in Grand Staircase-Escalante National Monument. **Colorado** is famous for autumn aspens; base out of Ouray in the southwest corner of the state and drive in any direction.

All roads lead to good color. In the **Upper Great Lakes,** autumn color in the beech-maple-hemlock forests starts by the end of the month, spreading across the Porcupine Mountains in the far western end of Michigan's Upper Peninsula.

OCTOBER

October is autumn color month in the east. New Hampshire's **White Mountains** are a favorite destination of leaf-peepers, so either make reservations long in advance or plan on traveling self-contained. **Central Vermont** also offers color, plus all the white churches and quaint towns that film can record. Maine's **Acadia National Park** is another great locale; don't miss the nearby blueberry hills flaming bright red near the aptly-named town of Blue Hill. Lighthouses along the coast are well-marked and well-photographed, but still a welcome addition to anyone's stock file. The **southern Appalachians** also have great color displays. Canaan Valley in West Virginia's **Monogahela National Forest** is an over-looked spot, also good for white-tailed deer. **Great Smoky Mountains National Park** can be crowded on pleasant-weather weekends, so work midweek towards the end of the month. In the western U.S., cottonwoods turn bright yellow while aspens drop their leaves. By the end of October polar bears gather in the far north at **Churchill, Manitoba,** waiting for Hudson's Bay to freeze. You stalk them in huge "tundra buggies," which make a close approach possible.

NOVEMBER

Two great gatherings of snow geese can be photographed this month. In the **Klamath Basin** of California and Oregon, thousands of snow geese are intermixed with swans and ducks. It's also a good wintering ground for bald eagles. In New Mexico's **Bosque del Apache National Wildlife Refuge,** huge flocks of snow geese are joined by thousands of sandhill cranes with the occasional whooping crane making an appearance. Around Thanksgiving, the largest gathering of bald eagles in North America happens along the **Chilkat River,** just outside Haines, Alaska, as the last salmon run of the year occurs just before winter sets in. Time your arrival as the river starts to freeze up, push-ing the birds nearer the main river channel, which runs next to the road bank from which you photograph. Take your longest lens and be prepared for cold, wet weather. In drier climes, head to **White Sands National Monument** (New Mexico) for vast scenes of pure white gypsum dunes. At this time of year there are far fewer people—read "fewer tracks" here—a good possibility of

AUTUMN COLOR, GREEN MOUNTAIN NATIONAL FOREST, VERMONT, OCTOBER.
Nikon F4, Nikon 50–135mm lens, Fuji Velvia.

blue skies, and less wind. This is graphic landscape territory, but don't be surprised if you see an African oryx trotting across the dunes, from a small herd introduced in the nearby White Sands Missile Range.

DECEMBER

December is the time for extremes. Head for **Hawaii** if you want warm weather, as it's most pleasant at this time of year. You could do Maui, with Haleakala National Park and the Hana Coast, or head for the rugged Na Pali coast of Kaua'i. For a wilder time, go far to the south and photograph in the **Falkland Islands, South Georgia, and the Antarctic Peninsula.** Each of these could easily be a destination in and of itself, but they are usu-ally combined into one photo tour. For this trip you'll definitely be with a tour group as, aside from the Falklands, there is no other way to travel to these places. The smaller the group the better, and make sure to travel with a photography-oriented group. Plan on at least a month's travel—this is the trip of a lifetime. One more thing: Make sure to take lots of film and batteries, since not even FedEx delivers overnight to ships in the southern oceans.

INDEX